Robert J. Flaherty : A Biography

Paul Rotha

Edited by
Jay Ruby

University of Pennsylvania Press
Philadelphia
1983

Robert J. Flaherty: A Biography

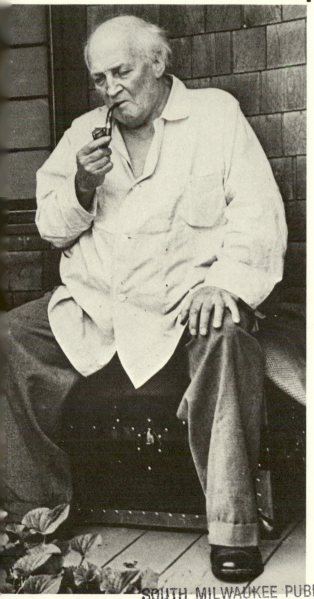

Photo credits:
The frontispiece photograph of Robert Flaherty is used with permission from Fred Plaut;

Plates 1, 2, 3, 4, 5, 6, 7, 8, 9, 10, 11, 12, 13, 14, 15, 16, 17, 18, 19, 20, 21, 22, 23, 24, 25, 26, 27, 31, 32, 33, 34, 35, 36, 37, 47, 48, 49, 50, and 51 are used with permission from the Robert and Frances Flaherty Study Center, School of Theology, Claremont, California;

Plate 11 is used with permission from the Royal Ontario Museum, Canada;

Plates 45 and 46 are used with permission from the Photographic Archives, University of Louisville;

Plate 51 is used with permission from the Robert and Frances Flaherty Study Center, School of Theology, Claremont, California, and International Film Seminars, Inc.

Library of Congress Cataloging in Publication Data
Rotha, Paul, 1907–
 Robert J. Flaherty, a biography.
 Bibliography: p.
 Includes index.
 1. Flaherty, Robert Joseph, 1884–1951.
2. Moving-picture producers and directors—United States—Biography. I. Ruby, Jay. II. Title.
PN1998.A3F5535 1983 791.43′0233′0924 [B] 83-6986
ISBN 0-8122-7887-9

Printed in the United States of America

Contents

Illustrations

Portrait

by Oliver St. John Gogarty

(1948)

The man I am writing about does me good to meet. It would do you good, too, merely to see him: a big, expansive man with a face florid with enthusiasm and eyes clear as the Northern Ice which he spent so much of his time exploring when he created one of his most famous pictures, *Nanook of the North*.

I often regret that I never met Walt Whitman. But there is a lot of him reincarnated in Bob Flaherty, who is further removed from the mediocre than any man I've ever known. For he, too, can take you into space—"to behold the birth of stars, to learn one of the meanings, to launch off with absolute faith and never be quiet again." And the more faith we have the easier it will be for us, when out time comes, to glide down the slips.

But absolute faith in what, you may ask? Absolute faith in the nature and the fate of man, a belief that there is a hero hidden in all men, and that when we are all in the same boat the hero will steer it. This is somewhat vague and abstract; but so is faith.

Bob Flaherty feels the need of great scenes where man is elemental and unspoiled by sophistication and machinery. This need can be felt in his picture, *Man of Aran*. It is what brought him to the extreme edge of Europe, to the last bulwark of the land where the limestone cliffs stand up three hundred feet and shoulder off seas that break in spray fifty feet above them, waves that come unimpeded all the way from Brazil. . . .

There is an island in Hudson Bay, about seventy miles long, called Flaherty's Island, for it was he who found it. "How big is it?" I asked him when I first heard of it. "It has two horizons," was his answer, a good one, for there are wide horizons in the man himself. He is the dramatic poet of

the screen, the only man who has realized to what heights of art it could be exalted and made to outdo the drama of the stage. . . .

In his great drama of the lives of elemental people he has the Shakespearian power of remaining off-stage, unseen and unsuspected, so thoroughly does he project his creations. When Flaherty tells a story his face is transfigured. It becomes lit with the light of the visionary scene. . . .

The world is Flaherty's stage. From the Pole to the tropical Isthmus of Panama he can range and tell of the trade that Spain did with China at the time of the conquistadors. All the precious art of the Chinese Empire—laconer, silk, jade, and porcelain—had to be taken across the Isthmus by porterage. Many priceless treasures were seized by bandits and recovered from their descendants by a dealer just recently. It was there a Chinese princess, on her way to visit the court of Spain, was captured and sold to a tribe of native Indians who to this day revere her as a saint; the Virgin of Guadalupe.

And listen to this, for Flaherty is a phrase-maker, and his generalities reveal deep thinking: "Every man is strong enough for the work on which his life depends."

But it is not Flaherty's story-telling that makes him the most magnanimous man I've ever met. It is his power of making you forget the trivial things in life and look only at the elemental things that build up the dignity of man. "If only men were honest, there would be no more wars." His face glows with the wonder of a child when he tells of the hidden paradise on the earth; or when he meets a friend. His finger never mutes the strings that vibrate in eternity. He has in him the expansiveness and generosity of the true American. . . .

The regions where his mind dwells few of us can commute, so the best we can do is to take care that we do not miss him when he comes to town. I hear that he is to be at the Coffee House Club for lunch today. Where is my hat?

Acknowledgments:

First thanks, of course, go to Mrs. Frances Flaherty and Mr. David Flaherty for their invaluable help in supplying information and checking the original manuscript of this book as well as their giving permission to quote so generously from their published works and those by Flaherty himself.

From the first interview at Black Mountain Farm, Brattleboro, in August 1957, up till the last moment, David Flaherty has been to endless trouble to assist us which, in view of his many other commitments, is greatly appreciated. We are also much indebted to the Robert Flaherty Foundation (now called International Film Seminars, Inc.) for making available documents, copyrights, photographs, and other material.

All the way through, the advice, anecdotes, and information supplied by Dr. John Grierson have been of immense value. We thank him for allowing us to reproduce some of his published work. Of equal help all through the preparation of our book, both in long firsthand talks and in correspondence, has been Richard Griffith, Curator of the Museum of Modern Art Film Library, whose own book *The World of Robert Flaherty* we have plundered so deeply. We thank him for his permission for so doing.

Both Griffith and Grierson knew Flaherty intimately, and we are indebted to the fact that they have read our original manuscript and set their seal of approval on it. Without it, we should have been unhappy.

We are also grateful to many others who knew Flaherty as a friend or who worked with him, which was often the same thing. Some of them sent us ample notes or appreciations specially written for the purpose and most of those listed now have read our original manuscript either in part or in whole: Richard Arnell, Osmond H. Borradaile, J. N. G. Davidson, Helen

Durant (van Dongen), J. P. R. Golightly, Irving Lerner, John Monck (Goldman), Newton A. Rowe, and John Taylor.

Of these, we specially acknowledge our debt to Helen van Dongen for putting at our disposal her production diary kept during the making of *Louisiana Story* and for various unpublished notes she made for a book at the time she worked on *The Land.* John Monck, who as John Goldman edited *Man of Aran*, sent us an admirable series of specially written notes of which unfortunately there has been space for only a short extract.

Many others have supplied us with memories and anecdotes, either in personal talks or by letter, of this remarkable artist who is the subject of this biography. They are Edgar Anstey, Teddy Baird, Sir Michael Balcon, Cedric Belfrage, Hans Beller, Sir David Cunnynghame, T. H. Curtis, Ernestine Evans, Hugh Findlay, H. Forsyth Hardy, Winifred Holmes, the Earl of Huntingdon, Augustus John, Denis Johnston, Boris Kaufman, Richard Leacock, Albert Lewin, Margery Lockett, Russell Lord, Evelyn Lyon-Fellowes, E. Hayter Preston, Adi K. Sett, Olwen Vaughan, Harry Watt, and Herman G. Weinberg. Others who have helped in many smaller ways include Ralph Bond, Hopie Burnup, Edmund Carpenter, D. R. C. Coats, John Collier, Alicia Coulter, Campbell Dixon, Edward M. Foote, Willi Haas, Frank Horrabin, R. V. H. Keating, Arthur Knight, Lord Killanin, C. A. Lejeune, Carl Lochnan, Jonas Mekas, Hans Nieter, "Pem," W. R. Rodgers, Col. H. A. Ruttan, David Schrire, and J. R. F. Thompson.

We also acknowledge the following:

Eileen Molony and Michael Bell for the loan of BBC scripts and telediphone recordings of talks made by Mr. and Mrs. Flaherty in London.

Oliver Lawson Dick for scripts and tape-recordings of the BBC program "Portrait of Robert Flaherty," produced by W. R. Rodgers on September 2, 1952.

Sir Arthur Elton for access to an unpublished manuscript left to him by the late Sir Stephen Tallents relating to the history of the Empire Marketing Board Film Unit.

W. E. Greening for permitting us to read parts of his unpublished manuscript of the life of Sir William McKenzie.

Among various organizations and the like to which we are indebted for their cooperation are the following:

The Museum of Modern Art Film Library, New York, and the National Film Archive, London, for their screenings of the Flaherty films; the British Film Institute for the help of its Information Department; and the National Board of Review of Motion Pictures, New York, the Royal Geographic Society, London; and the Central Office of Information, London.

We made acknowledgments to the following publishers, other than those mentioned above, for permission to quote from their books: *My Eskimo Friends* (Heinemann), *Samoa Under the Sailing Gods* (Putnam), *White Shadows in the South Seas* (T. Werner Laurie), *Mourning Became*

Mrs. Spendlove (Creative Age Press), *Footnotes to the Film* (Lovat Dickson), *Grierson on Documentary* (Collins), *Elephant Boy* and *Man of Aran* (Faber & Faber), *Eskimo* (Toronto University Press), *Best Moving Pictures of 1922–23* (Small, Maynard), *Forever the Land* (Harper & Brothers), *Cinema* (Pelican).

Among newspapers and journals from which we have quoted we are obliged to *The Guardian, The Observer, The Spectator, The New Yorker, Sight and Sound, National Board of Review Journal, World Film News, Close Up, Sequence,* and *Cinema Quarterly*.

We also remember with gratitude the generous help given in the United States during the summer of 1957 in the early days of research by the late Irma Bernay.

Finally, we thank those of Flaherty's old friends in England who helped make possible the completion of the original manuscript and its many weeks of revision in 1959.

PAUL ROTHA

The editor would also like to acknowledge the following people: Jo-Anne Birnie Danzker for asking me to write an article on Flaherty and thereby starting this whole process; Paul Rotha for allowing me to prepare his manuscript; Gei Zantzinger for his generosity and support; John McGuigan for seeing the book through publication; Jack Coogan, director of the Robert and Frances Flaherty Study Center; David Shepard; Basil Wright; Mary Corliss, Museum of Modern Art; Kenneth Lohf, Butler Library, Columbia University; S. I. Lockerbie, Grierson Archive, University of Stirling; and most of all Janis Essner, who prepared the manuscript for editing, typed most of the manuscript and put up with me during the project.

JAY RUBY

Introduction

Jay Ruby

Shortly after Robert J. Flaherty's death in 1951, Paul Rotha and Basil Wright, leaders in the British documentary film movement, began a study of the life and work of their friend and colleague. For the next eight years when they could find time away from their own full schedule of filmmaking and writing, they gathered primary materials, conducted interviews, and repeatedly viewed Flaherty's films. Eventually, Wright's commitment to his own work became too great and the burden of the project fell on Rotha's shoulders alone.

In 1959 the manuscript was completed. Rotha circulated it for comments to David and Frances Flaherty, John Grierson, Richard Griffith, John Taylor, Newton Rowe, John Monck, Helen van Dongen, J. N. D. Davidson, Irving Lerner, and J. P. R. Golightly. Their comments were incorporated into a final version, which was submitted to Hutchinson, the proposed publisher. Their response according to Arthur Calder-Marshall (1963:10) was that they "felt that the interest of this work would be confined to too small and scholarly a public and he suggested that a book about a character as colourful as Flaherty could be designed to meet a far wider public."

Rotha accepted the marketplace realities of the publishing world at that time and gave the manuscript to Calder-Marshall as "research notes." In 1963 *The Innocent Eye: The Life of Robert J. Flaherty* by Arthur Calder-Marshall was published by W. H. Allen and Company in London. (The U.S. edition was published by Harcourt Brace and World, New York.)

Although Calder-Marshall is clear about the source of his book and the modifications he made to Rotha's manuscript, I assumed, as did many people, that the differences between Rotha's manuscript and Calder-

1

Marshall's book were mainly stylistic and that the only substantive changes were to be found in Calder-Marshall's concluding chapter.

In 1979, while conducting research of my own on the early career of Flaherty (Ruby 1979, 1980), I discovered an unedited draft of the Rotha manuscript among the papers of Flaherty's widow, Frances, deposited at the Butler Library, Columbia University, New York. It had been sent to Frances and to his brother, David, for their comments. When I read the chapter on Nanook, I discovered it had a breadth and depth and, most important, a strong point of view that was lacking in *The Innocent Eye*. I contacted Rotha and secured his permission to publish the Nanook chapter in an issue of *Studies in Visual Communication* (vol. 6, no. 2 [1980]) devoted to Flaherty. It was clear that the entire study should be published. Through the good offices of John McGuigan of the University of Pennsylvania Press and the generosity of Gei Zantzinger, I obtained the means to do so.

I have prepared this edition of the biography by comparing the edited manuscript that Rotha deposited in the John Grierson Archive, University of Sterling, Scotland, with the unedited draft from the Flaherty Papers. I have tried to adhere as closely as possible to what I believe Rotha intended. I have not updated the study in any significant way even though it was written more than twenty years ago. The value of this book is the chance it gives its readers to understand the life and work of an American film pioneer from the viewpoint of a leader of the British documentary film movement who knew Flaherty for a major part of his professional life. The work has an integrity of opinion which would be disturbed by footnoting the text with recent material.

I have chosen instead to direct those readers wishing to examine the history of scholarship surrounding Flaherty before and after Rotha's study to William Murphy's 1978 book, *Robert J. Flaherty: A Guide to References and Resources*. A critical and annotated examination of works published by and about Flaherty, it is a thorough study that has proved invaluable for my own work and in the preparation of this manuscript. A glance at the long list of entries indicates the wide range of interest expressed in Flaherty's life and works. Rotha's biography can now take its rightful place in this tradition of scholarship.

It is the function of historical research to redefine if not construct the past in terms of the needs of the present. This book should be understood within two historical contexts. First, it is about a figure who has attracted attention both for the films he made and for the life he led. Second, the book was authored more than twenty years ago by a prime mover in the British film world. Since the book is about Flaherty and not Rotha, I cannot justify delving into the life and times of Paul Rotha. We will have to wait for Rotha's biography to provide that fascinating story. Instead, I will turn the reader's attention to three of Rotha's books—*Rotha on Film* (1952), *Documentary Film* (1936), and *Documentary Diary* (1973)—for insights into his approach to film.

Until recently the scholarship and popular press surrounding Flaherty have tended toward two extremes—portraying him in mythical terms and "worshiping" his films or debunking them as fakes and frauds and castigating him for a lack of social and political consciousness (Ruby 1979).

The creation and perpetuation of the "Flaherty myth" became a full-time preoccupation of his widow, Frances.[1] One might argue that the creation of this myth in turn created the need for a "debunking" reaction. Among the more positive results of her crusade, however, foremost is the creation of the Robert Flaherty Film Seminar, now in its twenty-seventh year and the oldest continually running seminar devoted to an exploration of the art of independent cinema, and next is the conserving of the Flaherty papers, photographs, and other memorabilia at Columbia University and the Robert and Frances Flaherty Study Center in Claremont, California. The conservation activities of International Film Seminars (the organization created to take over the running of the Flaherty Seminar when it became too much for Frances) and the Claremont Center make it possible to continue the tradition of scholarship necessary to keep the contribution of Flaherty alive in the minds of each generation.

The dialectical relationship between "Flaherty the myth" and "Flaherty the romantic fraud" is, in recent years, in the process of synthesizing into a view of Flaherty as a man of his time and culture who produced films consonant with his view of the world. Instead of debunking him, people have become more interested in demystifying him in order to be able to understand his films within the context of their time and the conditions of production and consumption.

This reevaluation has taken many turns and is still in process. It has, up to now, concentrated upon his early career in the Arctic and the making of *Man of Aran*. It manifested itself in the need to see *Nanook of the North* in a somewhat less modern transformation.

In 1947, *Nanook* was reedited to make it more marketable. The intertitles were removed, thus destroying Flaherty's editing rhythm, and a narration and musical score were added. The result bore little resemblance to the original. Purists had to content themselves with a slightly shortened but silent titled version distributed by the Museum of Modern Art in New York.

In 1972 International Film Seminars decided to produce a second version of *Nanook*. David Shepard painstakingly located missing portions of the film (see Dobi 1977 for details) and put together the most complete version possible. Unfortunately, another marketplace decision was made to commission a new musical score rather than employ the 1920s score designed to accompany the film. The result is a curious mixture of *Nanook* looking as close to the original as possible, with a musical accompaniment that is best forgotten.

When Rotha wrote this biography, certain aspects of Flaherty's early career were considered less interesting than others. The Flahertys—Robert, Frances and David—had decided that Flaherty's pre-*Nanook* ac-

tivities as photographer and filmmaker were not worth bothering about. Consequently, Rotha makes only slight reference to the 1916 film and says nothing about the early Arctic photographs.

In 1979–80, Jo-Anne Birnie Danzker, curator of the Vancouver Art Gallery, organized an exhibition of Flaherty's Arctic photographs and produced a catalog containing many important details of Flaherty's early career. She also began a process of giving back to the people the images borrowed long ago. The photographs are touring Inuit villages in the regions where Flaherty traveled. People are discovering their long-dead relatives, and people can now be identified in the photographs as well as the film. Through Danzker's work, we are able to understand the beginnings of Flaherty's career and how and why he "accidentally" became a filmmaker.

In a similar way, George Stoney has reexamined the making of *Man of Aran* in his film *How the Myth Was Made*. Stoney interviewed people connected with the making of the film as well as some of the actors used by Flaherty. Their recollections tell us how Flaherty's ideology served as a filtering device that systematically excluded aspects of the life of the islanders while at the same time creating the need to produce an image of life as it might have been, not of how it was being lived. The film nicely places *Man of Aran* in a cultural perspective, which makes questions about whether or not it is a "true" documentary far less interesting.

The reevaluation of Flaherty, his films, and his place in film history should continue. For once it stops and some final conclusions are reached, his importance will begin to diminish.

I trust this book will fuel the fires of debate and discussion. Both the author and his subject thrived upon the passionate expression of feelings and ideas. I think that they would be most pleased to discover they had done it again.

Some Flaherty Sayings

"All my films are only sketches—just an approach to what I hope some day to do, or what might be done by someone else."

"Making a film is like searching for a gold nugget."

"Hollywood is like sailing over a sewer in a glass-bottomed boat."

"As we grow old we think that we've taken leave of our vices, whereas the truth is our vices have taken leave of us."

"The making of a film is the elimination of the non-essential."

"A film is the longest distance between two points."

"Prestige never bought anyone a ham sandwich."

The North and *Nanook*

Chapter 1

I : Let a giant among men and a sultan of storytellers speak first:

Odysseus made his journeys and then Homer wrote about them. To discover and to reveal—that is the way every artist sets about his business. All art is, I suppose, a kind of exploring. Whether or not it's true of art, that's the way I started filmmaking. I was an explorer first and a filmmaker a long way after.

Even in my youth I was always exploring new country. My father was a mining engineer and, in a manner of speaking, we were a nomad family. We moved from one gold-mining camp to another in various parts of Canada. I was then about twelve years of age. I learned to track and hunt rabbits from the Indians and I had an Indian dog team and toboggan. It was a frontier country where the Indians were much more primitive than they are now. There used to be Indian dances near our camp. I also used to trade with the Indians in a small way. I couldn't speak Indian but knew a few words of a sort of patois.

They taught me many things. Hunting, for example. Hunting rabbits in the tamarack swamps. If you picked up the trails, you put your dog on one. He begins following the trail and chases the rabbit. All you had to do was to stand on another part of the same trail. The rabbit would come around to where you were because the trail was always in a circle. You had to be patient and wait, and then the rabbit would come loping along and you got him. This was in the depths of the cold winter, when there was deep snow on the ground and the rabbits couldn't burrow.

7

As I grew up, even in my teens, I went on prospecting expeditions with my father, or with his men, often for months at a time, travelling by canoe in summer and by snowshoe in winter. It was sometimes in new country, country that hadn't been seen before, the then little-known hinterland of Northern Ontario. We mapped it and explored it, or at least my father and his men did. I was just an extra.

Most of this country was to the west and north of Lake Superior, forest land with a great many lakes. More water than land, really. The lakes were interconnected by streams, so that you could canoe for hundreds and hundreds of miles. Sometimes I went out on prospecting expeditions with just one Indian in a birchbark canoe for as long as two months at a time.

On one expedition, I remember, we went north of Lake Superior and were away for two months. The expedition was headed by an English mining engineer, Mr. H. E. Knobel.[1]

He had been one of the Jameson raiders in South Africa. We went up north of Lake Nipigon, a wonderful lake about a hundred miles long, then up one of the rivers running into it to the Height of Land, where the water divides roughly going south into the St. Lawrence and north into Hudson Bay. As were crossing this Height of Land, the stream was very small—the beginnings of these streams were mere trickles—and we finally came into a lake called Little Long Lake. It was about twenty miles long. Knobel was in his usual position in the bow of the canoe. He'd do his mapping as we went along with a cross-section book and a little compass—a sort of mariner's paper compass.

Suddenly his compass began to turn around very quickly, more and more furiously as we went on. Then it stopped dead. We knew at once what was happening. We were passing over a body of magnetic iron ore under us in the lake. So with that little compass, we located a large range of iron ore. We staked out about five thousand acres of land covering several veins of this ore. They were not opened up until many years later. They were very far away and were simply held as a reserve. Thirty-five years later someone else went there and found gold.

There is a saying among prospectors—Go out looking for one thing, that's all you'll ever find. We were exploring only for iron ore at that time. (Flaherty 1949a, 1949b)[2]

Robert Flaherty was born in 1884. He was the eldest of seven children in the family of Robert Henry Flaherty and Susan Kloeckner. Robert Henry's father had emigrated from Ireland by way of Quebec in the mid-nineteenth century. Both father and son were Irish Protestants. Susan Kloeckner was a German Catholic from Koblenz.

David Flaherty recalls how his mother, known as the Angel of Port

Arthur, went to mass each day at six in the morning. "Maybe," says David, "my mother didn't know about music and such things, as my father did, but she loved people dearly and had a great and deep compassion."[3] Flaherty himself remembered the "poverty-stricken country in which we lived" in Michigan and how his father left the family to explore the little-known frontier country where gold had been discovered (Griffith 1953: xvii–xviii).

Several attempts were made to give the young Flaherty a formal education. "The boy learned with ease," writes Robert Lewis Taylor in a *New Yorker* "Profile" (June 11, 1949), "far outstripping his tractable colleagues, but he refused to observe the rules. His visits to the classroom were spasmodic. When the humor was upon him, he would turn up every day for a week or so, but he was likely to lounge in around eleven o'clock smoking a cigar. He would verify that the capital of South Dakota was Pierre rather than Bismarck, parse a sentence, exhibit a working knowledge of long division, and leave for the mid-afternoon fishing."

Although Taylor's "Profile" of Flaherty is both amusing and readable, it is not to be taken too seriously. It is fanciful and, in places, inaccurate. Nevertheless, at the time it was published Flaherty did not refute anything it said, even though it tended to picture him as something of a clown and playboy, which he was not.

In 1896, when Bob was twelve, his father took a job as manager at the Golden Star Mine in the Rainy Lake area of Canada, and the boy went along. Mrs. Flaherty remained in Michigan to care for the three younger children, two sons and a daughter. The population at the mine was a tough assortment of some two thousand miners from all parts of the world—South Africa, Australia, the United States, and Canada. Orthodox schooling was unknown. Bob and his father lived in a cabin but ate at a boarding-house. It was at Rainy Lake that Flaherty's love for the primitive, the unsophisticated, and the rough ways of "uncivilized" life began to ripen. Also, sometime during his youth, he was taught to play the violin, perhaps by his father; it was an accomplishment he retained throughout his life and from which he derived great satisfaction.

Father and son stayed at Rainy Lake for almost two years. Then the ore gave out and they moved to Burleigh Mine in the Lake of the Woods country, where they were joined by the rest of the family. Concerned about young Flaherty's education, his parents sent him to Upper Canada College at Toronto. There is a firsthand memory of him there.

About the year 1897 Sir Edward Peacock, then a master at the College, was one of those who attempted to educate this "tousle-headed boy who had little idea of the ways of civilisation."[4] This strong, healthy, self-reliant child found a knife by itself easier to use at table than a knife and fork. He was popular with the other boys.

Flaherty's own memories were of a public school that resembled Eng-

lish public schools with English masters. "They played cricket and football. I never learned cricket. We also played lacrosse, which is a Canadian game, and this I liked very much. It was originally an Indian Game" (Flaherty 1949a).

But at fourteen, Bob went back with his father to the frontier, the magic land of Indians, unknown lakes, tangled forests, and mysteriously winding streams (Griffith 1953:xviii). He remained in this wonderland for the next two years.

In 1900, the senior Robert Flaherty joined the U.S. Steel Corporation. He and his family moved to Port Arthur, which was to be their home for the next several years. In a final attempt to give formal schooling to their self-educated son, they sent him to the Michigan College of Mines, but he did not stay long enough to graduate. Richard Griffith tells us that the college authorities soon made up their minds that Flaherty had none of the qualifications considered necessary for an academic mineralogist and "bluntly fired him" (1953:xvii). During the seven months he was there, according to some reports, he took to sleeping out in the woods. When he was expelled, his father wrote wishing him the best of luck in whatever he elected to do on his own in the future (Taylor 1949).

Flaherty's brief sojourn at the Michigan College of Mines may not have enriched his intellect, but it was where he met Frances J. Hubbard, who was to be his wife and lifelong collaborator. Her father, Lucius L. Hubbard, was a man of academic distinction, a philatelist, bibliophile, ornithologist, mineralogist, and geologist. Boston, his home, was the main financial source for Middle Western mining operations. Dr. Hubbard had been the state geologist of Michigan; when he retired he brought his family to the upper peninsula, where he worked to develop new copper mines.

Although Frances had had a normal middle-class education, including Bryn Mawr and "finishing" in Europe, she also had the unusual advantage when still very young of accompanying her father on expeditions in which he charted for the first time great areas of the forests of Maine. This experience profoundly influenced her, and when the family settled in Michigan, she took to wandering again. "I used to go off alone every day on my horse," she remembers, "following the faint, overgrown trails of the old logging days. I would pick out on the map one of the tiny lakes or ponds hidden in the woods and set off to find it. Sometimes I got lost, or darkness fell before I could reach home and I would spend the night in one of the deserted lumber camps that the forests had swallowed up. What I liked best was to wander all night on the shore of the lake by moonlight. I thought no one cared about these things but me" (Griffith 1953:xix–xx).

When she met young Bob Flaherty one day at Sunday dinner, she found in his words an answer to all she wanted to know about the wilds. Despite their differences—he lacked formal education while she had had

the best; his upbringing and experience were at the opposite pole from hers—she quickly realized that he represented all she wanted from life. "I thought, when we were married, we would go and live in the woods," she said.

But a very great deal was to happen before these two young people were married.

It seems that young Flaherty elected to go and work for a time with some Finns in a Michigan copper mine. Then his father, now with U.S. Steel, took him on several explorations for iron ore and he met with H. E. Knobel, as he recounted earlier. Later, it is said, he was taken on by the Grand Trunk Pacific Railway, which wanted a survey made of its territory because it was expanding in competition with the Canadian Pacific. He took the commission of a wide survey literally, and once, when the railroad officials believed him to be in the Winnipeg vicinity, he contacted them from British Columbia, saying he was there because he wanted to see the west side of Vancouver Island.

Frances Flaherty does not remember that he ever worked for the Grand Trunk Pacific, but she confirms that he prospected for marble along the West Coast of Vancouver Island in 1906. She spent a couple of months with him there on the Tahsish Inlet in the Rupert District. H. T. Curtis, a retired mining engineer, remembered meeting Flaherty fortuitously about November 1906 at the Balmoral Hotel, Victoria. Curtis, who was assistant to the resident engineer of the Canadian Pacific Railway (Island Division), found the young man "a most likeable soul, kind-hearted, generous, but improvident."[5] He appeared to receive an allowance from his mother, but, although he paid the hotel bills, he spent the remainder on books, fancy ties, socks, and the like. He and Curtis went on canoeing trips, in which Bob was expert and altogether in his element, though he showed no enthusiasm for fishing.

Curtis introduced him to various people in Victoria, among them a well-known local architect, Sam MacClure, whose wife was musical. Flaherty often brought his famous violin to the MacClure house, where he met Mr. Russell, the conductor of the local Musical Society. This acquaintanceship resulted in Flaherty and Curtis sharing a house with Russell and his brother. "We more or less mucked in together," says Curtis, "and Bob filled the role of house-boy."

On Christmas Day 1906, Bob and Curtis went canoeing toward the Indian settlement on the other side of Victoria Inlet. Flaherty was captivated by the Indians' music and songs.

Curtis adds, "He talked at one time of going to Alaska when the spring set in, but to do what I don't remember. He never needed to have any specific aim as to occupation or employment. In fact, work in my idea and experience was right out of his ken. However, I learned in later years of his

success as a filmmaker, etc. I left British Columbia at Easter 1907 to follow my profession and had the occasional breezy note from Bob but finally lost contact."

Between 1907 and 1910, Flaherty worked as a prospector for a small mining syndicate above Lake Huron. Then he switched his services to a bigger concern and headed north to the Mattagami River over a route that had not been used for a hundred and fifty years. He may have been, in Curtis's words, "improvident," but for a young man in his early twenties he certainly knew how to find his way about the wilderness. He discovered some iron ore deposits, staked a claim for his employers, and went south to Toronto. There an event took place that was to shape the remainder of his life. Says Flaherty,

> A turning point in my life came when I first met up with Sir William Mackenzie, who in his lifetime was the Cecil Rhodes of Canada. He was building a great railway across Canada from the Atlantic to the Pacific. It was to be the Canadian Northern, now the Canadian National Railway. Mackenzie had heard that there might be iron ore and other mineral deposits along the sub-Arctic east coast of Hudson Bay on a little-known group of islands on Gulf Hazard. He asked me if I'd like to go up there and explore and then make a report to him. That was in August 1910. (Flaherty 1949b)

Flaherty first met Mackenzie through his father who, after ten years with U.S. Steel, had switched his services as a consulting engineer to the firm of Mackenzie and Mann in Toronto. It is not for us here to describe the tremendous part played by this firm in general and Sir William Mackenzie in particular in developing Canada at that time; we will only note that it was Mackenzie's judgment of men which helped to set Bob Flaherty off on his career. Nor do we propose to give detailed accounts of each of Flaherty's several expeditions for Mackenzie because they can be found better in his own words in his book *My Eskimo Friends* (1924), his articles in the *Geographical Review* (1918a, 1918b), and in his diaries[6] now in the Robert Flaherty Papers housed at the Butler Library of Columbia University. But the simple account he himself made as a series of talks for the BBC (June 14 and July 24, 1949) must not be omitted:

> I jumped off with one companion named Crundell, an Englishman, from the temporary railway frontier at Ground Hog in Northern Ontario. By small canoe we paddled down the Ground Hog River, the big Mattagami and the swift Moose to the great fur stronghold of the North, two and a half centuries old, Moose Factory, at the southern end of James Bay. From Moose Factory we traveled by open "York" sailing boat some seventy miles to Charlton Island, and from Charlton

took a schooner to Fort George, a little post on the east coast of James Bay. Because of the headwinds, the journey of less than two hundred miles from Charlton to Fort George took ten days. At Fort George, hardly halfway to our final destination, the Nastapoka Island, we were caught by winter. My companion returned south. When the sea ice had formed, I went on by sledge with a party of Indians as far as the last northern trees, at Cape Jones. The Indian country always ends where the trees end, and there is the beginning of the Eskimo country. The Indians left me at Cape Jones, from whence I was at the Eskimo camp at Great Whale, the last northern post. I spent the night in a tent. All the Eskimos were in igloos. During the night a terrific storm came up and in the morning I found my tent had collapsed. I was covered with canvas and an awful lot of snow, but I was able to breathe. The Eskimos came around and with much laughter they pulled off the canvas and took me into one of their igloos. I could speak only a few words of their language, about a hundred words or so out of a vocabulary: Is it cold? Is it far? I am hungry—that sort of thing.

Their language is not a very extensive one but it is very difficult to learn, much more difficult than the Northern Indian languages. But I could always make myself understood. One can do a great many signs. And the white man has a way of expression. His face reveals so much to a native. He can read your face like a book, while his face remains impassive.

It was a long haul with a twelve-dog team over 250 miles but at last I reached the Nastopone Islands with my Eskimo companion, whose name was Nero. He could speak a little pidgin English.

When I surveyed the islands (Taylor and Gillies) which Sir William Mackenzie had sent me to examine, I found there was iron ore there all right but it wasn't very important—not economically important. It was what we call "lean" ore. The island which had the largest deposits was only about twelve miles long and about half a mile wide. It lay along parallel to and about a mile off the coast. It was crested with snow-covered rocks. We were in the sub-Arctic in the middle of winter. It was bitterly cold. A complete desolation. And I had to face the fact that the long journey had been for nothing.

At the south end of the island I saw a monument sticking up near some slabs of rock. It was about six feet high, what they call an American Man in that country, for what reason I don't know. I think it is an old raider term. I noticed how the moss was encrusted in fractures of the stone, apparently very old, and it had obviously been up there a long, long time.

To show how different is the Eskimo idea of figures from our own, when I said to Nero, "This is very old, isn't it?" he said, "Oh, yes, very." "How old would you think it would be?" I asked him. "Oh," he

says, "maybe a t'ousand years." "How would you know it's a thousand years old?" "Oh," he says, "I see it when I am small boy." A thousand years doesn't mean anything to an Eskimo. . . .

It was on this trip, my first for Mackenzie, that Nero, my Eskimo friend, told me something that greatly interested me. He said that far out to sea, perhaps a hundred miles out to the west, there was another group of islands which was very big. I had noted these islands dotted in tentatively on the Admiralty charts. They were called the Belcher Islands. No white man had ever landed there. They had been put on the map by a Captain W. Coates, a shipmaster of the Hudson's Bay Company in the early eighteenth century. The company had established its first post in the bay in 1670. They've had ships coming in once a year from England ever since.

When the Eskimos told me that this was "big land," I could hardly believe it. They were only little bits of dots on the map. However, when I saw more Eskimos along the coast, they told me the same story. I asked them to make sketch-maps for me, and they all more or less coincided although drawn by different Eskimos.[7]

I asked Nero how far off the islands were. He said something like a hundred miles but I mistrusted his idea of figures. So in order to find out the size of the largest of the islands, I asked him, "How many sleeps would it take to sledge from this end of the island to that end of the island?" He said, "Two sleeps." So I knew that, if he spoke the truth, it was a big piece of land. He added also that there was a long narrow lake on the biggest island, so long that it was like the sea. What he meant was that looking from one end of it to the other, you could not see land. And he also told me that the cliffs of these islands looked as if they were bleeding when you scratched them.

Now one of the most important types of iron ore, hematite, looks blue but when it is scratched, it leaves a blood-red streak. So at this point I became really interested in the Belcher Islands. I had by now picked up so much information about them from so many Eskimos that I felt sure there must be something in the story. And when I finally returned to Lower Canada from this expedition in the autumn of 1910 and reported my findings to Sir William Mackenzie, he became as excited about the idea as I was. He asked me to make up another expedition and go back.

The second trip in 1911 took nineteen months and we got wrecked on the way trying to get out to the Belchers.[8] So I waited many, many months at the Great Whale River Post until the winter came. When we were about to cross over the sea ice, it broke the evening before our departure. It had been frozen 125 miles right across to the islands but now it began to drift. Sometimes the Eskimos got caught on big floes of ice this way. They may be adrift at large on the

sea for a year or more. They may drift as far as a thousand miles. The ice doesn't melt. As the summer gets on, the ice works north and begins to go through Hudson Strait, which is the discharge of Hudson Bay into the North Atlantic Ocean. Hudson Bay itself is twelve hundred miles long—an inland sea connected with the North Atlantic by a strait that is five hundred miles long and over a hundred miles wide. So the ice that gets through into the ocean doesn't begin to melt until it reaches down towards the Gulf Stream away east of Newfoundland. When Eskimos have been caught like this, maybe a family has been separated and they have not met up again for years afterward and then perhaps hundreds of miles away. There have been cases of an Eskimo family camping on the sea ice when it has broken during the night. The igloo has been cut in half just as you'd slice an orange. One part of the family went one way on the drifting ice and the other half went the other, not to meet up again maybe for many months.[9]

So, after the ice had broken, I decided not to wait and make another attempt to reach the Belcher Islands because almost a year had gone by. Instead, I made a survey of the Ungava Peninsula by sledge with an Eskimo. Also during this next summer (1912), I made two equidistant cross-sections of an area almost the size of Germany in the Barren Lands, about 125,000 square miles.[10]

This modest statement gives no indication of the hazards of these journeys or the degree of the achievement. Two previous attempts had been made to cross the barren of Ungava, one by A. P. Low and the other by the Reverend E. J. Peck. Both had failed through the failure to discover game to supplement the rations carried by sledge.

Flaherty's expedition was no better supplied. But whereas Peck had turned back with a heavy heart after eleven days rather than face starvation, Flaherty took the risk and won through after a journey lasting over a month.

He took with him four Eskimos. His favorite was Nero, a celebrated Great Whale hunter with a smattering of English who engaged to take them as far as Lake Minto and then return. Omarolluk and Charlie came for the deer they hoped to slay on the journey, and Wetunik was supposed to know the country between Lake Minto and Fort Chimo on the Atlantic coast of the Ungava peninsula.

The following extracts from the diary of the journey give some impression of the traveling conditions.

March 13: They clustered about me as I hung the thermometer on the ridge pole of the tent tonight. Of course I had to explain it all to Nero in our amusing "Pidgin English" fashion. He in turn explained it to his friends. But Omarolluk couldn't understand him very well,

couldn't see if that slender thread of mercury went down to the black mark, all water would freeze. He was sure that the cold made water freeze, not my thermometer.

March 16: Fed the dogs on seal blubber tonight. The dogs were tired and ravenous. Since we had no convenient way of tying them for the night, they were free. The scene just before feeding time was unforgettable. Omarolluk had to stand guard with his 6-fathom whip while Wetunik cut up the blubber. The dogs acted for all the world like wolves. They kept crawling up on their bellies from every direction, even braving the whip, a cut from which is certainly a painful affair. They are quick as lightning in snatching, a wolf's trait to the ground. Their fierceness and murderous temper as the odor of the seal meat came to the crouching circle of them is beyond telling. They foamed at the mouth. What would happen to us without them?

March 18: Our Waldorf fare of Army rations, jam, and canned steak will soon be exhausted, then beans forever. Nero spoke of the flies inland, that often kill the deer. He had seen them inches deep on the deer, the deer's face being raw and swollen by their work. In July this happens when there are hot days and calm. He had seen them after being killed, and says they are bloodless through the flies' work. The Eskimos keep their dogs in their tents during this time, imagine the smell. At one point this a.m. we reached the summit of a portage and started descending, but barely managed to stop short of a 75′ precipice. With our sledges that continually strain for speed, it was no small matter to stop in time. We also shortly discovered that while we were looking over for a new course, we were standing on a snow overhang which projected from the cliff about 25′. There are many snow formations like that in the rugged area here, and south along the Richmond Gulf country. The snow is everywhere wind-driven and packed to a picturesque extent, such as is not possible southward. This overhang of which I speak resembles the eave of a house on a huge scale. Many a hunter has lost his life through unconsciously walking to their edge, then suddenly breaking them off. Two men of Little Whale River Post plunged hundreds of feet to their death in that manner.

We are camped in a tiny valley, which contains a handful of stunted trees one of which is 5′ high. Camped early as the dogs are tired with their trying journey today. Do not seem to be in good condition. When we get to the deer herds they will improve again.

March 19: This entire area is barren of soil silt and trees. The rounded hills are everywhere interlaced with small lakes that are in shadow most of the day. The snow on the shadow sides of the lakes

and slopes and cliffs of the hills never disappears. It truly is a desolate area. The confusing network of lakes in today's travels were too much for Wetunik, and we were consequently delayed while he climbed the hills to locate our course. At 2 P.M. we descended onto the surface of Lake Minto, though having lost the Eskimo route to it, we came onto it in strange country, so that Wetunik wasn't sure we had hit it until we travelled eastward some four or five miles and he did some further scouting on the hills. We saw two partridges, one of which Nero shot. It was given to "Beauty" tonight for supper. Would an Indian give his dog a lone partridge?

March 21: . . . Omarolluk gave further information about whales last night. He said there were many whales on the north coast, that they were black, had divided spray, white about their mouths, and were very large. These are the Ottawa Island whales of which he speaks, and other unknown islands west of Hope's Welcome. At one time the Eskimos managed to kill one and the bones of it are still there. . . . This is Nero's last day with us. He turns back tomorrow for Great Whale River. . . . We missed the Eskimo trail completely coming to Lake Minto, it seems, and entered it on the south side. By tonight expect to be halfway across it. We depend upon getting to deer herds, and expect to see some signs of them today. At lunchtime Nero and Wetunik climbed one of the hills to look for our route, as Wetunik had become confused again. When they came down they proposed camp so that they could devote the morrow looking for the route. Made them go on however as we started late today. Wetunik located himself again. We then made for shore and camped. Camp will remain here for tomorrow. Dogs will have a rest which they need as they are very thin. Hope we get to the deer herds soon so as to get dog food. Wetunik says we are more than halfway across the lake now. Very fine day, brilliant sun which hurts my eyes very much though I wore goggles part of the time. Clear, calm. Aurora and sun dogs.

March 22: . . . Sun and snow reflection almost blinding. All but Nero off to north and south of lakes looking for deer. Nero baking bannock and fishing through ice. Hunters returned at sunset, and Wetunik saw fresh signs of about 80 deer. We push on tomorrow for east end of lake, there men will hunt for a day. Nero returns to Great Whale River tomorrow. Splendid calm and clear day. Nero drew map of lake for me in evening and we had a conference together afterwards covering route, deer herds, etc. Dog food is our greatest worry.

March 23: Said goodbye to Nero at eight o'clock and then started on our way to Fort Chimo. I felt lonesome at seeing him go. No one to

speak to now. My men cannot understand a word of English and I have a vocabulary of about 25 Eskimo words. Nero will arrive at Great Whale River in about seven days' time. He's one of the most remarkable men I've ever seen. Clever, a Jap's keenness for novelty and information, the greatest hunter of his people, a daredevil on ice or in a kayak, and the model generally of all his tribe, always smiling and alert, likes to be on journeys with white men, admires them, tho' withal intensely Eskimo. Nero is an illustration of the development the Eskimos are capable of. I parted from him this A.M. with regret indeed.

Wetunik confused again and later completely lost. We have travelled some forty miles today and are now camped within two miles of last night's encampment. But are located correctly this time! The lake is a maze of long finger-bays and islands. The saucer-like hills on every side hardly vary, and it is hard to pick up landmarks. And then everything is snow and ice, with no forests to relieve the color. Distances on that account are most deceptive. Have twelve dogs in fair condition, but a very heavy load, about 800 lbs. in all.

March 24: Head wind made a disagreeable day of it. About one o'clock Wetunik became confused again and the men climbed one of the high granite hills for sight. The lake is a monster and will prove to be the largest in Labrador, not excepting Lake Messtassine, I think.

March 25: There seems to be no change in appearance of country as a whole, ever-lasting hills of granite and at wider and wider distances little patches of dwarf trees, snuggled in the valleys away from the winds. Heavy load for our dogs, one of which shows signs of giving way soon. I hope we see the deer.

March 26: Arrived at the end of the lake about 10 o'clock. The discharge is a small open rapid. We travelled on a mile further, then camped as the drift is blinding and wind very strong. Trees are increasing in size and number, and we are camped in quite a grove.

March 27: Very cold day with a typical March wind and blinding drift. Became partly snowblind, and eye is very sore indeed this evening. About 2 P.M. came across deer tracks on river ice. Omarolluk went after them and Wetunik and I went on with the team. Camped at about three o'clock and no more than had it made when Omarolluk came with the news of two deer killed. He was as happy as a child over it as he has never even seen deer before, being an islander of Hope's Welcome. It means a great deal to us and nothing could have been more opportune. We all shook hands in high glee over it. The men returned at eight o'clock with the deer, cut and quartered, having

given the dogs a feast while cutting them. At noon they killed two ptarmigan which they are now eating.

March 28: Laid up with snow blindness, and a painful affair it is. The men are off after the deer with dogs and sledge. It seems Omarolluk wounded one besides the ones he got. It being a very stormy day, the deer will not travel but keep in the valleys. Omarolluck killed his deer yesterday with 30.30 shells in a .303 gun. He gave me to understand the bullets were very loose. The men returned at three o'clock minus deer. At supper tonight the men tried to tell me in signs and in our very limited vocabulary that the dog I purchased from Jim Crow died today, but I thought they said they were going back to Great Whale River. For a moment was alarmed and angry, but I caught their meaning in time. Much laughter.

March 29: Our travel was most trying and were in seemingly impassable places at times. All of us done up, Wetunik with snow blindness, Omarolluk with a lame knee, and I with cramps and headache after my snow blindness. Wetunik making me a pair of Husky goggles. Cached 80 lbs. of dog food. Sledge is very heavy.

March 30: Very fine travelling and in grateful contrast to yesterday. Dogs working very well after deer meat diet.

March 31: It was funny to see Omarolluk running ahead, and imitating a seal waving flippers in the air, to urge the dogs out of the ice jam we were stuck in today. Have acquired a few Eskimo words and our crazy-quilt conversations are laughable indeed.

April 1: Overcast and high southerly winds. Wetunik suffering agonies from snow blindness. Gave him some Cloridine for appearance's sake.

April 2: A late start, 9 A.M. Poor Wetunik in a bad way, cannot open his eyes and racked with headache. Have just put him in his blankets, a very sick Husky. Trouble at noon today. The men, I discovered, have been keeping their sealskin boots in my cooked-bean bag. The day is the warmest we have had. The iceing on our runners wore off quickly and part of our earthen shoeing is gone. Noted Omarolluk's method of baking bannock this evening: two handfuls of baking powder to about four pounds of flour—and we live!

April 3: Ruined our earth shoeing and had to run on the runners today. Tonight the men have made new shoeing. At feeding time one of the dogs mistook Wetunik's hand for deer meat and made a consid-

erable mess of it. It's one damned thing after another with Wetunik. Omarolluk's knee giving him trouble.

April 4: Last evening at camp noted a Canada Jay, first bird other than the ptarmigan seen on the trip. Travel very tedious and slow owing partly to the spring day, which makes both men and dogs very sluggish. We are all on edge now, expecting and wondering when we shall come to the sea.

April 6: About 1:30 arrived at the mouth of the river. Was much surprised and delighted as were the men. The river empties into a fiord of Ungava Bay. The mouth was choked with ice and we had a very hard time of it indeed. We were from 1:30 to 6 P.M. travelling about 3 miles, and then we had to camp on sea ice and walk about a mile for a few pieces of driftwood for a fire, with the result that we did not get into our blankets until about 9:45. Very tired but happy.

April 6: One of the most trying days we have had. We camped on the sea ice last evening and broke camp this A.M. at 8 o'clock. Very soon we were into impassable and treacherous ice, where at times we had literally to chop our way. Heartbreaking work. Left the team, climbed the hillside of the mainland and saw our course was hopeless. Open water in the distance and detached floes packing shoreward. There we were, like a fly in glue. Men and dogs done up. While in the thick of the ice, a snow squall came upon us with great force and blotted out everything. Fortunately was not of long duration. Pitched camp on mainland and tomorrow will attempt to travel overland and come out on southerly side of the bay, clear of the rough ice fields.

　　Work tried our tempers but all right now. Omarolluk baking bannock and singing fragments of Eskimo songs, and every little while humming the tune of "Waltz Me Around Again Willie" which he has heard on some phonograph at Fort George or Great Whale River. Our very limited conversations bear altogether on Fort Chimo and our arrival.

April 7: Stuck here for the day, a miserable camp with everything wet. Men off in the hills looking for a course for our travel tomorrow. Slight snow blindness again. Wetunik went off again this P.M. to see the ice fields from the top of the range. Returned at 5:30 saying ice was all broken. Expect we shall have a hell of a time tomorrow. Omarolluk and I poring over maps this P.M. The most miserable of all days, everything melting.

April 8: Started on our cross-country travel to avoid the rough ice fields. About 100 ptarmigan assembled on a distant knoll to see us

go. Very hard and long climb to an altitude of about 600' accomplished by noon in 100' jobs, with the usual Husky dog conversation at each one. In the true barrens now and away from trees. One long climb was compensated by a galloping coast down the long slopes this side of the range. Encamped on the main coast of Ungava Bay with another broken ice field staring us in the face. Fort Chimo seems farther away every day.

April 9: Wetunik confused and does not know the route from here to Fort Chimo. He is certainly a useless guide and "attulie" has been his cry ever since we left Nero. It seems from what I can gather from the men that the sea coast is impossible to travel by sledge and the Ungava Bay is open water. An Eskimo route starts in from this Gulf Lake overland for Fort Chimo. As Fort Chimo is more than 75 miles away in a straight line it is most important that we find the trail. The maps are misleading *extremely*. Travelled inland no more than a mile when in a clump of trees we found a fresh Eskimo cutting. Camped, then looked for tracks underneath the soft snow, found many Eskimo tracks but none of a sledge and as yet cannot tell if these cuttings indicate a sledge or not, which is an important thing to know. The signs indicate the Eskimos have camped here about seven or eight days ago. Wetunik went off to a distant mountain to scout, but returned with no information. Our grub is looking ill. Wetunik is pin head, I'm thinking. He has hunted this country and should know it. But Omarolluk makes up for him. Full of resource and brain, a "good Husky."

April 14: Westerly wind all night, heavy, still strong, less drift, partly clear. Travel fast and the excitement of nearing Fort Chimo a stimulus even to the dogs. We plied Charlie with anxious questioning all through the day trying to fix our location and nearness to the post. At about 4:30 we suddenly stood out on the last of the terraces. Fort Chimo, the great broad river, and a valley stretching to a blue haze of dazzling sun, lay before us. The white buildings of the post from our vantage looked like a strange far-off village. The descending sun shot into the innumerable windows. Bolts of light threw the surging figures of Eskimos, men and women, now aware of the arrival of a strange party, into vivid profile. The day and heat were made for our entry there, the color of sunset of the sky caught by the snow affected us strongly. The white mass of days of travel was at an end. (Griffith 1953:8–15)

Flaherty ended the journey across the Barrens of Fort Chimo with four Eskimo companions, Omarolluck, Charlie, Nero, and Wetunik. But when he returned to Lower Canada in the autumn of 1912 and reported on his findings to Mackenzie, he found that, as he had feared, from the geo-

logical or mineral point of view his surveys were not important. Today, however, the big iron-ore deposits he discovered in both Ungava and the Belchers are being very gainfully worked by the Cyrus Eaton Company, "bringing in untold wealth to the New World." [11]

Despite Flaherty's failure to find deposits which at the time would have been economical to work, Sir William Mackenzie still insisted that he should go north again to the Belcher Islands, this time by proper ship. Mackenzie was still impressed by Flaherty's report of what the Eskimos had told him about the size of these islands and by the maps that had been drawn. So he bought for Flaherty a topsail schooner called *The Laddie*, eighty-three-ton register, from an uncle of the famous Captain Bob Bartlett, who had been Admiral Robert Peary's skipper on his North Polar expeditions.

The Laddie, which had been built in 1893 at Fogo, Newfoundland, was rerigged at St. John's, and a crew of eight Newfoundland seamen was engaged under the command of Captain H. Bartlett. She was specially equipped for icebreaking and was outfitted for an eighteen-month expedition. All was set for departure on August 14, 1913. But one very important piece of equipment was missing.

Whether it was Flaherty's own idea to take a motion picture camera with him on this, his third expedition, or whether it was Sir William Mackenzie's suggestion is difficult to determine. Richard Griffith, whose book was written mainly under the eye of Flaherty and the bulk of it read by him before his death, gives the impression that it was his own idea. "When Flaherty excitedly declaimed his enthusiasm for Eskimo life to his employer, the ever-receptive Sir William *agreed* [italics added] that he should take a movie-camera along with him on his next expedition" (Griffith 1953:36). Flaherty, on the other hand, says:

> Just as I was leaving, Sir William said to me casually, "Why don't you get one of these new-fangled things called a motion picture camera?" So I bought one but with no other thought really than of taking notes on our exploration. We were going into interesting country, we'd see interesting people. I had no thought of making a film for the theatres. I knew nothing whatsoever about films. (Flaherty 1949a and 1949b)

Flaherty went to Rochester, New York, took a three-week course in motion picture photography from the Eastman Company, bought one of the earliest models of the Bell and Howell movie camera, and made some tests which were not very successful. He also bought a portable developing and printing machine, some modest lighting equipment, and, presumably, a fair amount of film. [12]

They sailed *The Laddie* a thousand miles northward round the Labrador Coast through the Hudson Strait to Baffin Land. Too late to have a win-

tering base in the bay itself, they put into Adadjuak Bay, and with the help of some forty Eskimos they set up a winter camp. In the last week of September, *The Laddie* sailed back south just before the ice began to form so that she could be wintered in Newfoundland. Flaherty and three of the crew settled in for the ten months of winter. There were two thousand miles of sledging to be done along the coast and island to the great lake of Amadjunk—and there was the filming. But Flaherty did not get around to using his new possession until early the next year, 1914. He tells us,

> February came, cold but glowingly clear and calm. Then we began our films. We did not want for cooperation. The women vied with one another to be starred. Igloo building, conjuring, dances, sledging and seal-hunting were run off as the sunlit days of February and March wore on. Of course there was occasional bickering, but only among the women—jealousy, usually, of what they thought was the over-prominence of some rival in the film. . . . On June 10, I prepared for our long-planned deer-filming expedition, and on the following day, with camera and retorts of film [13] and food for 20 days, Annunglung and I left for the deer grounds of the interior. Through those long June days we travelled for. . . .
>
> We were picking out a course when Annunglung pointed to what seemed to be so many boulders in a valley far below. The boulders moved. "*Tooktoo!*" Annunglung whispered. We mounted camera and tripod on the sledge. Dragging his six-fathom whip ready to cow the dogs before they gave tongue, Annunglung went on before the team. He swung in behind the shoulder of an intervening hill. When we rounded it we were almost among them. The team lunged. The deer, all but three, galloped to right and left up the slope. The three kept to the valley. On we sped, the camera rocking like the mast of a ship at sea. From the galloping dogs to the deer not two hundred feet beyond, I filmed and filmed and filmed. Yard by yard we began closing in. The dogs, sure of victory, gave tongue. Then something happened. All that I know is that I fell headlong into a deep drift of snow. The sledge was belly-up. And across the traces of the bitterly disappointed dog team Annunglung was doubled up with laughter. Within two days we swung back for camp, jubilant over what I was sure was the film of films. But within twelve miles of the journey's end, crossing the rotten ice of a stream, the sledge broke through. Exit film. (Flaherty 1924a:124–25)

Thus Flaherty describes with characteristic understatement the total loss of some of his first efforts at filmmaking.

The summer of 1914 was nearly over when *The Laddie* sailed back from the south. Flaherty and his men were ready to leave within a week, bound at long last for the elusive Belcher Islands.

This time the expedition was a complete success. They discovered—
or rather rediscovered—the islands and mapped them. They proved to
be even larger than Flaherty had imagined. The Eskimo maps, moreover,
were wonderfully accurate. A rectangle drawn round them would have en-
closed an area of some five thousand square miles. The longest island was
over seventy miles in length. It had a freshwater lake on it, as the Eskimos
had said. There, too, were the blood-red cliffs, just as Nero had forecast.
But when Flaherty reported on the area later, it was with the same result—
they were not considered to contain ore of sufficiently high grade to war-
rant operation at so remote a latitude.

Flaherty did, nevertheless, have two rewards for his expedition. The
Canadian government subsequently decided to name the largest of the
Belcher Islands after him. He had also in his possession a certain amount
of exposed cinematograph film.

While at Great Whale River Post, on the way back, Flaherty had his first
news that war had broken out in Europe. It was October, 1914.

> When we landed I glimpsed several forms flitting past the window
> lights and dissolving in the darkness. Puzzled, we climbed to the cabin
> and strode into a lighted but deserted room. Nearly half-an-hour we
> waited there, our surprise and curiosity mounting the while, when at
> last the familiar, long, lanky form of old Harold (the Post's half-Indian,
> half-Swedish interpreter) stood halting in the doorway. Recognising
> me in a moment, his fear-beclouded face became wreathed in smiles.
> He reached out for my hand, exclaiming, "My God, sir, I t'ote you was
> the Germans." And so it was that we first heard of the great World War.
> (Flaherty 1924a:43)

Flaherty's expeditions to the North had by now protracted his engage-
ment to Frances Hubbard for ten years, and it was an engagement con-
ducted, by force of circumstances, mainly by correspondence. But at last,
on November 12, 1914, they were married. The ceremony took place at the
home of one of the bride's cousins in New York City. Flaherty apparently
was low on money at the time; Frances bought the wedding ring and also
took him to the City Hall to get the license.

But it would seem—and after so many years these things can be
told—that Miss Hubbard was not the only young lady to whom the young
explorer had been paying attention. Writes Mrs. Evelyn Lyon-Fellowes, of
Toronto:

> I met Mr. Robert J. Flaherty a number of times when he appeared to
> be courting my chum, Miss Olive Caven. It was between his Arctic
> trips and his marriage. I chaperoned them once at lunch at the old
> Queen's Hotel (now demolished). On this occasion he gave me a

wonderful photo of a husky dog, taken I understand in an igloo. He gave Miss Caven many beautiful presents including a white-fox fur, and numerous photos of Eskimos which she accepted as she admired him very much. On his last return from Hudson Bay, he spent the first evening with her and left that night for the United States. A few days later he arrived back in Toronto with his bride, Frances, and asked poor surprised Olive to help them find a house to live in—which she did. She had not known of his engagement. She eventually recovered from the shock and married most happily and well. She died over a year ago.[14]

When the Flahertys were married, remembers Ernestine Evans, a longtime friend of theirs, the Hubbard family announced that they were seeking a Ford agency post for the bridegroom, assuming naturally that he would now settle down (Evans 1951). But the newly married explorer was to disappoint them.

During that winter of 1914–15, Flaherty put his film into some sort of shape. It was too crude to be interesting. But he was planning to go north again in the spring, this time to explore and winter on the Belcher Islands, and he was determined to attempt a better film (Flaherty 1924a:126).

Thus, even at this early stage, Flaherty expressed dissatisfaction with his work as a cinematographer although he was still no more than an amateur.

In the summer of 1915, Bob and his new wife with Flaherty Sr., Margaret Thurston, a Bryn Mawr schoolmate of Frances's, and David Flaherty journeyed by canoe with Indian guides from the railhead in northern Ontario down the Ground Hog, Mattagami, and Moose rivers to Moose Factory on James Bay. There they boarded *The Laddie*. At Charlton Island, in James Bay, all the party camped for several weeks except Bob, who, with *The Laddie* and her crew, headed for the Belcher Islands once more. The others stayed on the island, which David Flaherty described as being "carpeted with springy white moss covered with delicious wild currants and cranberries. We caught trout in the streams and shot yellow-legs along the shore. Frost was already in the air when in late September the once-a-year Hudson's Bay Company steamer *Nascopie* picked us up."[15]

Meanwhile, now on his fourth expedition, Flaherty had reached his destination and had set about more filming, which included a sequence of Mukpollo, an Eskimo, harpooning a big walrus, which Flaherty "filmed and filmed and filmed until the last inch was ground away." Wrote Flaherty,

During the winter, we compiled a series of motion pictures showing the primitive life, crafts, and modes of hunting and travelling of the islanders—an improved version of the film we had previously made on the Baffin Island expedition. With a portable projector bought for

the purpose, we showed the islanders a copy of the Baffin Island film, purposing in this way to inspire them with that spirit of emulation so necessary to the success of our filming. Nor were we disappointed. Enthusiastic audiences crowded the hut. Their "Ayee's" and "Ah's" at the ways of these their kindred that were strange to them were such as none of the strange and wonderful ways of the *kablunak* (white man) ever called forth. The deer especially (*Tooktoo!* they cried), mythical to all but the eldest among them, held them spellbound. (Flaherty 1918a:456)

Many years later Flaherty was to tell a story of how he was taught the rudiments of motion picture photography by a missionary whom he met on one of his expeditions and how later the missionary was found hanging by his neck in a hut that Flaherty had converted into a darkroom. We regard this story as almost certainly apocryphal, but Flaherty told it to at least three people.[16]

This expedition was also an adventurous experience. *The Laddie* had to be abandoned during the winter and its timbers used for fuel piece by piece. "Everything had to be left behind," Flaherty wrote, "saving the clothes we wore, some three weeks' food, notes, maps, specimens and the film—two boxes covered by the Eskimos with water-proofing of sealskin carefully sewn" (Flaherty 1924a:132).[17] Eventually they reached Lower Canada again.

Flaherty now had some seventy thousand feet of film in Toronto which had been taken during two expeditions. Encouraged by his wife, he spent some months in 1916 putting a print (taken from the negative) into some kind of continuity order. For an unexplained reason, fortunate in the light of later events, this assembled print was sent to Harvard, presumably to be screened by someone there. Later, while Flaherty was packing the seventy thousand feet of negative in his cutting room in Toronto, ready for dispatch to New York, "much to my shame and sorrow I dropped a cigarette-end in it." The complete negative, of course, went up in a sheet of flame, and Flaherty, having tried to put out the fire without success, narrowly escaped losing his life. He spent several weeks in the hospital. John Grierson notes that Flaherty carried scars on his hands from this fire all his life, but others, including the author, do not remember them.

Flaherty did, however, have the positive print that had been sent to Harvard, which he sent to New York to a laboratory in hopes that a new negative could be made from the print. But this process, so common today, was not possible at that time. Thus he had only one copy of his film, which would, of course, get scratched and deteriorate every time it was screened. He did show it a good deal, nevertheless—at the American Geographic Society, at the Explorer's Club in New York, and to sundry friends at his home in New Canaan, Connecticut. Of its reception, he said:

People were polite! But I could see that what interest they took in the film was the friendly one of wanting to see where *I* had been and what *I* had done. That wasn't what I wanted at all. I wanted to show the *Innuit* (Eskimo). And I wanted to show them, not from the civilised point of view, but as they saw themselves, as "we, the people." I realised then that I must go to work in an entirely different way. (Griffith 1953:36)

And later he added: "It was utterly inept, simply a scene of this and a scene of that, no relation, no thread of a story or continuity whatever, and it must have bored the audience to distraction. Certainly it bored me" (Flaherty 1950).[18]

Thus the "Harvard Print," as we might call it, the only example of Flaherty's first efforts with a film camera no longer exists. There is no doubt that he himself was only too glad to have it forgotten. His close friend and admirer John Grierson, who later described himself as his "self-appointed attorney" (1951b), saw a good part of the print and confirms Flaherty's poor opinion of it.[19] Grierson never mentioned it to him because "it was not in this thought or memory that anything survived." Grierson felt, however, that this first effort was important historically, for it meant that Flaherty was struggling to evolve what, after eight years of effort (1913–21), became *Nanook of the North*.

It would be fair to state that Flaherty had no intention of making a film that would stand professional comparison with other films of the period. He stressed all along that he merely took the movie camera with him to make visual notes of what he saw. We do not know if he was familiar with the cinema of that time, let alone with the numerous travel films that had been routine fare almost since the motion picture was born. But there is no doubt that his dissatisfaction with the results of his first attempt opened his eyes to the possibilities of the movie camera as an instrument of expression and not merely as a means of recording. He could very understandably have put aside all thought of future filmmaking. He was an explorer and mineralogist by profession, not a cinematographer. Yet to correct his early mistakes in filmmaking became an obsession. In his own words:

My wife and I thought it over for a long time. At last we realised why the film was bad, and we began to get a glimmer that perhaps if I went back to the North, where I had lived for eight years and knew the people intimately, I could make a film that this time would go. Why not take, we said to each other, a typical Eskimo and his family and make a biography of their lives through the year? What biography of any man could be more interesting? Here is a man who has less resources than any other man in the world. He lives in a desolation that

no other race could possibly survive. His life is a constant fight against starvation. Nothing grows; he must depend utterly on what he can kill; and all of this against the most terrifying of tyrants—the bitter climate of the North, the bitterest climate in the world. Surely this story could be interesting. (Flaherty 1950)

II : At this time, most of the world was occupied with the biggest and bloodiest war in history. It was hardly a good time to find financing for a filmmaking expedition to the Canadian North. After seventy thousand feet of film had gone up in flames, Sir William Mackenzie was unlikely to sponsor yet another film adventure.

So for the next four years, Flaherty and his wife spent some time with her parents in Houghton, Michigan, and later moved east to Connecticut, living for the most part in Silvermine and New Canaan. During this period, Flaherty began to write. He labored on his two detailed articles for the *Geographical Review*, and in 1923 he wrote a series for the magazine *World's Work*. Flaherty never found writing easy, but with the help of his wife he began on his book *My Eskimo Friends*, which was published in 1924. For this book he drew on the very full diaries which he had kept on his various expeditions. All this time he was trying to raise money for the film he was determined to make, but he had no success. The Flahertys' three daughters—Barbara, Frances, and Monica, were born during these years.

It was not until well after the war (in which he took no part) had ended that Flaherty came upon a source of finance which would enable him to realize his cherished film expedition. In 1920, when he was thirty-six years old, he met a Captain Thierry Mallet, of Revillon Frères, the well-known French firm of furriers, who were extending their trade in the north. They met, so the story goes, at a cocktail party, and Flaherty so inspired Captain Mallet with his enthralling tales of the Arctic that a day or two later the Revillon Company agreed to finance him to make his film at one of their trading posts, Port Harrison on Cape Dufferin on the northeast coast of Hudson Bay. This was actually in the sub-Arctic but to get there would take two months by schooner and canoe.

In return for backing the venture, Captain Mallet and John Revillon required that the opening titles of the film should carry the word "Revillon Frères presents," to which Flaherty readily agreed. He was unaware that the film trade generally was strongly opposed to such gratuitous screen advertising. The reported cost of the film varies, but we do not believe it to have exceeded $53,000—an exceedingly small sum even in those days.

That entertaining but not too reliable reporter of early movie years,

Terry Ramsaye, comments about the venture: "The expedition was under-written by Revillon Frères, the great fur-house, which coincidentally was an important advertiser in the smart traffic of Fifth Avenue. So it came that Mr. Flaherty became a frequent guest at the Coffee House Club, frequented also by such as Frank Crowninshield of Condé Nast slick-class magazine affiliations" (Ramsaye 1951). This was presumably Flaherty's introduction to the haunt with which in later years he was to be closely associated. It lies near Times Square, and its atmosphere and furnishing to an English visitor have an Old World quality which is more English than the English.

Flaherty selected his equipment with care:

> I took two Akeley motion picture cameras. The Akeley then was the best camera to operate in extreme cold, since it required graphite, instead of oil or grease, for lubrication. These cameras fascinated me because they were the first cameras ever made to have a gyro-movement in the tripod-head whereby one could tilt and pan the camera without the slightest distracting jar or jerk or vibration. (Flaherty 1950:13)

Camera movements are today so commonplace that it is worth em-phasizing how little they were used in those early days of cinema. D. W. Griffith had pioneered the plan (sideways movement of the camera on its own axis) and had used other daring camera movements, but the problem of panning and at the same time tilting the camera (a tilt being a vertical up or down pan) was a great problem because the two movements had to be carried out by winding two separate geared handles; this dual activity not only restricted speed of movement but also tended to become so jerky that the scene would be unusable. The invention of the gyro movement, oper-ated by one single arm, was therefore an important technical breakthrough.

Flaherty could rightly claim to be a pioneer in the use of the gyro tripod; and although *Nanook* does not contain many examples of pans or tilts, they are an important—indeed a vital—feature of all his subse-quent work.

He continues,

> I also took the materials and chemicals to develop the film, and equip-ment to print and project it. My lighting equipment had to be ex-tremely light because I had to go by canoe nearly 200 miles down river before I got to Hudson Bay. This meant portages, and portages meant packing the equipment on my back and on those of the Indians I took along for the river trip. And God knows, there were some long portages on that route—one of them took us two days to pack across. (Flaherty 1950:13)

Still conscious of his slight knowledge about making motion pictures, he is alleged to have made at least one tentative inquiry before leaving New York. According to Terry Ramsaye, he went to the Craftsman Laboratories in midtown, where Ramsaye and Martin Johnson were "trying to sort out an adventure feature from several miles of Martin's often unrelated film recordings. Bob wanted some advice. He said he wanted to do in the Arctic what Martin was doing in the tropics. Irked with problems, I puzzled one and offended the other by saying, 'Please don't!'" (Ramsaye 1951).[20]

Happily, Flaherty did not take this inane advice. Instead, he departed for the North:

> On August 15, 1920, we let go anchor in the mouth of the Innu-suk River, and the five gaunt and melancholy-looking buildings which make up the post at Port Harrison stood out on a boulder-ridden slope less than half-a-mile away. Of the Eskimos who were known to the post, a dozen all told were selected for the film. Of these Nanook (The Bear), a character famous in the country, I chose as my chief man. Besides him, and much to his approval, I took on three younger men as helpers. This also meant their wives and families, and dogs to the number of 25, sledges, *kayaks* and hunting implements. (Flaherty 1924a:133)

As in 1913, the Eastman Kodak Company had supplied the processing equipment and had taught Flaherty the rudiments of its use. The printing machine was an old English Williamson, which he screwed to the wall of the hut. He soon found that when printing the film with this machine, the light from his little electric plant fluctuated so much that he had to abandon it. Instead, he used daylight by letting in an inlet of light just the size of a motion picture frame (in those days, approximately 1 × ¾ inches) through the window. He controlled this daylight by adding or taking away pieces of muslin from before the printing aperture of the printer.

The biggest problem, however, was not printing the film or developing it but washing and drying it. The enemy was the freezing cold. He had to erect an annex to the hut in which he spent the winter to make a drying room. The only heating he could obtain for drying the film was a coal-burning stove. Film in those days, as Flaherty knew to his cost, was highly flammable, but this time no catastrophe took place. When he ran short of fuel before a reel of film had dried, he had to send his Eskimos out to scour the seacoast for driftwood to keep his stove alight.

Washing the film presented an even worse problem. The Eskimos had to keep a hole chiseled through six feet of ice all through the winter and prevent it from freezing and then haul the water in barrels on a sledge with a dog team up to the hut. Once there, they used all their hands to clear the

ice out of the water before it could be poured for the required washes over the film. The deer hair falling off the Eskimos' clothes into the water worried Flaherty almost as much as the ice did.

Setting up and operating his own laboratory equipment, and especially training the Eskimos to help him, are very important in the story of Flaherty's approach to his medium. He emphasized that such participation by his film subjects in the actual making of the film itself contributed to its ultimate success and sincerity. It is historically as well as technically significant to recognize that Flaherty was never simply a director-cameraman who dispatched his negative back to civilization for processing under ideal conditions. Flaherty, and we say it strongly and at the risk of repetition, made his films—or at least his early films—the hard way.

He continues his account:

> It has always been most important for me to see my rushes—it is the only way I can make a film.[21] But another reason for developing the film in the north was to project it to the Eskimos so that they would accept and understand what I was doing and work together with me as partners.
>
> They were amazed when I first came with all this equipment, and they would ask me what I was going to do. When I told them that I had come to spend a year among them to make a film of them—pictures in which they moved—they roared with laughter. To begin with, some of my Eskimos could not even read a still-photograph. I made stills of several of them as preliminary tests.[22] When I showed them the photograph as often as not they would look at it upside down. I'd have to take the photograph out of their hands and lead them to the mirror in my hut, then have them look at themselves and the photograph beside their heads before, suddenly with a smile that spread from ear to ear, they would understand.[23] (Flaherty 1950:13, 14)

Among the equipment Flaherty had taken a portable gramophone—the old wooden square type with a horn—and this he kept playing continuously with such records as Harry Lauder's *Stop Your Ticklin' Jock* and examples of Caruso, Farrar, Riccardo Martin, McCormack, Al Jolson, and the Jazz King Orchestra. Caruso's rendering of the *Pagliacci* prologue with its tragic finale was the comedy success of the selection. Nanook on one occasion tried to eat one of the records, an incident Flaherty filmed and included in the picture. Oddly enough, in his *New Yorker* "Profile," Taylor makes the unfortunate error of saying that Flaherty stopped filming just before Nanook bit the record; Taylor had no doubt not seen the film.

The little hut became a rendezvous for all the Eskimos, and Flaherty was able to command their friendship and understanding. He always kept

a five-gallon pail of tea brewing on the stove and sea biscuit in a barrel when the weather conditions outside stopped filming. He had also his violin with him, and he frequently played it to his Eskimo audience.

The first sequence to be shot for the film was one of the most ambitious—the walrus hunt. From Nanook, Flaherty had heard of Walrus Island, a rock, surf-bound island twenty-five miles out in the bay. Nanook had been told by other Eskimos that on its south end there were many walrus in the summer months. The surf round the island made it dangerous for landing kayaks but Nanook believed that, if the seas were smooth, Flaherty's whaleboat could make the crossing and a safe landing. Some weeks later, Nanook brought to Flaherty the Eskimo who knew at firsthand about the walrus on the island. "Suppose we go," Flaherty said to him, "do you know that you and your men may have to give up making a kill, if it interferes with my filming? Will you remember that it is the picture of you hunting the *iviuk* (walrus) that I want, and not their meat?"

"Yes, yes, the *aggie* (movie) will come first," the man assured him. "Not a man will stir, not a harpoon will be thrown until you give the sign. It is my word" (Flaherty 1924a:126). They shook hands and agreed to start in the morning. The story of the walrus hunt is best told in Flaherty's diary entry:

> But for three days we lay along the coast, before the big seas died down. The wind began blowing off the land. We broke out our leg o'mutton. Before the day was half-done, a film of gray far out in the west told us we were in sight of Walrus Island. We looked about for a landing. Just beyond the shoulder of a little cove, *"Iviuk! Iviuk!"* called Nanook, and sure enough, on the gleaming black surf-worn rocks lay a great herd sprawled out asleep.
>
> Down wind we went, careful as to muffled oars, and landed waist deep in the surf. Nanook went off alone toward the sleeping herd; he returned, saying they were undisturbed. However, it was much too dark for pictures; we would have to wait until morning.
>
> "Yes," said Nanook, in answer to my fears, "if the wind holds in the same quarter they will not get our scent." Not daring to build a drift-wood fire, we made our evening meal on raw bacon, sea-biscuit and cold water.
>
> As luck would have it, the wind did hold. With harpoon set and a stout seal-line carefully coiled, and my motion picture camera and film retorts in hand, off we crawled for the walrus ground. The herd lay sleeping—20 great hulks guarded by two big bulls. At about one minute intervals they raised their heads over the snoring and swinishly grunting herd and slowly looked round, then sank back to sleep again. Slowly I snaked up to the sheltering screen of a big boulder,

and Nanook, the end of his harpoon-line lashed round the boulder, snaked more slowly still out towards them. Once in the open he could move only when the sentinels dropped their heads in sleep.

Hours passed, it seemed, but finally he had crawled close in. The sentinels became suspicious and stupidly started toward him. Slowly they turned their slobbering heads to and fro; Nanook swung his own head in lugubrious unison. They rolled on their sides to scratch themselves; Nanook grotesquely did the same. Finally, the sentinels seemed satisfied; their heads drooped in sleep once more. Now only a dozen feet intervened; quickly Nanook closed in. As I signalled, he rose to his feet, and with his harpoon held high, like lightning he struck down at the nearest bull. A bellow and a roar, and 20 great walrus rolled with incredible speed down the wave-washed slope of the rocks to the sea.

By night all my stock of film was exposed. The whaleboat was full of walrus-meat and ivory. Nanook had never had such walrus hunting and never had I such filming as that on Walrus Island.[24]

The postscript to the walrus hunt is told better elsewhere than in the diaries:

When I developed and printed the scenes and was ready to project them, I wondered if the Eskimos would be able to understand them. What would these flickering scenes projected on a Hudson Bay blanket hung up on the wall of the hut mean to them? When at last I told them I was ready to begin the show, they crammed my little 15 by 20 hut to the point of suffocation. I started up the little electric-light plant, turned out the lights in the room, and turned on the switch of the projector. A beam of light shot out, filled the blanket and the show began. At first they kept looking back at the source of light in the projector as much as they did at the screen. I was sure the show would flop. Suddenly someone shouted, *"Iviuk!"* There they were—the school of them—lying basking on the beach. In the foreground could be seen Nanook and his crew, harpoons in hand, stalking on their bellies towards them. Suddenly the walrus take alarm; they begin to tumble into the water. There was one agonising shriek from the audience, until Nanook leaping to his feet thrust his harpoon. In the ensuing tug-of-war between the walrus now in the water and Nanook and his men holding desperately to the harpoon-line, pandemonium broke loose; every last man, woman and child in the room was fighting that walrus, no surer than Nanook was at the time that the walrus would not get away. "Hold him!" they yelled, "Hold him!" (Flaherty 1950:14–15)

"The fame of the film spread far up and down the coast," writes Flaherty in his book. "Every strange Eskimo that came into the post Nanook brought before me and begged that he be shown the *iviuk aggie* (Walrus pictures)." He continues:

One of Nanook's problems was to construct an *igloo* large enough for the filming of the interior scenes. The average Eskimo *igloo*, about 12 ft. in diameter, was much too small. On the dimensions I laid out for him, a diameter of 25 ft. Nanook and his companions started in to build the biggest *igloo* of their lives. For two days they worked, the women and children helping them. Then came the hard part—to cut insets for the five large slab-ice windows without weakening the dome. They had hardly begun when the dome fell in pieces to the ground. "Never mind," said Nanook, "I can do it next time."

For two more days they worked, but again with the same result; as soon as they began setting in the ice-windows their structure fell to the ground. It was a huge joke by this time, and holding their sides they laughed their misfortune away. Again Nanook began on the "big *aggie igloo*," but this time the women and children hauled barrels of water on sledges from the water-hole and iced the walls as they went up. Finally the *igloo* was finished and they stood eyeing it as satisfied as so many children over a house of blocks. The light from the ice-windows proved inadequate, however, and when the interiors were finally filmed the dome's half just over the camera had to be cut away, so Nanook and his family went to sleep and awakened with all the cold of out-of-doors pouring in.

To "Harry Lauder" (one of the Eskimos christened after the gramophone record) I deputed the care of my cameras. Bringing them from the cold outside into contact with the warm air of the base often frosted them inside and out, which necessitated taking them apart and carefully drying them piece by piece. With the motion picture camera there was no difficulty, but with my Graflex, a still-camera, I found to my sorrow such a complication of parts that I could not get it together again. For several days its "innards" lay strewn on my work-table. "Harry Lauder" finally volunteered for the task of putting it together, and through a long evening before a flickering candle and with a crowd of Eskimos around ejaculating their "Ayee's" and "Ah's," he managed to succeed where I had failed.[25]

The walrus-hunting having proved successful, Nanook aspired to bigger game—a bear-hunt, no less, at Cape Sir Thomas Smith, some 200 miles northward. "Here," said Nanook, "is where the she-bear den in the winter, and it seems to me that we might get the big, big *aggie* there."

He went on to describe how in early December the she-bear dens in huge drift-banks of snow. There is nothing to mark the den save a tiny vent, or airhole, which is melted open by the animal's body heat. Nanook's companions would remain at either side of me, rifles in hand, whilst he with his snow-knife would open the den, block by block. The dogs in the meantime would all be unleashed and like wolves circle the opening. Mrs. Bear's door opened, Nanook, with nothing but his harpoon, would be poised and waiting. The dogs baiting the quarry—some of them with her lightning paws the bear would send hurtling through the air; himself dancing here and there—he pantomimed the scene on my cabin floor, using my fiddle-bow for a harpoon—waiting to dart in for a close-up throw; this, he felt sure, would be a big, big picture (*aggie paerualluk*). I agreed with him. "With good going, ten days will see us there. Ten days for hunting on the Cape, ten days for coming home again. But throw in another ten days for bad weather, and let's see (counting on his fingers) that makes four times my finger—more than enough to see us through."

"All right," I said, "We'll go." And Nanook, his eyes shining, went off to spread the news. (Flaherty 1924a:136)

On January 17, 1921, Flaherty, "Harry Lauder," and Nanook set out on their bear hunt for the big scene of the film. They were away for eight weeks and traveled six hundred miles. The going was tough. Two dogs were lost through starvation.

We were breaking camp before the sun had cleared the horizon. The dogs fought like wolves as they wedged in through the door of the *igloo* we had just vacated; the crew tried vainly by grasping legs and tails to drag them out for harnessing; Nanook, his arms round the master-dog, carried him bodily to the sledge. I unlimbered the Akeley, hoping to get a few feet of it all on film. But, to my dismay, as soon as I started grinding, so brittle was the film that it broke into bits, like so much wafer-glass. The thermometer read 37 degrees below. . . . We went back into camp. By keeping the film retorts in the *igloo*, I found that within the hour they took on its temperature. The film regained its ductility. I told Nanook to bury the film retorts and camera in his deerskin robe henceforth when we broke camp in the morning. The crew were convulsed over what they called the "babies" for which he had to care.

But still no bear had been sighted. They were getting near the limits of endurance.

For the next three days what food sustained the dog-team was the *igloo* scraps and crumbs. When night came, cross-bars from the sledge and four 200 ft. rolls of film was the makeshift that boiled our tea.

Finally, they reached Port Harrison, their base. "What, no bear?" said Stewart, the post-trader, "Too bad, too bad, an' just to think that a week come Friday two huskies got a she-bear an' two cubs in a cave." It would have made a fine *aggie*, they said, what with the fightin' an' all—throwin' the dogs through the air an' chargin' here an' chargin' there, an' all this less'n a day away. (Flaherty 1924a:136ff.)

Flaherty remained on his location until August 1921. He had been at it for sixteen months. He used up his last few feet of film on a whale hunt made by the Eskimos in a fleet of kayaks, but nothing of this appears in the final film. It was Nanook's last big *aggie*, although he tried hard to persuade Flaherty to stay on for another year, talking of the wonderful things that could be filmed. Eventually the once-a-year little schooner arrived and Flaherty was aboard and the *Annie's* nose was headed south. Nanook followed in his kayak until the ship gathered speed and gradually drew away.

"Less than two years later," says Flaherty, "I received word by the once-a-year mail that comes out of the north that Nanook was dead. He died from starvation on a hunting-trip." By that time *Nanook of the North* had been shown in many parts of the world. Ten years later, Mrs. Flaherty bought an Eskimo Pie in the Tiergarten in Berlin. It was called a Nauk and Nanook's face smiled at her from the paper wrapper.[26]

III: "Films," said Flaherty many years later, "are a very simple form and a very narrow form in many ways."

You can't say as much in a film as you can in writing, but what you can say, you can say with great conviction. For this reason, they are very well-suited to portraying the lives of primitive people whose lives are simply lived and who feel strongly, but whose activities are external and dramatic rather than internal and complicated. I don't think you could make a good film of the love affairs of an Eskimo . . . because they never show much feeling in their faces, but you can make a very good film of Eskimos spearing a walrus.

Nanook is the story of a man living in a place where no other kind of people would want to live. The tyrant is the climate, the natural protagonist in the film. It's a dramatic country and there are dramatic ingredients in it—snow, wind, ice and starvation. The life there is a constant hunt for food so that among all Eskimos all food is com-

mon. It has to be—an Eskimo family on its own would starve. If I went into an Eskimo *igloo*, whatever food they had would be mine. They have no word in their vocabulary for Thank You. That is something that never arose between us. . . . These people, with less resources than any other people on the earth, are the happiest people I have ever known. (Flaherty 1949b)

The subtitles of the film, written by Carl Stearns Clancy, presumably in close association with Flaherty, are simple and informative. At the start we are told that the film was made at Hopewell Sound, northern Ungava. We are introduced at once to Nanook, the hunter, and his family emerging in surprising numbers from their kayak, or canoe. We are told they use moss for fuel. They carry a large boat down to the water (the launching is not shown). They go to a trading post. Nanook, a title tells us, kills polar bears with only his harpoon. He hangs out his fox and bear skins, which are bartered for beads and knives (the trading post itself is seen only in the far distance). While there, Nanook plays the old wooden gramophone and tries to bite the record. One of the children is given castor oil and swallows it with relish.

Nanook then goes off on the floating ice to catch fish. For bait he uses two pieces of ivory on a seal-string line. He also spears salmon with a three-pronged weapon and kills them with his teeth. News is then brought of walrus, and Nanook joins the hunters in their fleet of kayaks. They meet with rough seas. The walrus are sighted. One of them is harpooned by Nanook and dragged in by line from the sea to the shore. There is a great struggle. It weighs, a title says, two tons. After it has been killed, the hunters carve it up and begin eating it on the spot, using their ivory knives. The flesh is shown in close-up.

Winter sets in and a snow blizzard envelops the trading post. Nanook now goes hunting with his family. The dog team drags the sledge with difficulty over the rough ice crags. Nanook stalks and traps a white fox. There follows the building of an igloo, Nanook carving it out of the blocks of frozen snow with his walrus ivory knife, licking its blade so that it will freeze and make a cutting edge. The children play slides, and one of them has a miniature sledge. Everyone is gay and smiling. Nanook makes the window for the igloo with great care and skill out of a block of ice. He fixes a wedge of snow to reflect the light through the window. The family, with their meager belongings, then occupies the igloo. Nanook later shows his small child how to use a bow and arrow, using a small bear made out of snow as the target.

Morning comes and the family gets up. Nanook's wife, Nyla, chews his boots to soften the leather while Nanook rubs his bare toes. Then he eats his breakfast, smiling all the time. Nyla washes the smallest child with saliva. Presently they all prepare to set off for the seal grounds. They glaze the

runners of the sledge with ice. There is some savage scrapping among the dogs before the family finally departs across the snow field.

Nanook finds a hole in the ice and down it thrusts his spear. Then ensues a long struggle between Nanook hauling on his line and the unseen seal under the ice in the water. At one point Nanook loses his balance and falls head-over-heels. Finally, the other members of the family arrive on the scene and help their father to pull the seal out. (It is obviously dead.) They cut it up and fling scraps to the dogs, who fight among themselves over them. The dog traces get tangled, causing a delay in the departure for home.

They came upon a deserted igloo and take refuge in it. The snow drifts round outside and the dogs become covered and hardly recognizable. A special miniature igloo is made for some small pups. Inside, the family beds down for the night, naked inside their furs and hide blanket bags. Outside the blizzard rages. The film ends on a close-up of the sleeping Nanook.

Described this bluntly, the film sounds naive and disjointed, and in some ways it is both. Its continuity is rough, and there are many unexplained interruptions. The passing of time is either clumsily handled or deliberately ignored. Technically, it is almost an amateur's work. These, however, are minor flaws when compared with the overall conception which the film gives of this Eskimo family living what we are told is its normal, everyday existence. Some sequences, such as the now-famous, carefully depicted building of the igloo and the carving of its window and the howling dogs being covered by the drifting snow will always be memorable in the history of the cinema.

It is also important to note that the spearing of the seal is the first example of Flaherty's use of the suspense element in his work: Nanook struggles to drag the creature up through the ice hole out of the water for a seemingly endless time, but it is not until he finally succeeds that the audience can see that it is a seal. This element of suspense—keeping the audience guessing and revealing the secret only at the last moment—was to play a significant part in Flaherty's future films.

The photography, made on the long obsolete orthochromatic film stock, has some lovely moments, such as the sledge scenes across the vast snowscapes, and here and there appears a hint of Flaherty's skill for moving his camera on the gyro-head tripod of which he was so fond.[27] There is a tilt shot down onto Nanook in his kayak, for example, and a left-to-right pan shot along the walrus heads peering up from the waves. The dragging of the dead walrus up the beach is shown in greater detail than would have been found in any other film of the period; it is broken down into several shots from different angles, and the same is true, of course, of the igloo-building.

More important than these technical points is the fact that the film conveys the sheer struggle for existence of these people and their carefree acceptance of their fight for survival. Flaherty does not show any of the

amenities of the trading post, nor is any reference made to the fact that the use of guns and traps for hunting was common long before the time when the film was made. No reference is made to social practices such as the sexual life or marriage customs of the Eskimo, so the film has little real anthropological value.

This lack raises an issue that has come up many times in regard to all Flaherty's films and will recur when we come to examine many criticisms of his work. Did he intend us to accept *Nanook* as an accurate picture of Eskimo life at the time when he made the film, or did he intend it to be a picture of Eskimo life as it used to be, as seen through Flaherty's eyes? Was he concerned with creating the living present through the film medium, or was he trying to create an impression of life as it was lived by the father or grandfather of Nanook? This fundamentally important question will exercise us at the assessment of each of his films and we shall consider it in detail in discussing the criticisms of *Man of Aran*.

What concerns us now is that in *Nanook*, for the first time in film history, a motion picture camera was used to do more than just record what it finds before its lens. This is the major significance of *Nanook*.

Flaherty, in 1913, was not the first explorer to equip himself with a camera. Travel films, or "scenics" as the trade called them, had been popular since the turn of the century, beginning with what might be best described as moving picture postcards of familiar places in one's own or a neighboring country, which gave way in time to scenes in more distant and exotic lands. The word "travelogue" was used as early as 1907 by Burton Holmes in the United States. In her absorbing history of early British cinema, Rachel Low tells us:

> The fashion whereby explorers and big-game hunters took cinematographers with them on their expeditions seems to have begun when Cherry Kearton left England in 1908 to accompany Theodore Roosevelt on his African hunting-trip, and spent the next five years travelling in India, Africa, Borneo and America. . . . In the summer of 1909, Lieutenant Shackleton showed some of the 4000 feet of film exposed during his recent expedition in the Antarctic. Probably the most important of the big-game films was the 6000 ft. record of the Carnegie Museum Expedition in Alaska and Siberia, led by Captain F. E. Kleinschmidt. The expedition was organised in 1909, and during the two years it took to make the film some 10,000 ft. were exposed. . . . Soon a cinematographer was regarded as a normal part of an explorer's equipment although his films were not always originally intended for commercial distribution. (Low 1949:153–55)

Of all these travel and exploration films, Rachel Low very rightly claims that Herbert G. Ponting's record of Captain Scott's expedition to the Antarctic in 1910–11 was the most important. She calls it "one of the really

great achievements, if not the greatest, of British cinematography during this unhappy period." [28]

But there were certain vital differences between Flaherty and these other early cinematographers. First, he combined the talents of a trained explorer and mineralogist with those of a filmmaker. He learned the technique of cinematography for himself, the hard way, in order to express what he found among the people on his expedition. Second, he was familiar with Eskimos and the land where they lived and where he was going to make his film, having eight years of experience among them. He knew his subject at firsthand, a tenet that was to become an integral part of every Flaherty film. Third, and perhaps most important, his abortive first attempts at filming in 1913 and again in 1915 had shown him clearly that just to set up his camera and record scenes in a strange country was not sufficient to dramatize the struggle for survival of his friends, the Eskimos. Flaherty knew that something fundamental was lacking in his early efforts; he knew when he went north again in 1920 that it was not just to remake what he had lost in the flames at Toronto.

As Walker Evans, the distinguished American photographer, puts it,

> You learn that he [Flaherty] shot a lot of movie footage on exploration trips previous to the time of *Nanook*. You find that this led him to one of the best experiences a young artist can have: he got sore at himself for his own lack of originality. These first reels of his evidently looked just like the asphyxiating stuff ground out by any ass who's seen an Indian squaw or some mountain goats. Anger, almost certainly, gave Flaherty his first artistic drive. (Evans 1953)

This judgment is confirmed by Grierson's description of the first Harvard print of the abortive *Nanook*.

Nanook, as Flaherty gave it to the world in 1922, contained the seeds of "the creative treatment of actuality," John Grierson's often-quoted definition of the documentary approach to filmmaking (Hardy 1946:111). Grierson's assessment of Flaherty's film was as follows:

> *Nanook of the North* took the theme of hunger and the fight for food and built its drama from the actual event, and, as it turned out, from actual hunger. The blizzards were real and the gestures of human exhaustion came from life. Many years before, Ponting had made his famous picture of the Scott expedition to the South Pole, with just such material; but here the sketch came to life and the journalistic survey turned to drama. Flaherty's theory that the camera has an affection for the spontaneous and the traditional, and all that time has worn smooth, stands the test of twenty years, and *Nanook*, of all the films that I have ever seen—I wish I could say the same for my own—is

least dated today. The bubble is in it and it is, plain to see, a true bubble. This film, which had to find its finance from a fur company and was turned down by every renter on Broadway, has outlived them all. (Davy 1938:146)

Walker Evans writes:

No one will ever forget the stunning freshness of *Nanook of the North.* The mere sight of a few stills from the production has the power to bring it all back. Here is happy, feral little Nanook, seated beside the hole he has cut in the ice; his face hidden in fur; his bent-over figure shielded by that cunningly built ice-block shelter; waiting, with that steady ready knife; waiting for his seal. Here is the harpoon picture. Nanook drawing back for the throw: just the deadliness of these half-lowered eyes on the aim can drain the lining of your stomach again as it did in the theatre. Add to this the sheer line of that particular photograph: the diagonal shaft of the weapon, the sweep of the cord looping to Nanook's raised hand, then coiling in black calligraphy against the sky. . . . The core of Flaherty's whole career is in the solitary, passionate filming of *Nanook of the North.* (Evans 1953)

In a survey in 1923 of the best films of the previous year, Robert E. Sherwood, the critic and playwright, wrote:

There are few surprises, few revolutionary stars and directors of established reputation. *Nanook of the North* was the one notable exception. It came from a hitherto unheard-of source, and it was entirely original in form. . . . There have been many fine travel pictures, many gorgeous "scenics," but there has been only one that deserves to be called great. That one is *Nanook of the North.* It stands alone, literally in a class by itself. Indeed, no list of the best pictures of this year or of all years in the brief history of the movies, could be considered complete without it. . . . Here was drama rendered far more vital than any trumped-up drama could ever be by the fact that it was all *real.* Nanook was no playboy enacting a part which could be forgotten as soon as the greasepaint had been rubbed off; he was himself an Eskimo struggling to survive. The North was no mechanical affair of wind-machines and paper snow; it was the North, cruel and incredibly strong. (Sherwood 1923)

On the other hand, Gilbert Seldes, usually a discerning critic of the arts, in his book *The Seven Lively Arts*, dismissed the film as follows: "What can you make of the circumstance that one of the very greatest successes, in America and abroad, was *Nanook of the North*, a spectacle film to which

the producer and the artistic director contributed nothing, for it was a picture of actualities, made, according to rumor, in the interests of a fur-trading company?" (Seldes 1924:332). Flaherty is not mentioned by name anywhere in the book, which purports to be a survey of the American arts in the early 1920s.

The first suggestion that *Nanook* was not authentic, so far as we can trace, appeared briefly in Iris Barry's book, *Let's Go to the Pictures* (1926: 185), in which she quoted Vilhjalmur Stefansson as saying that it "is a most inexact picture of the Eskimo's life."

But Flaherty's conception in *Nanook* has been challenged on other and more important grounds than whether its material content was falsified and contrived. Flaherty was accused of ignoring the social problems and realities of the people among whom he made his films. As Forsyth Hardy commented:

> When Flaherty tells you that it is a devilish noble thing to fight for food in a wilderness, you may, with some justice, observe that you are more concerned with the problem of people fighting for food in the midst of plenty. When he draws your attention to the fact that Nanook's spear is grave in its upheld angle, and finely rigid in its downpointing bravery, you may, with some justice, observe that no spear, held however bravely by the individual, will master the crazy walrus of international finance. Indeed, you may feel that in individualism is a yahoo tradition largely responsible for our present anarchy, and deny at once both the hero of decent heroics (Flaherty) and the hero of indecent ones (the studios). (Hardy 1946:82)

The social-realist documentary movement which Grierson founded in Britain in 1929 represented a wholly different conception of the use of the cinema from that held by Flaherty, although the British group was deeply indebted to Flaherty's method of filmmaking, always acknowledged the debt, and always respected his superb visual sense.

IV: To have made the film *Nanook* single-handedly was in itself a heroic achievement. To get it shown to the public, however, called for a different struggle. Flaherty tells the story:

> When I got back to New York, it took the better part of a winter to edit the film. [He hired Charlie Gelb, a technician, to help him.] When it was ready to be shown I started to make the rounds of the distributors in New York with the hope that one of them would be kind enough to give it distribution. Naturally I took it to the biggest of the distributors

first. This was Paramount. The projection-room was filled with their staff and it was blue with smoke before the film was over. When the film ended they all pulled themselves together and got up in a rather dull way, I thought, and silently left the room. The manager came up to me and very kindly put his arm round my shoulders and told me that he was terribly sorry, but it was a film that just couldn't be shown to the public. (Flaherty 1950:16, 17)

Only slightly discouraged, Flaherty showed the film to First National, another big distributor, but "they didn't even answer the phone to me after seeing the film." He had to go to the projection room and apologetically ask to take the film away. Finally, after more setbacks, *Nanook of the North* found a distributor more by coincidence than by its own merits, a not uncommon event in the film industry.

Flaherty screened it to the Pathé Company in New York, which was an important distribution organization controlled by the parent Pathé Company in Paris. He hoped that because both Revillon Frères and Pathé were French in origin, some magic might arise and they'd get together on the film. Though calling it an "interesting" picture, Pathé did not think it could be put into the public theaters as a feature on its own account. (It was five reels, approximately seventy-five minutes long.) Pathé suggested that it should be broken into a series of short educational films.

A day or two later, however, when Flaherty was running his film again at the Pathé projection room, Madame Brunet, the wife of the president of the company, was present, as well as a friend of Flaherty's who was a journalist who worked with Pathé and was the only member of the company who asked to see the picture a second time. "They caught fire," exclaims Flaherty. Their enthusiasm for the film finally induced Pathé to take it and to release it in its original uncut form to the general public. Recalls Flaherty:

The problem then was to get one of the big theatres to show it. Now the biggest theatre in New York then was the Capitol, run by a great film exhibitor, Roxy.[29] But we knew very well that to show it to Roxy cold was to invite failure. Said Pathé, "We'll have to salt it." The sister of the publicity-head of Pathé was a great friend of Roxy's. So it was arranged to show it first to her and some of her friends and tell them where to applaud through the picture, and then they would come along to the showing to Roxy in his very elaborate projection-room at the Capitol. We also told them never to talk directly to Roxy about the film but to talk to each other across him as if he were not in the room. Well, by the time the film was over, Roxy was tearing his hair. He used such words as "epic," "masterpiece" and the like. He booked it. But even then Pathé were not too trusting, and they de-

cided to "tin-can" it (block book was the common trade phrase)—
that is to tie it to *Grandma's Boy*, Harold Lloyd's first big feature film
which every theatre in New York was scrambling for. Roxy could have
Grandma's Boy, but he'd have to take *Nanook* too!

A few days later when Major Bowes, the managing-director of
the Capitol, saw the film he threatened to throw Roxy out. His rage
knew no bounds. Desperately, poor Roxy tried to get out of the con-
tract, but no—No *Nanook*, no *Grandma's Boy*. (Flaherty 1950:17)

Nanook opened as a second feature on Broadway during a hot spell;
it did only middling business. Robert Sherwood records that it played one
week and did $43,000 of business, but he does not say if this was *Nanook's*
share of the double bill with *Grandma's Boy* or if it was the gross for the
two pictures (Sherwood 1923). Terry Ramsaye records that its total gross
was about $350,000, which if correct provided a modest profit to Revillon
Frères for what had been an advertisement investment (Ramsaye 1951).

Flaherty's brother David contradicts his account of the film's opening:
"*Nanook* did not share a double-bill with *Grandma's Boy* at the Capitol.
It opened there on Sunday, June 11, 1922, as the sole feature, ran a week,
like other pictures, and, according to *Variety*, did 36,000 dollars business,
which was considered good. It was a 7,000 dollar increase on the previous
week's 29,000 dollars take."[30]

This inauspicious beginning, accompanied by lukewarm or cautious
reviews by the critics, was no guide to the eventual impact of the film. As
time went on, *Nanook* began to attract press comments that differed sig-
nificantly from those of the trade or fan papers, who were interested only
in films from Hollywood. Editors and columnists drew attention to it as a
new approach, doing what the movies ought to do but never did. Similarly,
it attracted an audience often made up of people who were not habitual
filmgoers but were attracted by its realistic yet tender treatment of far-off
places and people.

In Europe, too, *Nanook* had wide success, opening in September
1922 and running for six months at the New Gallery, London. A royal com-
mand performance was held at Balmoral. The film ran for six months at the
Gaumont in Paris, was equally successful in Rome, Berlin, Copenhagen,
and other capitals. In Germany especially it had long runs everywhere and
was frequently revived in subsequent years. Critical reactions from over-
seas slowly filtered back to America and must have affected the attitude of
the film business. Few serious writers on film paid it much attention, per-
haps because the film was not recognized as an art form. Later generations
of writers were to make amends.

Flaherty's main lesson from his experience with *Nanook* was that over-
coming the obstacles to making a film is only the first hurdle and that getting
the finished film shown can be even more difficult. Throughout his life, with

the exception of the hybrid *Elephant Boy*, Flaherty had to fight hard to get adequate distribution for his films. He learned that showmanship was essential in dealing with the film-trade network that operates between the completed film and the public. Flaherty had sensible and imaginative ideas about film distribution methods that eventually were proved practicable and shrewd.

Nanook's release date in the United States was June 11, 1922. At about the same time the master filmmaker D. W. Griffith made the spectacular *Orphans of the Storm* about the French Revolution, Charlie Chaplin had recently shown *The Kid*, and Rudolph Valentino had burst upon the public in Rex Ingram's *Four Horsemen of the Apocalypse*. In the same year *Nanook* appeared, Douglas Fairbanks presented *Robin Hood*, Nazimova appeared in *Salome*, and Cecil B. De Mille gave his Swimming Pool Masked Ball in *Saturday Night*. Another Arctic film, Buster Keaton's *The Frozen North*, appeared the same year and would have made an ideal double bill with *Nanook*. Thus Flaherty's film predated *The Covered Wagon*, *Down to the Sea in Ships*, and *The Iron Horse*, all films made with a minimum of studio fabrication.

In Europe, the German cinema was entering its famous golden period of studio craftsmanship. In 1922 *Warning Shadows*, *Vanina*, and *Nosferatu* (*Dracula*) appeared. In France, Delluc had made *Fievre* and Abel Gance his locomotive film *La Roue*. In England, Bruce Woolfe had produce a reenactment of the war exploit, *Zeebrugge*. In Russia, Dziga Vertov was issuing a monthly newsfilm called *Kino-Truth* and developing his theories about catching life unawares; Sergei Eisenstein was still working in the theater.

None of these contemporary films was comparable to *Nanook*. Of the films mentioned above, only those by Chaplin and Flaherty have stood the test of time. The only one to be reissued was *Nanook*, by United Artists, twenty-five years after it was first released, in July 1947. It ran fifty minutes and had a narration written by Ralph Schoolman and spoken by Berry Kroeger and music composed by Rudolph Schramur. Its title was displayed in twenty-foot neon letters above the canopy of the London Pavilion, one of the West End's main theaters in Piccadilly Circus, sometimes called the hub of the world. London critics acclaimed it as the film of the week. In New York, it played at the Sutton Theatre shortly before the premier of *Louisiana Story* in the late summer of 1948. In 1950–51, this sound version was made available for 16-mm distribution, and it is still being widely shown in several foreign language versions as well as in its original American. It has been shown on television in the United States and Britain, as well as in West Germany, Italy, and Scandinavia.

The timeless quality of *Nanook* has been stressed by many critics, but the undisputed success of its reissue is the greatest tribute to its maker. Yet, at the time of its premier in 1922, the reviews by the New York critics were

not remarkable. "The notices were mixed," records Flaherty. "One critic damned it with faint praise, but then wrote a better review a few weeks later."

Says Richard Griffith,

> They had nothing but their own tastes to guide them, and those whose mouths were set for romantic make-believe called it a "novelty" and let it go at that. Some others cautiously opined that it was more than a novelty in the usual sense, that *Nanook* was indeed something new under the sun: a dramatic and human pattern, not contrived from paint and plaster and machinery, but elicited from life itself.
>
> The picture began to gather itself a Press entirely different from the trade and fan publications which attend feverishly upon the phenomena of Hollywood. Columnists and editorial writers praised it as the sort of thing people had always thought the movies ought to do, and now it was plain they could. And as it made its way through the theatres, it seemed to draw an unusual audience, an audience of people who didn't often go to ordinary movies but who liked adventure, or travel, or just simple beauty. (Griffith 1953 : 49)

Neither Flaherty nor *Nanook* occupies much space in the serious literature about the film industry written in the 1920s and early 1930s. Among English-language books, for example, no reference to the film occurs in Elliott's *Anatomy of Motion Picture Art* (1928), Messel's *This Film Business* (1928), L'Estrange Fawcett's *Films: Facts, Facts and Forecasts* (1927), or Rudolf Arnheim's *Film* (1933), nor is it included in the German edition of *Der sichtbare Mensch* (1924) by Béla Balazs, the distinguished Hungarian critic. In the two massive volumes of Terry Ramsaye's well-known *A Million and One Nights* (1926), *Nanook* is given one line (p. 600) as against an extravagant buildup for Martin Johnson and his lurid adventure films.

From its first issue in July 1927 until August 1928, in that little mine of information and theory, *Close-Up*, the only significant reference to *Nanook* was as a substitute for *Under Arctic Skies* ("which gives a good idea of northern life and links up, via Siberia, with Asia") in a suggested list of films for children. Bryher, the associate editor of the journal, added "I have always missed this picture [*Nanook*]" (vol. 1, no. 2 [1928]: 20).

Caroline Lejeune, however, in praising *The Covered Wagon*, compared it to *Nanook*: "There had been earlier films with an impersonal theme—Flaherty's *Nanook* the greatest of them all, with a sheer statement of drama that has never been equalled to this day. But *Nanook* did not impinge closely enough on emotion to win the suffrage of the public; its theme was too pure, too remote from audience psychology. It had successors; it was not sterile. . . . But it was *The Covered Wagon* that opened

the picture-house to the impersonal film" (1931:179–80). Even in Lewis Jacobs's commodious and valuable work, *The Rise of the American Film* (1939), *Nanook* received only a bare half-page, with a brief mention elsewhere. The British documentary group who were writers as well as filmmakers in the late 1920s and the 1930s were the first to recognize Flaherty and his *Nanook* (Rotha 1929, 1931, 1936). In France, Flaherty made a deep impact on such critics as Moussinac and Delluc, who were quick to point out what they called the *purité* of *Nanook*.

In 1925, a book appeared with the title *Nanook of the North*, by Julian W. Bilby (London: Arrowsmith). A publisher's note stated:

> For several years the name "Nanook" (The Bear), as that of an Eskimo hunter, has been widely familiar in England and America, since *Nanook of the North* was the title of a cinematograph film produced by Mr. R. G. [sic] Flaherty, and exhibited by Messrs. Revillon Frères and Messrs. Pathé. In that film was told the life-story of a certain Eskimo who chanced to bear the common Eskimo name—Nanook. Mr. Flaherty, in a chapter in his book *My Eskimo Friends*, has described how these pictures were taken. The present volume gives in words the life-story of a typical Eskimo—as the cinematography film gave it in pictures; but it makes no claim that this is the history of the Eskimo named Nanook who was known to Mr. Flaherty. On the other hand, the illustrations in this volume are reproduced, some from the film (by kind permission of Messrs. Revillon Frères and Messrs. Pathé) and others from photographs taken at the same time as the film; so that many of them contain portraits of the most celebrated bearer of the name.

Of twenty-nine illustrations, eighteen are credited to the film but they are not stills from it in the accepted sense but photographs taken at the same time, presumably by Flaherty. Some show incidents not in the film.

V : In *The World of Robert Flaherty*, Walker Evans reminds us that Flaherty was closer to Sherwood Anderson's generation than to Ernest Hemingway's. "He certainly had one foot in an age of innocence" (Evans 1953).[31] As an artist, Flaherty was self-educated and self-discovered. Moreover, he had found a new medium. When he made *Nanook*, such a film was only beginning to be recognized as an art form.

But if Flaherty belonged to Sherwood Anderson's generation, he was not creatively a part of it. Nor was he ever a part of the spirit of revolt that flared up when Greenwich Village became the new Bohemia around 1913 in the days of the birth of the *New Masses*, the *New Republic*, and the *Seven*

Arts. Rather than participating in the urban cultural revolution, Flaherty was being wrecked on the Belchers or wintering among his Eskimo friends at Amadjuak Bay. While the socialist writer John Macy was proclaiming in his *Spirit of American Literature* (1913) that "the whole country is crying out for those who will record it, satirize it, chant it" (quoted in Kazin 1943:178), Flaherty was actually accomplishing the first and last of these tasks. While Sherwood Anderson and Sinclair Lewis were becoming known as the new realists with publication of *Winesburg, Ohio* (1919) and *Main Street* (1920) and were soon to be challenged by the bitterly cynical writing of e. e. cummings, Ernest Hemingway, and John Dos Passos and by the new decadents and smart stylists including Carl Van Vechten, Thomas Beer, and the middle-aged James Branch Cabell, Robert Flaherty, a poet with a new visual perception, had produced and placed on Broadway one of the first masterpieces in a new medium which was revolutionizing all media of expression. And he had done it single-handed. His first work, born out of anger and frustration at his early failure, was destined to live a good deal longer and be understood by a great many more people all over the world than all but a handful of the literary products of the early postwar years in America.

Out of the tangled wilderness of northern Canada and the barren ice of Hudson Bay had come a man who, on the one side, challenged the art of the cinema as it had been gropingly developed up till then and, on the other, struggled against the industrially organized machinery of the film trade. It is impossible to overrate the magnitude of this challenge and the courage of the man who made it. But it would be wrong to think that Flaherty was part of the American cultural tradition.

The span of years Flaherty spent in the Canadian North were not only to find consummation in his film in 1922 but to have a profound and indelible effect on his outlook for the rest of his life. The emptiness, the expanse, the cold—the very loneliness of this barren snow-and-ice world where the wind seems never to cease—may have given him time to contemplate and to compose his thoughts. The small black figures on a vast white landscape, the snow drifting in the wind, the huge distances to be traversed with a minimum of equipment and comfort all bit deeply into a man whose intense china-blue eyes reflected his experience.

In the North Flaherty learned that when peoples' life situations were so hazardous that at any moment they might suffer disaster, they depended absolutely on each other. Thus there existed "an atmosphere of loving kindness and forgiveness of sins"—the words are Grierson's—that was extraordinary. Whatever was to happen later—in the South Seas, in the Aran Islands, in Mysore, and in the United States—Flaherty the artist, poet, and explorer was already developed and mature at the age of thirty-eight, the year he finished *Nanook*.

In his book *Eskimo*, Edmund Carpenter writes of the acuteness of ob-

servation of the Eskimos, of their ability to recognize the identity of objects or animals at great distances. He does not suggest that their eyes are optically superior to ours but that supersensitive observation is vitally important to them because they live in barren surroundings. Over years they have unconsciously trained their eyes to observe accurately and meaningfully. "Moreover," he adds, "they enter into an experience, not as an observer but as a participant."

Writing about their art—a word that does not occur in their language—he makes the significant point that the carver of a piece of ivory will hold it unworked in his hand, turning it around and saying to himself, "Who are you?" and "Who hides there?" Only after some thought does he decide that he will carve out of it a seal or a fox. He tries to discover its hidden form from within, and if that is not forthcoming he will carve at the ivory cautiously until a form suggests itself. "Seal, hidden, emerges. It was always there, he didn't create it; he released it. . . . The carver never attempts to force the ivory into uncharacteristic forms, but responds to the material as it tries to be itself, and thus the carving is continually modified as the ivory has its say." This attitude is reached only by long experience and contemplation.

We believe that these two Eskimo qualities—the acute power of observation and the letting of material shape its own meaning—form an integral part of Flaherty's art as a filmmaker. His training from early youth as an explorer and mining surveyor must have taught him to use his eyes acutely, but his many years of living in close contact with the Eskimo people and his love of them must have taught him even more about keenness of observation. We know, too, that he made a close study of Eskimo carvings and took many fine examples back home with him. He must have fully understood their attitude toward such craftsmanship.

Carpenter confirms our belief:

I am sure you understand that what I said (in the book *Eskimo*) about discovering the form within the ivory is just a minor illustration of an attitude towards life that pervades Eskimo thought and especially Eskimo human relations. Flaherty must have been very close to these people, as few Westerners have been; there are insights, observations in his writings that could only have come from the most intimate contact. His writings are so casual in style that someone unfamiliar with the Eskimo might regard them as happy travel stories, nothing more, and conclude that his relations with the Eskimo were fleeting. This could not be the case: one tale alone refutes it: that short story about the family marooned on an island and finally escaping via a crude craft. So it may not be unreasonable to suppose that Flaherty was influenced by the Eskimo, or at least found their attitudes understandable and congenial to his own temperament. His writing might mis-

lead readers into also supposing that his northern trips were without grim ordeals. Actually, he must have had some rough times.[32]

We shall discuss later an important part of Flaherty's filmmaking—the actual filming of raw material in real surroundings and the subsequent assembling of such material into a shape or form fit to be presented to spectators—and it will then be seen that an analogy can be found with the method of the Eskimo carvers. Both these points are emphasized at this early stage of the discussion because they may well have emerged from Flaherty's close association with the Eskimo people and their environment over almost a decade.

"Bob was forever always telling me," said Frances Flaherty, "that he wanted to go back to the north. 'I go to come back,' he would say. He wanted to go back to dwell in his mind, to find a refuge. The memory of the north never left him. But Bob never did go back."[33]

As Flaherty began this chapter, let him end it:

> You ask me what I think the film can do to make large audiences feel intimate with distant peoples? Well, *Nanook* is an instance of this. People who read books on the north are, after all, not many, but millions of people have seen this film in the last 26 years—it has gone round the world. And what they have seen is not a freak, but a real person after all, facing the perils of a desperate life and yet always happy. When Nanook died of starvation two years later, the news of his death came out in the Press all over the world—even as far away as China.
>
> The urge that I had to make *Nanook* came from the way I felt about these people, my admiration for them; I wanted to tell others about them. This was my whole reason for making the film. In so many travelogues you see, the filmmaker looks down on and never up to his subject. He is always the big man from New York or from London.
>
> But I had been dependent on these people, alone with them for months at a time, travelling with them and living with them. They had warmed my feet when they were cold, lit my cigarette when my hands were too numb to do it myself; they had taken care of me on three or four expeditions over a period of eight years. My work had been built up along with them; I couldn't have done anything without them. In the end it is all a question of human relationships. (Flaherty 1950: 18, 19)

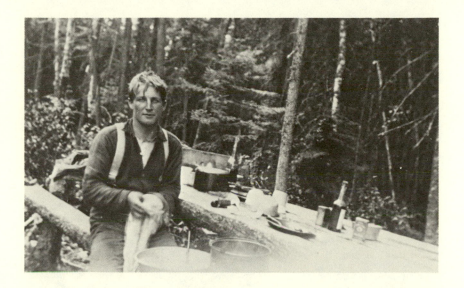

(Above) Snapshot in North Woods about age 20, photographer unknown

(Right) "Rob playing his beloved violin into the vastness, Vancouver, 1908," by Frances Hubbard (Flaherty) (print courtesy Public Archives of Canada)

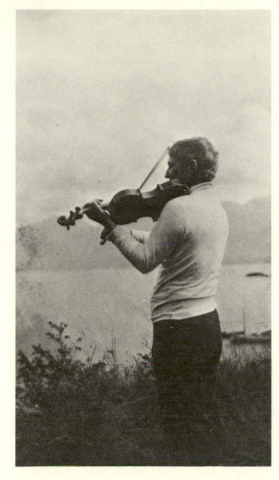

Frances Hubbard (Flaherty), ca. 1915, photographer unknown

"Flaherty as Arctic Explorer," photographer unknown (print courtesy Museum of Modern Art Stills Archive)

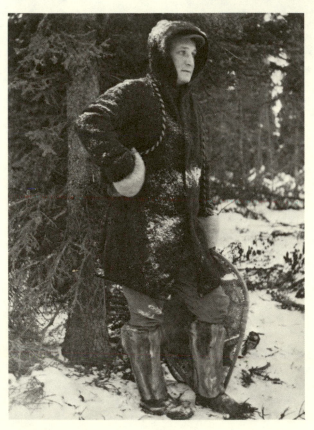

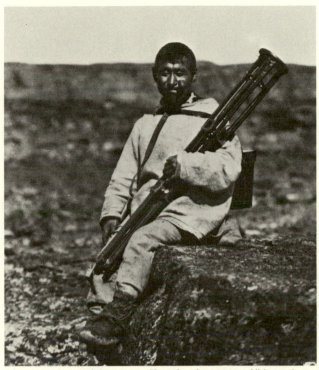

Film assistant, Belcher or Baffin Islands, 1913–16," by Robert J. Flaherty

"Flaherty with children in the Arctic," photographer unknown (print courtesy Public Archives of Canada)

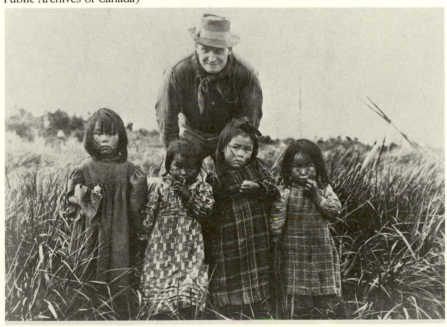

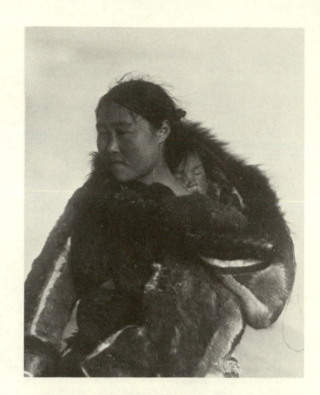

Nyla, by Robert J. Flaherty
(print courtesy Public Ar-
chives of Canada)

Flaherty's Arctic home—
interior, by Robert J.
Flaherty (print courtesy
Public Archives of Canada)

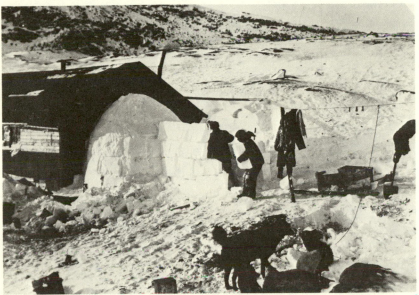

Flaherty's Arctic home—exterior, by Robert J. Flaherty (print courtesy Museum of Modern Art Stills Archive)

Portrait of Allakariallak, who played the title role of Nanook, by Robert J. Flaherty

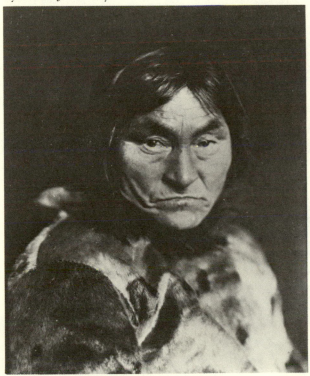

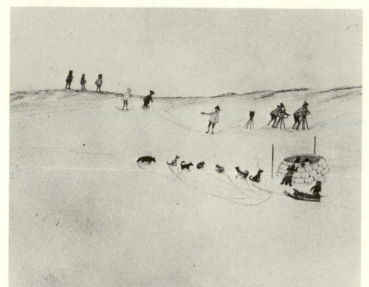

Moving pictures of the igloo. Original drawing on paper, most likely by Wetallok from the Belcher Islands (Danzker 1979)

Nanook. The gramophone, by Robert J. Flaherty

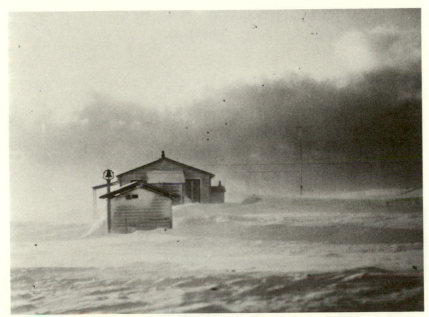

Port Harrison Trading Post, 1921, by Robert J. Flaherty

Nanook the harpooner, by Robert J. Flaherty

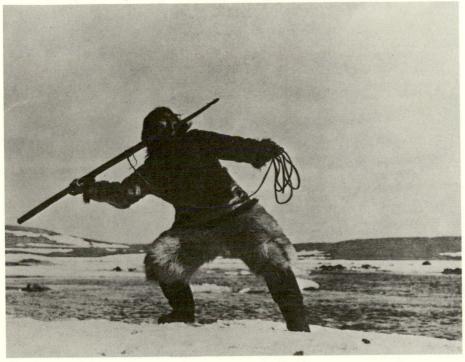

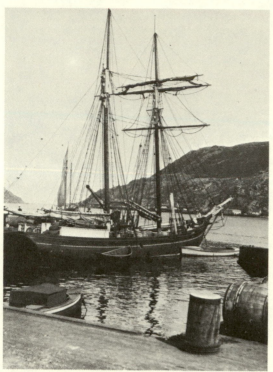

The Laddie, ca. 1915, by Robert J. Flaherty (print
courtesy Public Archives of Canada)

Flaherty using his Bell and Howell camera during the 1916 expedi-
tion, photographer unknown (print courtesy Public Archives of
Canada)

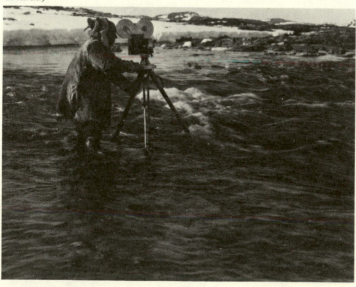

Moana and the Pacific

Chapter 2

It was wholly in Hollywood's character for the major distributing company that had spurned the first offer of *Nanook* to offer Flaherty the chance to produce his next film. A major reason was that Jesse L. Lasky, production head of Famous-Players-Lasky, the studio end of Paramount Pictures Corporation, was fascinated by exploration.[1] In his memoirs published in 1957, Lasky attributed this fascination to boyhood fishing trips with his father in Maine, later camping trips with Zane Grey, the writer of popular Westerns, and pack-trip vacations with hired guides in Alaska, the High Sierras, the Canadian Northwest, and down the Columbia River.

A second reason may have been that Paramount, like other American distributors, was finding that the overseas markets for its films were becoming very remunerative (Griffith 1953). Lasky may have realized that the picture Paramount had ignominiously rejected the year before was now doing good business in Europe and that it had cost peanuts to produce compared to the run-of-the-mill programme pictures coming from the studio. Lasky saw in Robert Flaherty an unusual filmmaker, who should receive more respect than the hack directors at his studio.

A third reason, suggested by John Grierson,[2] was the influence exercised by twenty-nine-year-old Walter Wanger, then working as a producer under Lasky. "Wasn't Wanger somewhat responsible for those special excursions into realistic cinema by Lasky," writes Grierson. "About that period Wanger read a piece of mine, brought me in to see Lasky, exposed the financial returns of Paramount to me and invited me to make an analysis of the bearing of realism on box-office returns. It brought the first analysis of the difference between 'Western' and 'Epic.' Wanger was sort of impor-

tant in all this. He was really interested in the new wave of criticism. He was the only intellectual they had on the Lasky level."

It is not clear whether Lasky went to see Flaherty, or whether he summoned Flaherty to come to him. It is known, however, that Lasky either wrote or spoke words to the effect of "I want you to go off somewhere and make me another *Nanook*. Go where you will, do what you like—I'll foot the bills. The world's your oyster."[3]

Flaherty, who presumably still considered himself an explorer rather than a professional filmmaker, must have been shaken. "I was elated," he wrote. When approached by Lasky during the winter of 1923, he was at his home in New Canaan working on writing. He promptly contacted Frederick O'Brien, whose book *White Shadows in the South Seas* had been a popular success in the United States since its publication in 1919. They arranged to meet for dinner at Flaherty's favorite haunt, the Coffee House Club near Times Square, to which representatives of Revillon Frères had introduced him. O'Brien brought George Biddle, a wealthy young man who had recently been painting in Tahiti, and it is said that Grace Moore, who was just beginning to sing at the Metropolitan, and Mrs. Flaherty were also present.

Before the evening was over, Flaherty had been convinced that, having spent so many years in the frozen North, the obvious and most sensible thing to do was to go to the opposite extreme. "You'll go south, to Polynesia," O'Brien is alleged to have said. "Study the islanders. You'll make a beautiful film" (Taylor 1949). Biddle and Grace Moore, both of whom had visited Tahiti, agreed with O'Brien. Samoa, the only place where a true Polynesian culture survived, was the location they recommended. "Go," said O'Brien, "to the village of Safune on the island of Savaii and you may still be in time to catch some of that beautiful old culture before it passes entirely away."[4]

Flaherty had made up his mind that at all costs his wife should accompany him on his next expedition. "But what about the children?" Mrs. Flaherty asked. They were six, four, and two years of age. Flaherty at once declared that they must go, too, to be schooled in the ways of nature. The decision that this time Frances Flaherty would go with her husband is important. For nearly ten years she had been living in different homes while Flaherty was in the North, first for Mackenzie and then making his film. She had been influential in the discussions on the editing of *Nanook* but had never before played an active role in filmmaking itself. She would become a gifted still photographer as well as a close collaborator on all future Flaherty films.

The expedition to Polynesia consisted of Flaherty, his wife, their three small daughters with a red-haired Irish nursemaid, and Flaherty's younger brother David, who was to be production manager. When called to join the

expedition, he was working in a coal and wood office in Port Arthur; he recalled that it was "the coldest winter on record." He first heard of the venture in a telegram that read approximately: "All arranged with Famous-Players-Lasky make film in South Seas STOP Sailing San Francisco for Samoa April 24th come earliest possible STOP Salary two hundred dollars a month—Bob."

"It changed the course of my life," says David Flaherty modestly, meaning that he was associated with making his brother's films for many years and became a good filmmaker in his own right. "Within two weeks," he adds, "I had joined Bob and his family in New Canaan and within weeks we were on the bosom of the broad Pacific, far from the snow and ice, coal-dust and clinkers."[5]

Flaherty took an electric generating plant, developing outfit, and 35-mm projector. But he also took a Prizma color camera. It was the Prizma camera that filmed the Kinemacolour film *The Delhi Durbar in India*.[6] He took two Akeley No. 5 motion picture cameras with a gyro-head tripod such as he had used on *Nanook*, and several feature films for showing to the movie-unconscious Polynesians. Legend has it that a piano was part of the equipment, but fact confirms only the presence of the famous violin.

Before they set off, the Flahertys were given a dinner in New York at the old Waldorf-Astoria. Eminent and influential personages from big business, Washington, the arts, sciences, and various powerful American foundations were present. All, however belatedly, hailed the discovery of this new kind of filmmaking Flaherty had demonstrated in *Nanook*. Speeches proclaimed this new use of the motion picture as a means to unite the world's peoples to create better understanding and serve the cause of international relations. The Flahertys departed with the unanimous blessings of this distinguished gathering of American culture.[7] This dinner was to be of some importance two years later when Flaherty ran into problems over the distribution of his picture.

They sailed from San Francisco in April 1923 in an old steamer, the *Sonoma*, bound for Tahiti. Frances Flaherty recalls:

> We were making a film for Hollywood, and we were very conscious of the fact. Bob had no illusions whatever as to what Paramount expected of him in the way of thrills and sensations for the box-office. All the way down on the steamer we talked about it, about the sea-monsters there doubtless were down there around those islands; doubtless the Samoans had encounters, fights for their lives, with them. And when one day a report came in from another ship at sea that one of these monsters had been sighted—a giant octopus, its tentacles spread over the waters from a body the size of a whale—we were sure we were on the right track.[8]

Before he left New York, Flaherty had been given a glowing description of Savaii by Frederick O'Brien. It was the last remaining island uncontaminated by modern civilization; its inhabitants, "an almost Grecian race," were as superlatively beautiful as the landscape; and in the village of Safune there lived one white man who knew the Polynesians and their language and would therefore be invaluable. To this man, a German trader named Felix David, O'Brien gave Flaherty a letter of introduction, which was to have strange and unexpected results.

O'Brien's glamorous description of Samoa was somewhat exaggerated. A more realistic account of both islands—Savaii and Upolu—at that time may be found in Newton A. Rowe's enthralling book, *Samoa Under the Sailing Gods* (1930). Rowe held the post of agricultural or district inspector and spent the years 1922–26 on the two islands. In his book, he not only recounts with sympathy and understanding his experiences with the native population, but he also provides a documented indictment of the administration under the mandate of the New Zealand government, to which I later refer. He describes the island to which the Flahertys were going as follows:

> Savaii—said to be the cradle of the Polynesian race—the largest and most westerly of the Samoa group, is split up into separate parts, or natural fertile divisions, by three lava-fields which have flowed down fan-wise to the coast from the central wooded masses of the volcanic interior, which attain a height of 6000 feet. It is about 170 miles in circumference. . . . Between the lava-fields range long and fertile districts; and along their shores lie the bulk of the native villages, for there are but few settlements inland. Above the villages rise or straggle native coconut-plantations, penetrating the forest, from which are produced copra. In every village of any consequence, numerically, is a store or trading-station. . . . The island is encircled by a fairly good road, which stops short, however, of the lava-fields. (Rowe 1930:147)

Both Flaherty and his wife wrote colorful descriptions of the two years they and their family spent preparing for and making the successor to *Nanook*. The account that follows has been put together from the writings of both of them, some written at the time and some in later years, together with subsequent notes supplied by David Flaherty.

They arrived at Pago-Pago in American Samoa in early May and then took the schooner to Apia, the main town on the island of Upolu, which with the nearby island of Savaii had been mandated by the Treaty of Versailles in 1919 to the New Zealand government. After spending two or three weeks outfitting in Apia, they took another schooner to their final destination on Savaii, the village of Safune. Flaherty described the voyage:

I don't think that either of us will ever forget the morning we stood off the reefs at Safune waiting to get in. All that long we'd been crossing the sea, the boat rocking and rolling. We had to keep awake and watch the children from rolling like logs into the sea. All we could hear was the thunder of the sea—of big seas smashing.

We waited there a long time before at last daybreak came. I've never seen such big seas in my life. They were higher—and we reared higher—than the boat was long. How in the world we could get a passage through the reef I couldn't imagine because it looked like a solid wall of rearing water.[9] However, our good skipper began maneuvering until a small lull opened between the seas. Then he opened up the engines and shot through a passage not much wider than the boat itself.

When we got into the lagoon, we were like a cloud floating through the sky. The water was as clear as the air too. We could see down to the coral gardens, the slowly waving plants and fishes all colors of the rainbow. From the very first everything seemed fabulous—a fantasy. Here ahead of us was the gleaming crescent of the beach with the great coconut-trees towering above it. Nestled among the trees were the native huts, beautiful houses of bamboo and thatch shaded by the palms, red acacias and perfumed frangipanis, and among them a great trading-station, a white, weather-worn and green-shuttered structure. It had two flower-grown verandas, one around the main floor and one around the second story. Even from a distance, it was obvious that the lower floor was the store and the upper the living quarters of its occupants.

When the schooner finally berthed at the long, slender finger of a wharf, we could see the white-clad figure of the man we had come so far to meet. From the upper veranda he gazed at us through binoculars. The natives streamed down the wharf and gave us the friendly welcome that so endears one to the Polynesians.[10]

The landing party was conducted up the beach to the gates of the compound and then up the stairway to the upper veranda, where their host, the German trader Felix David, welcomed them. His hair was white, and he had a mustache in the Kaiser Wilhelm style. His face told at first glance of the many years of isolation he had chosen for himself. He called himself the king of the island.

The visitors were served a vast breakfast on the rear of the veranda, where a table was laden with food—mummy apples, breadfruit, pineapples, coconuts, roast wild pig, and the rarest of rare mangoes. Flaherty often recounted in later years the sumptuousness of this welcoming feast. Behind each chair stood a lovely Polynesian girl, naked to the waist, who

fanned the guests, and in one corner a group of boys sang with their eyes half-closed and slapping their hands in rhythm.

"There were little bananas no bigger than your finger," says Flaherty, "and there were huge ones almost as long as your forearm. And I never tasted such pineapples. I don't think anyone who has never been in the tropics knows what a pineapple can taste like. Then there was a big fish the trader opened up for us to eat. He looked carefully inside first and picked out a silver shilling. If the shilling had been tarnished, we couldn't eat the fish."

The breakfast lasted for several hours, after which their host led them into the big living room, the great doors of which opened onto the blue sea. The white fringe of the eternally booming surf was visible in the distance. The atmosphere in the room was as unreal as their host. On the walls were old lithographs and chromos, framed photographs of great figures of the German stage and opera of the 1880s. Outstanding among this faded gallery was a painting of an imposing military figure, presumably Felix David's father, a rigid Prussian with fierce, upturned mustache, holding a sword in front of him. In one corner stood a piano of the same period, laden with tattered, fly-specked music scattered at random.

Felix David, to whom Flaherty had sent Frederick O'Brien's letter in advance of arrival, told them that he had informed the island chiefs that a motion picture was going to be made about the people of Safune. None of them had ever seen a film, nor in fact had David, who had left Europe in his youth twenty-seven years before.

Every evening the trader entertained the natives of the island with a vocal concert. He had been trained as a young man to sing an operatic baritone but had been thwarted from pursuing a promising career by the firm objections of his Junker parent. As a result, the young Felix had shaken the dust of European civilization and culture from his feet and had installed himself on this island paradise, consoling himself with memories of what his career might have been had it not been for his father. His tour de force in the evening recitals to the peace-loving villagers of Safune was Siegfried's death scene from *Götterdämmerung*. Some of the older islanders had probably heard this powerful rendition five thousand times, but they always came back for more.[11]

The Flahertys began to settle in. They had come to make a picture of people to whom they were complete strangers—unlike the situation when Flaherty was making *Nanook*—and whose language they could not speak. Felix David would be invaluable as an intermediary. It appeared that the people obeyed his every command and that he ruled them in Teutonic style. Frances Flaherty recalled:

> The people we met when we arrived were like creatures of another time. We remembered the words of Henry Adams, friend of

Robert Louis Stevenson, who with John LaFarge the painter, lived in Samoa in the 1880s: "It is a deep wonder to me that I have not been told that here is rustic Greece of the Golden Age, still alive, still to be looked at."

The villagers lived in about a hundred houses, which served mostly as shelters against tropical storms, since life was actually lived out-of-doors, on the beaches, in the clement sea that was as warm as the air, and in the palm jungles, where lurked no dangerous beasts except the wild boar, who kept himself to himself if left alone. Here men and women played through the long days like children. Time had no meaning. Life was a game, a dance, a frieze on a Grecian urn. (Griffith 1953:52)

Before their arrival on the island, the sixteen tons of equipment for the laboratory, the electric generator, the projector, and other apparatus had arrived. Because for insurance purposes high values had been assigned to the equipment, Flaherty was at once called the "Melikani Millionea." For several days a chain of natives carried boxes and bales up to an old, disused, and overgrown trading post which, after another team had made it habitable, was to be their headquarters. It was situated among giant palm trees within view of David's residence. It was the house where Frederick O'Brien had lived. In due course, a greensward was cleared away under the coconut trees so that a cinema screen could be erected at one end and the lighting plant and projector set up at the other. A little hut was built at the mouth of a cave that would be converted into a laboratory, sheltered by a huge, outspreading breadfruit tree.

David had arranged a meeting to introduce the Flahertys to the chiefs of the island. Some twenty-five chiefs, all of Safune, gathered in the village guesthouse to be told why the white visitors had come to Samoa, especially to Savaii and Safune, and how much Flaherty admired the Samoan people and their way of life. In return, the chiefs welcomed them, said that they hoped all would go well, and promised help. A great feast followed.

"Our big idea," said Frances Flaherty, "was that we should make a film after the pattern of *Nanook of the North*. We should find a man like Nanook the Eskimo, a sturdy, dignified chief and head of a family, and then build our picture round him, substituting the dangers of the sea, here in the South Pacific, for those of snow and ice in the North. We would present the drama of Samoan life as it unrolled itself naturally before us, as far as possible untouched by the hand of the missionary and the government. We began by trying to tell the Polynesians in a booklet about the Eskimos and the purpose behind filming *Nanook*" (Griffith 1953:54).

A graphic description was then unrolled by Flaherty of how he had lived with the Eskimo people and won their friendship and confidence. He had made the picture of them because "love overflowed in his heart for the

people of that country, on account of their kindliness and their bravery, and also on account of their receiving him well, and because they look very happy every day of their lives in a life most difficult to live in the whole world." The men in New York (i.e., the film's backers) had seen that Mr. Flaherty had done a very useful thing in making this picture. "Such pictures as this will create love and friendship among all the people of the world." Misunderstandings and quarrels among nations will cease, said Flaherty. And so the big men in New York (Hollywood was apparently not mentioned, perhaps because it might have given the islanders wrong ideas) had now sent Flaherty to Samoa to create another such picture among the descendants of the pure Polynesian race of ancient times as they were in the days before missionaries and traders had arrived to change their customs. (We wonder how Felix David liked interpreting these words.)

Frances Flaherty recalled, however, that the screening of *Nanook* some weeks later made little impression on the islanders. They appeared pleased to see something which Flaherty—or Lopati as he was now known—had made, but apart from that, Nanook's celluloid activities left them unmoved. "I do not believe," adds Mrs. Flaherty, "they had any sense of importance that we wanted to make a picture of them, too, for the benefit of some far-away country." One doubts, also, if Jesse Lasky, sitting in his executive suite some five thousand miles away, would have wholly subscribed to the altruistic motives that were said to be the reason why his studio was backing Flaherty's second production.

While the organization of the unit's headquarters and equipment went ahead, Flaherty was at pains to get to know Felix David better. He found time to go and have a glass or two of mummy beer and a chat at the trader's house. Felix continually showed his pleasure at Flaherty's presence. He was anxious to see the films that Flaherty had brought. "Ach, Gott!" he would exclaim. "The new art. Are we not brothers in the craft just as O'Brien had predicted." And the more beer he drank, the more he would sink into maudlin reminiscences of his frustrated career. In his eyes the considerable sums of money the film unit would pay him for his services were a small fortune.

In between his fits of despondency, Felix David was at first very helpful. His servants scoured the island for suitable subjects for filming, information, and whatever else Flaherty might need. But Flaherty was confronted with a problem which only he, with perhaps the aid of his wife and brother, could solve. What was to be the theme of his film?

"No sooner were we landed," writes Frances Flaherty, "than Bob began a search of the deep-sea caverns underlying the coral reefs which fringed the island, for giant octopuses and tiger sharks. For weeks and weeks he searched. And when at last he did not find them and had to admit they simply were not there . . . he just sat on our verandah with every thought falling away from him." [12]

Flaherty himself wrote of this period from the location itself:

> During my first few weeks in Samoa, I was disgusted. The drench-
> ing heat did not help my feeling for the charm and spirit of the coun-
> try; the natives I could only see as mobs and rabble. The fortunes of
> the film seemed low indeed. These reactions, however, were simply
> those of any superficial traveller hovering around Pago-Pago or Apia,
> the two ports of call. Only when I left the white man's settlements
> in this incredible spot, became acclimated and began personally to
> know the Samoans, to live amongst them, to have them in my house,
> to journey with them, did my interest and enthusiasm revive. . . .
> We are living in one of the finest native villages in all Samoa. . . .
> It stands within the shelter of the tall rocking coconuts. Beyond the
> screen of trees and the outline of the chocolate-topped thatched *fale*
> (house of the village chiefs), is the strip of sea, blue as blue, save for
> the single thin line of white which is the booming, grumbling reef
> (without which no South Sea island is complete).
> It has been no easy task to get the right characters for the film.
> Like the Eskimo, the photographable [sic] types are few. Taioa, the *tau-*
> *pou* (village virgin) of Sasina was my first find. Here should follow the
> inevitable picture—raven hair, lips of coral, orbs (meaning eyes) etc.,
> etc. But to you, not knowing the fine type of Polynesian, such a pas-
> sage of words would mean nothing. I can only say that when, after a
> feast of pigs, *taro*, breadfruit, wild pigeons, mangoes and yams, to the
> accompaniment of *siva sivas* and *Ta'alolos* hours and hours long,
> I bargained for and bought her face from the proud and haughty
> albeit canny chiefs of Sasina, and she and her handmaid came up
> the palm-lined trail to Safune, the old women here told her between
> their teeth that they would see she was killed by dawn. (Flaherty
> 1924:9–13)

He tells us elsewhere that when he met the chiefs of Safune, he found
that they were so proud that their village had been chosen as the location
for the film that they boasted of it to every other village on the island.[13]
Every morning the Flahertys could see from their veranda all the chiefs
walking in a solemn procession to their meetinghouse, wearing *lava-lavas*
round their waists, their torsos gleaming in the sun from the coconut oil
with which they had been anointed, fly-switches over their shoulders, and
a big, blazing, red hibiscus tucked behind each ear, as was the custom in
Samoa. They would go to their *fono-fali* and begin their ceremony for the
day with the drinking of the *kava*.

The *taupou* in Samoa is a village's principal maiden, not only because
of her rank but also, theoretically, because of her beauty. She is treated like
a princess. She officiates at all ceremonies, especially the making of *kava*

when visiting chiefs arrive. The higher the chief, the more important is the ceremony. All the chiefs plan one day to marry off their *taupou* to a visiting chief, the higher the better so that she may bring great prestige to her village.

Flaherty searched the village of Safune for a girl suitable to play the heroine in his film but without any success. The chiefs then came to him and offered him their *taupou* for the part—the highest honor they could pay him. Special arrangements could be made, they said, to make her available to Lopati. But Flaherty had already noted the *taupou* of Safune, who was far from young or even attractive. He solemnly thanked the chiefs for their offer but courteously declined to accept it.

Shortly after, he found the ideal girl for his film. She was the *taupou* of the nearby village of Sasina. He did not know, of course, that no two villages on the island of Savaii were as jealous of one another as Safune and Sasina. He knew only that he had made up his mind that Sasina's *taupou*, whose name was Taioa, was perfect for the part. The chiefs of Safune received this news with a marked lack of enthusiasm. Flaherty turned to Trader David to solve the problem.

Two days later, the chiefs of Sasina brought the beautiful Taioa and graciously presented her to Flaherty for his film. He expressed gratitude but noticed none of the local Safunes were in sight. The blinds were drawn on their huts, and the village was as empty and still as a graveyard. After the Sasina chiefs had left, Flaherty asked Trader David how he had arranged for the girl to be brought. "It was simple," said Felix, "I just asked the chiefs of Safune if they wanted you to go and make the picture at Sasina. They were so infuriated by this idea that they at once agreed to allow you to bring here and use the *taupou* from Sasina" (Flaherty 1924b).

Taioa was given a space for her sleeping mat on the Flahertys' veranda. There she sat by the hour, strumming her guitar and smiling. Camera tests were made, and Flaherty was delighted. He set about solving other problems. But one month later there was a vacancy on the veranda. All that was left was a piece of green velvet. Soon it was discovered that one of the boys from the village was gone, too. "And," said Flaherty, "the Safune chiefs just laughed and laughed."

Undismayed, the Flahertys found another girl, Saulelia. She had less fascination than Taioa, admitted Flaherty, but she had beautiful long black hair. They began filming with her and were happy with the results. As time went on, Flaherty became more and more enthusiastic about Saulelia and shot some twenty thousand feet of film on her. But one morning she arrived for work with her hair cut as short as that of a man. Flaherty could not believe his eyes. Weeping, Saulelia revealed that she had been deserted by her lover and, *fa'a Samoa*, she must cut off her hair.

Finally, Flaherty had success with a third girl, Fa'angase. She had followed him around shyly wherever he had been filming. Occasionally she

would bring him a flower. She was very young, almost a child when they had first arrived at Safune, but as the months went by she was growing up. Fa'angase came from the other end of the village. Her father was a high chief. He agreed that his daughter should take part in the film but insisted that Lopati must treat her as if she were his own daughter. He explained that his end of the village was very high in rank, but the end where the Flahertys had their house was low and always had been so. Therefore the boys around the visitor's house were not high class, and Flaherty must be very careful how they behaved when Fa'angase was around. Promises were given and filming began again with the new heroine.

Two boys had been trained to work in the laboratory that had been constructed in the cave. They had to work in semidarkness, and they made up jokes and sang and laughed to keep away the evil spirits. When Fa'angase was cast in the picture, the boys couldn't control their excitement. They teased her unmercifully. When they emerged from the cave laboratory, having helped to process some film that had been shot of the young girl, they shouted, "O Fa'angase, her legs are bowed, and her eyes—one looks one way and the other looks the other way." Happily, Fa'angase took it all in good humor.

One day, however, the joking and high spirits were missing. Wondering what was wrong, the Flahertys saw that the chiefs from their end of the village were huddled together in a meeting. Alarmed, Flaherty asked Trader David what was happening. The chiefs, it seemed, were angry. Trouble was brewing between the two ends of the village. The chiefs from the high-class end were coming to take Fa'angase away from the film. All work was stopped until the matter should be settled.

That night a procession of chiefs from the high-class end of the village approached the Flaherty house. Flaherty was dismayed at the prospect of losing his leading lady, upon whom he had spent thousands of feet of film. At that moment, Fialelei,[14] the woman who acted as an interpreter for the visitors, arrived in great agitation. All the chiefs from the low-class end of the village, she said, were hiding among the coconut palms with knives in their hands. But by this time the procession of high-class chiefs had arrived at the house. With grave courtesy, they said they wished to ask a favor of Lopati: would he go with them down the path to the bridge across the river, which divided the village into its two halves, so that they could return in safety to their homes? Fa'angase was not mentioned. Flaherty hesitated a moment. Then he and Frances stepped forward and, with the chiefs between them, led the way down the path in the half-light to the bridge, over which the chiefs filed to their own end of the village. Not a sign or sound came from the men waiting with their knives in the shadow of the palm trees.

The next morning, Fialelei came to the Flahertys to say that Willy, the houseboy, wanted a holiday. "What for?" asked Flaherty. "Willy is married,"

Fialelei replied. "Married?" exclaimed Mrs. Flaherty, in surprise. "To whom? And when?"

So the story came out. While all the trouble had been going on about Fa'angase, the boys who worked for Flaherty had gone across to the other end of the village and abducted a bride for Willy. Who should the bride be but the *taupou* whom the Flahertys had rejected for their first heroine!

Fa'angase stayed with the film until all the shooting had been finished to its maker's satisfaction.

The summer months of 1923 glided away. Flaherty was still searching for some of his characters and his theme but at the same time making innumerable tests of likely types. October came and still not a foot of film had been shot that would be of use in the final picture. Then two momentous events occured, the first of great technical importance and the second of significance for the film's theme.

In addition to his two Akeley cameras for black-and-white work, Flaherty had taken with him a Prizma color camera, which required a film sensitive to color; some of the new panchromatic film had been shipped out for this purpose. This special stock was not in general use at that time, films being photographed on orthochromatic stock such as Flaherty had used for *Nanook*.

When they developed the orthochromatic tests made of scenes of Safune and possible characters and projected them at night, the Flahertys were disappointed with the results. The lovely golden bronze of the Samoans, the wide range of greens of the island's luxurious foliage, the red of the flowers which the villagers wore in their hair, all came out dark and shapeless and with none of the luminosity that made the location and its people so beautiful.

One day, for some unrecorded reason, maybe pure Flaherty cussed curiosity, Flaherty loaded an Akeley camera with a roll of the panchromatic stock intended for the color camera, which had broken down. The results were in black and white, of course, but the figures of the Samoans had a wonderful bronze quality, and the greens of the foliage appeared in a wide range of true tones. Flaherty's enthusiasm was unbounded. As Frances Flaherty wrote, "The figures jumped right out of the screen. They had a roundness and modelling and looked alive and, because of the colour correction, retained their full beauty of texture. The setting immediately acquired a new significance. . . . At last we had the solution to our problem. The drama of our picture should lie in its sheer beauty, the beauty of *fa'a* Samoa, rendered by panchromatic film" (Griffith 1953:54).

Panchromatic film stock had to be developed in total darkness, whereas orthochromatic, which is not sensitive to red, could be developed with the illumination of a red light. For this reason, using panchromatic, the work in the Flaherty field laboratory installed in the underground cave

would become doubly difficult. In addition, although the newly invented panchromatic stock had been used in Hollywood for special effects such as skyscapes with cloud formations, it had never been used for a full-length production. The manufacturers of the stock, Eastman-Kodak, had in fact warned Flaherty that it was tricky and good only for occasional use for cloud effects.

It was typical of Flaherty's love of experiment that he made the momentous decision to ignore the experts' warnings and to shoot the whole of his picture on panchromatic stock. He scrapped all forty thousand feet he had already shot and cabled Eastman-Kodak for more panchromatic. But he did not inform Lasky. This decision was momentous not only for Flaherty and his final film, notable even today for the extreme loveliness of its photography, but the results when seen in Hollywood were without doubt a major factor in the general adoption of panchromatic in place of orthochromatic stock by the film industry in all countries.

A second factor not recorded in Flaherty or his wife's writings but about which Flaherty told me in London in 1931 was that he first experimented with the panchromatic stock at the time of day when the sun is low—either in the early morning or late afternoon. That is the time when the sun's low rays creep underneath foliage so that shadows are long and a stereoscopic effect is achieved on the screen. Flaherty said that whenever possible thereafter he filmed only in the early morning or late afternoon light (Rotha 1931:19).

It was this second discovery, just as important as the use of panchromatic stock for black-and-white photography, coupled with Flaherty's selection of pictorial compositions and mobility of camerawork that gave his completed film its famous visual beauty.[15]

Flaherty still had not found a theme for his film. Beautiful photographic effect is one thing; quite another is the story or theme the film intends to convey. It seemed as though for several months he expected something sensational to happen.

Mrs. Flaherty records:

From white old-timers we eagerly questioned at the beginning, we received little comfort. One by one our list of hopes—sharks, octopuses, robber-crabs—they negatived. A big octopus they had never seen—did not believe it existed, certainly not in Samoa. "Wait," said Bob to me, nothing daunted. He had had a similar experience among the Eskimos; one need not expect these aliens to know anything of the country except their own particular business in it. "Wait and question the natives, you'll see." (Griffith 1953:58)

Then one day the Safune chiefs gave the Flahertys a feast to celebrate the passing through of a party of chiefs (*malanga*) from villages along the

coast of the island. Some of the party reported that a giant octopus had been spotted in the passage of the reef at Sataua. It was *tele lava*, they said, with a body as big as one of the houses in the village here.

The Flahertys did not find the idea of such a creature incredible. They had heard once that the carcass of an octopus that was bigger than any known whale had washed up on the Madagascar coast. They had also heard that in the deepwater reef at Asau Bay on the way to Sataua there were tiger sharks. So they decided to scout the coast of the island westward and sent word of their coming by messengers.

When they arrived at Asau, all the chiefs were assembled to greet them, sitting cross-legged on mats. The usual welcoming ceremony and speeches took place. Each of the chiefs and guests drank in turn in an order of precedence that strictly adhered to tradition. Finally, when all the ceremony was done, they came down to business.

They agreed to do everything the Melikani Millionea requested. Sharks could easily be lured with bait placed on the rocks by the shore in the early morning. Armed with iron-pointed spears, they would await them. But, said the puzzled chiefs, why should the great Millionea bother himself with the pointless hunting of sharks when a special dance had been prepared for him? Thus the Flahertys involuntarily found themselves the guests at yet another massive feast followed by a series of wonderfully rhythmic dances which held them enthralled. The people of Asau, aware that the white visitors were going to proceed in due course to the villages of Vaisala and Sataua farther along the coast, were determined to present a performance that would outshine any that might be organized by the rival villages.

When they left in the morning, the Flahertys regretfully observed the hunters waiting in vain on the shore, the shark bait lying untouched on the rocks.

At Vaisala and Sataua, of course, exactly the same events took place— more *kava*, more feasting, more dancing, more promises, each village anxious to show off its best. But there were no sharks, no octopuses, no sign of drama from the sea. "We returned from our *malanga* without an additional foot of negative," sadly writes Mrs. Flaherty.

Sometime after this abortive search for what obviously did not exist, Flaherty must have concluded that his preconceived idea of making another *Nanook*, based on the struggle of the Polynesian people against the sea, could not be done. The drama of the fight for existence against hunger and climate, which had been easy to find in the Canadian North, was not duplicated in the sunlit, peaceful Samoan Islands. On the contrary, although food had to be hunted or fished, this was regarded more as a game than as a struggle to live. "Drama exists," writes Frances Flaherty, "but it is a very subtle thing, quite apart from everything we understand. It is to be

found in nothing more or less than custom—*fa'a Samoa*. Therein the people build their whole lives. If you break *fa'a Samoa*, you break their lives to pieces and they die" (Griffith 1953:62).

Flaherty had, however, learned much from the making of *Nanook*, most important, that to make a film interpretation of real people living their real lives it was first necessary to live with them and to get to know how and why they do the most simple everyday things. He had yet to realize that this simple everyday act of existence might in itself be the basis of drama, that it did not need heightening by fights with octopuses and sharks. Mrs. Flaherty perceived this in hindsight, as indicated in the above quotation, but Flaherty had not yet reached this solution to his problem. He had, however, shot many scenes of everyday incidents in village life, possibly with the intention of familiarizing the natives with his camera, for making tests for his own observation, and for processing experiments in the laboratory.

Among the islanders who came to visit the Flaherty house was a woman named Tu'ungaita, who later appeared in the finished film as the mother of Moana's family. She came to the house to offer for sale baskets which she made from strips of *pandanus* leaf dried in the sun. Mrs. Flaherty had the idea that it would be sensible if her own daughters also learned how to make baskets, and Tu'ungaita came to stay at the house with them.

The old lady was equally skilled in the process of making *tapa*, which was a bark-cloth used for *siapos*, that is, *lava-lavas*. It was even then a dying craft; most of the printed cloth used for *lava-lavas* already came from Manchester or Japan by way of traders at Apia. But to watch Tu'ungaita make *tapa* was to watch a beautiful exhibition of craftsmanship, and the younger women and girls in Safune would gather round her to watch in admiration. Flaherty, with his affection for traditional skills, was quick to observe the beauty of this time-worn process. He filmed it in loving detail, presumably first on orthochromatic stock. It occupies a beautiful sequence in the final film, however, so he must have retaken it later on panchromatic.

Possibly it was the screening of this *tapa*-making sequence and other similar scenes of everyday occurrences that finally opened Flaherty's eyes to the all-important fact that the real theme of his film lay right under his nose and fine blue eyes. He may still have gone octopus hunting, but when he ultimately made up his mind, he had either to confess failure and return to the United States or to recognize that his elusive theme was there and had been there all along. Mrs. Flaherty believed that the discovery of the rich potential of panchromatic stock gave Flaherty the clue to his theme. We agree that it may indeed have helped, but something other than a technical discovery differentiated this new film, when it was finished, from the earlier and more primitive *Nanook*. It was the dawning realization in Flaherty that the theme for which he had been searching for so many months

was no more and no less than *fa'a Samoa*—the elaborate ritual custom of Samoan life. At some unrecorded moment, this vital recognition must have been seeded in Flaherty's mind.

In all, Flaherty exposed some 240,000 feet of negative in making his film of the Safune family. Today such length would not be considered excessive on a major feature film, but in the mid-1920s, it was a very great deal of film to be used by a single director-cameraman on one location. There is no record, however, that Lasky ever complained. What was surely remarkable was that this incredible amount of footage was developed and printed by hand in a remote cave and that the two laboratory hands were Samoan boys who had no previous experience with motion pictures. Flaherty must have trained them very well, and they in turn, like the Eskimos, must have been brilliant learners. But the value of using the local people in actually making the film had been firmly established in Flaherty's mind in *Nanook*. It was an integral part of his belief that the art of filmmaking was a one-man job on the actual location. The less he relied on industrial processes, the purer the film would be.

On Savaii, however, there were unexpected difficulties. After about twelve months' work, it was noticed that dark flashes appeared on the developed negative at regular intervals. When projected in the coconut theater, the positive film was clearly unusable. Was the panchromatic stock unreliable, as Eastman-Kodak had warned? Flaherty at once stopped shooting and carried out innumerable tests and experiments through June and July 1924 but failed to trace the cause of the defects. Morale sank low. Flaherty sent a young assistant whom he had hired in Apia, Lancelot Clarke (a Tasmanian and secretary to the resident commissioner in Savaii), to Hollywood and to Eastman-Kodak in Rochester, New York, to seek advice.

Meanwhile, back at Safune, the filmmakers had an idea. On a trip to Apia on the other island, David Flaherty had told a government chemist of their problem. The chemist had suggested that the water in the cave which they had fitted up as the laboratory might be too salty and had given David some silver nitrate to make a salinity test.

In David's words, "We knew the cave water was saline but in desperation we made the test anyway, dipping the test-tube into the cave water. The silver nitrate gave a precipitate, proving salinity. Then Bob suggested we make another test, taking the water right from the bottom. This we did, and got the same precipitate. But this time the water had a foul chemical odor. We realized that the chemicals which came off the film when we washed it, instead of being flushed out with the change of tide from the sea as we had imagined, had been depositing themselves on each following batch of film. This must be the cause of the waver." [16] From then on they abandoned the cave water and washed the film in rainwater instead. The results, when projected, were perfect.

Henceforth, all would be well—but every foot of film that had been shot for the picture up to that time would have to be retaken. To do so would not take long because they knew now exactly what scenes they wanted and which of their characters to use. The whole of the film as we know it today was shot between July and December of 1924. Moreover, retakes are usually the bugbear of the film director.

The discovery of the reason for the spoiled negative had a second effect: it explained the strange illness to which Flaherty had succumbed during the expedition round the coast in the previous year's search for the big octopus and tiger sharks. No one had thought at the time that the sickness might have been due to Flaherty's casual habit of drinking the water in their cave laboratory.

Flaherty had suddenly taken ill at a small village called Tufu a long way from their house at Safune. He was unable to eat any food and became very weak. All he could do was to take regular doses of an opiate to ease the pain. But it was clear that something must be done. A messenger was dispatched to ask Trader David to send a boat to Falealupo, the nearest calling point to the village where Flaherty lay ill.

All Tufu was deeply concerned at the Millionea's strange illness. Five days must pass before the boat could arrive at Falealupo. Mrs. Flaherty gave instructions for a litter to be made ready on which Bob would be carried to Newton Rowe's house at Falealupo.

A procession was formed to make the journey to Falealupo, headed by Rowe mounted on his horse and including a native missionary with an umbrella. All went well until Rowe suddenly became aware that the procession had stopped behind him. The missionary was insisting, with the assent of the Samoan members, that, ill as he was, Lopati must walk a short part of the way. Rowe was mystified but knew the people well enough to advise the Flahertys to agree to the request. Bob was assisted on foot for a short distance until a spot was reached where he was again placed on the litter.

Not until some time later did they find out the reason for this strange incident. It seemed that the place where Flaherty had been required to walk was a spirit path that led to a rock on the coast from which dead spirits had dived into the sea to find Polutu, their land of the dead. To have carried Lopati across that spirit path would have gravely endangered his life. Others had died that way, and the people loved him too dearly to allow such a risk.[17]

At Falealupo, Newton Rowe, an old captain, and a white-bearded Catholic missionary, Father Haller (whom the islanders wanted to burn), cared for Flaherty until the boat arrived with a Dr. Ritchie aboard.[18] On the way to Apia, David Flaherty was landed at Safune so that he could rejoin the three children who had been left in the care of their Irish nurse. Dr. Ritchie took Mr. and Mrs. Flaherty on to Apia, where proper medical attention could be

found. A month later Bob was back at Safune safe and well. But it was not until the next year, when they discovered that the silver nitrate from the film had remained in the cave water and that Bob had been in the habit of drinking it, that the cause of his sickness was diagnosed. Flaherty said that he was never comfortable in the heat of the Samoan Islands, probably because of having spent many years in the opposite extremes of the far North.

By the time production was suspended because of the trouble with the negative, Flaherty had filmed most of what he wanted except for a final sequence in the film. Now he had to reshoot everything and, in addition, he still had to find a climax. The climax must be an incident that arose logically during the course of the people's existence. It was found in the ceremony of the tattoo, an idea that was first suggested to Flaherty by Newton Rowe. In his book, Rowe writes:

> A Samoan who is not tattooed—it extends almost solid from the hips to the knees—it has been remarked, appears naked beside one who is; and in no way can the custom be considered disfiguring. Indeed, it enhances the appearance of a Samoan. The missionaries—with the exception of the Catholics—hated it, and still hate it, as a relic of "heathenism." It matters nothing apparently to them that, while the custom stands, it militates against immature mating; and that it is the one test in these islands, where life is so easy, that the youth has to go through. (Rowe 1930:85)

"I remember discussing the importance of tattooing with Bob and Mrs. Flaherty," recalls Rowe, "and it was I who contacted the old tattooer in Asau and persuaded him to go to Flaherty in Safune. I remember it particularly because there was some slight coolness between this old bird and myself over government business, but his cupidity got the better of him." [19]

In the sequences already made and retaken, Flaherty had spun a slim thread of love between Moana, his hero (played by Ta'avale) and his heroine (played by Fa'angase). But until he was tattooed, Moana was still a boy, no matter his age. Thus the ceremony of the tattoo was the turning point in his life, an event of the greatest importance, marked by much ritual and celebration.

Flaherty filmed the process in great detail. He had previously watched it being performed on two other villagers and thus knew exactly what would happen.

> The process is very painful. Needle points of bone—like a fine-tooth comb, impregnated with dye—bite into the skin under the tap-tap of the hammer. The skin is held taut and the surplus dye and blood are wiped away as the needles tap along the line marked out for the pattern. The whole pattern, like breeches of fine blue silk, extends

from above the waist to below the knee, solidly. But only a little tattoo-
ing is done at a time, the amount depending on the strength of the
subject. Tattooing is the beautification of the body by a race who, with-
out metals, without clay, express their feelings for beauty in the per-
fection of their own glorious bodies. Deeper than that, however, is its
spring in a common human need, the need for struggle and for some
test of endurance, some supreme mark of individual worth and proof
of the quality of the man. The Eskimo has struggle thrust upon him—
he could not escape it if he would. He meets it like a man and we
admire him. In Polynesia, what is it that can keep alive the spirit of
man but his own respect for what he is—the God that is within him?
And so it is that tattooing stands for valor and courage and all those
qualities in which man takes pride. (Griffith 1953:69–70)

The tattooing of Ta'avale took six weeks, and a further two weeks were
needed for his body to recover. Flaherty kept filming at regular stages all
through the ceremony, with the boy's "family" in attendance, soothing him
and cooling his wounds. Ta'avale himself was said to have been proud of
the ceremony.

Late in the year, during the final weeks of production, an incident took
place that could have had ugly results for the film, involving the two boys,
Samuelo and Imo, who were doing the laboratory work. A young man
from Sataua, who was one of a government *malanga* (traveling party) that
was spending the night at Safune on its way round the island, made over-
tures to one of the girls in the village. She was the wife of the native mis-
sionary's son, and Samuelo and Imo, as a point of honor, the pride of their
village, told the young man that he had committed a very wrong thing *fa'a
Samoa*. In the heat of the ensuing quarrel, Imo thrust a bullet-tipped cane
into the offender's neck. Within twenty-four hours the young man was
dead, the thrust having reached his spine. He was not found dead on the
beach (as some accounts of this incident state) but spent his dying hours in
a Samoan *fale*, attended by the government's Samoan doctor, who was one
of the *malanga*, and the sorrowing Safune chiefs.

In Samoa, the native law demands a life for a life. At any moment,
therefore, the people from Sataua might be expected to invade Safune to
take revenge. The village was cleared of all its women and children, while
the men patrolled all night on guard. The Flahertys stayed behind their
bungalow walls. The immense amount of film that had taken so long to
shoot was stored in camphorwood chests on the veranda. The family mem-
bers, armed with a shotgun, took turns guarding the chests.

One account of this affair states that Trader David was at the root of
the trouble and had made the two boys drunk (Taylor 1949). According
to David Flaherty, this was not true.[20] Felix David, however, had become

a source of worry to the Flahertys. As the months passed, he had seen his influence over the island population increasingly stolen by the visitors. His manner toward Flaherty cooled considerably, and he began to drink deeper of his mummy-apple beer. He took a particular dislike to the evening screenings of films, which he saw as a threat to his own operatic performances.

Among the entertainment films which Flaherty had brought with him was a copy of the famous German picture *Der Golem*, which became the most popular. Other titles were *It Pays to Advertise*, *The Miracle Man*, and *Sentimental Tommy*, all Paramount pictures. The massive stone figure of the monster, as played by Paul Wegener, so caught the imaginations of the Safune people that it is said that for some years later many children were named after *Der Golem*.[21] On more than one occasion the dominant figure of Felix David had risen up into the bright beam of the projector and shaken a fist at this rival attraction.

The killing of the young man from Sataua brought a confrontation. Imo and Samuelo were taken to Apia to the jail. The Flahertys wrote a letter on their behalf to the authorities, stressing their good character, previous good behavior, and faithful discharge of their duties. When Trader David heard of this letter, however, he reported to the resident commissioner of Savaii that the Flahertys were "obstructing the course of justice."

For some time the Flahertys had known that Felix David, half-insane with jealousy, would welcome any misfortune that befell them and given half a chance would even induce it. They had known, too, that he was in league with the resident commissioner, and it had lately been disclosed that the bond between them was that they were both homosexuals, committing their offenses against Samoan boys. But they knew, too, that both men were soon to be exposed.

The two laboratory boys were tried in Apia, their charge being reduced to manslaughter. Imo was sentenced to five years of imprisonment, Samuelo to six months. Sataua was thus appeased and Safune freed from the fear of Sataua's vengeance. According to Newton Rowe, Father Haller stopped the boat party from leaving Sataua to attack Safune.

Not long after, the government launch from Apia with the justice authorities stopped first at Matautu, eleven miles along the coast from Safune, to investigate the charges against the resident commissioner. It was told that the administrator in Apia would give him the option of leaving the country, in which case the charges would be dropped. The commissioner gave the officials dinner, put them up for the night, and said he would give his reply in the morning. The next day they found his lifeless body slumped in a chair in his office with an army rifle, the trigger tied to his toe, lying on the floor.

The justice authorities went on to Safune and arrested Felix David. He

was taken to Apia and after trial banished forever from Savaii. He withered away and died a few years later.[22]

Finally, one day in December 1924, Flaherty decided that he had all the film he needed, and a date for departure was fixed. The 240,000 feet of film shot over two years (including all the wasted material) had under Flaherty's instructions been reduced by Lancelot Clarke to the essential footage for taking back to Hollywood.

The leave-taking was inevitably a sad moment. The Flaherty family had formed strong friendships with the cast of their film and the other inhabitants of Safune. The children especially had come to live almost like Samoans. They dressed like them, spoke their language, and had learned their songs and dances. It was a tearful and emotional moment when the parting came. A great feast was held with much dancing.

At the last moment, as Flaherty records, there was nearly disaster:

> The boat that was to take us away lay rolling outside the reef. Our all-in-all, family, film and everything, was in one canoe. The seas were mounting. We made the passage through the reef—at any time a dangerous journey—safely. We got up to the rolling ship waiting for the moment to close in, unload and climb aboard. Suddenly the ship rolled violently over towards us. As it did its counter caught the gunwhale of our canoe. For a second we were sure we'd capsize, children, film and all. We were trembling when we climbed aboard. (Flaherty 1950:22–23)

At Pago-Pago they boarded the *Sierra*, bound for San Francisco; from there they went to Hollywood. They spent the next few months making a rough cut of the film. During this period Flaherty screened it in a very long version to Laurence Stallings, the journalist and playwright, who wrote a piece about it, titled "The Golden Bough," in his regular column in the *New York World*. Stallings wrote of the as-yet unfinished film: "I do not think a picture can be greater than this Samoan epic." As a result, Famous-Players-Lasky's eastern office (Paramount) telegraphed Flaherty to go at once to New York and complete the editing there.

In New York, more months were spent editing the film. Famous-Players assigned one of its top writers, Julian Johnson, to write the subtitles. The final screen credits read, "Edited and Titled by Julian Johnson," but we are assured by David Flaherty that Flaherty and his wife wrote the titles and edited the film.[23] Finally, a twelve-reel cut of the picture was ready for screening to Jesse Lasky, Adolph Zukor, Walter Wanger, and other top brass of the studio. Their first reaction was enthusiastic, and they decided immediately to put out the film on a road-show release to play at selected key theaters at special increased admission prices. The film was,

however, too long, and Flaherty was told to reduce it by approximately half. More months went by as this was done, and then the film was re-screened to the Paramount executives and salesmen.

This time, far from hailing it as a masterpiece and a worthy successor to *Nanook*—by then a world classic—the Paramount boys were bored and disappointed. "Where's the blizzard?" one of them asked. Lasky said only that the film was still too long. A publicity woman with a very long cigarette holder, who sat in the front row, complained that "there are not enough tits." Interest in *Moana* dropped below zero. The salesmen declared it had nothing to sell it to the great American—let alone the European—market—no octopuses, no tiger sharks, not even a hurricane or a typhoon. There was this time, admittedly, a thin love interest, but the boy and the girl did not do anything. Any idea of road-showing the film was dropped.

Once again Flaherty realized that to spend more than two years making a film in immensely difficult circumstances was only half the battle. Once again, as with *Nanook*, he would have to persuade the one-track minds of the motion picture distributors and their salesmen that *Moana* was a picture people might want to see if they were given the opportunity. For months he argued futilely with the Paramount office. He screened the film to such influential men as William Allen White and Otis Skinner and persuaded them to write supportive letters to Paramount. At last he was told, "Look here, this is what we'll do. We'll make a test of the picture to see if you're right or not. We'll put the film out in six towns with no more and no less advertising than our usual run of pictures. These six towns will be the hardest-boiled on our list. If it gets by them, okay, we'll put the picture out on general release."

In order of importance, these six tough spots for movies were Pough-keepsie, New York, in the East; Lincoln, Nebraska, in the Midwest; Pueblo, Colorado, in the Far West; Austin, in the huge state of Texas; Jacksonville, Florida, in the deep South; and Asheville, North Carolina, in the mid-South. "There was a saying about Poughkeepsie in the theatrical world," remembers Flaherty. " 'If you think your act is good, try it on Poughkeepsie!' " (Flaherty 1950:23).

Thus challenged, Flaherty was cornered. He knew full well that if his film was presented in these towns with no more publicity than Para-mount's run-of-the-mill program pictures, it was bound to flop. So, without any reference to Paramount, he went to see Wilton Barrett, the head of the National Board of Review of Motion Pictures in New York, and Colonel Joy of the Hays Organization. Both liked the picture and wanted to help. With Flaherty they concocted a plan. They obtained the mailing lists of various magazines and lecture societies, which consisted of people who were not habitual moviegoers. These people could be considered discriminating, what in recent years came to be called the "latent" audience. The National Board then had leaflets printed about *Moana*, describing it frankly and

telling how it differed from the routine movie and what Flaherty's aim had been in making it. Thousands of these leaflets were mailed to the names on the lists.

When the film was shown in Poughkeepsie, it did not flop as the Paramount executives had predicted, nor did it do record business. It had a week's run, which was rather better than average. Reports from the five other towns showed the same results as in Poughkeepsie.

At first Paramount's people were elated. They even momentarily revived the idea of road-showing the film, normally done only for very costly and spectacular productions, which *Moana* had no pretense to be. On second thought, however, they once again dropped this idea and decided to put out the film in the normal way without any special exploitation. The six-town experiment was wasted. Paramount advertised the film as "The Love-Life of a South Sea Siren." It was booked for an opening week at the Rialto Theatre on Broadway on February 7, 1926.

Flaherty was now forty-two years old.

II : *Moana* opens with a sequence reminiscent of *Nanook* but shown in greater detail and with many more individual shots. A tilt-down from the sky through luxuriant foliage reveals the girl, Fa'angase. The little boy, Pe'a (Flying Fox), is there, too. Moana is pulling taro roots. Presently they move off toward the village, laden with food they have gathered. A trap is set for a wild boar. The village of Safune is introduced by a lovely vista shot. A boar has been caught in the trap, and there is a struggle to catch and tie it up. Everyone returns to the village.

A fishing sequence follows, starting with the launching of a canoe. Fish are seen under the crystal-clear water. They are speared. The girl finds a giant clam. Everything is gay and carefree. Then in the quiet of the village, the mother, Tu'ungaita, is shown making bark-cloth. The process is seen in great detail with much use of close-ups. Finally, the cloth is ready to be used as a *lava-lava*.

The little boy twists a rope ring to use as a grip for his feet in order to climb a soaring coconut tree. The camera tilts up, following his movements, tilt by tilt, as he climbs higher and higher until he can twist off the fruit. The sea breaks over the reef into the lagoon, white spume shooting up through the blowholes. Moana, his elder brother Leupenga, and his young brother Pe'a, breast the waves in their outrigger canoe. The canoe is finally swamped, and its crew swim in the sea. They go off fishing along the rocky shore, the waves breaking over them.

Among the rocks, the little boy is busy searching for something. He makes a fire of coconut husk by rubbing two sticks together. A mystery is created by uncertainty over what he is trying to catch. It turns out to be

a giant robber crab. Then follows a turtle hunt. A turtle is speared, and a hard struggle ensues to get it into the canoe. When they reach the shore, Moana drills a hole in the turtle's shell and tethers it to a tree. Fa'angase strokes it like a pet.

A meal is now prepared with great care and ceremony. Coconuts are shredded, breadfruit made ready, and strange foods wrapped in palm leaves are baked in an oven of hot stones. As with the bark-cloth making, all is shown in detail and in close-ups.

Moana is now anointed with oil in preparation for his elaborate dressing for the *siva* dance. He and his betrothed perform their dance, the camera concentrating almost wholly on the boy, following his beautifully rhythmic movements.

The villagers gather for the ceremony of the tattoo. The old *tufunga* (tattooer) prepares. A long sequence shows the gradual tattooing of Moana, the tap-tapping of the needlepoints into the skin, the rubbing in of the dye, the sweat being wiped off the boy's brow, the mother fanning him with a palm leaf, and the grave, impassive face of the tattooer.

Meanwhile, the ritual of making the *kava* goes on. When it is made, the coconut shell from which it is drunk is passed by the chiefs from hand to hand in order of precedence. The people of Safune are now in full dance with their *siva*. The sun is getting low. The dancing gets faster and faster. Inside, the camera pans across the boy's parents to their youngest son, Pe'a; he is asleep. The mother covers him tenderly with a *tapa* cloth. Outside, Moana and Fa'angase dance their betrothal dance as the sun sinks over the mountain.

Between the making of *Nanook* and the completion of *Moana*, Flaherty not only stumbled upon the wonderful visual qualities of panchromatic stock but he also discovered the power of that fundamental attribute of the film medium—the close-up. In *Nanook*, a few close-ups occurred occasionally but only as if its director-cameraman thought the audience would want to see something or somebody close up. Most of the action of the film was shown in long or medium shots. Close-ups, when used, appeared in isolation, inserted into a long shot at random as is often seen in amateur films.

In *Moana*, Flaherty uses the close-up, sometimes very large indeed, in a succession of shots, not in isolation but in continuity, usually to show a process. The three outstanding and beautiful examples are the making of the bark-cloth, the preparation of the meal, and the ceremony of the tattoo. In the last, the contraction of the boy's facial muscles at the pain of the bone needles and the anguished expression on his mother's face as she fans his tortured limbs and waist—all this was complete truth shown large on the screen, giving audiences a new experience. The way these se-

quences were shot, the choice of camera setups, and the camera movement could not be bettered today. In fact, it is doubtful if Flaherty himself ever surpassed them in his later work.

It may have been Flaherty's desire to select and throw on the screen in large visual images the countless significant details of the everyday life he was filming that led him to use close-ups. Every admirer of Flaherty's work—and their number is legion from *Nanook* to *Louisiana Story*—comes to admire his superb powers of observation. His fine, searching eyes missed nothing. We have said already that we believe his experiences in the North helped him to this end. In the tiny Samoan village, unlike the vast expanses of the North, the world was very close to him, and he reacted by using giant close-ups of the details of its life.

Moana shows, too, an increased use of camera movement, of panning and tilting to follow or anticipate action. Flaherty learned this technique from no one. It was an instinctive response through the lens of the camera. No other director-cameraman used such camera movement at that period. The Russians favored in the main a static camera. The Germans mounted their camera on wheels to give it mobility. The Americans copied the Germans but made the operation more complex. Only Flaherty used the camera itself on the gyro head to interpret his instinct for capturing movement. The little boy climbing the coconut tree has become a classic example of Flaherty's camera movement, but there are many others in *Moana*, culminating in the final slow pan shot from the parents to the sleeping boy.

Long-focus lenses were also used more daringly than before, heralding Flaherty's frequent use of them in future films. His tendency to enlarge through the long-focus lens may have been associated with Flaherty's discovery of the close-up. When he found that he and his camera could not physically approach close to what he was shooting—such as the giant waves breaking over the reef and the canoes coming in on the surf—he used his long-focus lens for its proper photographic purpose.

Flaherty, it should always be remembered, made no claim to being a professional cinematographer. He did not then possess, nor did he ever attain, the expertise of the professional Hollywood cameraman. Both Frances and David Flaherty make the point that Flaherty was like an amateur. He learned by trial and error. He used only two filters in his camera all the time he was his own photographer as well as director.

The visual quality of *Moana* is very lovely. The panchromatic emulsion reveals the luminosity of the sun-drenched scene, the solidity and roundness of the bronze Samoan bodies, the wide range of greens of the luscious foliage, the depth of the blue sky. Seeing the film today, one feels no need for color.

It must also be observed that, as with Nanook and the seal, Flaherty again used the suspense element. The most notable example is when the

little boy goes off to search for a robber crab. He spends endless time in smoking it out of the rocks, and what he is trying to catch is not revealed until the final act of capture.[24]

The film as a whole has a wonderful organic unity. Everything that happens in it is an integral part of the Samoan family's daily life. No extraneous incidents are introduced, no spectacular events fabricated. It is a film of great calm and peace, reflecting Flaherty's conception of the Samoan way of life. Even the sequences of the dances and the tattoo have no violent or aggressive qualities. There is no conflict, only the boy's suffering during the ritual of the tattoo.

The one extravagance, if such it could be called, Flaherty allowed himself was an almost unlimited supply of film stock. Film, he would rightly contend, is the raw material of the cinematographer, just as paper or canvas are the raw materials of the writer or painter. If nearly a quarter of a million feet of film were used to produce the six thousand feet that finally made up *Moana*, its use was justified. Nor must we forget that all the footage shot in the twelve months before the discovery of the spoiled negative in the summer of 1924 was wasted. The ratio between the length of the finished film and the amount of the footage shot after the source of the defects was found would be much smaller; but this is a figure for which we have no record. Yet whatever the total footage used, the result is what counts. And if film stock is costly when compared with paper or canvas, or clay or stone, it is nearly always one of the smallest items in a film's overall budget.

If the photographic quality of *Moana* still looks good today, it is a fine tribute to its maker, to the Samoan laboratory boys who handled the processing, and not least to the manufacturers of the film stock, Eastman-Kodak. And we must also remember that the copies we screen today are taken from dupe negatives, perhaps made many years ago; and if we see it on 16 mm, the quality will have further lessened. We recall well the deep impression made by the photography when we saw the film for the first time in London in 1928. We had experienced nothing like it before.

Another important quality of *Moana* was the degree of intimacy which Flaherty achieved. For all its human feeling and warmth of approach, *Nanook* had a detached quality as if one were observing its characters from the outside. In *Moana*, Flaherty took the viewer in among the people to become one with them and no longer a detached observer. Partly by his camera setups and partly by his consistent use of close-ups, Flaherty developed this particular cinematic skill wholly out of his own experience. *Moana* was, after all, only his second film, and he was exploring the art and technique of the motion picture in a remote location without reference to what was taking place in the film world as a whole. At that time he could have known nothing of the new German camera techniques or the Russians' exciting discovery of the basic principles of film editing.

The intimacy with which Flaherty was able to invest his film was also attributable to two other factors. First, time was essential—time for him to study his subject at firsthand and to achieve an understanding with and win the confidence of the people who were to be the characters of his film. Second, very few people were needed to put the film onto the screen. Only three people were involved: Flaherty was the combined director-photographer; David and Frances Flaherty helped him organize, gave ideas, and made the wheels of production turn smoothly. The processing of the negative was mainly a mechanical matter. In other words, Flaherty himself was able to reduce the technical mechanics that stood between him and his subject to a minimum. This fact is of great significance.

All filmmakers know from experience that if you are trying to catch through your camera the actions and thoughts of real people—not professionally trained actors—the more you can reduce the technical side of the task, the less likely are your subjects to be inhibited, self-conscious, and camera-shy. Flaherty was able to achieve a degree of intimacy with his subjects which for many reasons, including the inflexible personnel requirements of British and American trade unions and the need for sound-recording equipment, has been rarely equaled since.

III: The fake palm trees that decorated the facade of the Rialto Theatre in New York were capped with snow when *Moana* was premiered on February 7, 1926. But the weather was not to blind the critics and other influential persons who came to see what Paramount billed as "The Love-Life of a South Sea Siren."

Of all the many lavish reviews, some from well-known critics, the most important in historical perspective was one that appeared the next morning, under the pseudonym of "The Moviegoer." Grierson tells how he came to write this famous piece:

> I first met Robert Flaherty around 1925. He had just come back from British Samoa with *Moana*, and he was having the difficulties he was always to have in the last stage of production. In this case it was Paramount that did not see it his way. There was talk of a grass-skirted dancing troupe at the Rialto on Broadway and a marquee offering of "The Love Life of a South Sea Siren."
>
> I was doing an extra column at the time for the *New York Sun*, in which I was supposed to be a bit more highbrow than Cohen, the ranking film-editor, and the sort of odd body who looked after lost causes, including, as I remember, most of the people who happened to be good. I took Flaherty's case like a sort of critical attorney.[25]

The review read as follows:

> The golden beauty of primitive beings, of a South Seas island that is an earthly paradise, is caught and imprisoned in Robert J. Flaherty's *Moana*, which is being shown at the Rialto this week. The film is unquestionably a great one, a poetic record of Polynesian tribal life, its ease and beauty and its salvation through a painful rite. *Moana* deserves to rank with those few works of the screen that have the right to last, to live. It could only have been produced by a man with an artistic conscience and an intense poetic feeling which, in this case, finds an outlet through nature worship.
>
> Of course *Moana*, being a visual account of events in the daily life of a Polynesian youth, has documentary value. But that, I believe, is secondary to its value as a soft breath from a sunlit island, washed by a marvellous sea, as warm as the balmy air. *Moana* is first of all beautiful as nature is beautiful. It is beautiful for the reason that the movements of the youth Moana and the other Polynesians are beautiful, and for the reason that trees and spraying surf and soft billowy clouds and distant horizons are beautiful.
>
> And therefore I think *Moana* achieves greatness primarily through its poetic feeling for natural elements. It should be placed on the idyllic shelf that includes all those poems which sing of the loveliness of sea and land and air—and of man when he is a part of beautiful surroundings, a figment of nature, an innocent primitive rather than a so-called intelligent being cooped up in the mire of so-called intelligent civilization. . . .
>
> Surely the writer was not the only member of the crowd that jammed the Rialto to the bursting point yesterday afternoon, who, as *Moana* shed its mellow, soft overtones, grew impatient with the grime of modern civilization and longed for a South Sea island on the leafy shores of which to fritter away life in what "civilized" people would call childish pursuits.
>
> *Moana*, which was photographed over a period of some twenty months, reveals a far greater mastery of cinema techniques than Mr. Flaherty's previous photoplay, *Nanook of the North*. In the first place, it follows a better natural outline—that of Moana's daily pursuits, which culminate in the tattooing episode, and in the second, its camera angles, its composition, the design of almost every scene, are superb. The new panchromatic film used gives tonal values, lights and shading that have not been equalled.

After analyzing the structure of the film, Grierson discusses the sequence of the tattooing:

Possibly I should become pedantic about this symbolizing of the attainment of manhood. Perhaps I should draw diagrams in an effort to prove that it is simply another tribal manifestation of the coming of age? It is not necessary, for the episode is in itself a dramatic truthful thing. And if we regard the tattooing as a cruel procedure to which the Polynesians subject their young men—before they may take their place beside manhood—then let us reflect that perhaps it summons a bravery which is healthful to the race.

The film, time and time again, induces a philosophic attitude on the part of the spectator. It is real, that is why. The people, these easy, natural, childlike primitives, are enjoying themselves or suffering as the case may be before the camera. Moana, whom we begin to like during the first reel, is really tortured and it affects us as no acting could. Moana's life is dramatic in its primitive simplicity, its innocent pleasure and its equally innocent pain.

Lacking in the film was the pictorial transcriptions of the sex-life of these people. It is rarely referred to. Its absence mars its completeness.

The most beautiful scenes that Mr. Flaherty conjures up are (1) Moana's little brother in the act of climbing a tall, bending tree flung across the clear sky; (2) the vista showing the natives returning after the doer [sic] hunt; (3) Moana dancing the *siva*; (4) all the scenes in the surf and underwater; (5) the tribal dance.

I should not, perhaps, say that any group of scenes is any more beautiful than any other; for all are beautiful—and true.

Moana is lovely beyond compare. (Grierson 1926)

In this review, Grierson used for the first time the word "documentary," derived from the French critics who thought up the word "documentaire" to describe serious travel and expedition films as distinct from boring travelogues. The word was to stick, to be widely defined, to be widely misapplied by critics and others who never troubled to search for its origins; but nevertheless to become a descriptive term not only in the cinema but in theater, fiction, radio, journalism, and television.

Of other contemporary reviews, the following epitomizes the outpourings of praise bestowed on Flaherty and his film:

Mr. Robert E. Sherwood wrote, "It has within it the soul of an admirable race." Said Mr. Austin Strong, Robert Louis Stevenson's son-in-law: "You have no protagonist nor have you betrayed us with a falsified story—instead, with the unerring instinct of the artist, you have weaved a pattern from Nature herself, from sky, clouds, water, trees, hills and the everyday simple acts of men, women and children. Theocritus did no more. He took the sky and clouds, trees, shepherds and maidens,

and sang of goats and swineherds, and the hills of his beloved Sicily.
Heaven knows I don't want to be fulsome, but as I told them last night,
and they afterwards agreed with me, *Moana* reaches the dignity of
an epic poem, and will always be a classic in the hearts of those who
see it."

And Matthew Josephson added: "Flaherty has done more than
give us only a beautiful spectacle. With his broad vision he has sud-
denly made us think seriously, in between the Florida boom and our
hunting for bread and butter in Wall Street, about the art of life. Here,
he says to us, are people who are *successful in the art of life*. Are
we that, with our motor-cars, factories, skyscrapers, radio-receivers?"
(Griffith 1953:71–72)

For all this rapturous reception, however, *Moana* was not chosen, as
was *Nanook*, as one of the ten best films of the year. The *Film Daily Year-
book* of 1926 records the votes of 218 critics. The German film *Variety*
(known in England and Europe as *Vaudeville*) headed the list with 169
votes; the Hollywood picture *La Bohème* was tenth with 49 votes. In be-
tween were *Ben Hur*, *The Big Parade*, *The Black Pirate*, *Stella Dallas*, *The
Volga Boatmen*, *What Price Glory?* and *The Sea Beast*. *Moana* was in-
cluded among the honorable mentions with 24 votes. On the other hand,
like *Nanook*, Flaherty's new film was to receive high critical acclaim in Eu-
rope, this time especially in France and Sweden.

Finally, Flaherty received a letter from C. H. Hall, an Australian en-
gineer based in Apia, who was keenly interested in photography. After ad-
vising the Flahertys about some of their problems, he had accepted an
invitation to join them and was with them for most of the filming. When a
group of chiefs came from Savaii to Apia to see the film, Hall was present:

The film possessed no new beauty [to them]. They watched si-
lently the feats of climbing, swimming, pig-hunting, and canoe adven-
tures as commonplace events in the old Samoan way of life. But they
missed nothing of the scarcely perceptible gesture and detail of cere-
mony so full of significance to them.

The picture faded from the sheet, and they turned sadly away,
knowing full well that never again would these things be. To my en-
quiries, the picture was *lelei lava* (good exceedingly). Their only
other answer to my many questions was that it was *fa'a* Samoa; setting
it aside at once as something *sa* (sacred) and beyond the comprehen-
sion of the alien *papalangi*. (Griffith 1953:72–73)

It is no real surprise that *Moana* did not do as well at the box office as
its predecessor. Terry Ramsaye notes that it "grossed about $150,000 in

a period when Sidney Kent was distributing Gloria Swanson pictures for a million apiece" (1951). Because it will never be known what the film cost to make, its profit or loss cannot be calculated. Even if it made a minute profit, however, which is unlikely, we should remember that the motion picture industry is not, and never has been, interested in modest or even what any other industry would regard as reasonable profits. It wants 100 percent profit or more.

Paramount's head distribution executive told Flaherty later that if the studio had had a series of such good but modest-budget films as *Moana*, it might have developed a specialized form of distribution such as Flaherty had proved could be made to work. As it was, *Moana* was left to its own isolated fate. Its cost was but a drop in the ocean of the company's annual expenditure on production. It could easily have been written off among a half-dozen program pictures.

A further point regarding *Moana*'s commercial value to Paramount came to light when in 1931 or 1932 David Flaherty went to a meeting of the Academy of Motion Picture Arts and Sciences at the Hollywood Roosevelt Hotel. The occasion was to welcome Sidney R. Kent, formerly Paramount's distribution wizard, who had recently been made head of 20th-Century Fox. Speaking of distribution problems, Kent said, "Now there are some pictures that are off the beaten track, pictures that don't jump out of the can, thread themselves into the projector and say, 'Here I am, go out and sell me.' These pictures require more effort and special handling. But if it weren't for pictures like these—pictures like *Moana* and *Grass* and *Chang*—where would our foreign distribution be today?"[26]

A postscript to this account of *Moana*'s distribution is worth telling in view of the revolution in distribution methods that resulted from competition from television. Flaherty proposed to the Rockefeller Foundation in New York a plan for a permanent organization to do for any worthwhile "offbeat" film from any part of the world what had been done for *Moana* in the six tough towns—an exploitation aimed at the "latent" audience. The foundation's officers were impressed and arranged a meeting of their board in a club on Wall Street to discuss the project. Among those who were invited was one of the chief officers of the Hays Organization, the trade body that represented a domestic censorship for the industry. Without attacking the proposal, this gentleman maintained that any such interesting project should come within the province of the Hays Organization and not be the business of a foundation. Those words doomed Flaherty's proposal for specialized distribution.

"Some years ago," wrote Flaherty in 1950, "fearing that the negative of *Moana* might somehow get lost, I wrote to Paramount and asked them if it would not be possible to turn it over to one of the film museums so that it might be preserved. The letter was never answered. And only recently, while getting the prints of *Louisiana Story* made at the company's labora-

tories on Long Island, I learned that the negative of *Moana* no longer existed; to make room, no doubt, for other newer films, it had been destroyed"[27] (Flaherty 1950:25).

IV: During the year 1925, after the completion of *Moana* but before its premiere in February 1926, Flaherty stayed either in New York or at his home in New Canaan, Connecticut. His reputation among the motion picture trade in Hollywood may not have rated high, but his status as an artist of the cinema was recognized and respected by the intelligentsia of New York. In the course of the year he made two short films for private sponsors.

The Pottery-Maker was produced for the Metropolitan Museum of Art in New York and sponsored by the actress Maude Adams, who was a great admirer of Flaherty's. It was a humble experiment using the new Mazda incandescent lamps, the first film to use them exclusively instead of mercury-vapor lamps, and was shot in the basement of the museum in collaboration with the arts and crafts department.

It opens with a title about the craft of the potter and then discloses a potter working in his shop. A little girl looks in through the window and then enters the workshop with her mother, who was played by the widow of General George Custer. They are dressed in late nineteenth-century costumes. The potter greets them and, to their delight, proceeds to demonstrate his craft. The little girl hops around the room, and while the potter's attention is distracted, she damages the pot he is molding. He cheerfully starts over again. The lady finally buys a pot, and the potter makes a present of another sample of his work to the little girl. They leave, and the potter goes on with his craft, firing the pot he has just made.[28]

The film runs to a full reel and conveys information only through a few subtitles. The action, such as there is in a small room, is broken down into numerous camera setups, with a good deal of close-up work on the little girl's feet and on the potter. In showing the latter at work, there is just a hint of camera movement following his hands, an anticipation of the famous camera movements that were to distinguish the pottery-making sequence in *Industrial Britain* five years later. But the film is not important to Flaherty's development as a filmmaker. Unless one knew, one would hardly recognize that it had been made by him.

Flaherty's collaboration with Maude Adams inspired that energetic lady to try to launch a film based on Kipling's *Kim* in India, to be made in color, but the project never got beyond wishful thinking.

The second film he made in 1926 was *Twenty-Four Dollar Island*, financed, we are told, by a "wealthy socialite," but no one seems to know for what purpose.[29] It consisted of a series of shots, some chosen with a good

sense of design, others pedestrian, of rooftop vistas of Manhattan Island and its harbor. A great many shots were taken with a long-focus lens from the tops of skyscrapers, producing a curious, flat, foreshortened effect. "The film," Flaherty is quoted as having said, "had a viewpoint of New York that people in the streets never have." He overlooked the fact that a large proportion of New Yorkers work in high buildings whose windows provide views similar to those he took with his camera. He added, "It gave the effect of deep, narrow canyons thronged with the minute creatures who had created this amazing city" (Weinberg 1946).

Herman Weinberg thought the film had some "wonderful shots of incoming liners via telephoto-lenses, poetic vistas of ships, smoke lines of rope, dock activities, etc. It also had much footage showing New York in 'abstract' compositions (in which the city looked like the one in Fritz Lang's *Metropolis*, a cold, soulless mound of concrete, steel and glass). There were few people shown, except occasional workers on excavations and the like."[30]

Lewis Jacobs thought highly of the film, which he called unique:

> Flaherty conceived the film as a "camera poem, a sort of architectural lyric where people will be used only incidentally as part of the background." Flaherty's camera . . . sought the Metropolitan spirit in silhouettes of buildings against the sky, deep narrow skyscraper canyons, sweeping spans of bridges, the flurry of pressing crowds, the reeling of subway lights. Flaherty also emphasized the semi-abstract pictorial values of the city: foreshortened viewpoints, patterns of mass and line, the contrast of sunlight and shadow. The result, as the director himself said, "was not a film of human-beings, but of the skyscrapers which they had erected, completely dwarfing humanity itself."
>
> . . . Fascinated by the longer-focus lens, he made shots from the top of nearly every skyscraper in Manhattan. "I shot New York buildings from the East River bridges, from the ferries and from the Jersey shore looking up to the peaks of Manhattan. The effects obtained with my long-focus lenses amazed me. I remember shooting from the roof of the Telephone Building across the Jersey shore with an 8 in. lens and, even at that distance, obtaining stereoscopic effects that seemed magical. It was like drawing a veil from the beyond, revealing life scarcely visible to the naked eye." (Jacobs 1949:116).

The unknown sponsor of the film, however, did not have the same response as the appreciative Jacobs and Weinberg. In some devious way, the film came to be first shown as a backdrop for a stage ballet, *The Sidewalks of New York*, presented at the Roxy Theatre, but was drastically shortened to one reel for the purpose.[31] The original two-reel version has not been preserved, but a copy of a one-reel version is in the Museum of Mod-

ern Art Film Library, New York. When screening it for reassessment in August 1957, we could not wholly subscribe to the above fulsome praise. Much of it seemed ordinary even for the time at which it had been shot and certainly most repetitive, but in fairness it must be recorded that Weinberg remarks that the best footage is missing from the one-reel version.

We do not favor the notion, however, that a potential minor masterpiece was the victim of vandalism, as implied by Jacobs and Weinberg. As John Grierson remarks—and he worked in a modest capacity with Flaherty on the film, "learning how to get behind a camera"[32]—Flaherty never intended it to be a complete film in itself; it was a notebook. He was loaned two cameras to shoot it, and the stock was supplied free, possibly by Eastman-Kodak.

With *Manhatta* (1921), made by Charles Seeler, the painter, and Paul Strand, the photographer, which was also a visual pattern expressive of New York City, *Twenty-Four Dollar Island* can certainly claim to be among the earliest of the city genre of films, later to be developed by Cavalcanti in *Rien que les heures* (1926–27) and Walter Ruttmann in *Berlin: The Symphony of a City* (1927) and followed by many others. It was without doubt an ambitious display of the peculiar properties of long-focus lenses, if not particularly imaginative in its conception.

When he was shooting this picture, Flaherty relaxed in the evenings at the Coffee House Club or some other favorite haunt. He often invited friends, or strangers met by chance, to come along the next morning to watch him at work on such-and-such a location. The following day, he either went to an entirely different location or he had forgotten the invitation and regarded the visitors with complete surprise.

Toward the end of 1926, Eisenstein's *Battleship Potemkin* was given a spectacular premiere on Sunday, December 5, at the Biltmore Theatre with seats selling for $5 (Seton 1952:87). Flaherty attended the opening with Ernestine Evans and Maude Adams and, according to Miss Evans, he went to see it again several times. He said, "*Potemkin* is one of the most revolutionary steps forward ever made in the cinema" (Weinberg 1946).

In the summer of 1927, Flaherty was surprised to be again approached by Hollywood. His friend Howard Dietz, then in charge of publicity at Metro-Goldwyn-Mayer, first sounded him out and then with his agreement recommended him to Irving G. Thalberg, Hollywood's "boy genius," who was in charge of production for MGM at its Culver City studios in Hollywood.[33] Thalberg had bought the screen rights of Frederick O'Brien's *White Shadows in the South Seas*, a book that had made a deep impression on Flaherty.

By long-distance telephone, Thalberg asked Flaherty to co-direct the film with W. S. Van Dyke II, one of MGM's staff directors, who had a reputation as a successful maker of Westerns. Mrs. Flaherty apparently viewed the offer with suspicion, but Flaherty, with the almost childlike and unbounded

enthusiasm for new propositions that characterized his entire life, accepted the invitation. If all worked out well, it was agreed that Frances and the children should join him in Tahiti, where the film was to be made.

Arriving in Hollywood, he soon found that, as often happens in the movie world, Thalberg had bought O'Brien's book only for its intriguing title. The book had no real story; it was a series of episodic but fascinating travel incidents by a sensitive writer aware of the exploitation of the Polynesians. Laurence Stallings was called in to collaborate with Flaherty in trying to work out a story line from the book. They tried instead to sell Thalberg the idea of making *Typee*, Melville's great story of the South Seas, but the young studio boss stuck to his choice of *White Shadows*. Stallings apparently then quit the project and was replaced by Ray Doyle, an MGM staff writer, whose name is bracketed with Jack Cunningham's as co-author of the "original story" on the screen credits of the finished film.

While in Hollywood, Flaherty met Albert Lewin, who subsequently produced such films as *The Good Earth*, *Mutiny on the Bounty*, and *The Moon and Sixpence*, but who was at that time a scriptwriter and assistant to Thalberg. He recollects that Flaherty, as well as writing the screenplay, was busy casting. Among those tested for the part was Francesca Bragiotti, a dancer, who later married John Lodge, the United States ambassador to Spain. Bob often went to Lewin's home. "We had good times," says Lewin, "good food, drinks, singing, dancing and talk—lots of very eloquent and exciting talk."[34]

Headed by Van Dyke, a full-scale technical unit with assistants and assistants to the assistants, Clyde de Vinna as cameraman, and Raquel Torres and Monte Blue as the two stars set sail for Papeete. It was an armada compared with the little unit that had gone to Savaii. From the start, Flaherty must have found himself ill at ease with a group of technicians who were skilled only in Hollywood's synthetic methods of filmmaking. The inevitable happened, as described by Richard Griffith:

> It was the behaviour of the men from Hollywood, when they got to Tahiti, that revealed to Flaherty that he would never succeed in making a film out of his friend's book. Civilization was creeping into Tahiti, but it was still a terrestrial paradise. The tropic moon shone down on the beach, the soft waters lapped it, the Tahitians sang Polynesian songs in the coconut groves beyond, and, down on their knees in the sand beside a tiny radio, the cameramen were listening to Abe Lyman and his orchestra from the Coconut Grove in Hollywood. "Why not go back to California and make the picture in the Coconut Grove there?" asked Flaherty.[35] (Griffith 1953:76)

It was not long before Flaherty told Van Dyke that he had seen enough to know they could not work together, that their viewpoints were diametri-

cally opposed, and that he intended to return to Hollywood. He did so and tore up his remunerative contract with MGM.

About this time, early 1928, an American contributor to *Close-Up* reports having met him in Hollywood:

> Flaherty is a humorous, sandy-haired, somewhat portly Irishman. He has the air of a harassed papa dumped unceremoniously down in a nest of madmen. By the time this is published, he may be in the South Seas, or in the Canadian Rockies, or in the insane asylum; but at the moment he is tearing his hair out by the roots in the M-G-M lot at Culver City, a dreadful suburb of Los Angeles. *Moana* was his last independent [sic] venture. In order to continue making pictures he was forced to accept a contract that would assure him money enough to go on with his experimental ideas. But he soon discovered that movie producers experiment with money, not with ideas. (Needham 1928:48–49)

Flaherty is also remembered in Hollywood about this time by Margery Lockett, who recalls that he was often in the company of a group of students from the Harvard Film Foundation. They formed a devoted entourage and brought encouragement to Flaherty after the debacle of *White Shadows*. "He could be found," says Miss Lockett, "out on the cliffs taking long-focus shots of the ocean," but she does not remember why he was shooting except for "experiment."[36] He usually ate, it seems, at the unfashionable Japanese seafood restaurants and was a vagrant in Hollywood.

When Flaherty returned to his home, he accepted an advance royalty payment from his friend Maxwell Perkins, then with the publishing house of Scribner's, to write his autobiography. Flaherty always found writing about his experiences difficult, and although he had already published *My Eskimo Friends* and was later to write other books, it seems fairly safe to say that he did not write one word of the autobiography. It is said that one day Perkins and Flaherty collided in a club (presumably the Coffee House) and the latter said, "Why don't you put me in jail, Max?" to which Perkins astutely replied, "My dear fellow, the longer you wait, the more story I'll have"[37] (Taylor 1949).

After the debacle of his disagreement with MGM, Flaherty had every reason to believe that any working partnership between himself and Hollywood was inconceivable. Nevertheless, the Hollywood mind is perversely unpredictable. In the early summer of 1928, the Fox Corporation engaged him to make a film about the Pueblo Indians in New Mexico. He went there with his wife, David, and Leon Shamroy as cameraman. Reports on what exactly happened vary. A gossip note at the time said, "Robert J. Flaherty is preparing another screen-opus, this time with the Hopi Indians

in New Mexico . . . with headquarters established at Santa Fe, he is at present living among the people of this aboriginal *pueblo* tribe, securing scenes of their picturesque daily life and their ancient ceremonies" (Anonymous 1928:64).

According to Robert Lewis Taylor, the filming had begun before the Flahertys arrived.

> He hurried out to join the unit. When he got off the train, he found that the work was clipping along nicely. The studio beauticians were greasing up a pair of fairly well-known Hollywood stars, who would provide the love-interest that, Flaherty learned, was to be the backbone of the Acoma study, and for the mob scenes the casting people were hiring all the Indians in sight, including large numbers of Navajos, Apaches and Utes. He stuck around for a week or so, made the acquaintance of two authentic but stunned Acomas, and then returned to the East, richer by no wampum. (Taylor 1949)

Like other parts of Taylor's readable "Profile," this fanciful account does not tally either with Weinberg's Film Index or with David Flaherty's recollections. Weinberg states—and we should remember that Flaherty collaborated in compiling his work—that the unit worked for a year on the picture and that much footage was shot but Flaherty abandoned the project when Fox wanted to inject a love story that was "incompatible with the film as planned.—(R.J.F.)" (Weinberg 1946).

David Flaherty relates that he was taken off the picture and brought to Hollywood toward the end of 1928 to work as a technical adviser "on a film that Fox was going to make in Tahiti of a South Seas story my brother and I had written." Berthold Viertel, the German director, was already engaged on the script. David made a preliminary visit to Tahiti, and when he returned "a few months later and was about to rejoin the unit in New Mexico," he learned from F. W. Murnau, the distinguished German director also working for Fox, that the picture had been called off (D. Flaherty 1952).

Both these accounts suggest, therefore, that Flaherty spent at least seven or eight months on the Acoma Indian film. Richard Griffith simply remarks that "production was stopped when first rushes revealed that the film was beginning to center around a small Indian boy instead of the 'romantic leads' (white) whom Fox had sent along to adorn the tale" (Griffith 1953:76). At some point during the production, David Flaherty recalls, Flaherty went down into Mexico proper to find a "star" for the film. It was there that he heard for the first time the story, said to be true, of the bull being "pardoned" in the bullring. When he returned to Santa Fe, he wrote the story, calling it "Bonito, the Bull."[38]

The Acoma Indian film was never completed, and no record exists

as to what happened to the footage. It was almost certainly destroyed in one of those periodic turnings-out of film storage vaults which all studios make from time to time. This third flirtation with Hollywood was to be Flaherty's last.

V : It is a matter of film history that in the late 1920s there took place a big exodus from Germany to Hollywood. The world impact of the golden period of German cinema (1920–26) caused the Hollywood moguls to send a shower of tempting offers across the Atlantic, and a procession of directors, writers, cameramen, art directors and actors streamed into the big American studios.

One of the most talented of these was Friederich Wilhelm Murnau, a tall, thin Westphalian with keen eyes, a soft voice, and hair variously described as reddish or golden. A shy, sensitive, and lonely man, he was an absolute dictator and a perfectionist in his film work. At the time of his arrival in Hollywood, in July 1926, he was thirty-seven, five years younger than Flaherty. His film *The Last Laugh*, scripted by Carl Mayer and starring Emil Jannings, was already regarded as one of the great screen classics of all time and had made a deep impression in the United States, as had his two subsequent films, *Tartuffe* and *Faust*.

William Fox considered himself more than fortunate in having secured Murnau to direct a film in Hollywood. On *Sunrise*, from a script by Carl Mayer (who did not go to Hollywood), he spared no money. Despite vast sets and highly elaborate camera mechanics, *Sunrise* was only partially successful, an uneven mixture of Murnau's sincerity and Fox's pretentiousness. But Murnau's prestige with Fox remained high. His second Hollywood picture, *The Four Devils*, despite a dialogue sequence added at the last moment, was far less successful. Murnau then began his third and last film for the studio, *Our Daily Bread*, much of which was shot on a farm at Pendleton, Oregon. The aim was to make an epic film of life in the Dakota grainfields revolving aroung the farming customs and traditions, with wheat as the never-changing symbol. When it was nearly finished, Fox got cold feet. Talking sequences were added and comic gag incidents inserted, but to no avail. The film was eventually released as *City Girl* in an abbreviated version, but it never played New York or other big cities.

David Flaherty had met Murnau in 1928 with Berthold Viertel. On this occasion Murnau lavished praise on Robert Flaherty, saying, "Your brother makes the best films." He also indicated that he was getting impatient with Hollywood methods.

Their next meeting was so important that it is best told in David Flaherty's words:

A few months later, I was back in Hollywood from Tahiti. I had hardly checked in at a hotel near the Fox lot when there came a phone call from Murnau. "You must come along to dinner this evening," he said.

As it happened, I had just arranged to dine with one of my few friends in Hollywood, a Danish actor named Otto Matiesen. I said I was awfully sorry . . . any other evening. . . .

"But you must come!" Murnau protested. I could see he was used to having his own way.

"But I really can't," I said.

"All right, then. Tomorrow." He was obviously annoyed.

Murnau lived alone with his servants in a castle perched on the highest hill in Hollywood. I felt flattered to be the only guest at the long table which gave an eagle's eye view of the lights of Hollywood and Los Angeles far below. His face glowed as he told me that he had just purchased a yacht, a Gloucester fisherman. She was a beauty— there were pictures of her—*The Pasqualito*. But Murnau was changing the name to the *Bali*, for to that far paradise he would sail her.

Hollywood was taking too much out of him, all this pressure from the studio, all this artificiality. He would break out of this prison. On the way he'd stop at Tahiti.

"You'll never believe an island could be so beautiful, Mr. Murnau," I said, "I'll give you some letters."

He'd stop at Samoa, too: I could give him letters to people I knew there, too. Lord, how I envied him!

Then almost casually, he said, "Like to come along?"

When I recovered my speech, I stammered that I'd give my right arm to go along, only I had to get back to New Mexico and the Pueblo Indian film. Then he broke the news that the studio was about to call off the film. The camp near Tucson had been burned out, and besides that, Bob and the studio were not seeing eye to eye on the story—the studio wanted to work in a love-story and all that.

Now Murnau unfolded his plan. Bob was through in Hollywood. He himself was fed up with it. He had bought this yacht. He and Bob would join forces, go off to Tahiti, Samoa, Bali, and make their pictures far from the heavy hand of Hollywood.[39] We'd put in a call to Tucson. We'd drive the 500 miles there in Murnau's roadster and see Bob the next day.

At Tucson, Bob told Murnau the story of a pearl-diver which had come out of his unhappy *White Shadows* experiences in Tahiti. Murnau was fascinated.

"This will be the first Murnau-Flaherty film," he said.

The news that Flaherty and Murnau were quitting Hollywood to

make their own films in faraway places created quite a stir in the film capital. Murnau's technical excellence and Flaherty's nose for the drama in primitive peoples—these were not long in attracting capital to the enterprise. Murnau, whom Flaherty conceded was a better business man than he, signed the contract with Colorart, a young company which, like William Fox a few short years before, was hungry for prestige. (D. Flaherty 1952)

Thus Flaherty and Murnau formed a partnership to make, they hoped, a series of films under the banner of Murnau-Flaherty Productions, Inc., independent of the major studio companies. Flaherty's sole experience with studio work had been the little *Pottery-Maker* film in the basement of the Metropolitan Museum! Murnau's first recognition that the real scene might be more convincing than studio fabrication had occurred only the previous year in the wheatfields of Oregon after more than ten years of concentrated work in the controlled conditions of the efficiently equipped studios of Neubabelsberg and Hollywood! It was, to say the least, a curious collaboration of talents and outlooks. But the two men had one priceless virtue in common—integrity.[40]

Frances Flaherty had different ideas about the new setup, which had no connection with filmmaking. First, the three Flaherty daughters were growing up fast and Mrs. Flaherty believed that not only was American education very expensive but it might also fall short of European standards. Second, she remembers that she had the premonition that a gigantic economic collapse in the United States was not far ahead.[41] She was correct. The big crash on Wall Street came very shortly after she left with her three daughters for Germany.

The *Bali*, with Murnau and the film unit, including David, sailed from San Pedro late in April 1929. Flaherty followed the next month by mail steamer, but, since Murnau stopped at the Marquesas and the Paumotos, Flaherty reached Papeete well ahead of the *Bali*. The news Murnau gave them was not good. He was living on credit. Colorart had not sent the payments called for in the contract. There followed weeks of cabling back and forth, and at last they all had to accept the unhappy truth: Colorart was not a sound concern. They were stranded.

Murnau then did the only thing possible: he decided to finance the undertaking himself. Flaherty had no money. But the picture would have to be made as economically as possible. As a start, Murnau paid off the crew of his yacht and sent them back to California, replacing them with Tahitians. "Had Murnau been by nature prodigal," adds David Flaherty dryly, "and Bob frugal, the arrangement might have worked out well. But since Murnau was by nature frugal, and Bob notoriously the opposite, it brought little comfort to either. Neither one had asked for this situation;

there it was." But it was Murnau who now held the purse strings (D. Flaherty 1952).

Flaherty had a very clear idea of what he wanted the film to be about. " 'We'll make the kind of picture they wouldn't let me make of *White Shadows.*' It was not to be 'another *Moana.*' He did not want to record again the fading forms of *fa'a* Samoa, but the reasons why they were fading. It was a theme that had fascinated him for a long time—the impact of 'civilization' on primitive cultures" (Griffith 1953:77–78). In his many years in the North and again in Samoa and Tahiti, Flaherty had seen how contact between the exploring, trade-seeking white man and the indigenous native could bring out the worst in both their natures. Hence we can surmise that with sudden, new-found freedom from Hollywood control and an inspiring partnership with the sensitive, intelligent Murnau, Flaherty must have been passionately anxious to make *Tabu*, as the film was to be called, into an indictment of the impact of white civilization on the Polynesians.

In *White Shadows in the South Seas*, O'Brien had written of the Marquesans:

> They were essentially a happy people, full of dramatic feeling, emotional, and with a keen sense of the ridiculous. The rule of the trader crushed all these native feelings. To this restraint was added the burden of the effort to live. With the entire Marquesan economic and social system disrupted, food was not so easily procurable, and they were driven to work by commands, taxes, fines and the novel and killing incentives of rum and opium. The whites taught the men to sell their lives, and the women to sell their charms. Happiness and health were destroyed because the white man came here only to gratify his cupidity. (O'Brien 1919)

This was the situation that Flaherty wanted to portray in the new film, and plenty of evidence was available in Tahiti.

In his now customary way, Flaherty set up a laboratory in a back-street shed in Papeete and trained a seventeen-year-old half-caste boy to carry out the film processing. Another half-caste, Bill Bambridge, a member of an influential commercial family, was engaged as a major-domo, interpreter, and (with David Flaherty) assistant director. Bill had performed in a similar capacity for the MGM units that made *White Shadows in the South Seas* and *The Pagan*, and he had proved to be an indispensable and invaluable member of the small unit. He also played a small part in *Tabu* as a culpable native policeman.

Though he had brought with him his Akeley camera, Flaherty was not this time to undertake the sole burden of the photography. During the frantic period of cabling back and forth with Colorart in Hollywood, that

shaky company had sent out a Hollywood crew consisting of a professional cameraman, a laboratory man, and a unit manager. This trio, however, arrived in Papeete without any funds and found themselves stranded like the others. Murnau promptly sent them back to Hollywood on the next mail steamer.

When Murnau finally decided to break with Colorart and to finance the picture himself, the camerawork again devolved on Flaherty. But the Akeley camera was giving trouble. Around Christmas, when they were on location at Bora-Bora, it finally broke down altogether. David Flaherty remembers Murnau saying with wistful sadness, "If only Floyd Crosby were here with his Debrie camera!" (Murnau had met Crosby on the trip to Tucson, where the latter was working as second cameraman on the ill-fated Acoma Indian film.) The next day, by a remarkable coincidence, a schooner from Papeete brought a cabled message to Murnau and Flaherty: "Just finished filming in Caribbean STOP May I join you in Tahiti—Floyd Crosby." Crosby arrived with his Debrie camera on the next mail steamer.[42] One further member of the crew who was recruited was Bob Reese, a young American who was at loose ends on the islands and became a general assistant.

The divergence of views between the two creative partners must have occurred at an early stage. Flaherty, as in his previous films, sought a story that arose out of the Tahitians and their environment, the story of their exploitation, while Murnau was influenced by a career in which most of his films had depended on versions of stories with well-defined plots adapted from novels or plays. He wanted, therefore, a story with a well-defined plot rather than the Flaherty conception of creating a film around a slender but central theme. Murnau found his plot in a legend derived from the age-old Polynesian custom of the *tabu*, in which a maiden is consecrated to the gods and as a result is forbidden to all men. Tragedy must overwhelm any who try to violate the *tabu*, even if moved by love. The young pearl fisher who falls in love with the maiden is destined to be consumed by the sea. The gods win.

However much Flaherty revolted against this fictionalized story, he did not break openly with Murnau. He was far too gentle-natured to create trouble for a fellow creative artist. This situation was very different and far more difficult for him than the one with Van Dyke. Murnau was a gifted filmmaker whose work Flaherty admired; a man of sincerity and artistic talent. The problem was that their approaches to the subject of the film-to-be were utterly divergent. And Murnau, Flaherty must have known, was carrying the full burden of cost. What course could Flaherty take but tactfully and courteously to withdraw more and more into the background as the film progressed?

David Flaherty makes the historically important point that it was on the basis of Flaherty's original pearl-diver story told by him to Murnau at Tucson

that Colorart backed the venture. When Murnau and Flaherty learned in Tahiti that Colorart had withdrawn, Murnau decided to change the story "so that Colorart could have no grounds for suing Murnau-Flaherty Productions, Inc., for the money they had actually been advanced."[43]

Visitors to Tahiti at the time were Jack Hastings (later the earl of Huntingdon) and his wife, and their recollections are of interest:

> Both my wife and I fell under Flaherty's spell, were charmed and loved to listen by the hour to his stories. He related them so vividly that I can still clearly see Flaherty driving his team of huskies with the inevitable violin tied to the top of the load. . . . I was puzzled how two people with such divergent points of view as Murnau and Flaherty had decided to make a picture in partnership. . . . Murnau thought that he had the certainty of a release for the film but only if it turned out to be the sort of picture which *he* considered would be acceptable and sure of a box-office success. Flaherty was only interested in making what he believed would be a work of art with integrity. He refused to compromise or have anything to do with a "dramatic" story; for him the drama was in the life of the islanders.[44]

To play the part of Reri, the virginal maiden, they had found Anna Chevalier in a local bar. She was seventeen and very beautiful, with "Grecian features," according to Flaherty. She had, it would seem, none of the shyness and modesty of the Savaii girls whom Flaherty used or tried to use in *Moana*. On the contrary, once started on movie work, it was hard to curb her enthusiasm.

As production went ahead during 1930, Flaherty was less and less involved. In September he decided to sell Murnau his share in their company for a few thousand dollars, which he later received in irregular installments. Lord Huntingdon writes:

> About this time, money was short and as I had call on some capital from a small film company of which I was a director, I decided to join Murnau and got the consent of the other directors to invest the cash in this project.[45] Murnau naturally kept complete control over the direction but I found him amenable to accepting another point of view though usually only after considerable argument. As far as I was aware, Flaherty never resented my joining with Murnau nor the ultimate success of the picture but it was a subject we simply did not discuss. Perhaps Flaherty was fortunate in not being in the partnership any longer because the whole project turned out to be unlucky. We went to Bora-Bora and Murnau insisted against the strong feelings of the islanders in using as a location a small atoll in the main lagoon called Motu Tapu which was exceedingly convenient and undisturbed

but which the Polynesians were most reluctant to go near. By a strange coincidence, from then on everything went wrong. Film stock was lost, schooners failed to arrive on time, Reri (our leading-lady) became pregnant, we nearly all contracted mumps and Bob Reese, the young assistant, got so badly burned in an accident that he had to spend weeks in hospital.[46]

In spite of these mishaps, however, production was finished to Murnau's satisfaction toward the end of the year, and the whole unit, including Flaherty, sailed back to California on the mail steamer.

A resume of *Tabu* and our own reassessment of it are not included here because we do not regard it as a Flaherty film. It was essentially Murnau's work with very few of Flaherty's ideas or conceptions, and it revealed little of his influence.[47]

Flaherty stayed in Hollywood only a short time after returning from Tahiti and took no part in the editing of *Tabu*. He is rumored to have tried to set up a film based on his "Bonito the Bull" subject. Douglas Fairbanks and Alexander Korda were both reported to have been interested in the idea but nothing materialized (Weinberg 1946). Weinberg also mentions that Flaherty helped Eisenstein, who had fallen out with Jesse L. Lasky of Paramount, to obtain a visa for Mexico. This probably occurred when Eisenstein was arrested in Mexico City in December 1930, and several internationally known people, including Chaplin and Einstein, cabled the Mexican government on his behalf (Seton 1952:193).

By this time, Frances Flaherty was safely settled with the three girls at Odenwaldschule in southern Germany. Flaherty decided to join them and arrived in time to spend Christmas 1930 in the Bavarian Alps. He thought he might manage to get invited to make a film in Russia. When Flaherty left the United States, not to return for almost ten years, he was forty-six and had produced only two films, which had gained world renown—*Nanook* and *Moana*. David Flaherty remained in Hollywood and worked on some scripts for Murnau before the latter's fatal accident, but Robert Flaherty did not learn of Murnau's tragic death until he was in Germany.

In the 1950s when we touched down at Honolulu during a world flight, the first thing noticed outside the airport was a huge neon sign advertising a filling station. It blazed one word—MOANA.[48]

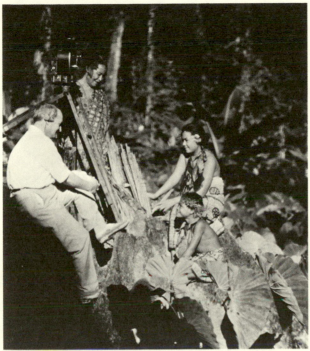

"Moana, 1923–25," by Frances Flaherty (print courtesy
Museum of Modern Art Stills Archive)

Making the bark cloth for lava-lavas, by Frances Flaherty (print courtesy
Museum of Modern Art Stills Archive)

Samoa, 1923, by Frances Flaherty (print courtesy Museum of Modern Art Stills Archive)

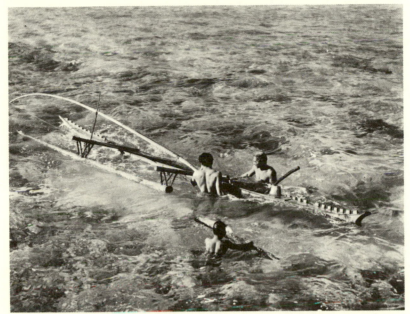

Outriggers, Samoa, 1924, by Frances Flaherty (print courtesy Museum of Modern Art Stills Archive)

Fishing, Samoa, 1923–25, by Frances Flaherty (print courtesy Museum of Modern Art Stills Archive)

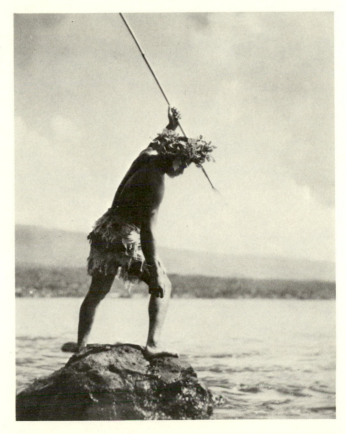

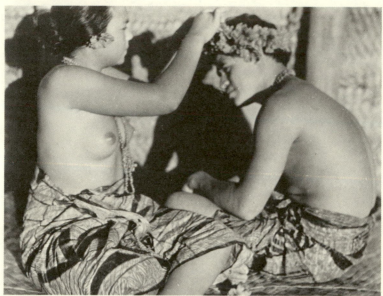

Making ready for the ceremony, publicity still for the film, by Robert J. Flaherty (print courtesy Museum of Modern Art Stills Archive)

Rehearsal for the siva, by Frances Flaherty (print courtesy Museum of Modern Art Stills Archive)

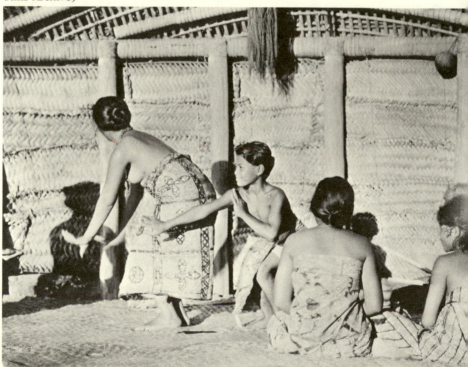

Moana dancing, by Frances Flaherty (print courtesy Museum of Modern Art Stills Archive)

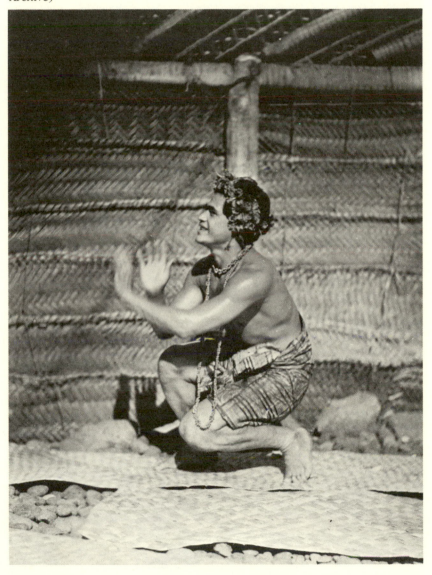

The tattoo, by Frances Flaherty (print courtesy Museum of Modern Art Stills Archive)

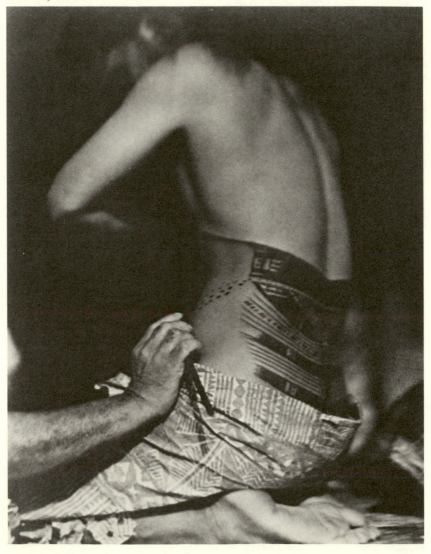

Europe, England, and the Atlantic

I : In the New Year of 1931 Flaherty went to Berlin, where he was to find a warm welcome. *Nanook* and *Moana* had been much liked by both the German public and intellectuals, and his reputation has always stood high in that country. *Nanook* in particular was often revived. He was deeply shocked, however, by the social life of Berlin. Some months later when he came to London, he would tell and retell of the licentiousness he saw paraded on the Berlin streets. The serried ranks of prostitutes who lined the Friedrichstrasse (also the street where the film producers were located), the shop-window displays of sexual and particularly of sadistic literature and photographs, the lesbian and homosexual bars and night spots horrified the man who had only recently come from the innocence of Tahiti.

The main reason for Flaherty's visit to Germany was his anxiety to get into the Soviet Union. It is not clear whether he had received an offer from the Soviet film industry, or whether he made the first overtures himself through the Soviet film-trade house in Berlin, which had been distributing films with great success in Germany ever since the impact made by *Potemkin* in 1926. Fred Zinnemann, then a young man associated with the making of *Menschen am Sonntag* ("People on Sunday") met Flaherty early in the year.[1] He writes:

> The curious thing is that during our association, which lasted for seven months in Berlin, not one foot of film was shot. But I used to sit talking with him and listen to him, drinking a lot of beer, and I found

out a lot about motion pictures . . . the thing that was tremendously important for me was the fact that Bob was preoccupied in showing the spirit of man. . . . What I learned from him was that if you want to make a picture, you should try to tell the truth as you see it, and try not to compromise nor deviate from what you are trying to say. (Zinnemann n.d.)

He remembers that Flaherty talked of wanting to make a film about the decaying civilizations in Central Asia but that the Soviet officials with whom he was in touch preferred instead a film about the modernization of the primitive life. John Grierson, on the other hand, says that Flaherty was waiting for an invitation to go to Russia to make a film about the Russian women.[2] The Ufa Company was to supply the film stock for Flaherty's film, the Russians were to have the internal rights with the proviso that they could take out scenes from the film but not put anything in, and Flaherty would have the rights for the rest of the world with a similar proviso.[3] But the deal was never consummated.

After this setback, a group called the Porza, headed by Dr. Dimitri Marianoff, a son-in-law of Einstein, employed by the Handelsvertretung, USSR, tried to raise funds for Flaherty to make a film in Germany, but this, too, came to nothing.

After Murnau's tragic death in March of that year, Flaherty received no more payments from the sale of his shares in Murnau-Flaherty Productions, Inc., until legal matters had been settled by the executors. David Flaherty had remained in Hollywood to represent his brother's interests. The legal representatives of Murnau's estate even fought over the yacht *Bali*. It was not until 1932 that a hearing took place on the suit brought by Colorart against Murnau's estate and against Flaherty. Colorart lost, and Flaherty's money was released to him. The Flahertys in Berlin were rapidly exhausting their meager funds. Suddenly they remembered John Grierson in nearby England.

One summer evening, the few of us who were then working at the little Empire Marketing Board (EMB) Film Unit were gossiping about the day's work in the pub The Coronet, just off Soho Square. Jimmy Davidson, the staff cameraman, came into the bar and said to Grierson, "There's a Mrs. Flaherty calling you from Berlin up in the joint."

At this point it is necessary that we leave the Flahertys suspended in a telephone call upon which much depended in order to describe briefly the state of development reached by the British documentary movement at that time. It is important to understand in perspective the deep impression Flaherty would make on his British co-workers as well as the motivation behind the British documentary movement, which was in many ways very different from Flaherty's approach since *Nanook*. The divergence between

the Flaherty and the British documentary points of view later grew into open disagreements that continued until his death.

The Empire Marketing Board Film Unit was nearly two years old. Nurtured by Sir Stephen Tallents, its head, and by John Grierson, who after the success of *Drifters* decided to form a group of filmmakers rather than continue personally to direct films, the unit was the only experimental film workshop in the world outside the USSR. It also represented the beginnings of a realization by government and by Whitehall that film could be used in the public service.

Starved for finance, staffed with a handful of young film aspirants who made up by enthusiasm what they lacked in technical knowledge, the unit was probably the laughingstock of the commercial studios of the period. It had cutting rooms, a small projection theater, and a couple of offices in Oxford Street opposite the now defunct Frascati's Restaurant. Its members included Basil Wright, John Taylor, Paul Rotha, Arthur Elton, Stuart Legg, and several others.

But in 1931 the unit had little to show for itself apart from *Drifters* (now eighteen months old) and a couple of compilation films that had received favorable press notices, particularly from Cedric Belfrage, Caroline A. Lejeune, and the *Times*. Most of the members of the unit spent their spare time writing and lecturing with remorseless persistence about the aims of documentary.

Now, with an increased grant, the EMB unit was on the verge of going into full production. Its tyro directors and cameramen must face the challenge and see if they could in fact practice what they preached.

Grierson at once realized that to have Robert Flaherty working with his EMB unit would not only add to its luster but would also give a unique chance for the young tyros to learn at firsthand about his instinctive handling of a movie camera and his wonderful sense of observation. Tallents accepted the idea with some reserve, though his decision was eased by the recent agreement at the imperial conference to widen the EMB's terms of reference to include Empire markets overseas as well as inside Britain.

A few days after the telephone call from Berlin, the Flahertys had checked in at the York Hotel, Berners Street, which was a bare couple of stone-throws away from where the unit was housed in London's most vulgar shopping thoroughfare. We well remember Flaherty and his wife being conducted by Grierson round all the two floors of the unit's premises and going to their hotel to look at the superb photographs of Savaii that Frances Flaherty brought with her. We remember especially Flaherty's delight at discovering the English-made, spring-driven, Newman-Sinclair camera, with its easy portability, its rapidly interchangeable film magazines, its excellent range of lenses, and, in particular, its extensions, which could make ultra close-up work possible. Flaherty positively gloated over this fine example of English precision engineering.[4]

Newton Rowe, who had resigned in disgust from the New Zealand government service in Samoa and had just published *Samoa Under the Sailing Gods*, went to see Flaherty at the York Hotel. He took with him Hayter Preston, the widely traveled and knowledgeable writer, who at the time was working for the *Sunday Reference*. A memorable session took place, which ended outside the hotel at dawn with Flaherty making friends with the roadmen hosing down the street. "A magnum of champagne stood unopened all night on the dressing-table," says Rowe, "and it took all Bob's charm to get the incredulous night porter to keep finding more bottles of whiskey."[5]

The EMB unit, of course, was still operating on a shoestring, but Tallents had contrived to get some money—2,500 pounds, which was a vast sum to us—to make a film about craftsmanship in British industry. The subject had been offered by Grierson to Anthony Asquith, who had graciously refused it. It was therefore agreed that Flaherty should go off and produce a film that would reveal the craftsmanship that persisted in even the most modern of British industries, even behind the smoke and steam and grime of the industrial Midlands.

An early achievement of the unit had been to destroy the fallacy that existed in the British film industry that the British weather was a hindrance to exterior filmmaking. For economic reasons alone, many of the EMB films had to be shot in any weather, and some remarkably good cinematography resulted. "There remained to be destroyed," writes Tallents, "the belief that the industrial life of Britain and her grey city atmosphere could never be portrayed on the screen. The real point of bringing in Flaherty at this moment was to destroy that fallacy."[6]

In the unit's humble circumstances, it was impossible for Flaherty to be allowed to pursue his established method of digging himself in for months before starting to shoot his film. But Grierson realized the importance of letting him become acclimatized, even if briefly, to the English scene. Basil Wright was about to begin shooting his first film, *The Country Comes to Town*, about milk production (other elements were added later), with some of its locations in Devonshire. Grierson suddenly decided that it would be fine experience for Flaherty to accompany Wright to see something of the Devon countryside, while Wright would have the benefit of Flaherty's wisdom and advice in the initial stages of shooting. Says Wright,

> So it came about that I found myself driving Flaherty—whom I regarded with immense awe—in a very dilapidated Buick two-seater roadster from London to Exeter and points west. . . . It soon became clear that he was extremely nervous and he indulged in a good deal of "backseat" driving. Round about Runnymede he confessed the reason for this. He had been deeply affected by his friend Murnau's recent tragic death in an automobile accident in California. . . .

However, by the time we reached Camberley, he felt in need of refreshment, so I was instructed to pull into a pub. Here the fascinating unpredictability of the great man hit me for the first time. I was terribly anxious to push on and get established on the Devon location as early as possible; but over pints of bitter (which I don't think he liked but was drinking as an experiment), he suddenly caught sight of a shova-ha'penny board. . . . He wanted to know everything about the game. What's more interesting, perhaps, is that before he even learnt the rules, he had in a purely tactile series of gestures appreciated the physical qualities of the board—the silky smoothness of the wood's surface, the need for accurate craftsmanship in the brass-strips which, carefully hinged, separate one "bed" from another up on the board. Inevitably, some locals appeared and we became involved in a series of games. . . .

With a lot of very nervous tact I eventually got him back into the car. After a bit he mercifully fell into a doze, and we took the Bastingstoke-Stockbridge run at full-speed. . . .

At Salisbury we lunched. I remember nothing of the meal except that he cannot have enjoyed it. I do remember, however, that he demanded to see the Cathedral. We drove to the Close. He was rapt in admiration, viewed the Cathedral from several angles, and then went inside. Like everyone else, he was disappointed. "It's an exterior job," he said. . . .

On the outskirts of Salisbury, just where the road crosses the railway and aims at the open country, there were a lot of chaps looking over a wall. "Stop!" cries Flaherty, "let's see what's going on." It was a cricket match.

Flaherty was fascinated. He stood up on the floor of the car. He balanced himself on the seat-cushions. He asked a Niagara of questions. But here he had, in a minor sense, met his match. Young then, I disliked cricket and all it implies more even then than I do now. I began to talk about schedules and Grierson and the problems of the EMB unit expenditures, and, after about twenty minutes, got him to relax in his seat and off again we went.

The next thing I recollect is that we were established in a tiny pub called *The Lamb*, between Exeter and Cotley, which was where the farm was located that we were to use in the film. We were all rather crushed together in the pub but I contrived that Flaherty had a room to himself. He expressed the warmest gratitude for this, and gave me the impression that he did really like the opportunity for solitude.

The other thing I remember about *The Lamb* was Flaherty's interest in the girl who looked after the bar and the bedrooms. This interest I must add had no sex implications at all. She was one of those

strapping Devon wenches who are tall, with a fine figure and splendid vital statistics, dark flashing eyes, black hair, and a heightened colour. Flaherty was fascinated by her, because of what you might call her "foreign" (non-Saxon) appearance; and when I, or someone else in the unit, brought up the old legend of shipwrecked mariners from the Spanish Armada mingling with the local population, Flaherty's excitement knew no bounds. I would give a lot of money to be able to remember the ideas which flooded out of him on that occasion. But, alas, I can only remember being very excited and, at the same time, trying to put some curb on his ideas, which (solemn young documentarist as I was) seemed to be going, as it were, over the edge of probability.

What, however, I can remember is the soft, careful and tactful manner in which, over a number of days' shooting, he (as it were) lent us his wonderful eyes. He never said, "Look, how wonderful, you must shoot that!" What he did was, almost as if it were in passing, to comment on the play of light on fields and woods and distant landscape, or on certain movements of horses or cattle, or even on the way a lane twisted between hedges to reveal the half-seen gable of a house. It's almost impossible to explain his way of seeing things in this manner, and how he, often in an undertone, conveyed it to you. I certainly would say that in those few days he enriched my understanding of looking at a thing and people in terms of movie in a way which ten million dollars couldn't buy. Incidentally, when I was actually shooting, he went as far away as possible and sat down (if he could find somewhere to sit). He never advised or interfered. But he opened up for me a new field of revelation every day, whether we were driving to our location, or walking about looking for camera set-ups. I have never known a man with such an eye. (Basil Wright, personal communication, n.d.)

When Flaherty returned to London, he found that Grierson had engaged a production manager for him. J. P. R. Golightly had been an estates manager in the west of England and in that summer was between jobs when he met Dr. Anthony Grierson, who suggested to Golightly that his brother, John, might be able to make use of him at his film unit in London. An interview was arranged, and, before he knew what had happened, Golightly found himself signed on to be what he describes as a "man-of-all-work" on Flaherty's new film. He had had no previous experience in filmmaking.[7]

The two of them set out in a very old Austin car, Golightly at the wheel, together with a Newman-Sinclair camera and what, for an EMB film, was a generous amount of film stock. Mrs. Flaherty stayed in London. Their destination was Saltash in Devon near Plymouth, where Flaherty was to

film the steel bridge. For a few days nothing was heard of them. Then one morning, when some of the unit's rushes were being viewed, there came on the screen several reels of shipping scenes and shots of cranes at some unidentifiable docks. There were also some curious shots taken from what appeared to be a railway coach window, which were unusable because of the vibration of the train. There were, in addition, some very fine shots of Saltash Bridge.

After some discussion, it was agreed by the process of elimination these rushes must be from Flaherty. They were. But Grierson and others were shocked by the amount of footage shot on things that could not be remotely related to the subject of the film. Matters were not made easier when, cautioned by Grierson over the telephone about the amount of film stock he was blazing away, Flaherty explained that the rushes were only "tests" he had made to get "the feel of things."

Before the production had started, Grierson had explained to Flaherty that "someone" in Whitehall—meaning the top people at the EMB—would want to see a script of the film he was going to make. At first Flaherty point-blank refused. He had never written a script before, and he was not going to start now for any civil servant. Grierson was polite but firm. Flaherty retired sulkily to the York Hotel and remained there hermit-like for several days. Then he appeared at the unit and gave Grierson a thick wad of paper. On the top sheet were the words in Flaherty's heavy hand, "INDUSTRIAL BRITAIN: A Film About Craftsmen: by Robert J. Flaherty." On page 2 were the words: "A SCENARIO" and underneath, "Scenes of Industrial Britain."[8] Nothing more. If anyone in Whitehall ever read a script for the unit's new production, that script was certainly not written by the maker of *Nanook* and *Moana*.

Meanwhile, the two-man unit proceeded on its way. Golightly recalls that Flaherty wanted to film everything he saw. "We would be going along in the old Austin and suddenly Bob would see a string of electric pylons striding across the landscape. Immediately he would instruct me to make a detour so that we could film the pylons." The windmill shots at the opening of the finished film were taken this way, wholly by chance.

Golightly was not a little worried. Knowing nothing about the film world, he could not have been expected to have held Flaherty in awe, but he was, of course, aware of the tremendous respect with which the whole unit regarded him. But his new employer had urged on him the need for strict economy and thrifty expenditure, especially for film stock. So, as a high proportion of the total amount of stock allocated to the film seemed to be being used up on what Flaherty called his "tests," Golightly's anxiety increased. The unit shortly returned to base, and a serious and probably stormy meeting took place between Flaherty and Grierson.

Loaded with two small lamps and appropriate lengths of cable for lighting interiors, the Austin and its crew now set out for the industrial

Midlands. Golightly was to make the contacts at the places where Flaherty wanted to film and get the necessary permission, arrange for the hotel rooms, find the electricity supply when they wanted to use the lamps, shift the lamps about at Flaherty's orders, look after the money, keep the accounts, and drive the car. Eventually, Flaherty observed that even a man of Golightly's resources could not cope with this multitude of tasks. After a word to London, a young man named John Taylor (Grierson's brother-in-law), aged seventeen, was sent to join the unit.

Golightly relates that Flaherty would watch a process, such as glass-blowing or pottery-making, for a long time and with great concentration. He would note every movement of the men on the job so that when he came to use his camera, he could anticipate their actions in advance. The rushes of both the glass-blowing and pottery-making sequences were sent to Flaherty, and he ran them at a local cinema so that the men who appeared in them could see how they looked. They were proud of what they saw and full of respect for Flaherty as a craftsman in his own medium.

Among the industrial processes to be shot was steelmaking. Golightly had great difficulty in obtaining permission for Flaherty to film at a particular works near Birmingham. "He could be very irritable and impatient," says Golightly, "if permits to shoot could not be got quickly; he was surprised that factory owners had not heard of him." Finally, permission was granted, but certain parts of the steel plant, unfortunately some of the best from a photogenic aspect, were banned to them. Flaherty accepted this ruling with bad grace, but they shot all morning.

The same evening, Grierson and Jimmy Davidson showed up unexpectedly at the hotel where they were staying in Birmingham. Grierson was in high spirits because that afternoon, on their way up from London, he and Davidson had shot some spectacular steel material which they had chanced to run across. The more lyrical Grierson's description waxed, the more apprehensive became Golightly and the more furious became Flaherty because it soon became obvious that Grierson had been at the same steelworks as had Flaherty and had shot the very things that had been forbidden, apparently without seeking permission.

But Grierson's visit had a more serious purpose. By now, Flaherty had used up all but £300 of the £2,500 allocated for his film. Grierson realized that he had no other choice than to stop the production, however painful that might be. After he, Flaherty, and Golightly had eaten a very good dinner—the bill for which, Grierson noted, went down to expenses on the film—he said: "Bob, your money is running out."

"But, John," protested Flaherty, "this is only the beginning. I'm still just making tests. Look, unless there's £7,500 for the picture, I quit."

"Bob," said Grierson warily, "you don't know the British Treasury."

"You go down and see them in Whitehall," said Flaherty, "and get some more money out of them. Don't they know *who* I am?"

"D'you *really* want to know what they think you are in Whitehall?" asked Grierson innocently, and paused. Flaherty waited.

"They think you're just a bloody beach photographer," said Grierson.

Flaherty drew himself up to his full height and size, raised his clenched fists to the ceiling of the crowded hotel restaurant, and bawled his best four-letter Anglo-Saxon swear word.

They were all requested to leave the hotel.[9]

Despite this incident, Flaherty did not immediately stop work. He insisted that he still had £300 to spend. They moved over to Northern Ireland, where they were to film in the shipyard of Harland and Wolff at Belfast. It was there that Flaherty managed to get his bulky form wedged in a gantry high up over the yard. "It took fully half a dozen men to free him," says Golightly. "He was a very scared man and had to stay in his hotel several days to get over the shock although he wasn't actually hurt in any way."

There they finally ran out of money. Golightly sent telegram after telegram to the unit in London but received no reply. Finally, Flaherty became very angry and telegraphed Grierson that unless some money came by return, he would sell the Newman-Sinclair. Some money then arrived. They paid the bill and left for London.

When Flaherty returned to London, it became perfectly clear that although some superb footage had been shot, there was no picture. It was tactfully agreed that Flaherty would not edit the film. Grierson pledged that he would do it himself.

A screening of the rushes at once suggested that further filming must be done and that the stock library must be raided. Basil Wright was sent to shoot some waterways and flying boats; Arthur Elton went down a coal mine. Grierson appointed Edgar Anstey his assistant, and the footage was removed to a room in Grierson's house in Merrick Square, on the south bank of the Thames, which had been fitted up with primitive editing equipment and a hand-turned projector. In his very few months at the unit, Anstey had done some general editing—trainees always began on that job—of Canadian footage acquired by Grierson earlier that year and had proudly cut his first film called *Burma Cheroots* out of material obtained from heaven knows where.

Anstey remembers that about twelve thousand feet of Flaherty's material were turned over to him, which was hardly excessive and does much credit to Golightly's stewardship of Flaherty on location.[10] There was, of course, no script from which to edit. Anstey states that he never had anything on paper from which to work. During part of the time, Grierson was ill and confined to bed, where he would edit the film by eye. It was completed as a silent film, and when Anstey left it (to go off on H.M.S. *Challenger* to film a surveying expedition in Labrador), it was two reels long and very similar to the way we later knew it as *Industrial Britain*. At no

time during the editing, says Anstey, did he see anything of Flaherty, nor to his knowledge did Flaherty see the film.

All the next year, 1932, the film lay fallow; but then the EMB concluded a distribution deal with Gaumont-British Distributors for six two-reel pictures to be known as the "Imperial Six" for general cinema release. They were *Industrial Britain*, *The Country Comes to Town*, *Upstream*, *O'er Hill and Dale*, *Shadow on the Mountain*, and *Big Timber*. Part of the deal was that Gaumont-British would provide sound-recording facilities so that music and commentaries could be added to the films, under EMB supervision. The release of the "Imperial Six" was necessarily held up until all of them had been synchronized; as a result, *Industrial Britain* did not have its first showing until the fall of 1933. It carried a joint credit to Grierson and Flaherty. The series played with popular success at London's main West-End cinemas and later throughout the United Kingdom and overseas.

Industrial Britain opens with a reminder sequence of British traditional skills in rural industries—basketmaking and weaving, with power from windmills and transport by barge—making the concluding point that even in the machine age, "the human factor remains the final factor," thus setting the key to the film. The sequence ends with some sweaty shots of miners hewing coal the hard way much as it was done a hundred years earlier.

A Midlands exterior of smoke and steam (black, white, and gray) leads into the famous pottery-making sequence, which is followed by the equally famous glass-blowing sequence, where in the "Glory Hole" at Smethwick we meet Sam Hasselby, the king of the goblet makers. Then the film shows the making of giant lenses for lighthouses and airport beacons, with the refrain "behind the smoke beautiful things are being made." Steel is introduced by a subtitle with mood music, followed by a fast-moving, impressionistic sequence of furnace-tapping, pouring, ingot-forging, and so on. Then we are back with the "keen eyes of the individual," the testing of steel for aero engines, and the fine skill of precision engineering for supercharged rotors: "The process may change but the man doesn't."

A final roundup sequence shows the products of all these skills going out to the world—British ships and planes taking the craftsmanship of British workers to markets overseas—intercut with the fine faces of the men who made the product.

Thus a great deal of the footage shot by Flaherty remains, which, with the Grierson-shot steel sequence, forms the backbone of the film. The narration, written by Grierson, was spoken by the actor Donald Calthrop in an emotional, sentimental style; the music, from stock records because of economy, was romantic and tuneful, except for some heavy "machine" music for the steel scenes. Extensive use was made of Beethoven's *Coriolan* overture.

As an example of Flaherty's work, the film is notable for his continued use of big close-ups, already explored in *Moana*, with very simple lighting; for its sensitive camera movements following and often anticipating the actions of the potters and glass-blowers; and for its photography, catching and contrasting the blacks, whites, and multitude of halftones of the industrial landscapes of the murky Midlands. The wonderful faces of these craftsmen—mostly men of middle age or over—caught in deep concentration on the job in hand, linger in one's memory. If *Industrial Britain* was significant for no other reason, it put the true faces of British workmen on the public screens in a way not seen before. The British worker—for so long portrayed in films as a comic stock figure—was at last given his rightful dignity. It was also significant of the EMB outlook that one of its most displayed posters was a steelworker, not a fancy-dress John Bull.

In addition to *Industrial Britain*, a silent one-reel film was edited by Marion Grierson from the Flaherty pottery footage. It was called *The English Potter* and was destined for school distribution. "It is," wrote Grierson, "thank God, still silent and, except for a synthetic ending, a lovely thing to see." [11] Of the parent film, Tallents wrote, "I always thought the magnificently photographed *Industrial Britain*, with its vivid shots of steelworkers and potters and glass-blowers, and its closing portrayal of a ship outward bound with the exports of Britain, as moving as any that the unit in those days yielded." [12]

In hindsight, Grierson wrote of the film:

> Before Flaherty went off to the Aran Islands to make his *Man of Aran*, I had him up in the Black Country doing work for the EMB. He passed from pottery to glass and from glass to steel, making short studies of English workmen. I saw the material a hundred times, and by all the laws of repetition should have been bored by it. But there is this same quality of great craftsmanship in it which makes one see it always with a certain new surprise. A man is making a pot, say. Your ordinary director will describe it; your good director will describe it well. He may even, if good enough, pick out those details of expression and of hands which bring character to the man and beauty to the work. But what will you say if the director beats the potter to his own movements, anticipating each puckering of the brows, each extended gesture of the hands in contemplation, and moves his camera about as though it were the mind and spirit of the man himself? I cannot tell you how it is done, nor could Flaherty. As always in art, to feeling which is fine enough and craft which is practised enough, these strange other-world abilities are added. (Grierson 1932:147)

There is no question but that *Industrial Britain*, with *Drifters*, was the most successful and generally liked film to come out of the EMB Film Unit.

It was still in circulation by British Information Services in countries out-side Britain years after World War II. A proof of its longevity is found in the following piece by the dramatic critic, Alan Dent (1951):

> Being about five minutes late at one of the Edinburgh Festival's docu-mentary film sessions, I found myself instantaneously enthralled in watching a number of skilled craftsmen in close-up. A young potter fashioned a vase with expert hands and earnest gaze—an elderly glass-blower made goblets with cheeks fantastically distended as he blew. The commentary was pithy without being facetious, and it was plentifully interspaced with music that drew attention to the peculiar dignity of especially skilled labour—Beethoven's *Coriolan* overture. Nothing was overemphasised, no sequence was unduly protracted, and the artist-craftsman had that absolutely complete lack of any kind of camera-awareness which is to be seen in only the supremely well-directed order of documentary.
>
> In my ignorance, I assumed for a minute or two that a striking new master of the medium had arisen. But as soon as the little master-piece was over, three authorities stood in the flesh before us and one of them said, "You have just seen an early documentary made by the greatest master of documentary, Robert Flaherty."
>
> But I found, coming away, that the Flaherty-Beethoven had a lingering effect even over and above these supremely good things. I was haunted by the noble music, as one often is after any performance of it, but this time the music in my inward ear was accompanied on the inward eye by the recollection of Flaherty's beautifully composed visual images.

II : Flaherty's withdrawal after he had done his shooting for the EMB caused Grierson considerable concern. But it was no secret that Flaherty had set his heart on making a film about the people of the Aran Islands, off the west coast of Ireland. To help that hope to fruition, Grierson got in touch with Angus McPhail, who was in charge of the story department of Gaumont-British (GB). At the same time, Cedric Belfrage, outspoken film critic of the *Sunday Express*, challenged the perennial bleat of Brit-ish film executives that there was no creative talent around by reminding them in his column that a movie genius of some note was in London need-ing work. Belfrage had met Flaherty in Hollywood when he was preparing to go to Tahiti to work on *White Shadows in the South Seas*.

A lunch was arranged at the Savoy for Flaherty to meet Michael Balcon, who was in charge of production for the Gaumont-British Motion

Picture Corporation, then controlled by the Ostrer brothers. Angus McPhail and Hugh Findlay, GB's publicity man, also attended. Flaherty unfurled his project for making a feature-length picture about the Aran Islands.

He had been keen to make such a film since meeting a young man from Cork on the boat from the United States to Germany late the previous year. Some of the passengers had been sitting around a table in the smoking lounge discussing the major topic of the time, the Great Depression. The company was gloomy about the future. All at once the young man from Cork spoke out:

> You chaps make me tired with all your lamentations about misfortunes, poverty and all that. You don't know what poverty is. Why, there are three barren islands off the west coast of Ireland which are just rocks without trees. The people there have to make soil out of seaweed and sand. First they have to scrape the rocks to make them smooth and then spread the seaweed and sand on them. It isn't much thicker than a rug and out of it they grow potatoes. They are almost the only food they can get from the land. For the rest, they go to sea in primitive little boats. And it is one of the worst seas in the world. The islanders have been doing this for a thousand years or more. If any of them have to leave the islands and migrate to America, they only do so because they're forced to it. When they leave, all their relatives foregather on the wharf and keen them away, just like exiles going to Siberia.[13] (Griffith 1953)

Flaherty was deeply moved and was astonished when he was told that these Aran Islands were only some fifteen hours from London. He read the works of John Millington Synge and was particularly impressed by *Riders to the Sea* and Synge's travel book, *The Aran Islanders*.

All this he poured out to Michael Balcon. When Flaherty waxed enthusiastic about an idea, he could be wonderfully persuasive. Balcon reacted favorably. The Aran project might be just what he was searching for at that moment in British film production.

In 1932, Gaumont-British, with C. M. Woolf in charge of distribution, was the biggest organization in the British film industry, consisting of two studios, a distribution company, and several hundred important cinema theaters. The Gaumont-British Company announced that year that out of its program of nineteen pictures scheduled for production by itself and by its associate company, Gainsborough Pictures, ten were to be musical comedies, five comedies, two melodramas, one unknown, and one real-life drama. The last was Flaherty's film. For this program of nineteen films, Ostrer and Woolf "tossed a million pounds at producer Balcon with instructions to spend it as he thought best" (Belfrage 1932). Balcon decided to risk exactly one-hundredth of his total production budget on Flaherty!

The scheduled cost of *Man of Aran* was £10,000. This was less than *Nanook*, a silent film, had cost, and this one was to be with sound.

It was rumored that GB backed Flaherty with the deliberate aim of proving that the kind of film he made—and for which many people were clamoring—was neither economically nor artistically wise for the British film industry to undertake. In other words, the Ostrers and Woolf (we do not associate Balcon with this conspiracy), were prepared to lose £10,000 in the hope that they would rid themselves of the irritating carping of the film community.

To his credit, Balcon was prepared to allow Flaherty to proceed with his project without a script. "Flaherty merely told me," he writes, "that he wanted to deal with a community who kept alive on minimum standards, even to the point of reclaiming the soil for their barren rocky island. The fishing and hence the shark sequences . . . were never mentioned in our original discussions . . . Flaherty undertook that the film would not cost more than 10,000 pounds." [14]

In the autumn of 1931, Balcon arranged for Flaherty and Mrs. Flaherty to go across to Ireland for a preliminary visit. Their guide was J. Norris Davidson,[15] who had worked at the EMB Film Unit during that summer. Writes Davidson:

> One day late in August, Grierson telephoned us from London. Elton took the call. He then gravely told us that Jack Miller and I were both fired and that he, Elton, was to go on half-salary. "The EMB," Grierson had said, "was under the economy axe."
>
> When we got back to London, I started looking around for some other form of film-employment. I chanced one day to meet Grierson. He was at once very angry with me for not being at work with his unit in Oxford Street. I explained to him that he had sacked me, but he seemed to have forgotten all about it. He said, "You are going to go to Ireland with Flaherty."
>
> Now I had never met Flaherty, only heard about him, and being very ignorant could not imagine an American film director being anything other than the "typical" Hollywood director of the movies. The first time I met Flaherty he bought me apple-pie *à la mode* and coffee at the snack-bar almost next door to the EMB unit. The next time was in a genteel hotel in Berners Street. I could not make the snack-bar and the hotel and *Tabu* (which was then running in London) add up to this amiable, grey-flanneled character—or that's what I thought he was.
>
> Grierson had told me some story about Flaherty having met a ship's engineer on the liner that had brought him from New York to Europe and that this engineer had told him about the Aran Islands. I could never get from Flaherty, however, anything more than the

vaguest answers about the man; in fact, I began to wonder if he ever existed. Flaherty himself seemed most anxious to see Ireland but not any particular part of it. It was Grierson who kept talking to me about the Aran Islands; he knew that I had stayed there not long before in a tent. Grierson, I should add, had restored me to the EMB staff (at half-salary) but when Tod Rich put me on the Gaumont-British payroll, Grierson withdrew all financial support and yet—I never knew why—in some way I continued to be the property of the EMB.

Anyway, I drove off to Liverpool and brought the car to Dublin, meeting the Flahertys a few days later and bringing them to a well-known hotel. "Young man, never again bring me to an American-style hotel," he said, and promptly moved to another one. It took a long time to get him out of Dublin. I introduced him to a lot of local notables (including Lennox Robinson) and he settled down to absorbing Irish life, while I fumed with impatience. . . .

It was then late October. We finally took the road and went to Achill Island off the Mayo Coast. We settled into one of those old-fashioned and comfortable fishing hotels that don't exist any more. I then began to find out how difficult Flaherty could be. When anyone annoyed him or differed from his views, Flaherty would sadly comment that "he was suffering from a mental hook-worm." But he seemed content to peek and pry and take photographs and talk and talk and talk. In my ignorance, I did not understand that he was simply trying to settle himself into a new country. I stupidly thought that we could get into action any day, that cameramen, generators, lights, etc., would arrive—but nothing happened. Looking back on it, I realise how discerning the Gaumont-British people were. In my odd contacts with them by telephone, they seemed quite undismayed by any delays or vagueness. God knows, the EMB unit in Scotland with Elton, Jack Miller and myself, had seemed a bit small and mean, but when Flaherty said, "Cameramen? I don't like them!" I felt he had said something not quite nice.

Mrs. Flaherty was taking a lot of stills with her Leica all this time. She also had a portable developing-outfit of some kind that gave endless trouble. One afternoon she spoiled a whole roll of film. She and Flaherty had a furious row. She locked herself in their bedroom where she had been doing the developing. He sat on the stairs outside and pleaded with her. She refused to come down to tea. He said he would have no tea if she wouldn't come down. She still refused. So I had three teas—jam, cake and buttered potato-bread.

Time passed and still Flaherty showed no interest in going to the Aran Islands in spite of all I told him. Indeed, it looked as though he might make the film in Achill Island. He spoke of sending to Kodak's in Dublin for a 16-mm camera we had seen there. He would shoot on

16 mm and get the film "blown up" to 35 mm, he said. No plot, no script and not a whisper about any sound. . . .

At last one day Flaherty decided to look at the Aran Islands. By now it was sharp cold autumn weather and my car was an open one. Flaherty sat in what used to be called the "dickey" seat (they don't make them any more) and he used to fortify himself with whiskey. But the weather was so cold that we used to stop for more whiskey (Mrs. Flaherty disapproving) and then he used to have to get out to relieve himself and the cold would strike him and that meant more whiskey in the next town and then more stopping for his comfort. . . .

Finally we got to Galway. We spent some days there sight-seeing while we waited for the sailing-day of the *Dun Aengus*, the island steamer of those days. We went to the cinema every night no matter what was showing. . . . Galway had put Achill right out of his head and he began to question me about Aran. He told me to buy a bottle of whiskey to give to the parish priest there. This would have been a very bad move but I did buy the whiskey (on G-B) and it was later put to other uses. I also got Flaherty to admit shyly that he played the violin. It's not hard to break the ice in Aran—there's no ice to break—but a violin player would have given much pleasure since they have only melodians there. . . .

When we got to Kilronan harbour, the first man Flaherty noticed on the quay was Pat Mullen's father. . . . The Leica soon went to work. Pat himself was then about seven or eight years back from America and was known locally as The Socialist. People said it was bad of me to get The Socialist to drive the Flahertys around on his side-car.[16] But we drove about the island of Inishmore with Pat Mullen and I tried without success to interest Flaherty in the village where I used to stay. I did, however, show him two small boys who used to bring water, fish and letters—or nothing at all—to my tent the year before. They were Josie and Mikeleen Dillane. Flaherty took to the younger one at once and he later took part in the film.[17]

In January of 1932, Flaherty arrived back on Inishmore, the largest of the three Aran Islands, which he had chosen for his base because of the plentiful supply of fresh water, which would be needed for processing the film. He writes:

The first thing to do, and a most important one, was to choose from among the islanders someone to be the perfect diplomatist in our dealings with them. For when one came into a strange community to make a film of that community, negotiations to begin with were delicate indeed. This man we found in the person of Pat Mullen, who,

though an Aran Islander by birth and preference, had travelled far in his earlier days and had spent seventeen years in America.[18]

There are no motor-cars on Aran, no movie theatres, no luxuries of any kind. The young man from Cork had not exaggerated the barrenness of the island. To the islanders their hard-won soil is more precious than gold. They would not part with a foot of their land, barren as it is, for any consideration. [When Flaherty told about this, he would cup his two hands together as if they were filled with grains of soil.]

Nor had my friend of the boat exaggerated the sea. All the way from America the North Atlantic sweeps in and hurls itself against the high rugged coast, sometimes climbing three hundred feet to the cliff-tops and then sweeping in over the land. (Griffith 1953:84–85)

With Flaherty were his wife, their three daughters, and John Taylor, who had worked on *Industrial Britain*. John was to look after the film processing and also to do some extra camerawork. Later he found he was expected to be the accountant as well. The unit established itself at Kilmurvy on the leeward side of the island. To the north, the great pillars of Connemara loomed across Galway Sound; to the west, the wide Atlantic surged.

They settled in the best house on the island, rented from a Mrs. Sharman who owned it but lived in London. Two freshwater springs were at hand, near an old stone wharfhouse that was to be used as the laboratory. The main house was large enough only to provide living quarters for the unit. Another was needed in which to film any interiors that Flaherty might decide to shoot. So with the aid of local labor, they set about building one for this purpose out of the hard, gray limestone of the island. It was to be as thick-walled as a fortress, with a turf-covered roof thatched with straw.

Man of Aran is the first Flaherty film for which firsthand reports from many people who worked on it are available. The story is best told in their reminiscences.

The building of the "film" house is described by Pat Mullen who provided the Flahertys' local transport in the form of his own jaunting cart.

An Irish cottage had to be built for the inside scenes, and Mr. Flaherty left this job to me. . . . I searched the three most westerly villages of the island for a gang of picked men, men whom I knew were good at handling stone; then I searched through the different villages for a tumbled-down old house that had in it an arch over the fireplace suitable for our cottage. A friend of mine in Gortnagapple village owned one and, like the fine man he is, he tore down the walls of the old house, took out all the stones that formed the arch, put them on his own cart, brought them to where we were building the cottage, and made us a present of them. While this work was bustling along, I

spent some days driving Mr. and Mrs. Flaherty around. We met and spoke to many people here and there along the road. Mr. Flaherty looked these people over very carefully with an eye to finding suitable people for his cast. We also visited people in their houses and chatted with them partly to become on sociable terms with them and partly with the idea to find out if they would be suitable for the film.

This is a method which Flaherty followed in all his films. He selected a group of the most attractive and appealing characters he could find to represent a family and through them he aimed to tell a story. It was always a long and difficult process, this type finding, for, as Flaherty said himself, "it is surprising how few faces stand the test of the camera."

For a long time the people didn't quite know what to make of us. To begin with, the name Flaherty itself—every other person in the Aran Islands has the name of Flaherty or O'Flaherty, including Liam O'Flaherty, the famous writer, who was born there, and there were some who were quite sure he had assumed the name in order to gain their confidence. We had already had a brush with the name in Galway. There was still an inscription over the old Spanish Gate which had been built when Galway was a walled city. It read as follows: "From the furious O'Flahertys, may the good Lord deliver us!" (Mullen 1935:65)

John Taylor, on the other hand, did not spend his first week on the island quite so industriously as did the Flahertys. He was instructed to pick out on a typewriter the wording of a long title Flaherty composed, which was to unfold upwards on the screen at the opening of the completed film. Flaherty constantly changed his mind about the wording, and John became bored with the assignment.

One day Flaherty spotted a small boy called Mikeleen Dillane. A few days later, Flaherty took test shots and, when he saw them, he knew that Mikeleen was the boy for the film. Pat Mullen was sent to Killeany to talk to the boy's parents, who were very poor. The mother refused to let the boy go to Kilmurvy to work for Flaherty.[19] The Flahertys were surprised because they were offering far more money than Mikeleen's mother had seen in her life. Her husband was a fisherman and earned very little money. Mrs. Flaherty went frequently to the family home and sat patiently by the fireside, sharing tea with her. But still she shook her head. Weeks went by, and the boy's mother still refused. At last they hit upon an idea. Flaherty went to Father Egan, the priest of the island. He gave him a donation and pleaded with him to entreat with the boy's mother. He did. They got the boy.[20]

It was not until they were well along on the picture that Pat Mullen told them why the mother had been reluctant. At the time of the potato

famine some hundred years previously, Protestants came over from England and offered Irish peasants soup if they would become Protestants. The boy's mother had thought they were trying to make him a "souper," as the converts were called.

Meanwhile, the exhaustive search for the cast went on. Flaherty had to see almost every man, woman, and child on the island before he made his final choice. It was not easy going, but Flaherty was the most persistent man that Pat Mullen had ever met. Says Pat:

> Rumours were rife that Mr. Flaherty was a Socialist. Not many on Aran know what Socialism means. To the great majority it means an organisation backed by the devil. Other rumours said that the cottage we had now nearly built was to be used as a "Bird's Nest." "Bird's Nests" were buildings or homes that were put up in Ireland during the famine years, and there destitute Catholic children were clothed and fed and brought up in the Protestant religion. . . .
>
> Mikeleen came to Kilmurvy, but for many weeks he did nothing but fool around the place, doing whatever he liked. . . . The rest of the cast had to be found before Mikeleen could be used. (Mullen 1935)

Actually Flaherty was letting the boy get to know him well and acquire confidence in him so that he would not be self-conscious during the filming.

One of the men who helped to build the cottage was Patch Ruadh, a fine old man with a red beard. Flaherty fancied the look of him and told Pat Mullen that Patch looked "very dramatic." Some tests of him were very successful. The old man was delighted to have been chosen but asked Pat why. Pat told him he was "very dramatic" and surmised that the drama must lie in his handsome red beard. Patch was engaged for the rest of the film but frequently could not be found when he was needed. Pat Mullen finally discovered that every morning he disappeared behind a big boulder near the shore, where he spent half an hour or so combing his beard before a cracked piece of mirror to keep, as he said, "the drama in it."

Maggie Dirrane, who eventually took the part of the mother of the family, was discovered by the Flahertys as she stood with her baby on her arm in the doorway of her cottage. The first tests of her were not good, but a second lot convinced Flaherty that she was right for the part:

> Maggie was a wonderful character. She was the poorest of the poor, and a great believer in the fairies. Her husband crippled himself carrying seaweed up from the sea. Maggie was so poor that she had no milk for her children, so we gave her a cow. She came over to see my wife with tears in her eyes. My wife asked her why she was crying— didn't she like the cow? "Oh," said Maggie, "it's wonderful, but what I am thinking of is if the children should get used to the milk and then

they couldn't have it because the cow died." She had three children and they were all dressed as girls. One day I pointed to one of them and called it a little girl. "Oh, no," said Maggie, "no sir, he's not a girl, he's a boy." "Well, Maggie," I said, "if he's a boy why do you dress him like a girl?" "Sure, sir," she said, "the fairies don't steal girls." [21]

John Taylor claims that Maggie was not so provincial as Flaherty suggests. She had worked in Dublin for ten years and was one of the few people on the islands who could swim.[22] She did all the housekeeping for the Flahertys as well as playing a leading part in the film.

Incidentally, it is a melancholy (or inspiring) thing to note that three months after the unit had left the island, Maggie gave all the money that had been paid to her for her work on the film to a missionary priest who came from the mainland.

Flaherty had already shot some footage of both sea and land material before he eventually found the man he wanted for the hero of the film. Several types were tested, but either they were not suitable or they refused to cooperate. One day one of Flaherty's daughters was on Kilmurvy Pier and caught sight of a man who seemed exactly what her father wanted. Pat Mullen identified him as Colman King, brother of a young man who had already been approached to make a test but had not turned up for it. Tiger King, as he was known, was by trade a blacksmith, but like most of the islanders he was also a boatbuilder, a fisherman, and a bit of a farmer. Flaherty says,

> The hardest one of all to make friends with was Tiger King. I wanted him very much because there was no one so picturesque or so well suited to play the part. But there was a terrible lot of gossip still going on among the people about us. One of the stories about me, so I was told by the priest, was that I used to carry a bottle of water with me and if I happened to meet a child walking home by itself from school, and I could get near enough, I would spill the water . . . over the child and change it into a Protestant. The priest also told me that there was a flower which had only begun to grow on the island since we had come and which, if it took root, would lead the whole population to damnation. . . .
>
> Tiger King was one of those who believed all these tales. . . . He was finally subdued and captured one night at a wedding. . . . Pat Mullen was there too, for one purpose—in the forlorn hope of winning over Tiger King. He noted that Tiger was drinking well. And naturally the drink that makes weddings so successful in the west of Ireland is potheen. One gulp of it is very strong, enough to knock the tail off a mule. And this was a highly successful wedding! That's how Pat Mullen captured Tiger King—with potheen. When we got him

across to our cottage, we set up our lamps and camera and made a test of him. With great difficulty we sat him on a stool. But soon we all became friends.

Flaherty tells about the seas round the islands:

The Aran Islander in order to survive has to fight the sea. The craft he uses is a curragh—one of the oldest and most primitive craft that man anywhere has devised. In the old days it was a framework of ribs of thin wood covered with hides and it was propelled with long thin oars with an extremely narrow blade so as not to "trip" in the heavy seas. But the curraghs used in Aran today are covered with tarred canvas. It is wonderful the way they can manoeuvre them in the big seas. If they are heading into a very large sea which is too big to take head-on, they will sidle over it in much the same way as a gull rides the water.

There was one instance of a crew in a curragh trying to get into land. The following waves were so overwhelming that when a wave larger than the rest towered behind them, they had to swing round and face it, sidle over it, and then turn and run until the next wave came on and then the performance had to be gone through all over again. That day the seas were so high that they couldn't make a landing on the island at all but had to keep on and on and finally landed at the head of Galway Bay some thirty miles away. I have never anywhere in the world seen men so brave who would undertake such risks with the sea. Yet the Aran Islander can't swim a stroke. If he touches the water, he gives up and goes down like a stone. . . .

We lived one-and-a-half winters on Aran, and during the second winter the storms were incredible. On the seaward side of the island was a cliff-face that in its highest parts was over 300 feet high. Often after a storm, walking along the top of these cliffs, we picked up pebbles and seaweed thrown right up there by the fury of the sea. In one of the culminating scenes of our film, the sea soars up against one of these cliffs and not only rises up to its head but keeps on rising until it reaches a height of some 450 feet from water-level—a towering white wall of wrack and spume, which then slowly bends in like a wraith or ghost over the island itself. . . .

In one of our scenes for the film, we had Maggie coming up from the sea with a heavy load of seaweed dripping on her back. She had reached a point well above where we thought any sea could ever break. Suddenly as we were filming, the sea reached up without warning and caught her. I thought the heavy burden might have broken her back and we rushed to help her. Maggie was still lying in a smother of sea when Tiger King got to her. He grabbed her by the hair as another wave came pounding in and submerged them both.

When Maggie rose, bleeding and cut from the rocks, her face was deathly white. She muttered something to us, and in her eyes was a wild look of fear. She mumbled to us something about the sea which trailed off into an unintelligible Gaelic—something more like a wail, a primitive animal sound, than a human voice. Never in my life have I ever seen anyone so frightened. She was weak with fear, but unhurt. But there was a look in her eyes which went far back into primeval time.[23] . . . I should have been shot for what I asked these superb people to do for the film, for the enormous risks I exposed them to, and all for the sake of a keg of porter and five pounds apiece. But they were so intensely proud of the fact that they had been chosen to act in a film which might be shown all over the world that there was nothing they wouldn't do to make it a success.

We had picked three skilled men to be the crew of the curragh in the film. There was one scene I remember which took place so quickly in the finished film that most possibly it wasn't noticed—when the curragh is racing and trying to get to land. Suddenly a jagged tooth of rock is revealed by the momentarily sagging waters and the curragh comes to within a foot of it. If it had struck that tooth of rock, the curragh would have been ripped from bow to stern and the three men would have been drowned before our eyes.

As has been said, the men are very superstitious. Everything had to be propitious for the crew or they wouldn't go to sea. One day I had all our cameras set. The men were about to launch the curragh to do a scene in a raging sea, when one of them saw a dead fish rolling in the surf. That was enough. That day we did no filming.

One day in April of our first year on Aran, we caught sight of a strange creature swimming in the cove just below our house. It was enormous in size and had a black fin sticking up about a foot, maybe two feet, above the water. It was slowly swimming around in the clear green water. We got into the curragh and rowed out to it. It didn't seem to want to be bothered by us. It came slowly alongside and passed the curragh not four feet away. Its huge mouth was open—like the mouth of a cavern, at least two feet in diameter. I asked Pat Mullen what it was. He said it was a sunfish.

This puzzled me because the sunfish, as I knew it, was a different kind of creature. This monster, judging by the length of the curragh which was eighteen feet long, must have been at least twenty-six or twenty-seven feet in length. Pat went on to tell me that soon there would be a lot of them there. They were to be seen every Spring, hundreds and hundreds of them, so that the sea "would be filled with them."

Staying with us at that time was my friend Captain Munn, an explorer and hunter, who had been pretty well round the world. When

he left to go back to London, I asked him to call at the National Library in Dublin and find out more about what Pat Mullen called a sunfish. He did finally dig up a book written in 1848 by J. Wallop Brabazon. At the time it had been written, there were sunfish fisheries all along the West Coast of Ireland. The sunfish was known as the basking-shark and it was hunted for its liver which, as is common in sharks, was enormous. Out of the liver of one basking-shark could be rendered as much as one hundred gallons of oil. This oil was used for illumination. It was poured into a small shell with a rush for a wick. The shark was hunted with harpoons and lines, in the old way of hunting whales.

Sure enough, as Pat Mullen had foretold, the basking-sharks soon began to come in in schools. One Sunday we sailed through one of these schools in Galway Bay. The sharks averaged a length of about twenty-seven feet, the tail being six feet across. This school was four miles long. Looking down into the water, we could see that they were in layers—in tiers, tier after tier of them until we could see no deeper. There were thousands and thousands of them. They come every year to the west coast, approach the islands, and then pass further up the coast to the Hebrides and the Faroes, up the coast of Norway and out beyond the Arctic Circle.

Dr. Maher, the Curator of the Museum of Antiquities in Dublin, became very interested in these creatures. He entered into much correspondence for me with various museums, particularly one in Bergen, in Norway, and we found out that even today these creatures are hunted off the coast of Labrador and that a hundred years ago they were hunted off the coast of Maine.

I had this shark-oil analysed, hoping that it might contain some valuable vitamins which are found in the livers of cod and halibut, but we got negative results. Later I understood that they are being used for some medicinal purposes. They are also using the meat and a fishery has been started on the West Coast of Ireland.[24] This basking-shark is not a scavenger and there is no reason why the meat shouldn't be quite palatable. It is a curious compromise between the whale and the shark. Its mouth is formed of whalebone and the food it eats is the minute sea-life, such as plankton, which it sifts through the whalebone, straining the water, as it were, of the contents just as does the whale. Its throat is very narrow, far too narrow to swallow any fish. I have always felt that the story of Jonah and the Whale must be a bit cockeyed somewhere.

Flaherty's lengthy description of basking sharks and whales demonstrates his great interest in all his surroundings, especially if he could discover some little-known or forgotten object or idea. The arrival of the basking sharks off Aran had more than curiosity value. It caused Flaherty to

change the shape of his picture. "Originally," John Taylor tells us, "Flaherty was going to shape the film round Liam O'Flaherty's story *Spring Sowing*, but once the sharks appeared he started to waver."[25]

He was determined to include a spectacular sequence showing the islanders hunting these creatures with harpoons, even though no living Aran man had ever handled a harpoon, let alone pursued a basking shark with it. They would have to be taught. Undaunted, Flaherty estimated that by sheer good fortune he had stumbled on a spectacular high spot for his film, which would also be good box office in the Hollywood idiom.[26]

It fell, of course, to the indefatigable Pat Mullen to find out what he could from the old men of the islands as to how the hunting of the Levawn Mor, which is how the giant basking shark is called in Irish, was carried on sixty years ago. He unearthed two or three rusty old harpoons, which were given to a blacksmith in Galway so that he could make replicas:

> Next day we sighted two of the monsters close in shore. They swam around in wide circles, for this is the way they feed: they surround whatever it is they live on and with their great mouths wide open swim around in ever narrowing circles until, I suppose, they swallow the feed all up. . . . We laid planks across two curraghs and with ropes that went from these planks around the bottom of the canoes we bound them firmly, keeping the canoes about four feet apart to give the whole thing steadiness. A platform was erected on the planks between the two curraghs and on this Mr. Flaherty stood working his camera. Two oars on the outside of each curragh were used for driving them ahead and on fine days they were pretty steady. (Mullen 1935)

That summer Flaherty also hired a Brixham trawler, the *Successful*, and many trips were made far and wide pursuing the sharks and letting the crew get experience in harpooning. As had been done in the old days, sentinels were stationed on high points at strategic places on the coast. As soon as a sentinel spotted a shark, he would come racing down to where the boat was waiting, and out it would go. But the season for the sharks was ending and little usable film had been taken of the hunting. Tiger King and his boyos (sic) had still to master the technique of harpooning, which had been the pride of their grandfathers.

Flaherty had intended to finish his shooting by the end of November 1932, but it was clear that to get his spectacular shark sequence he would have to extend his schedule by twelve months. Gaumont-British agreed to the extension, and the unit remained on the islands until the end of the summer of the next year.

Various land sequences remained to be shot and, of course, more storm scenes could be expected during the winter. The unit had been

strengthened by the arrival late in October of David Flaherty from America, with an Akeley camera, to help with additional shooting and take over the accounts from John Taylor. Gaumont-British sent £500 a month in £5 notes. "These," John says laconically, "I kept in my back-pocket and doled out cash to Flaherty as and when he asked for it."

In November, John Goldman arrived from the Gaumont-British studios. He was one of a small group of young university men whom Balcon had recruited with the estimable aim of raising the quality of British production personnel, which was hardly rich in intellectual, let alone educated, talent at that period.[27] When Flaherty had made arrangements for his production with Balcon, Goldman had been on vacation in the USSR. He had acquired editing experience working on such studio pictures as *Sunshine Susie*. When he got back to England and heard about the Flaherty film, Goldman determined to join the unit in Aran. He tried to persuade Balcon to send him over to learn camerawork from a maestro. Balcon, however, demurred, and it was not until Flaherty himself paid a brief visit to England (which he did periodically all through the production) that Goldman induced him to let him work on the film.

No actual processing of the film was done on the island until October, when an expert from Kodak arrived, reorganized the field laboratory, and put it into working order. All the rushes until then had been sent to London for processing, and Goldman brought out with him a selection of the print. He was not able to bring all that had been shot because an argument between the Eire and United Kingdom governments, which had begun halfway through the film, had resulted in a high import duty being levied on the film. By the time Goldman arrived, however, the laboratory was in operation. Film was beginning to accumulate. "It was natural, I suppose," says Goldman, "that I should get my itchy fingers on it. Everyone was doing a bit of everything. We all had to, so the film material naturally fell to me. . . . Someone had to break down and classify this increasing mountain of film, and maybe put it into some kind of order. No one else there had any kind of professional editing knowledge so somehow I got around to the job. Flaherty seemed to accept the fact."[28]

The famous storm sequence with which the film was to end was, in fact, the first sequence to be edited. A lot of film still had to be taken for it during the approaching winter, but Goldman had enough material to start in on a rough assembly. That sequence was cut and recut innumerable times over a nine-month period before they were satisfied with it. Even when they returned to London the next year, some further work was done on it. But the film worked backward, so to speak, from that final big sequence.

Denis Johnston, the distinguished Irish playwright, says, "Flaherty himself, after the day's filming, would be in and out from the sitting room to the laboratory, from the lab to the cutting-room, and every time the film-projector would be switched-on inside in order to run through another

section of his film, all the other lights would dim with the extra load on the current. And you could hear Flaherty and his editor roaring at each other above the hum of the machine." [29]

Flaherty was known for his seeming profligacy in the use of film stock. For *Man of Aran* he shot a total of some two hundred thousand feet of film. John Taylor, who had been schooled in the austerity of the EMB Film Unit, might have been shocked to see such apparent flagrant disregard of film. "But," he says, "I was full of admiration at seeing someone to whom it was a great pleasure and excitement just to use a camera. I can remember him once, when we were short of film and I was told by Flaherty to ration him, shooting for hours with an empty camera purely for the pleasure of doing it." [30]

The supply of stock sent out by Gaumont-British was made up of what are called short ends, that is, leftover negative from other productions, and thus it had already been paid for and did not add to the film's cost. Its processing on the island cost a fraction of what it would have if done at a London laboratory. On one peak day's work Flaherty himself with two cameras (John Taylor loading for him) shot 5,600 feet of stock between 10:00 A.M. and 3:00 P.M. on sea scenes.

Goldman recalls:

> Much the worst example of his profligacy, was his addiction to panning his camera. Perhaps the smoothness of the gyro-head tripod had something to do with this, and touched a tactile nerve in him. One shot—quite pointless in itself—consisted of a complete magazine (200 feet) of an unbroken pan shot ranging over the perpendicular walls of a cliff from the top—though never showing the skyline—down to the sea and back again until it finally lost its way. I think he was trying to establish by feeling it the height of the cliff. It was typical of him to try and do this by the camera rather than by cutting. His feeling was always for the camera. This wanting to do it all in and *through* the camera was one of the main causes of his great expenditure of film—so often he was trying to do what could *not* in fact be done. [31]

In connection with this seemingly reckless use of film, Mrs. Flaherty has written:

> It may be that I am oversimplifying Bob's approach to filmmaking when I point out that he simply went out with his camera and shot and shot and shot, exploring every angle, every vantage, every location, every light, delving as far as imagination could take him into his subject, photographing exhaustively everything about it that the camera's eye could possibly see. The complaints against him always were: "He

takes too long, he uses too much film." Indeed he did spare neither time nor film nor himself nor anybody else. He made his films alone; they were one-man films from their first conception to the final cut, not excepting the processing of the film which he always did himself in a laboratory which he took along with him.[32] But he also used everyone around him. They were not professionals, for professionals had their way of doing things and could not adapt to his way, nor he to theirs.[33] He had to have helpers he could break into his ways, young people, and particularly native people, the cast with whom he was making his film. Our cast on Aran became partners in our work. "God bless the work," they would say.[34] They lived with us as one family; they served us and the film hand and foot; they lived and died with us with the ups and downs of the film. It was a way Bob had. . . .

Bob's procedure in his work was by trial and error, and trial and more trial. . . . Our cameras with their long lenses were taken from one location to another; perhaps some of them would be better than the one before. "He'd see some spot in the distance," says Pat Mullen, "where he would figure he should put up his camera. Well, nothing could stop him getting there. He made a direct line, and he'd bolt through a field of briars, you know, that would hold a bull—that sort of way. He had that fire in him; you see—say nothing, but do it if it costs you your life." (F. Flaherty 1953)

John Taylor recalls that Flaherty was becoming shortsighted and that John often had to focus for him. The lenses he used were the 6, 9, 12, and 17 inches, obviously necessary for the shots of the curraghs at sea and the storm scenes. He rarely used any filter but a K2, but he always did his own operating, that is, he himself handled the camera for the panning shots. "He was," says Taylor, "very strong physically. Even a Newman camera on a heavy-duty gyro-tripod was no light weight but Flaherty would shift it from place to place with effortless ease. He told us that once in Canada he had won a five dollar bet by carrying four sacks of flour—one under each arm and two in a line from his forehead—a total of 480 pounds—for a quarter of a mile. We believed him!"

Goldman stresses the difference in Flaherty when on Aran making his film and when acting as host in the Cafe Royal, London:

Bob on the job was not only bereft of all humour and wit but was utterly concentrated on the film to the complete exclusion of all else, and this twenty-four hours out of twenty-four, waking and sleeping. His being was, as it were, both wrapped around the subject and at the same time engulfed within the subject. Nothing else existed or had meaning for him. The result was an atmosphere difficult to describe if not experienced. It was heavy, thick and charged. There was tension

everywhere, an unbearable tension, thunderous black tension, a tension you could feel with your hand, smell and sweat in, stale tension, sulfurous tension, all-pervading, contagious and paralytic. It would swell and inflate and grow thicker and darker; emptiness and frustration and failure; pressing at the sides, bursting at the seams; your very blood thickened into a sludge and life slowed down into profound depression, compressed, explosive, dangerous. The subsequent explosion was like a volcano blowing its top. It had to be. The atmosphere then lightened, work started anew and grew into a furious pace until the tide ebbed again and the fog gathered round and the tension again grew and stretched and brooded. And there was no relief.

It would be wrong to talk of Flaherty's temper. It was not temper. It was not anger. It was much more than that. It was temperament, real temperament, the tremendous power of a force of nature. Those of us who could get away across the fields and rocks up to the old fort at Dun Aengus, we were lucky. We would sit on the cliffs on a peaceful sunny day, and rest our eyes on the ocean away to the west, or lose ourselves across the Sound to the east, in the blue still mountains of Connemara. But Flaherty could never escape from himself, from his brooding and passion. God! How that man suffered.

. . . . Did Flaherty love his film? I can only say that there was a strange light in his eyes. He was as a man possessed. And the smell of this possessedness pervaded and spread through the unit. We all felt it. We were all touched by it. There was nothing rational about it. There was nothing rational about making a film with Flaherty from the beginning to the end. And when I heard him talking of the making of his earlier films, I could recognise the same atmosphere, the same irrational forces at work. When he told us of his troubles during *Moana*, the accidents, the passions, the murders, I could understand them for they were the product of the tensions generated. Murder could have happened on Aran, too, might have done, perhaps nearly did. Any one of us was capable of it in the miasma of madness in which we lived. But it just did not happen. It was an atmosphere far, far removed from the Cafe Royal or the Coffee House Club.[35]

John Taylor says the Flahertys lived in "a house of slamming doors. The carpenter was for ever fixing them again. During the twenty months we worked on Aran, I was fired twice and quit once but I was still there when the picture closed down."

By about the autumn of 1932, Harry Watt was sent out from the EMB Film Unit to join them. There was, it seems, the prospect of a film project being set up in Ceylon, which would call for a field laboratory, and Grierson thought that Watt, a newcomer but under consideration for the Cey-

lon venture, might pick up some useful knowledge from the Aran unit. Watt says:

> I was sent out to Aran as a sort of "willing lad." I had thought and it had been indicated to me that I was going to rough it. In point of fact, I had never lived in such luxury . . . I went out there loaded with sea-boots, oil-skins, etc. . . .
>
> When I arrived, there was a kind of notice-board in the large house which Flaherty had taken, and on it there was a little note marked "Shots Wanted" and below it was written "Maggie on the cliffs" and "Seagulls." As far as I know, that was the only script that ever existed and when I left the notice was still on the board. . . . We juniors lived in some converted cottages and we had a pretty easy time because shooting was always desultory, just when it came up Flaherty's back, and it generally didn't start too early in the morning. John Taylor made an enormous contribution. He developed and printed every foot of film; one of my jobs was just sitting in the dark-room doing labourer's work. We used to take a bucket over to the big house every night and have it filled up with Guinness and then sit round enormous peat fires . . . and drink stout and we all got very fat. . . .
>
> I was never quite certain how the Aran Islanders thought of Flaherty. They are an intricate and tricky people. . . . I think they admired him as a man, but felt in their hearts that he was exploiting them. . . . In point of fact, he was one of the greatest exploitationists that I have ever known. I remember that when anybody from Gaumont-British came to visit us, Bob had sold them on the rushes and the excerpts before they ever saw them. He was quite unabashed at sitting there while rushes were being run and yelling, "Isn't that great! Isn't that the greatest stuff you've ever seen!" and so on.[36]

In addition to Denis Johnston (who based his play *Storm Song* on this experience), many people visited Flaherty on Inishmore during the twenty months that he was there. John Grierson came and, according to some reports, which he denies, was nearly harpooned by Tiger King during a lengthy potheen session. Cedric Belfrage went across in an airplane and wrote it up for the *Sunday Express*. Hugh Findlay, the Gaumont-British publicity man, is convinced that it was the only time in his life that the leading lady of a film brought him an early morning cup of tea. Others who spent time there were Jack Yeats, the painter; Professor Robin Flower, deputy keeper of manuscripts at the British Museum; Newton Rowe, the old friend from Savaii; Tod Rich, the studio manager from Gaumont-British; Tom Casement (Sir Roger Casement's brother), Geraldine Fitzgerald, Charlie Lamb, Arthur Elton, Ria Mooney, and a strange character named De

Silber, who was, it appears, both head of censorship in London during World War I and chief receiver of espionage for the Germans at the same time! Said Grierson of Flaherty, after one of his visits, "He is like a feudal baron among his retainers."

It was on the Aran Islands, too, that Orson Welles first met Flaherty. "He was on Inishmore and I was on Inishmaan, and for a long time I took a very dim view of what I imagined was a Hollywood film-maker ruining this strange and delightful out-of-the-way part of the Irish world. And then by accident on a trip by curragh, I found myself on Inishmore and in the midst of a long and very rich conversation with Flaherty . . . this was the great director whom I'd been loathing from my little island a few miles away."[37]

Flaherty had been a poor sleeper ever since the fire in Toronto in 1916. He had had sent to Aran a complete set of the *Everyman's Encyclopaedia*, which he read at night in bed. At breakfast, he often questioned the company on recondite subjects about which they displayed ignorance. He would then discourse knowledgeably on the matter, which he had, of course, read about during the night. He had also imported a miniature billiard table upon which he delighted to play; to refuse to join him was an act of unpardonable rudeness. A piano, too, had been shipped across from the mainland, which Frances Flaherty would play while Bob displayed his skill on the violin. When they were there, the Flaherty daughters would entertain the company with songs and dances learned in Samoa.

"At three o'clock in the morning," recalls Goldman, "we would stagger exhausted, blind and stupefied with cigarette-smoke from the projection room, which was also the film store, cutting room and my bedroom and had an open peat fire at either end, into the next room to play billiards until four A.M. or later. Bob hated going to bed."[38] John Taylor adds, "One of Flaherty's standard pastimes was printing stills. Most of the film that was used on tests was actually used trying to get the laboratory working properly. All the tests for the cast were made by Mrs. Flaherty on a Leica. During the first ten months when the laboratory wasn't functioning adequately, Mrs. Flaherty also took three or four rolls a day of stills which matched the shots which Flaherty was making and she continued at this rate throughout the whole production. The rolls were developed before supper and Flaherty usually spent the evening enlarging them. . . . Before breakfast, he used to sit in his dressing-gown with a large pot of coffee trimming the prints. One hundred prints a night was normal, but sometimes it was two or even three hundred."[39]

One evening, Flaherty suddenly had an inspiration that by using the projector he could turn the film into a three-dimensional stereoscopic production. He insisted on collecting every looking glass in the house and with Goldman spent hours arranging them in relation to their hand-turned Ross projector. The experiment ended in failure. Although fascinated by

mechanical tricks or invention, Flaherty was opposed to theory or study. One day he found Goldman deep in a book on optics and photography. He at once objected. He believed profoundly that experience was the only teacher. "To him," says Goldman, "the camera was the magic box. All you needed to know was how to make it go—how to keep it clean—how to care for it. To learn the theory of its magic properties was to place a barrier between yourself and the box. What you really needed to know was the scene that you were shooting—not the magic box itself." [40]

As winter came near, Flaherty filled in time until the big storms should break by filming scenes of people on the shore and cliffs to cut in with the storm in the final sequence and took many shots of the curragh and its crew. During that winter they got all the fabulous material out of which the famous storm climax of the film was assembled.

In February, the weather became warmer and they began to talk again about the return of the basking sharks. Flaherty had been in touch with an old friend from his Arctic days, Captain Murray, who had been captain of the whaler *Active* of Dundee. He had sailed the last whaler out of that port and had brought back the biggest pair of whale jaws ever seen. The captain was now retired and living in Scotland. Flaherty decided that it would be a grand idea to get him to come over to Aran because he would know the technique of harpooning and could instruct the cast how to go about it more successfully than they had the previous year.

Captain Murray, variously described as "powerfully built, with a barrel chest" and "small, wiry, and precise" was lame in one leg and very popular except with Flaherty, whose tales of his Arctic days he constantly interrupted by remarking that Flaherty's version was not accurate and that he, the captain, was the only one who could tell it.

The captain brought with him a harpoon gun, which was at once adopted by Tiger King, who was a great man with guns of all kinds, having spent some time in the Irish Free State Army. Tiger cleaned and polished the harpoon gun, which had been made in 1840, as if he had owned it all his life.

This year Flaherty decided to hire a steam drifter, the *John Summers*, from Galway, to use as his camera boat; he called her the dirtiest drifter on the west coast of Ireland. On the day she arrived, Flaherty anxiously questioned her master and crew if they had sighted any sharks on their way there. "Why, yes, sir," said the master, "several of them." "How big were they?" asked Flaherty. "Oh, maybe some were thirty feet—some perhaps forty feet long." Flaherty was jubilant. The master and his crew exchanged glances. "Of course, sir," said the master, "there were one or two real big ones." "How big?" demanded Flaherty. "Well, there was one for sure I'd swear was sixty feet long, maybe even more," replied the master. Flaherty almost embraced him and shouted for all to hear, "We'll have the biggest fish in the world! Nothing that size has ever been known!"

It was only later that John Goldman found out that the master and his crew had, in fact, seen no sharks on their way. "Then why did you tell him the story?" asked Goldman. "Why, sure, we hated to disappoint him," said the master. "Mr. Flaherty wanted us to have seen sharks so we said we had to make him happy."

The summer went by with Flaherty shooting each day with infinite patience and returning again and again to shoot more footage. The shark-hunting took place as successfully as it ever could. By August 1933, the unit had been on Innishmore for twenty months. Gaumont-British probably wanted the production to be wound up. The only film that had been sent back to the studio was the roughly edited storm scenes. By this time, recalls Michael Balcon, the film was widely regarded as "Balcon's folly." He screened the seemingly endless storm scenes on Saturday afternoons when the rest of the studio was empty to avoid the caustic remarks of some of his colleagues. One Saturday afternoon, when Balcon believed himself to be alone at the studio, Isidore Ostrer (the head of Gaumont-British Corporation) and his wife unexpectedly came into the projection room. They sat down without saying a word. They were enthralled by what they saw and, says Balcon, "After that, life became a little more tolerable."[41]

Nevertheless, the hard facts were that Flaherty had shot some two hundred thousand feet of film and thirty-five thousand feet of tests, had extended his stay in Aran by nearly a year, and had inevitably exceeded the budget of £10,000.

Goldman recalls working with Ted Black, the London-based production manager, to end the shooting.

By now, Flaherty was ultra-sensitive about the length of time the film was taking. If he thought anyone was questioning it, he would blow up. I myself was surprised by the lack of complaint from London. On my few visits there, I would naturally be asked why it was taking so long, how far we had progressed, how much longer would Flaherty take—but there was never any complaint from Balcon or Black. In fact, it was I who finally told them that unless the studio closed the unit down, Flaherty might go on for months. He had reached the stage where he could no longer bring himself to finish. Thus when I asked Ted Black to close it down, he did so at once. From Bob I expected a storm but he accepted the recall with such good grace that I have always suspected that he was relieved to have had the decision made for him."[42]

The editing of the film in England at the Gainsborough Studios in Islington during the winter of 1933–34 established an important precedent in Flaherty's work. Up till then he had edited his own films with con-

siderable help from his wife and an assistant. Now, however, he had to form a relationship with a professional film editor, John Goldman.

Their points of view in regard to the editing process in filmmaking were opposite. It was perhaps largely because of Goldman's tact, as well as his respect for Flaherty, that the film was finished without a shattering battle. Balcon, as producer, had the wisdom not to interfere. No one else at GB, says Goldman, seemed to care about the film's existence, except Ted Black and Hugh Findlay, the publicity man. Despite many arguments between Flaherty and his editor, the film that finally emerged as *Man of Aran* was the film as the Flahertys wanted it to be. Balcon had his doubts at various stages of production but was wholly behind Flaherty in everything that was done.

To understand the conflict of views between Goldman and Flaherty we should explain that the former was a constructivist editor, albeit a young and not greatly experienced one. He believed that a film did not have breath and life, shape and form, until the raw footage reached the cutting-room floor. He was greatly under the influence of the editing principles and methods of the great Soviet filmmakers Pudovkin and Eisenstein, whom he met in the USSR in 1931. Thus his approach to the Flaherty film was based on his idea that only in the editing could the creation of effect and meaning by juxtaposition of shots and their related lengths and rhythmic content be achieved. He was not alone; any other documentary filmmaker in England at the time would have handled the Flaherty film the same way.

Flaherty, on the other hand, had no knowledge or understanding of such "scientific" editing techniques, but he did have an intuitive feeling for putting one shot after another so that they followed the obvious logic of storytelling. As he frequently told Goldman, he "photographed what the camera wanted to photograph," not what an editor wanted. It is possible that he did not possess any feeling for the principles of continuity that are a basic necessity to film technique. If Goldman explained to him while they were still shooting on Aran that he wanted a link shot between, say, a man coming out of a cottage and the same man arriving at the seashore, Flaherty would say, "No, the camera doesn't want to shoot it—the camera doesn't see a shot like that." "You can always cut away to some other shot," he would say, and Goldman most often did just that. If Goldman became insistent that the sequence would not make sense without this missing shot, the shot was sometimes taken with reluctance, but Flaherty had no interest in it. Flaherty often made an analogy between his use of film and the Eskimos' carving of ivory. When he would say, "I photograph what the camera wants me to photograph" or "The camera doesn't see it like that," he was expressing his belief that the material dictated its own shape and meaning. He thought that no shape or form should be imposed on the subject and that if you waited long enough, with infinite patience and con-

templation, the film would, in a sense, make itself. It is also why he endlessly screened his material in the belief that finally the material itself would suggest its own shape.

Flaherty was very anxious not to impose his own personality on a shot. If a particular shot was singled out for praise by someone in the projection room for its lovely composition or photographic quality, he would at once ask Goldman to discard it as being "self-conscious." He had a dislike of general long shots unless they revealed some specific action or object. "Long shots don't reveal anything," he would say.

In retrospect, Goldman thinks Flaherty had no sense whatsoever for what is known as the "rhythm of film." He had, as so much of his work shows, a wonderfully sensitive feeling for rhythm as it arose in the people or things he photographed. No one had a more observant eye for the movement of a gesture—as the dancing in *Moana* or the pottery-making in *Industrial Britain* testify—and no cinematographer has ever moved his camera better than Flaherty, but this understanding of movement and rhythm stopped short when he came to the editing of his films. Flaherty's delight was in a shot per se, and not in the cumulative effect of a number of shots arranged in a particular way.

John Goldman's notes indicate how this film was a turning point in Flaherty's career, as will become clear when we study the conflicting criticisms of it.[43]

To make such a film as *Man of Aran* requires an extreme awareness, an openness to reception which in my experience is rare among people. The difficulty for Flaherty, and for any film-maker for that matter, is that at outset he has to give some reason to potential backers for making the film at all. There has to be a subject; the backer wants to know what the film will be about. But from the moment when Flaherty peered through his camera, he as it were disrobed, he undressed, he shed the logic and convention of himself as a human being and became only aware of what the camera revealed. When he set up his camera on the rocks of Aran, he was no longer seeing the Aran Islands, he was seeing what the camera told him.

This is a very subtle thing, very difficult and profound. It requires a degree of openness, a degree of freedom to receive, and a degree of liberation from the convention and thought of modern life, a dropping of the whole edifice of knowledge and expectation that we acquire as we go through life, that only the most direct and simple person can ever achieve. This freedom to be aware was, I believe, Flaherty's great gift. The more intensely aware you are, the freer and more fluent is the act of creation. In Flaherty's case, this act was infinitely difficult and prolonged. . . . All the time I was on Aran I never saw Flaherty deliberately pose his camera. The camera was set up and

he peered through it. Either what he saw through it was right, or absolutely wrong. And by right I mean not conscious, deliberate composition, but life. Either what he saw had its own life and existence, or it was dead and lifeless, meaningless in its own terms. All sensitive film-makers have experienced this. The act of such photography is the first act.

The second is seeing the rushes of what you have shot. This was a vital and profound study for Flaherty. It was often hard for those who worked with him to know why he rejected some shots and retained others. And often infuriating. But I found his decision always most definite and I can think of no occasion when, after many months, if I had retained some rejected shot in the film for some reason or other of my own, he did not spot it and again reject it with the same decisiveness.

When seeing rushes, it is easy to see and reject the shots which are failures, which are lifeless. And Flaherty had a very high proportion of such failures. These having been rejected, the second stage of selection came, and here the difficulties really began. During these viewings nothing existed for Flaherty except what was on the screen. Gone was the moment when he took the shot. Gone any preconceived idea of what he wanted for the film. Gone were any notions of good photography or of focus or exposure. In the theatre, he would sit for hour after hour, smoking cigarette after cigarette, heaving with his peculiarly laboured breathing, concentrating wholly on the screen. He was free and open to receive what the screen had to say to him. Now anything was rejected which to his awareness had the slightest blush of self-consciousness, the faintest scar of imposed will whether from the camera or from himself. He often and repeatedly referred to the elimination of nonessentials. Each shot had to contain nothing that was nonessential to its own life. These were not so much judgements as perceptions.

Thus Flaherty's actual film-making took place not in the camera, not on the cutting-bench, but in the projection-room. Here he would sit, running through reel after reel over and over again, cutting, sorting, eliminating the dross and joining up what remained, always sifting, panning for the gold nugget, and the only criterion for the recognition of this nugget was his own bare awareness, this freedom from other sophistications, this freedom to receive what the shot on the screen had to say.

During all this long, tedious process there was no shape to the film, no beginning, no end; only cans and cans of rushes with two-thirds of the material eliminated. Imperceptibly during this sorting process, the shots would start to sort themselves, migrating from film can to film can and gathering like molecules round a nucleus. But

there was no conscious thought directing it. Certain shots would seemingly remain outside the main swarm during the shifting about, and then they would get put into another can and tagged on to the end of another reel where the process of swarming would start all over again. And then one day, months after the start, Flaherty would suddenly realise that he was looking at a sequence. It was a peculiar sensation. One day a mere collection of shots joined up together; the next, a perceptible semblance of a sequence, seemingly self-generated, organic, belonging. And that, so far as that sequence was concerned, was the end of the second stage in making the film.

The third stage now began, similar in process to the second but longer, more difficult, more demanding in patience and perception. Each sequence was built up in this way. Some simultaneous with one another; some immediately after another; some months afterwards when the third and fourth stages had been completed on other sequences. Again the projectionists would work day and night. They would have endless strips of paper which they would insert in the reel of film on the projector when Flaherty pressed the buzzer in the theatre. "Cut that shot in half—Take out that long shot, it's dead." And from the first germ of life, the sequence would start to grow up, the hard way like any human child. First the internal life in the individual shot, then the internal life in the sequence. I recall one sequence growing this way into life and then it seemed to wilt and die, stillborn. "We've been preconceiving," Flaherty said. And so every shot had to be broken down and shuffled up and the reel put back again into rushes. And for long weeks no progress seemed to me to be made. From time to time there would be pressure from the studio. When would the film be finished? And this made Flaherty inarticulate and helpless in despair. Would the film never grow? Had he lost the touch of helping it? And tempestuous storms of utter helplessness would boil within him, caged, boxed-in, and no way out. These were difficult times. Endless games of billiards, sleeplessness. Upheavals. You cannot sympathise with a volcanic eruption; you can only stand back in awe while the lava flows down and quiescence returns from utter exhaustion. "You'll have to finish the film, John. I'm done." Peace.

Then the process would begin again. Just as patient, just as long, just as alert, watching for that tell-tale gleam in the quartz. No shortcuts here. So he must have been during his wanderings in the Arctic. Weeks and months of sledging, stores used up, exhaustion and nothing to show for it. But always tomorrow. . . .

And so the individual sequences came to life and grew, some lusty and some poor, twisted and misshapen, ruthlessly to be destroyed and refertilised. "I'm missing that shot, John, where is it? You've taken it out." Which shot? No clue. No shot had been taken out.

But some memory of a shot in his mind from some forgotten film can. So the spare reels would be run again and a lost shot rediscovered and put back into place.

Then the next stage would begin. Individual sequences would be linked up together. Disaster. Whole sequences built up and grown after long months of loving care and fatigue would have to go, or once again must be taken apart and allowed rebirth. But never for one instant did Flaherty himself intrude on the film. Always he allowed it to grow from within, the chromosomes dividing and doubling, growing, according to its inheritance, beautiful or ugly, strong or weak, but it came from within not from without.

Here I come to a strange fact. Just as I said that Flaherty was never concerned with the conscious composition of a shot, for to him either the shot lived or was dead, so you found him in the same attitude towards rhythm. The complex of shots, the sequence of shots grew from within and conformed to no preconceptions about rhythm and flow. The rhythm in the film flowed from life, not life from rhythm. If it was disjointed and jerky, maybe that's the way it was; you can't change it because it is not pretty and smooth. If the thing lives and breathes, then it must have rhythm, the rhythm of life. . . .

To me there are two kinds of creative people. Those who create by inspiration and those who create by revelation. Flaherty in my mind was not an inspired artist: he did not work by inspiration but by revelation. And for such people the way is long, laborious and frustrating. It requires fantastic patience and a degree of sustained awareness and perception that is exceeding rare. I have always thought that Flaherty possessed these qualities *in excelsis*.

Having written of Flaherty's method, if it can be called such, that is of allowing a film to grow organically out of its material and the material out of what he called his "tests," there remains the other side—the stylistic and grammatical idiosyncrasies particular and individual to him. However much he may not have wished it, these were in fact imposed upon his work. What had begun as an almost imperceptible style in *Nanook* had become an exploited habit by the time of *Man of Aran*.

He had very definite ideas of what he meant by drama and the dramatic. All his later work was based on these conceptions. As a dramatic film director, I found his grammar and vocabulary using those terms in a film sense, curiously limited. His drama was based solely on suspense and since this was the one weapon in his armoury, so to speak, he used it increasingly hard and extended it to a degree that could be said to be monotonous. On the other hand, this suspense drama was ideally suited to his needs. I have said that he was a creator who worked by revelation and this ran through every facet of his

work. Suspense was always based on revelation, and the revelation delayed until the last possible moment.[44] He was very careful about the exact moment of the resolution of the suspense, the moment of revelation. This had to be of the briefest, cut as short as possible on the screen. He was afraid of anti-climax. One of his maxims was "Never reveal anything." In close-ups of people, he hated full-face shots. He preferred three-quarter profiles, heads shot from behind, anything which did not reveal the full face. The full face showed too much. Similarly he disliked the medium and mid-long shots because they revealed without hiding. They contained no drama, no suspense, no resolving by revelation. In all his films after *Nanook*, he proceeds from close-ups eventually to a long-shot as a pay-off. Keep the audience guessing was his belief. Never reveal anything. Keep people asking questions even after the film is over. "If they want to know more," he would say, "you know you have got them."

He also believed profoundly that it is not the task of a film to do all the work. The audience must meet the film, at least halfway. To get them to do this is the craft of film-making by drama and suspense and revelations never fully revealed. This relationship between the film and audience was never absent from his mind. It was upon it that he relied and worked in constructing his whole film.

Flaherty insisted that the bigger the thing he had finally to reveal, the longer he could keep the audience in suspense. The shark sequence in *Man of Aran* is an example. The whole sequence is built up on this method, from the moment of Mikeleen seeing something (we are not shown what) while he is fishing on the cliff-top to the launching of the boats, to the first sight of something indefinable in the sea, to the harpooning, the fish being twice lost, until finally the revelation of the basking shark in all its length and turbulence. The technique has not varied from the earlier films but become more complex with suspenses within suspenses. The weakness of this method in Flaherty's case is, in my opinion, the monotonous regularity with which he uses it. . . .

Now I come to the last sequence of the film, the great storm sequence. This appears to me to be quite different from anything else in all Flaherty's work. In this sequence Flaherty hinted at and started to develop an entirely new breadth and splendour of expression. Here was something that was new and deeper than anything he had previously attempted. Technically, too, it was different because no tricks, none of his stylistic habits, play any part in its construction. And the sustained power and drama owe nothing to his previous ideas of suspense and revelation.

It stems, of course, from the final sequence of *Nanook* where the blizzard howls round the igloo and the dogs get covered in snow, but

in *Man of Aran* the storm is utterly transformed. It rears up as a gigantic piece of nature, majestic and profound where human beings are as fragile and pathetic as mosquitoes in a summer storm. Here is the force of eternity bursting upon us; and all that frail human beings have to pit against it is their human spirit, their courage which proves eternal and enduring as the prodigious cataclysm of the Universe. This is a spectacle beyond spectacle. This is a grandeur of conception that I have not seen equalled on the screen, Lear-like in its force and expression and, I have always felt, fully realised.

How can this extraordinary sequence be explained? Granted that the storms we saw that winter on Aran were stupendous and breathtaking. Granted the superlative use Flaherty made of every change in light to photograph them, yet there is something beyond all this in the dark poetry of the scenes as they flow before us and produce on us a new and unique experience. I believe that in this sequence the whole pent-up fury of Flaherty's genius flared up and expended itself, like some giant volcano bursting in its great moment of glory.

Perhaps it is worth recording something about the making of this sequence. To start with, it took us two-thirds of the whole time we took to make *Man of Aran* to make this one sequence. Day in, day out; night in, night out. This was the first sequence to be finished, and until nearly the end, the only one. We had a rough-cut of the shark sequence and only vague attempts, all to be discarded, of the others. The Land sequence was finally put together in one night and, apart from some trimming, never altered. The opening sequence was finished previous to the Land sequence and fairly easily achieved. Mikeleen on the cliff-top put itself together and remained hanging about in a rough-cut version for a long time, waiting for a place to be found for it in the film. From rough-cut to final version required only a day or two of delicate trimming. I wonder if a single reel of film—some ten minutes—has ever before or since had the better part of two years' devotion lavished upon it? I was on Aran the most part of a year and I began work on putting the sequence together as soon as I arrived. The main shots were made during the second winter. We had a definitive fine-cut of it when we returned to London in the autumn of 1933, but despite this we worked on it the whole of that winter and spring and even when we fitted the sound-effects, we still made small changes. But I must stress that this storm sequence was profoundly Flaherty's work. Yet there are aspects of it which I believe came about through a unique collaboration between us and through a deep sympathy and understanding which merged us.

Perhaps what I did contribute was to suggest a way of editing the material that was different from the way he had approached construction before. My natural approach was not by drama of suspense but by

the drama of overwhelming emotional experience. I remember that after many attempts, I had got the sequence into four reels, built on my method of construction. I screened it to Flaherty who sat through it in silence, lighting one cigarette from another. As I threaded up the last reel, he said "What, is there another reel?" At the end he said nothing for a while. Then he said, "Patsy must see this." So Frances was fetched and the four reels were run again.

It never occurred to him that here was a new way of editing a film. He had grasped and felt the essential element of monumental building that was in any event implicit in the material. Here was no violation of his own fundamental approach to the material. It was following its own logic, developing its own life. Throughout that whole sequence we worked in complete harmony, except for my minor irritations when some inner rhythms were upset by his changes. The only problem lay in reducing the four reels to one. Flaherty never made any attempt to alter the fundamental style. On the contrary, the style became his and it was under his direction and guidance that the final version took life and breathed its remarkable fire. He never suggested incorporating any of his favourite suspense drama. I have always thought that this showed the real greatness of the man as a film-maker, that he could grasp and master a new method and bring it to perfection as I believe he did with this sequence.

Although it has been asserted that complete sequences from *Aran* never appeared in the final film, John Goldman denies that any such sequences ever existed. John Taylor, on the other hand, states that there was a "magnificent sequence of almost a reel of the beach at Middle Island (Inishmaan) with about 300 or 400 people, cattle, pigs, horses and a bull. The canoes were swimming the animals out to the *Dun Aengus*. The sea was rough and the horses and beasts kicked and plunged as they were dragged into the water. This sequence was dropped because Mrs. Flaherty thought it was too cruel."[45]

The majority of the leftover footage—some 193,000 feet—consisted of alternative shots, unusable takes, or shots that did not fit in with the sequences as finally edited.

Man of Aran, although a sound film, contains several subtitles. Their exact wording caused Flaherty endless worry. He would write, rewrite and rewrite them, and continually try them out on people. But although he spend hours and days settling their final wording, he believed their main value to be as pauses—as punctuation to the film. He and Goldman agreed on this point, but the inclusion of these titles was a matter of dispute with the distribution people at Gaumont-British. By 1934, subtitles were considered a thing of the past, and every effort was made to persuade Flaherty to take them out. But he doggedly refused. They stayed in.

At length, the picture part of the film was completed more or less to Flaherty's and Goldman's satisfaction. The immense footage had been reduced to some seven thousand feet. Now the sound track had to be compiled. Flaherty's previous films had, of course, been silent. No dialogue, sound, or music had been recorded on Aran. Portable tape recorders were not known then and it would have been crazily expensive even if practicable to have shipped a large sound-recording truck, such as was then in use for location work, across to Aran from London. Thus they had to construct a sound track of the film from scratch.

Two decisions were made. First, David Flaherty was sent to Aran to bring to London Pat Mullen, Tiger King, Maggie, young Mikeleen, Big Patcheen, Connelly, the crew of the curragh, and lesser members of the cast. Second, after a sound track had been built up from snatches of voices, sound effects, shouts, and so on, a music score would be specifically composed for the picture.

None of the islanders except Pat Mullen had been to London or England before. They stopped overnight in Dublin and arrived at Euston Station the next evening. They were met by Flaherty and his wife, Barbara Flaherty, John Goldman, and Hugh Findlay. The buffet at Euston was the scene of a Guinness party for the press, after which they all moved on to an Irish boardinghouse where they were going to stay. The singing and drinking continued far into the night. They were good "copy" because they had naturally traveled in the only clothes they had—Maggie in rough homespuns and shawl, the others in much the same clothes as they had worn in the film. They stayed in London for nine weeks and spent much of the time at the Islington Studios.

One night they were asked to see a reel of the film for the first time. When the lights in the projection room went down and the beam of the projector streamed out onto the screen, they all turned round to see where the beam of light came from. When they saw on the screen the curragh out in the stormy seas, it appeared magical but real to them. They shouted and gesticulated. "There they are! There they are!" Maggie moaned and cried, "Oh, they'll never come in!" And Pat Mullen's father called out in a frenzy to warn the men in the curragh on the screen that a big wave was coming in behind them. "There was pandemonium in that small room that night," says Goldman, "but that's how the idea of using their voices was born."[46] Subsequently snatches of speech, shouts, cries, and so on—some in Gaelic—were recorded. Especially remembered was Maggie's spontaneous breaking into a keening over the scenes of the wrecked curragh.

When Goldman had assembled the sound track, John Greenwood was commissioned to write the music. He was given three weeks to get his work ready for recording. After that the music and sound effects tracks were "mixed" and a few last-minute cuts were made.

Two visitors in London who were invited by Flaherty to see the film at

this penultimate stage were Lewis Milestone and Albert Lewin.[47] Flaherty had become well acquainted with Lewin at the time of the *White Shadows* fiasco. Both men were tremendously impressed with the film and warmly congratulated Flaherty. Goldman, who was present, remembers that in Flaherty's absence for a few moments, Milestone made a few suggestions about recutting. Goldman suggested that Milestone should tell Flaherty, but he got a strong rebuke. "That's something you just can't say to a guy at this moment in his picture!"

Man of Aran ran into trouble with the British Board of Film Censors, at that time a notoriously reactionary body. Brooke Wilkinson, then secretary of the board, informed John Goldman that "it is not the policy of the Board to let films show poverty on the screen."[48] The film, however, eventually obtained its certificate and had its full-dress premiere at the New Gallery Kinema, London, on April 25, 1934.[49] The band of the Irish Guards was on the stage to play a selection of Irish folk music. The audience was in full evening dress. Some of the islanders had been brought over again and appeared in their homespuns. They all had dinner at the Savoy. The film and its maker were given a stirring ovation.

The Gaumont-British publicity department had pulled out all the stops. Everything had been done to give the picture a big buildup. A basking shark had even been brought over from Dublin to be stuffed by a taxidermist firm in North London and placed in the display window of GB in Film House, Windsor Street. Flaherty flew into a royal rage when he learned that a section had had to be cut out from the middle of the creature in order to fit it in the window. Someone had slipped up on the measurements. (When the window was needed for another display, recalls Hugh Findlay, the shark was stored at a charge of £2.10 a week at the taxidermist's, but no department at GB would accept the continued responsibility for the charge, and it was eventually publicly presented by Anna Lee, a GB starlet, to the Brighton Aquarium, where it may still well be.)

Flaherty threw his flair for publicity and exploitation into the campaign. "He knew every trick—the journalists ate out of his hand—he understood completely what was good copy," says Goldman. Hugh Findlay and his assistant, Hugh Gray (later to become a close friend of the Flaherty family) worked as they had never worked before. The press was very well disposed to the film. But GB distributors had their misgivings. The film was certainly well set for its West End London prestige run, but as the film trade knew so well, the West End was not the country as a whole.

The GB Corporation was satisfied by the prestige gained at the New Gallery Kinema. It would gain more prestige from future international awards. But the Wardour Street salesmen saw *Aran* as a specialist film and therefore a menace to the organized distribution methods of the regular, routine run of pictures going out week after week to the cinema circuits and the independent cinemas.

The distribution and exhibition methods of the American and British film industries since the end of World War I had been developed on the lines of mass production and the mass sales of products geared to a public taste conditioned by national advertising. Cinemas changed their programs once or twice weekly on rigid clockwork schedules. Only exceptional, very costly, major films were afforded a different treatment; they were road-shown, a form of presentation that was a hangover from the legitimate theater. Thus an isolated, "unusual," or as we should say today "offbeat," modest film, no matter how good, threw the distribution machinery out of gear. It fitted into no accepted sales methods. It might draw a specialized audience for the one week it played, but what of the week after? It might even tend to disperse or alienate the regular, unquestioning, weekly audience who went to the pictures as a habit and who might not return for weeks. And above all, such a film demanded individual attention, and this meant extra expense.

When Flaherty saw that the distributors were prepared to let his film die a natural death on general release, after its London premiere run, he resorted once again to his *Moana* experiment. We say "natural" death because no mass audience, conditioned to going to the cinema as a habit, conditioned, moreover, by sensational advertising methods to pay to see much-publicized stars and spectacular "epics," was going to be pleased to see *Man of Aran* when it expected to see a run-of-the-mill program picture. As Flaherty and many others realized, the public *might* go if it was told *in advance* of spending its money at the cash desk that it was to be shown something *different*. Flaherty's idea for specialized distribution to selective audiences was sound economically, but it was alien to the cinema trade's conception and proven methods of selling mass entertainment, and it certainly was not attractive to an industry unsatisfied by anything less than 100 percent profit.

To be fair to Gaumont-British, the firm let Flaherty try his method, perhaps out of the devilry of being sure that he would fail. With Hugh Findlay and two of the cast, special presentations of *Man of Aran* were arranged at six British cities known for their undiscriminating audiences—Manchester, Birmingham, Wigan, Sheffield, Liverpool, and Leicester. Flaherty and John Goldman went, too.[50] Leaflets were printed and sent out to people on mailing lists, as had been done for *Moana*. Access was obtained to the lists of subscribers to the *Daily Telegraph*, the *Times*, *Punch*, and the *New Statesman*. Schoolchildren were specially invited to afternoon performances. Findlay promoted wide local publicity in the press. The *Sunday Referee*, owned by the Ostrer brothers, serialized an autobiography of Flaherty about the same time.[51] But this effort was all to no avail. Gaumont-British was not impressed. *Man of Aran* was only a nuisance to its well-established methods. Even if the film paid off, and this was the important point, it might seriously jeopardize the success of the more conventional

pictures the studio was making or renting from Hollywood. Might it not even attract to the cinemas an audience that would in future discriminate in its filmgoing, that might begin to ask why more such films were not made? To sum up, *Man of Aran* was distributed as "just another picture" like any from the mass assembly line of the studios. It was most often booked as a second feature.

Nevertheless, this film that cost about £25,000 to produce and advertise grossed £50,000 after six months' release in the United Kingdom and £80,000 after twelve months.[52] Flaherty, whose contract with Gaumont-British called for a share in the profits after a certain figure had been reached in the takings, never saw a penny from the film except for the salary of £40 a week while he was on the job.

An interesting sidelight on this matter was provided by two incidents. In September 1934, *Man of Aran* was presented at the second Venice Film Festival, not as the official British entry but by special invitation of the festival authorities. It was awarded the first prize as the best film of the year. The official British entries were *Blossom Time* by Paul Stein and Korda's *Private Life of Henry VIII*, neither of which received any recognition. The Gaumont-British representative at Venice, we are told, actually protested the award. On October 18 the film was presented at the Criterion Theatre, New York. Michael Balcon, Marc Ostrer, Flaherty, and some of the islanders went across. During this visit, the Venice award was received by Gaumont-British. The film was further honored as the best film of 1934 by the National Board of Review.

The day after the news of this second award was known in London, everyone still on the Gaumont-British payroll connected with *Man of Aran* was given notice, including Flaherty, Goldman, and his assistant. The following day, the *Sunday Referee* proudly listed the awards and prizes gained by the film. It also announced the news that the future production policy of the Gaumont-British Corporation would include more such films of real life! Flaherty was not asked to make one of them.

Of the visit to the United States Flaherty says:

When the ship entered the harbour in New York, the first people to come aboard were, of course, the reporters and photographers. Maggie, Mike and Tiger King were taken on up to the hurricane-deck to see the skyline. The ship was slowly passing the Empire State Building which rises some fifteen hundred feet above the streets. Now Tiger King was a man who always had a ready presence of mind and the reporter has yet to be born who could dislodge him. Incidentally, Tiger King did not like reporters any too well. One of the reporters pointed to the top of the Empire State and turned to Tiger, "What d'you think of that, Tiger?" he asks. Tiger looked at the reporter and looked at the top of the Empire State Building, looked back at the re-

porter and then looked higher into the sky where the sun was trying to burn its way through a cloud. Pointing up at it, Tiger King said to the reporter, "Well, and what d'you think of *that*?"

We were in New York some six weeks. Maggie, still in home-spuns, was wonderful. She sang folk-songs to students in Greenwich Village and to students at Princeton, too. Tiger dined with the Governor of Massachusetts and spoke at Harvard. And when Maggie went to Boston, she found a sister she hadn't seen for thirty years. . . .

Two other things I must mention about Aran and its people. They have a wonderful gift of language and narrative—a wonderful imagery in their language. One day there were white-caps on Galway Bay. Maggie and I were standing on the shore looking at them. She turned to me and said, "Look at them, sir. White flowers growing in the fairies' garden." And one day Pat Mullen was telling folk-tales to the children. He described the giants in his tale as, "They were so big that their beards bristled like a field of spears, and between their legs you could see the whole wide world." (Flaherty BBC Talks, October 1, 1949c)

A postscript to the making of *Man of Aran* from Norris Davidson: "The making of the film had a curious effect on the islanders, changing them for ever. The white woolen caps now sold as tourist souvenirs and even worn in the islands themselves, had not been seen for fifty years until Flaherty revived them. The Middle Island belt, the woven *crios* is now made in tourist form all over Ireland. The film brought a sudden prosperity to the Islands. It made the generation who took part in it very island-conscious and if they did hurl themselves into the tourist business with a dreadful zest, who can blame them?"[53]

Of those who took part, Patch Ruadh is dead. Maggie is still alive. Tiger King is working as a blacksmith in England. Mikeleen returned to the island and was later sent to school on the mainland. He ran away and came home and decided (or was persuaded) that he had a vocation for the priesthood. He went to a Passionist Novitiate but ran away from home again. Then he joined the army but deserted and joined the British army and later the Palestine police. He turned up in England again, married and with children.[54]

III: The critical storm that burst over *Man of Aran* was almost as rough as the seas round the islands. Flaherty was accused of escapism and falsification to the point where his whole philosophy of filmmaking was called into question. The issues, both for and against, are so important they must be dealt with at length.

The storm had been rumbling on the horizon ever since *Nanook*. As early as 1926, Iris Barry, in her book *Let's Go to the Pictures*, suggested that *Nanook* was not authentic. Barry, at that time film critic of the *Daily Mail*, had done secretarial work for the great expert on the Arctic, Vilhjalmur Stefansson, and she quoted him as saying, "It is a most inexact picture of Eskimo life" (Barry 1926:185).

In 1928 Stefansson, in his book *The Standardisation of Error*, elaborated on this inexactness, but in a curious manner. Referring to "parents who were greatly incensed at a movie called *Nanook of the North* which, although not true to the native life of the Eskimos, had been shown in their children's school and recommended as true," he claimed that the parents were wrong:

> To begin with, the *Nanook* story was at least as true as that of Santa Claus which those parents approved. It was the same sort of partial truthfulness, only greater. Real as well as Santa reindeer have horns, four legs and are driven before sleighs in harness, though not such sleighs quite, nor in such harness as the ordinary Christmas pictures show. . . . Thus the Santa story, while fiction in a way, does represent truths.
>
> Similarly, with the movie *Nanook*. There are Eskimos in Hudson Bay where the picture was taken, and the people you see on the screen are Eskimos, which is more realism right from the start than you have ever had in a Santa Claus picture. The country you see, too, is the real Hudson Bay. True enough, not even the coldest month up there averages as cold as *Nanook* tells you the whole year averages (35 degrees below zero) but then you must have something exceptional in a movie or it would not impress. You are told, too, that the Hudson Bay Eskimos still hunt with their primitive weapons, and this is justified. For it would spoil the unity of the picture to tell the truth about the weapons, though it is an interesting fact in itself that the fore-fathers of the Eskimos shown on the screen have had guns for generations, as the Hudson Bay Company has been trading in the Bay since 1670. Moreover, the titles do not actually say that the Bay Eskimos hunt with primitive weapons *only*, so you can take it any way you like. Doubtless the director meant nothing more than to say that the children (who are certainly Eskimo) still play at hunting (which would be hunting of a sort) with bows and arrows.
>
> No real Eskimos, in my belief, ever hunted seals through the ice in the manner shown in the picture, nor do I think that a seal could be killed by that method unless he were a defective. But it is true that certain Eskimos in other parts of the Arctic (about half of all there are) do know how seals can be killed through ice. That the Hudson Bay Eskimos with whom our director had to deal did not know such

methods was no fault of his, and he would have been deficient in re-
source if he had allowed that to stop him. Neither are there libraries
in Hudson Bay where he might have borrowed a book that described
the method so that he could have studied it up and taught it to the
local natives. There they were, the picture had to be taken, and audi-
ences in the South would demand to be shown what they had heard
of—Eskimos sealing through the ice. And so a method was developed
(perhaps by the Eskimos themselves along lines roughly indicated by
the director) which photographs beautifully and gives as much feel-
ing of enlightenment to an audience as if it showed the real technique
that does secure seals.

I have gone to *Nanook* many times for the purpose of observing
the audience. In several cases some movie fan has noticed that the
seal ostensibly speared in the picture is stiff and dead, clearly planted
there. But that, it seems to me, is all the realism you could expect in a
play. You would not demand that Fairbanks really kill all his adver-
saries, though you do appreciate seeing a bit of good swordsmanship.
And in *Nanook*, what seal but a dead one could possibly be expected
to allow himself to be speared in the manner shown?

Another thing I have overheard *Nanook* audiences complain
about is that they have heard somewhere that Eskimos' snowhouses
are warm and comfortable inside, while the *Nanook* picture shows
the occupants shivering as they strip for going to bed, and there are
clouds of steam puffing from their mouths and nostrils. These erudite
fans are still more troubled when they see the movie title which says
that the Eskimos must always keep their snowhouse interiors below
freezing to prevent them from melting, for they have read a book by
someone who has lived in a snowhouse and who has explained the
principles of physics by which, when the weather is cold enough out-
side, (and no weather was ever quite so cold as the *Nanook* country
was supposed to be), the snow does not melt though it is comfortably
warm inside—say, as warm as the average British or Continental
living-room in winter. But the answer is simple, and the director is
quite justified by it. An Eskimo snowhouse is too small for the inside
photography and the light might not be good enough. So to get the
best light and plenty of room for the cameraman, half the house was
cut away (like the "sets" you see in the movie studios) and the poor
Eskimos were disrobing and going to bed out-of-doors. But it would
have spoiled the picture to have introduced such technical details.
Hence the director had to explain the shivering people and their visi-
ble breathing by the harmless pretence that snowhouse interiors have
to be colder than freezing to prevent the roof and walls from thawing.[55]

And so on for the whole picture.

It was the very fact just stated and others like them which made

my friends angry. That may have been because the realities of the pic-
ture were not so charitably interpreted to them as we have done
above. It is possible to make the same facts look a good deal worse if
you try. (Stefansson 1928:86–92)

In 1947, when *Nanook* was reissued with a sound track, the question
was raised again. Under the heading "Is Nanook a Fake?" the late Campbell
Dixon, who had viewed the film a day or so before, wrote in the *Daily
Telegraph*:

> Is Flaherty's *Nanook* the classic documentary it has passed for
> this quarter of a century, or is it an elaborate fake, as Mr. Geoffrey
> D. M. Block, M.A., quoting Stefansson's *The Standardisation of Error*,
> invites me to believe? He writes: "To put it mildly, *Nanook* is a pho-
> ney. As Stefansson is a pretty well-known explorer, his view can be
> accepted as final. I can still remember with what delight I came across
> Stefansson's exposure of the imposter—I am prepared to accept your
> judgement of Flaherty's poetic vision—yes, he showed plenty of that
> —but 'integrity?' No, I am afraid I can no more swallow that than I
> could swallow the bucketsful of blubber that old fabricator Nanook
> allegedly gulped down for breakfast."
> Stefansson is an accepted authority; but his favourite line—The
> Friendly Arctic and so forth—is dismissed by many others as a Tech-
> nicolor dream, an expression of he-man rejoicing that he can flourish
> where weaklings go under—Mr. Block ridicules the shot showing
> Eskimos eating blubber. Dr. Stefansson flatly declares that no human-
> being can contain oil—this apropos of a shot of a child swallowing
> castor oil with relish. The film does not suggest that the child so tip-
> pled all day long. . . .
> *Nanook*, I would add, is not a White Paper. I dare say Flaherty
> took liberties with his material, arranging, foreshortening and colour-
> ing, as every artist must do. This, surely, hardly justifies a charge of
> wholesale faking against a man whose honesty in *Man of Aran* and
> other classics has never been seriously challenged, and who parted
> company on just such issues with his fellow-director of *White Shad-
> ows in the South Seas*. (Dixon 1947)

The first hint that Flaherty's conception of Samoan life as seen in
Moana was in part a reconstruction and in part true to life as he found it
in Savaii in 1923 was contained in a contemporary review by Robert Littell
in the *New Republic*: "The Heaven in the South Seas which the white man
thought he had discovered for himself is not for him at all. It might have
lasted for the native. In a very few corners some traces of it may still be
found. Whether Mr. Flaherty found one of these corners intact, or whether

he wedded traces of the real thing with his imagination of it does not matter. His reconstruction remains a living reconstruction" (Griffith 1953:72).

In his *New York Sun* piece, Grierson inserted his one reservation about *Moana*: "Lacking in the film was the pictorial transcriptions of the sex-life of these people. . . . Its absence mars its completeness" (1928). And in his *Cinema Quarterly* evaluation: "he built up in his camera what *he considered* the essential story of their lives" (1932) (italics added). Many years later, Grierson was to amplify this judgment: "I think it is true to say that Flaherty lived for two years in Samoa in genuine illusion that he was near to the earthly paradise; yet six months after he left, a commission from New Zealand was sent to clear up a situation on the islands that was, to say the least, not exactly salubrious" (1951c).

On the other hand, we must remember that Flaherty had definite intentions in *Moana*—to enshrine and preserve on the screen the last vestiges of a dying culture. As he said:

> The cooperation of the chiefs too was very important. At first they came to us in such costumes as the missionary and the trader had brought to the island. But when we told them that it was their old costumes and customs, *fa'a* Samoa, that we wanted to film, they were deeply moved. They began to tell us many things of the old days, things gone and almost forgotten. The reason for our coming to Savaii, this remote island, where but few white men had ever been, was because here some of the old Polynesian culture was still alive. In other Polynesian groups in the South Seas it had long since disappeared." (Flaherty 1950:25–26)

Frances Flaherty writes of the showing of the *Moana* rushes:

> And then we would project it on a screen set up under the cocoa-palms, with all the villagers making the film with us looking on, telling us what they thought, particularly the older chiefs who still remembered forgotten ways and could help us to recapture them and tell us if our film was true. . . . One of the old customs that has died out almost entirely is tattooing. In that idyllic country where Nature is kind and life is easy, there is no conflict, no suffering, no pain. Where there is no suffering, there is no strength. The people instinctively know this. They invent suffering—a painful ordeal. Tattooing—like hunting in *Nanook*—is the courage, the pride and dignity of the race which gives it grace to live. Naturally, it became the climax of our film.[56]

Mrs. Flaherty's writing elsewhere, however, indicates that the youth who played the part of Moana had some reservations about being tattooed for the film. "Would Ta'avale go through with it for us—for the film? If ever

there was a young god physically, it was Ta'avale. But Ta'avale was human, too, and he did dread the ordeal. Once started, he would have to go on with it—six weeks of torture and two weeks more of a crippled body! Many Samoan boys are not tattooed these days because the missionaries discourage tattooing. It was really hard for Ta'avale to decide. But at last the plunge was taken. He would follow the tradition of his race" (Griffith 1953:70).

Newton Rowe, who was present at the time, adds that when Flaherty decided that he had shot enough footage of the tattooing process, Ta'avale thought that he, too, had had enough and he did not go through with the remainder of the ordeal, preferring to remain in a state of half-tattoo. "For long afterwards it was a matter of common gossip on Savaii that his tattooing was only half-completed. There was something about him which made one regard him as a rather unsatisfactory character, which was typified by this. . . . In my opinion, however, *Moana* could not be regarded as 'faked.' Warfare had ceased and all were nominally Christians, but otherwise the culture was intact." Rowe does, nevertheless, contradict Mrs. Flaherty's statement that "one of the old customs that has died out almost entirely is tattooing." Rowe says, "It was very rarely that one saw a native man who was not tattooed, with the exception of the native missionaries. The white missionaries had done all that they could to stop the custom, without much success. In fact, it was so general that it was said that a native who had not 'got his pants tattooed on him' looked naked."[57]

Of the basic motives of *Moana*, Mrs. Flaherty writes:

We would present the drama of Samoan life as it unrolled itself naturally before us, as far as possible untouched by the hand of the trader, the missionary and the government. . . . Oh, the heart-rending difficulty of getting behind the past hundred years, behind the missionary, the trader and the government . . . even here in Safune—and seeing the Samoan as he really was! . . . The old primitive Polynesian life was changing so rapidly that already one had the sense of the end, of hurry to catch it as it went—as a matter of fact, we had come only just in time to see a fleeting ghost! (Griffith 1953:54–55)

Some aspects of Samoan social life did not, as Grierson pointed out, have a place in the film. Nor did the impact on Samoan life of the traders, the missionaries, and the government. But let us be clear about this. It was never Flaherty's intention that they should, as both he and his wife make abundantly plain in their subsequent writings.

The fact remains that although Flaherty was able to create a beautiful earthly paradise of Safune in the early 1920s, the maladministration of the New Zealand authorities on Savaii and Upolo, which climaxed in a main

street in Apia on December 28, 1929, was already well under way during the time that *Moana* was being made.

When *Man of Aran* appeared, attacks of varying degrees of intensity were launched on it from various quarters. In the *Observer* the noted film critic Caroline A. Lejeune wrote:

> *Man of Aran* is lovely to look at—sincere, virile and understanding. It has been made by a man who loves the place and the people, and his passion has been communicated in every shot. Everyone will go to see it—everyone should go to see it—for Flaherty has not his like in the film-making world. But it is not a great picture, in the sense that *Nanook* was great. It is superbly free of trivialities, but the struggle for existence, which is the basis of all Flaherty's films, is never made dramatically clear to an audience who are, after all, strangers to this sea folk, and unversed in the difference between the incidents and accidents of their lives. . . .
>
> *Man of Aran* has no story, not even the trace of a story that was to be found in *Moana* and *Tabu*. It barely recounts the movements of a nameless father, mother and son through their daily life of fishing, seaweed gathering, the planting of potatoes, the harpooning of sharks.
>
> It works up to a formal climax in the onset of a storm at sea, but that, one feels, is more to round off the film in proper shape than because the idea demands it. It is safe to surmise that Flaherty intended all these incidents to be illustrative of a central theme, but he is himself so familiar with the theme that he has come to believe that the bare statement of circumstances is enough to suggest it. When Flaherty sees a woman walking along the shore with a basket of seaweed on her back, it is for him exciting and dramatic, because he knows by experience the struggle for existence that the load represents. But when the audience see the same picture, they see only the woman and the seaweed. *Man of Aran* is a sealed document, the key to which is still in Flaherty's own mind. (Lejeune 1934)

This soberly expressed criticism brought a sharp reply:

> Sir,
>
> May I express my deep disappointment with Miss C. A. Lejeune's notice of the exceptionally significant picture, *Man of Aran*. . . . Miss Lejeune . . . misses the "soul" of the picture in her anxiety to describe how the picture is made and should be made. Yet the "soul" is there for anyone who wants to see it. The wonderful sociological, anthropological, biological, and ethical values are very plain indeed. There are the geographical conditions that produced Labour and the Labourer.

There are the conditions that produced the primitive hunter engaged in the great game of war on Nature. There are the conditions that produced the vital primitive types possessing the qualities of simplicity, endurance, loyalty and sacrifice. . . .

These types are the fine flowers of primitive life. And there are the conditions that produced a code of morals that ennoble and transform individuals and communities and do not degrade them, as the Hollywood code does. If there has been a better picture with a finer story of a little community fashioned and impassioned by constant and close contact with Nature, I have never seen it. . . .

<div align="right">

Faithfully yours,
Huntly Carter [58]

</div>

Lejeune promptly replied:

Mr. Huntly Carter puts my case exactly when he says "If there has been a better picture, with a finer story, of a little community . . . etc." Anyone who has talked for five minutes with Flaherty will appreciate that there is such a story on Aran, that none of us have ever seen it, and that, owing to the modern system of commercial film-making, few of us ever will. When I said that *Man of Aran* had no story, I was, perhaps unwisely, quoting Flaherty himself. The real story of Aran, as he sees and tells it, is the fight to hold the land against eviction—the women and children gathering on the cliffs, with their heaped stones and other missiles, the police rowing out through the storm in open boats, with orders to pull the roofs from the cottages and hew down the walls. This, and the story of the wind-jammers out in the big seas off Aran, where the Armada broke, is the picture that Flaherty wants to make. He calls the present picture "an idealised cross-section of life on the island," and says frankly that it is designed "to pique the curiosity of the audience and make them want to know more." [59]

In that sense, it is a kind of "trailer" to a bigger picture. I agree that *Man of Aran* is a brilliant, if overlong, essay. If Gaumont-British are enterprising enough to let Flaherty go back to Aran, and back to the extent of 40 or 50 thousand pounds to make the real epic of western Ireland, I shall have nothing but praise for the director's acumen and the producer's courage. But if *Man of Aran* is to be, as experience teaches us to expect, the final account of western Ireland so far as the screen is concerned, I shall continue to feel that seaweed is a poor substitute for story. (Lejeune 1934)

This item is, as far as we are aware, the only reference to Flaherty's desire to make another film about western Ireland, or of an admission that *Man of Aran* was an "idealised" conception.

Lejeune was not alone, however, in her comments. Charles Davy, another film critic, wrote:

> The programme says that a few cattle are kept in artificially grassed pounds surrounded by stone walls. The film omits this; it omits the potheen and the dancing; scarcely touches the indoor life of the cottages; does not tell us whether the children ever go to school or how the islanders communicate with the mainland. . . . In order to discover what life on the island is really like, we have to turn to the programme." (Davy 1934)

Our own reaction at the time was as follows:

> There are moments in the film when the instinctive caressing of the camera over the movements of a boy fishing or of men against the horizon brings a flutter to your senses; so beautiful in feeling and so perfect in realisation that their image is indelible. And again there are softer passages when you have to collect your thoughts and wonder if the sequence construction is built up quite so firmly as a documentary of any kind demands; and whether dawdling over a woman carrying wet seaweed across the shore, beautiful in itself to behold, does not tend to weaken the main shape of the picture. It might be that two minds have disagreed, each seeking the major issues of the theme and each finding a different answer. Either the dramatic grandeur of the sea or the thrill of the sharks must take precedence, but they disturbingly share the peak between them. So great is Flaherty's shooting of the sea . . . and so overwhelming the sweep of the Atlantic that the sharks, I feel, are commonplace. . . . Here is the living scene *as it appeared* to Flaherty, recreated in terms of the living cinema. . . . His approach is wholly impersonal. What really happens on Inishmore is not his or our concern in this conception. (Rotha 1934)

Each of these reviews touches on Flaherty's failure to come to grips with and to throw on the screen his central theme. But they do not imply that he distorted what he found. In Venice, the film was given a rapturous ovation. "It was the documentary film that carried the day at the Second Festival. By awarding the Grand Prix to Robert Flaherty's *Man of Aran*, the Venice Exhibition gave indisputable proof of its artistic character and the announcement of this award was received with delirious applause by the very numerous public crowding the hall of the Excelsior on the last evening of the Festival" (Paulon 1953:19).

In the United States, Richard Watts, Jr. gave the film as the best of the year in the *New York Herald-Tribune*, while in the *National Board of Review Magazine*, James Shelley Hamilton wrote:

Man of Aran comes closer than *Nanook* or *Moana* to the life we know or our forebears knew to our racial past. Flaherty tells no complicated story of this man; he simply—but with great eloquence—lets his camera show the daily routine of events of the man's life on one of the sea-stormed isles of Aran; and those events are a profound and stirring drama, a promethean struggle of puny man against a vast and cruel welter of nature's wildest forces. The epitome of this struggle is caught and fixed again and again in pictures of the woman and boy against bleak land, vast threatening rocks or cloud-tossed sky, or of the man's boat continually lost to sight among the heaving mountains of waves.

The whole effect is a heartening, thrilling effect of a unit of life—man, woman and child, the continuing link in the human race—winning survival in an unending war with the grim impersonality of the elements. It comes, probably, as near as one need wish for to pure cinema, a complete expression of its intention through the camera. . . . The film is a symphonic poem in pictures. As an instructive motion picture it is chary of giving information that might be interesting, what community life there is on the Aran Islands, what the boats are made of, how broken rock and seaweed help in the raising of potatoes. But the injection of such informative bits would interrupt the sweep of the picture-music, just as the few titles that are used interrupt it, in the fashion of pauses between the movements in an orchestral symphony. Actually they are no more needed than program notes when listening to Debussy's *La Mer*.

No actors, but natives of Aran live the lives that Flaherty's masterly camera has caught and preserved. They are so real in the everyday simplicity of their actions that small as they are against their stupendous background they let show through them a spirit that dominates even nature. Their labours, exciting a sympathetic straining in a watcher's muscles, are exhausting to look at, but ever and again, and especially at the end, comes a deep, rewarding sense of rest after work done, but deeper still an uplifting feeling of pride in one's race, that simple mankind can be so quietly and invincibly brave. (Hamilton 1937)

But fulsome appreciations of this sort were duly swamped by more ferocious attacks from the left wing. Ralph Bond, a British filmmaker and a Marxist, left Flaherty in no doubt as to his status vis-à-vis the Communist outlook:

Probably no Flaherty film has been so eagerly awaited. . . . There is no doubting Flaherty's genius for dramatising the conflict between man and nature. The storm scenes in the opening and closing se-

quences reveal Flaherty cutting at its best. But two storms and a shark-hunt do not make a picture and we are more concerned with what Flaherty has left out than with what he has put in. For here we come up against the element of escapism. *Man of Aran* is escapist in tendency, more so probably than any other previous Flaherty production. Flaherty would have us believe that there is no class-struggle on Aran, despite ample evidence to the contrary. There is a sequence in the film showing the islanders scraping for precious drops of soil in the rock crevices, but no mention, as Ivor Montagu said in the *Daily Worker*, of the absentee landlords who sent men to tear down their huts and scatter their soil, in default of payment for things they had made themselves.

If Flaherty lived on these islands for two years, he must have known these things. Why then, does he not tell us about them? Why does he merely present us with the spectacle of a handful of islanders (out of a population of 1200) waging incessant war against the fury of the sea? We must assume that he is a romantic idealist striving to escape the stern and brutal realities of life, seeking ever to discover some backwater of civilisation untouched by the problems and evils affecting the greater world outside. But his field is being narrowed down: the backwaters themselves reflect, on a smaller scale it is true, these very problems and evils. Nowhere in the world can we escape the realities of life—the struggle of man not only against nature but against land-sharks and capitalist exploitation, and the poverty and slavery that goes with it. Thus Flaherty's world is a world of dreams; it exists only in his imagination. Unfortunately, fairy tales, however beautiful and artistic, have nothing to do with documentary.

Flaherty has not only concealed the existence of the class-struggle on Aran. He (or Gaumont-British) has gone all out for box-office sensationalism.[60] We are led to believe that the men in the shark-hunt faced fearful dangers, whereas the sharks in these waters are comparatively harmless creatures.[61] A small boat rides through a sea so gigantic that no ordinary boat could live in it for five minutes.[62] And so on. Very little is seen of the life of the island itself and nothing of the island customs, traditions and ceremonies. It is one more example of the Barnum method of beating the drum furiously on the principle that the more noise you make the better the picture must be.

It is all rather tragic—for *Aran* had all the makings of a superb documentary film. But then perhaps Gaumont-British would not have been so interested. (Bond 1934:245–46)

We are surprised in the above review written from a Communist viewpoint that a major omission from Bond's list of Flaherty's failings is the avoidance of the religious beliefs of the Aran Islanders and the dominance of the Roman Catholic church on their outlook and way of life.

In the same issue of the journal in which this review appeared, H. Forsyth Hardy, in his introduction to "Films of the Quarter," wrote:

All that Flaherty has stood for in the cinema, all his fine achievement amidst an unfriendly film-world, led us to expect a restrained if romantic record of the life of a people, significantly selective in detail and appreciative of the nuance of common feeling. To a certain extent of course, the film successfully reflects the life of the islanders; any other result would surely be impossible after some two years of filming on the islands; but far too much of its length is *Man of Aran* concerned with sensational incidents which are unjustified when not set against a natural background to give them perspective. The Flaherty of *Nanook* and *Moana* is the last person from whom we expected box-office sensationalism. . . . If the real story of Aran is "the fight to hold the land against eviction" and "windjammers in the big seas off the islands, where the Armada broke," why did Flaherty spend so much time and energy in recording with painstaking elaboration two storms at sea and a tussle with a shark? . . . With infinite regret—for Flaherty represented the one hope of carrying documentary into the wider field of the picture-house—we must write off *Man of Aran* as a beautiful essay in box-office sensationalism with little more significance than if it had been produced from purely box-office motives. (Hardy 1934)

In an essay, "Subjects and Stories," Graham Greene was equally damning: "Photography by itself cannot make poetic cinema. By itself, it can only make arty cinema. *Man of Aran* was a glaring example of this; how affected and wearisome were those figures against the skyline, how meaningless that magnificent photography of storm after storm. *Man of Aran* did not even attempt to describe truthfully a way of life. The inhabitants had to be taught shark-hunting in order to supply Mr. Flaherty with a dramatic sequence" (Greene 1937c:61–62).

In 1935, Richard Griffith, who was later to become a fervent defender of Flaherty against these attacks, said:

Man of Aran finally arrived and was the most disappointing film I can remember. This is heresy, but my dislike was inescapable. All my criticisms of documentary apply here with double force. The characters were non-existent as personalities. One knew that they were human beings because of their form, but nothing more. There was nothing to distinguish them as Aranese, or as members of any nationality. That was what first amazed me. The second was the utter failure to dramatise the conflict between man and the sea. With all the marvelous material at hand, that conflict came through more because of the sub-titles than the cutting. I can find no explanation for it save

that Flaherty is so in love with primitive man merely because he *is* primitive that he feared to deflower the virgin freshness of Aran by intruding a civilised editorial point of view. But a film must take an attitude; otherwise it is a soulless record. And that is my final impression of *Man of Aran*.[63]

The Marxist attitude to the film already expressed by Bond, again found outlet in a piece written from Dublin by Brian O'Neill:

> Flaherty's *Man of Aran* is a Robinson Crusoe. He and his family stand alone on the island skyline. We gather that he has no relations with human kind even on the island. This is a travesty of reality. Inishmore itself has a population of some 2500 and possesses a public-house; there are over 3000 persons on three islands. A steamer calls regularly. The people have to buy things; they have to pay rates to the Galway local authorities for the upkeep of roads, the county mental asylum, etc. They have the *ceilidthe* (dances and sing-songs); they discuss politics and the world with degrees of sharpness; they go to mass, the priest takes his tithe from them and strives to keep their minds captive. But of all this, of the warm human relationships that are the outstanding feature of island life, there is not one hint in Flaherty's film. In short, he has portrayed not the real Man of Aran, but the Robinson Crusoe of his own creation, as much the product of the studio as if Tiger King lived normally in a palace on Beverly Hills. (O'Neill 1934:29–30)

But the longest and most damaging attack on Flaherty and all that he was supposed to represent came from David Schrire, a South African with political sympathies with the Trotskyists:

> Pictures by Flaherty *et hoc genus omne* have no real title to be styled "documentary." To do so is to water down the essential purpose of documentary, abort its functions and render impotent its *raison d'être*. The words "idyllic" or "evasive" as applied to that type of picture are preferable to the term "escapism." For "escapism" lays the emphasis on and evaluates the picture in subjective terms of the director's mind; and not as an objective sociological phenomenon.
>
> Idyllic documentary is documentary in decay, documentary with pernicious anaemia. It is the wax moth of true documentary. It changes the nature of documentary, gives it a new quality, a new form. It may be realistic, deal with actual people and things; but realism inheres not alone in the material used but in the material *plus* treatment. It is the purpose to which a film dealing with natural material is put that classifies it and not the material employed. . . .

Man's struggle with nature to wrest from her his means of subsistence has lost importance today. It is his struggle for the right to divert what he has produced to the interests of humanity that is the vital question. And it is there that documentary has its justification, in truthfully depicting modern economic relationships, in rendering audiences conscious of their interests, of the economic claims, aware of their remedy. That is the true sphere of documentary if it is to serve the most urgent purpose beyond itself. . . .

Flaherty reveals a joy, an unholy pleasure in his subject-matter; he revels in it. And its distinguishing quality is a deliberate turn to the fringe of civilization or to an anthropological present, a present for which the Industrial Revolution need never have taken place; and romanticism and "Lo, the Noble Savage!" pervades the whole, wraps it in the old miasmal mist of irrelevancy and distraction. In Flaherty's world of the cinema there are no such things as machinery and smoke-grimed factories, hotels and labour-camps, unemployment and hunger, tenement-houses and mansions. But the primitive Eskimos, bronzed Polynesians, virgin snows and coconut trees, surf and elemental storms are the normal material for his celluloid.

And it is not as if he is a sensitive soul who cannot bear to contemplate the misery and pain of our modern economic life; Flaherty is no emotional vegetarian. For he can face and shoot individual pain with an all too facile relish (*vide* the tattooing scenes in *Moana*). It is just that he is a throw-back, an artistic atavism to whose apologia "I like this idyllicism. It satisfies my artistic conscience," there is no reply. For "aesthetic" individualism cannot be overcome by rational argument. The only course to follow is to give the "artistic" product of such people the tribute of our condemnation.

Flaherty is an institution. He rushes to the bucolic present for material to fashion into his exquisitely finished product. Our economic system breeds such types as this by the score and their film prototypes are merely logical reflections of their role in every aspect of modern culture. (Schrire 1934)

A fast defense of Flaherty against this broadside came, surprisingly to some perhaps but characteristic to those who know him, from Flaherty's self-appointed "critical attorney." Grierson wrote:

Flaherty with his *Man of Aran* has caused almost as much division of critical opinion as *Thunder Over Mexico*.[64] David Schrire's article puts the principal objections: that Flaherty is a romantic escapist and that his film is only so much idyllic fudge. As I originally, I think, invented the word "escapism," and used it on Flaherty in the very early days of *Cinema Quarterly*, it may seem scurvy in me to double-

cross a supporter. But I do not agree with this estimate either of Flaherty or *Man of Aran*.

In the first place one may not—whatever one's difference in theory—be disrespectful of a great artist and a great teacher. Flaherty taught documentary to create a theme out of natural observation. He brought to it for the first time a colossal patience in the assembly of effects. And this was necessary before the discursive travelogue could become a dramatic—or dialectical—analysis of event.

It is of course reasonable for later generation of film-makers to want a documentary tougher, more complex, colder and more classical, than the romantic documentary of Flaherty. It is fitting that it should want a documentary in which both material and theme are found in our own social organization and not in literary idyll. But there are considerations one must watch carefully. The first one is that Flaherty was born an explorer, and that is where his talent is: to be accepted on its own ground. It would be foolish, as Professor Saintsbury once remarked, to complain of a pear that it lacks the virtue of a pomegranate.

I call it futile, too, to ask of Flaherty an article which cannot under commercial conditions be possible. Some of us can make do with a thousand pounds on a production, and we buy our independence accordingly. Flaherty's method involves the larger backing of the commercial cinema. He has of necessity to obey its rules. These rules are not always articulated but they are understood. Whatever Flaherty's *carte blanche* on the Aran Islands, the controlling factor, you may take it, was that he did not want to let his masters down. This factor was undoubtedly responsible for making his film more sensational and more spectacular at the expense of the elements—possibly deeper elements—which under other conditions he might have included.

But rather than complain of the result, I wonder that so much was done within commercial limitations. No English film has done so much. Not half-a-dozen commercial films in the year can compare with *Man of Aran* in simple feeling and splendid movement. I am all for congratulating Flaherty on pushing the commercial film brilliantly to its limit. I am all for commending his fortitude in yet another sickening encounter with commercialism.

It is good to remember when these arguments arise how—till the gold plaque came in from Venice—lacking in unanimity was the first enthusiasm. Even *Man of Aran* was too difficult and too highbrow for the trade generally, and might have fizzled indeed if Flaherty had not gone out himself with his collection of islanders to ballyhoo it into appreciation. It is plainly a difficult world to manage anything at all in, when the artist has to turn showman in self-defence.

Flaherty had not only to make the film but he had to sell it. War-

dour Street, which knows how to sell its own line of damarroids, had never the belief nor the salesmanship to sell anything different. Where, as in the case of France, the *Man of Aran* job was left to the usual commercial agents, the film was cut to a five-reeler and billed below the line as a subsidiary feature. As they congratulate themselves on their gold plaque, Gaumont-British should pause to consider this strange anomaly.

A last consideration, which Flaherty himself urges strongly. *Man of Aran* has been blamed for distorting the life of the islanders, for going back into time for its shark-hunting and its dangers, for telling a false story. But is it unreasonable for the artist to distill life over a period of time and deliver only the essence of it? Seen as the story of mankind over a period of a thousand years, the story of the Arans is very much this story of man against the sea and woman against the skyline. It is a simple story, but it is an essential story, for nothing emerges out of time except bravery. If I part company with Flaherty at that point, it is because I like my braveries to emerge otherwise than from the sea, and stand otherwise than against the sky. I imagine they shine as bravely in the pursuit of Irish landlords as in the pursuit of sharks.

In the commercial cinema, however, sharks are definitely preferable. You can stuff them and show them in a Wardour Street window. You can even cut them down, as Gaumont-British did, to fit the window. You cannot, unfortunately, do the same with Irish landlords. (Grierson 1934:12–17)

In spite of Grierson's statesmanlike defense of Flaherty, he had stated another point of view while Flaherty was still making his film on Aran, in a piece called "First Principles of Documentary":

With Flaherty it became an absolute principle that the story must be taken from the location, and that it should be (what he considers) the essential story of the location. His drama, therefore, is a drama of days and nights, of the round of the year's seasons, of the fundamental fights which give his people sustenance, or make their community life possible, or build up the dignity of the tribe.

Such an interpretation of subject-matter reflects, of course, Flaherty's particular philosophy of things. A succeeding documentary exponent is in no way obliged to chase off to the ends of the earth in search of old-time simplicity, and the ancient dignities of man against the sky. Indeed, if I may for the moment represent the opposition, I hope the Neo-Rousseauism implicit in Flaherty's work dies with his exceptional self. Theory of naturals apart, it represents an escapism, a wan and distant eye, which tends in lesser hands to sentimentalism.

However it be shot through with vigour of Lawrentian poetry, it must always fail to develop a form adequate to the more immediate material of the modern world. For it is not only the fool who has his eyes on the ends of the earth. It is sometimes the poet: sometimes even the great poet, as Cabell in his *Beyond Life* will brightly inform you. This, however, is the very poet who on every classic theory of society from Plato to Trotsky, should be removed bodily from the Republic. Loving every Time but his own, and every Life but his own, he avoids coming to grips with the creative job insofar as it concerns society. In the business of ordering most present chaos, he does not use his powers. . . .

I think we shall find that there are other forms of drama or, more accurately, other forms of film, than the one he (Flaherty) chooses; but it is important to make the primary distinction between a method which describes only the surface values of a subject, and the method which more explosively reveals the reality of it. You photograph natural life, but you also, by your juxtaposition of detail, create an interpretation of it. (Grierson 1932)

To some extent, *Man of Aran* was damned before it was ever made in the eyes of any documentary filmmaker who was also a social believer. But let us also note that Richard Griffith, who denounced *Man of Aran* in no slight terms in 1935, fully recanted his first judgment fourteen years later:

The adventures of Robert Flaherty in the thirties . . . much resemble his first battles with the film-world in the pioneering days of *Nanook* and *Moana*. But a new element in his personal struggle crept in when, after *Tabu*, the sphere of his operations was removed to Europe. From that time on he had to contend not only with commercial stupidity and cupidity, but also with the criticism and, I am afraid, the envy of some of his own disciples.[65] Not even Von Stroheim's career contains a greater irony.

When Flaherty arrived in England in 1931, he was welcomed by the newly-developed British documentary movement. Led by Grierson, these enthusiasts hailed him as the inventor and master of the technique of camera observation which they meant to make their own. They looked to his presence to give new impetus and inspiration to the development of documentary in Britain. That all was not perhaps well was indicated by the fate of the first attempt at a Flaherty-Grierson collaboration, *Industrial Britain*, which finally reached the screen as a co-operative work of several hands. When Flaherty ensconced himself on Aran for Gaumont-British, the islands became a Mecca; young men went there to watch and learn, to serve their apprenticeship.[66] But *Man of Aran* took, as usual, two years to make, and they were years of momentous transition for British documentary. Its

tyro directors had emerged from a period of absorption with techni-
cal problems, and were face to face with the problems of a world sunk
in depression and moving towards war. In that mood, Flaherty's pre-
occupation with the classic beauties and braveries of human existence
seemed to them irrelevant if not actually evasive or dishonest. React-
ing against aestheticism, they insisted that documentary must deal
with the actual problems of modern existence, or it was not docu-
mentary. Their point is, or was, at least arguable, if only because, at
that period, too many *soi-disant* documentaries were really aesthetes
in disguise, ready, willing and able to fall permanently into the rut of
lyrical impressionism.

But no considerations of group unity, social realism, or propa-
ganda for the great usefulness of documentary could explain or justify
the outburst of denigration which followed the appearance of *Man
of Aran* in Britain. It had its echo among even the more politically-
minded documentarians in the United States. The film made its way
through the cinemas and as usual, gained enthusiastic admirers from
among all kinds of people, but, judging from their published com-
ments, the documentarians were not among them. They denounced
the film as a vehicle of reaction. They seized upon the honours it won
from the Nazis and Fascists as proof that Flaherty's aim was the glorifi-
cation of the cult of the folk. They even minimised it as a work of art,
though none comparable with it emerged from anyone's camera any-
where in the world in the years of its making.[67]

I cite this not only to make this point that a film-maker who
strives to maintain his independence has no friends, but also as a
warning. Hindsight is easy, but it is necessary to suggest that the sub-
terranean snubbing or ostracism of Flaherty's films was a major error
for the documentary movement, the more so because it took place in
public.[68] Maybe Flaherty and his work have but little relation to the
informational and propagandist aims of the documentary movement
as they happen to be conceived by this or that exponent, at this or that
time. Nevertheless, the world public responds to the humanism of
Flaherty's films as they have to the work of no other documentary di-
rector. More sensible strategists would have made use of that appeal
as an advanced salesman for the whole documentary idea. Flaherty's
prestige and relative popularity have had just that effect. But it is an
effect he has had to get for himself, working for the most part against
the grain.

Be that as it may, after *Man of Aran*, Flaherty once more stood
alone, though in the midst of a flourishing movement based largely
on the method he founded. He is not one to show bitterness, nor to
act on it if he felt it, but to put it mildly, he was chilled by the profes-
sional reception of his film.[69] (Griffith 1949:520–22)

We should point out one important error in Griffith's passionate argument: he implies that at least in Britain all adverse criticism of *Man of Aran* came from the documentary filmmakers. In the reviews quoted here, neither David Schrire, Graham Greene, C. A. Lejeune, Charles Davy, Forsyth Hardy, nor Brian O'Neill were members of the British documentary group. The only hint of criticism from the senior documentary people was found in the *Sight and Sound* review (Summer 1934).

The reason why Flaherty did not include Bond's and O'Neill's absentee landlords was no doubt the same as why he avoided the trading conditions and the sex habits of the Eskimos, or the missionary-ridden, trader-exploited, and maladministered aspects of Samoan life. He knew about these things; he even talked about the true fact of Aran to Caroline Lejeune; but it was not in his conception or his intention to include them in his films. It is just possible that in his own, discarded conception of *Tabu*, which became suppressed by Murnau's dominance over the picture, he would have made a sociological counterpart to *Moana*, remembering his respect for O'Brien's revealing book about the Marquesas.

Criticism of Flaherty's falsification of material conditions as he found them on his chosen locations as distinct from the authenticity of his approach to his subjects was not ignored by him. His brother, David, records him as saying on more than one occasion, "Sometimes you have to lie to get over the truth."[70] In his "Profile," Robert Lewis Taylor quotes Flaherty: "'One often has to distort a thing in order to catch its true spirit,' he says, voicing one of his main tenets of artistic creation" (Taylor 1949).

It is relevant that in writing about restaging and reenactment in the famous film *Potemkin*, Eisenstein also defended such acts of contrivance, calling on Goethe for support: "For the sake of truthfulness one can afford to defy the truth" (Eisenstein 1959:23). It is the divergence in ways of defining and serving truthfulness that matters and that is where, of course, Flaherty and other great filmmakers part company with the world's commercial producers in Hollywood, Britain, and elsewhere. Of *Nanook*, Eisenstein said, "We Russians learned more from *Nanook* than from any other foreign film. We wore it out, studying it. That was in a way our beginning" (Evans 1943:4–7).

What probably shocked and perhaps angered some of the British documentary people (though at first they kept a discreet silence) was that though they had reverence for Flaherty in far-off places, it was tougher to stomach his man against the sky only a few hours from London. The point at the period—and perhaps only Grierson's critically astute but at the same time appraising eyes saw it—was that whereas documentary took several different forms, there was only one Flaherty.

Nevertheless, the critical reception of *Man of Aran* as a whole—and we repeat that the most aggressive public criticism did not come from the documentary people—led to one of those unhappy breaks between

Flaherty and his documentary friends in England. It was sparked off in all innocence by Alistair Cooke, while serving as the BBC film critic. One afternoon Mr. and Mrs. Flaherty were paying a friendly social visit to the General Post Office film unit's little studio at Blackheath in South London. Flaherty at once said that he was most anxious to listen to a radio talk by Alistair Cooke in which he knew mention would be made of his film. A radio was hastily rustled up, and they all sat down to listen. Unhappily, Cooke took a poor view of both *Man of Aran* and its maker, and what was worse, compared it unfavorably with the current work of Grierson's unit. Flaherty was furious. "Goddam it, John!" he cried, "You've fixed this!" He flatly refused to believe that Grierson had not deliberately inspired Cooke's comments. For two long years there was an unbroken silence from Flaherty although Grierson sent him messages of good intent by mutual friends and did his utmost to reestablish their long friendship, once described by him as "a dialectical pub-crawl across half the world."

In form, *Man of Aran* follows closely the formula of *Nanook* and *Moana*. It opens as they did by establishing the family. The boy, Mikeleen, is discovered searching in a rock pool. Maggie, his mother, is in their cottage at the cradle. The sea breaks in on the rocky shore. Maggie goes out onto the clifftop, is joined by Mikeleen, and they watch the curragh, with Tiger King and his crew, trying to make the run in to the shore. After a terrific struggle, the curragh is half-wrecked, but the men get ashore. They nearly lose their net, but Maggie saves it. Thus in the first sequence the ferocity of the sea and the islanders' fight against it is made clear.

A title tells us how the people are dependent on what potatoes they can grow and how they scrape together the soil and seaweed for the vegetable to grow in. Tiger is seen breaking up rocks, while Maggie gathers seaweed. Tiger then patches and caulks his battered curragh. Mikeleen is up on the clifftop fishing with a line which he holds between his toes. Suddenly he sees something down below and begins to scramble down the cliff. It turns out that he has spotted a basking shark. A title tells us about the sharks—that they are the biggest fish found in the Atlantic. Then follows the sequence of the men in their curraghs harpooning the sharks in a comparatively calm sea. At the same time, we see Maggie and Mikeleen in the cottage. Night falls.

The struggle with the sharks goes on for two days, a title informs us. The oil from their livers is wanted for the lamps in the houses. The men put to sea again, which is now rougher. Maggie and Mikeleen watch from the cliffs. Other islanders appear on the shore. A big caldron is rolled along the cliff. A peat fire is made beneath it. On shore a shark is cut up. Maggie stirs the caldron. Night falls again. The boy and the animals—a lamb and a setter—are asleep.

Next day Maggie is carrying a heavy load of seaweed on her back

along the cliffs. Mikeleen joins her on the rocky shore. A ferocious sea has arisen. They catch sight of the curragh fighting its way back through giant waves toward a landing. As in the opening, there is a tremendous battle between the men and the sea before they finally get to the shore. The curragh is lost, but Tiger saves his harpoon and lines. The film ends with the family—Tiger, Maggie, and Mikeleen—staring out at the wrath of the sea—their eternal enemy. That is all.

No critic would deny that the foremost quality of the film is in its sea scenes. As was written at the time, no film before had even captured the ferocity and danger of the sea so dramatically, so breathtakingly, as did *Man of Aran*. And no film has done so since. With many long-focus lens shots, sometimes panning sideways along the tops of the waves, sometimes following a giant wave from above as it breaks in on the shore, this was some of the finest shooting ever done by Flaherty. The sea and its fury, both in the opening and ending sequences, are in fact far more impressive and memorable than either the shark-harpooning sequence, which is tame and confused, or the struggle for soil to grow food. Other sequences are strongly reminiscent of the earlier films: Mikeleen fishing from the cliff-edge, Tiger mending his curragh, Maggie gathering seaweed. Photographically, the film is a triumph.

Technically, it has two major weaknesses. First, the editing is curiously disjointed, creating the effect that Goldman was trying to impose a style on the footage which was not shot with any style in mind. We know about the divergent views of Goldman and Flaherty, and this lack of agreement does, unhappily, show on the screen without either of them being to blame. Second, the recording of the snatches of speech and the general sound effects which was made at the Gainsborough Studios has the regrettable quality of indoor sound, which in fact it was. Everyone knows the big difference between the sound of speech spoken out-of-doors and the sound of it in a room. The shots of the islanders and the occasional few words from Maggie thus appear to have no connection with their place of utterance on the screen. This unfortunate effect gives the complete film a strange and off-putting artificiality and makes it seem just what its makers were trying so hard to avoid, a silent film with sound added as an afterthought. The technical level of the recording leaves a great deal to be desired; it was much inferior to most sound recorded at that period.

The music, too, does not rise to the challenge; it is pedestrian, uninspired, and undramatic. It appears and disappears in the sound track for no real reasons. Its alleged dependence on Irish folk tunes is without noticeable effect.

Flaherty's direction contains a defect more obvious than in his earlier films. The three people with whom the film is concerned have no character; they are flat and lifeless in a setting that has much strength and solidity. Awe-inspired as we are by their primitive fight against the sea, it is impos-

sible to feel with these people. They are remote from us. This is least true of Mikeleen, who like many children on the screen behaves without inhibitions or self-consciousness. But both Tiger King and Maggie appear posed and stiff and wooden unless they are engaged in vigorous action.

Man of Aran is not a subtle film in its simplicity, as we believe *Moana* was; it is in many ways a naive film and, excepting always the sea scenes, it is not a major Flaherty work. Those who sing its praises today, and there are many, are inclined, we suggest, to find qualities in it which they like to think are there but which it actually lacks.

What is difficult to understand is not Flaherty's avoidance of examples of capitalist economy or the class struggle but those ideas of Aran life which are movingly described by Synge's book, written twenty-six years before Flaherty went to Aran. Even then the basking sharks had not been there for over fifty years. If the men of Aran had forgotten how to harpoon sharks and had to be shown, they had not forgotten the life described by Synge. It is the stark tragedy of the islanders themselves which is pointedly missing from Flaherty's film. The sea in all its fury is there, but not the common human experience of the people.

Was it perhaps that in all his films up till now Flaherty refused to admit that unhappiness existed in the life he found around him? The keynote of the Eskimos in *Nanook* and the Samoans in *Moana* as Flaherty showed them was unbroken happiness. And even the Aran Islanders in their titanic struggle against the elements—natural, that is, not human—were not unhappy as Flaherty gave them to us. Did he not miss the whole inherent tragedy in their lives?

Some who worked with him, and thereby came close to him, suggested that Flaherty was inarticulate—that he could neither fully nor clearly express himself. And yet, as Grierson put it so well later, "It is curious to think now that while his films reflected all his innate grace and gentleness of taste, not one of them ever reflected his uproarious power of drinking joyfully into the night, or his quite *unusual command over narrative* on these more ebullient occasions" (italics added) (Grierson 1951b).

India and the Elephants

I : Flaherty liked London, and we liked having him. In the very first days, with the EMB unit, he often spent the early evenings with us in The Coronet in Soho Street. As all through his life, he was overgenerous in buying rounds of drinks, and he became friends, by no means solely for this reason, with everyone in the unit. English beer never attracted him; Scotch was almost always his call, although later there was a Bacardi rum period. From 1931 until he left for America in 1939, Flaherty made the Cafe Royal brasserie his spiritual home when he was between films. It became a haunt for him as had the Coffee House Club in New York.

In the years before the war it was the only place in London habitually used as a meeting place by people in the various arts, show business, and journalism, with the odd progressive politician thrown in. One recalls in the smoky haze the faces of such people as Augustus John, Jacob Epstein, James Agate, Tom Driberg, Graham Greene, Frank Horrabin, Raymond Postgate, Liam O'Flaherty, A. P. Herbert, Gerald Barry, Nora James, Richard Winnington, Nina Hamnett, and many others.

Flaherty had only to spot you through the smoke among the crowd and he would wave you across to his table. As the evening wore on, the circle round him grew wider. More chairs were dragged up. More drinks appeared. Flaherty loved an audience, especially one that would listen to his fabulous tales. His sparkling pale blue eyes, his square but beautiful hands, his wide shoulders and bulky body, his magnificent, massive head with its silky white fringe of hair, and his rather high-pitched, almost nervous laugh, his constant chain of cigarettes from a box of fifty which he always carried with him, his shapeless, soft felt hat which he crammed on

161

his head as he left—this was the physical image of Flaherty which one re-members vividly from that time.

Among those who were often around his table were Jacob Epstein, the sculptor; Hayter Preston, the journalist; John Dulanty, the Irish high com-missioner in London; Newton Rowe, who had, of course, known Bob since Samoan days; Vaughan Wilkins, writer on Victoriana; Cedric Belfrage, the film critic; Margery Lockett, the educational film expert; Jack Moeran, the musician; Peter Gorer, the pathology research worker; sometimes Grierson, Cavalcanti, and others of the documentary group, and the ubiq-uitous J. P. R. Golightly.

One night an intense argument sprang up between Flaherty and Ber-thold Viertel, a Gaumont-British director of such films as *Little Friend, The Passing of the Third-Floor Back*, and *Rhodes of Africa*. A charming, highly cultured man with a quiet manner, Viertel was a man of the theater work-ing in the cinema. Flaherty became infuriated by his dogmatic views on the precise use of the movie camera, where and how it should be placed to record to best advantage the acting taking place on the studio set. Neither gave in, Viertel, remaining calm, quiet, and mild-spoken, and Flaherty, be-coming enraged and spluttering to find the right words of attack. They parted still arguing. Closing time stopped the battle.[1]

One evening, Flaherty expostulated on the inanity of a new Zoltan Korda film, *The Drum*:

> The movie camera can show you one man. You can take it back and it shows you two men. You take it back further still and it shows you three men. You go on taking it back until it shows you ten men. But each time you take it back, the men may get more in number but they also get smaller in size and so lose their impact on you. The so-called crowd scenes in this film are plain stupid. You can't see what's hap-pening. The man who made it just doesn't understand how to use a movie-camera.

Flaherty's tales from the Arctic, the South Seas, and other places he had been have become legendary. He could tell a story that lasted a full half-hour and hold his listeners for every minute of it. Like most gifted tell-ers of tales, he needed a responsive audience. He intensely resented any interruption. He was impatient with anyone who argued with him and be-came irate if contradicted. It is said that only two people could ever get the better of Flaherty in a talking match: Oliver St. John Gogarty and John Grier-son. Grierson knew Flaherty's weaknesses better than most and could not resist the gentle art of goading, at which he is adept. Their verbal quarrels were fabulous.

The generosity of Flaherty is remembered by all who knew him. One typical example took place during the promotion of the Aran film. Tickets

for the Albert Hall to see the Peterson–Len Harvey fight were at a premium, recalls Hugh Findlay, when suddenly Bob revealed that he had bought a box at a ridiculous price, and he invited everyone to share it with him. There are dozens of such stories, and they must all be believed. No matter how low in funds, Flaherty always insisted on being the host.

Unhappily, after the mixed reception of *Man of Aran*, Flaherty no longer came to The Coronet. Flaherty never liked English pubs except when he was gathering material and meeting "interesting" members of the more primitive orders. He did not know the common people, and we suspect that he only wanted to know the uncommon ones. He was infinitely more at ease in the Cafe Royal or the Coffee House Club than in pubs, saloons, and bars.

When Flaherty returned to London from promoting *Man of Aran* in the United States late in 1934, he soon met Alexander Korda, whose star was ascending in the British film industry.[2] In 1935, Korda was gathering a galaxy of talents. He loved to have around him a group of illustrious names. He accumulated prestige as some men accumulate antiques. He also accumulated antiques. Robert J. Flaherty was not an antique, but he was pure, unadulterated prestige. Among the many "greats" who decorated the Korda studios in that year were Douglas Fairbanks, father and son, Elizabeth Bergner, Paul Czinner, Leslie Howard, Robert Donat, René Clair, Paul Robeson, Nina Mae McKinney, Jean Parker, Laurence Olivier, Harry Bauer, Raymond Massey, Anthony Asquith, Gigli, Georges Perinal, and others. Many more were to visit and work in the rose garden at Denham before the great crash came, bringing hard times not only to Korda's company but to the entire production side of the British film industry.

It is not recorded how Flaherty and Korda came to meet this time. They had met before in Hollywood. But now Flaherty had an agent, T. Hayes Hunter, of Film Rights Ltd. Before the first interview took place, Hayes Hunter impressed heavily on Flaherty that as soon as the subject of a contract or money came up, Flaherty must remain silent and let his agent handle the matter. Korda and Flaherty got along like brothers. Finally, with his inimitable charm and magnetic powers of persuasion, Korda purred, "Now we are both of us artists, Bob, we understand each other, so you can safely leave the contract side of our friendship in my hands." Engulfed by the Hungarian's charm, Flaherty hastily agreed, leaving Hunter speechless with a fait-accompli on his hands. As a result, the contract contained clauses that gave Korda overriding supervisory powers.[3]

Flaherty always had the enthusiasm and confidence of a child when he met a producer whom he believed understood him. Only later did he, to his cost, have his trust destroyed, and then his gorge would rise. A short time after he met Korda, he underwent a hernia operation. Visiting him in a private nursing home, one found him sitting up in bed with a pile of pillows behind his head, looking more massive than ever. All he could talk

about was the genius, the kindness, the artistic understanding of Korda, with occasional asides of vitriol for the Ostrer brothers and Michael Balcon of Gaumont-British. Four years earlier, his fulsome praise would have been for the latter. Now, after *Man of Aran*, he sometimes called them bastards and he did not care if the whole nursing home did hear it. Everyone ought to hear it. He could not understand why *we* had not cultivated Korda, whose integrity, he insisted, embraced the documentary conception.

When we told him we had patiently negotiated with Korda for two years without result, he brushed these remarks aside. At long last, he maintained, thumping the bed, after all his terrible experiences with Lasky and Fox and Thalberg in Hollywood and with those Ostrer brothers and that Woolf man in London, now he had found the producer who really believed in Robert Flaherty, and he had found him right under our own insensitive noses in England.

Mrs. Flaherty gives a different account of the coming together of Korda and Flaherty:

> Wherever we took our camera, from one primitive scene to another, we used the native people as our characters and took our material from the stuff of their lives. We found what good actors native children can be, and how appealing they unfailingly are to an audience. So we had this idea—why, if we wrote a film-story around extraordinary adventures that a native boy might have in his native environment, wouldn't it be possible to "star" that boy himself in the film?
>
> We set about to write a story. The first one we wrote was of a Spanish boy and it was based on an actual happening—the pardoning by public acclaim of a famous Spanish fighting bull in the bull-ring. Our story, following the adventures of the two together, developed the devotion of the boy for the bull up to his pride and agony in the final life-or-death scene. . . . But we were uncertain of the bull; we were uncertain whether we could show a bull on the screen and make him so convincing in his lovability as to be sufficiently appealing and sympathetic.[4] (F. Flaherty 1937:4)

Flaherty had stumbled on the bull story in Mexico City and had written it up at Santa Fe. He is alleged to have tried to sell it to Douglas Fairbanks and Korda in Hollywood after returning from Tahiti in 1930. It would seem, however, that the Flahertys had worked further on "Bonito, the Bull" in Berlin in 1931 and that the locale of the story had been shifted from Mexico to Spain. Mrs. Flaherty continues:

> With what animal, we asked ourselves, would it be easier to do this? Why, of course, with that great lumbering, antediluvian pet, that

greatest oddity and most peculiarly engaging of all God's creatures on earth—the elephant! Our story shifted instantly to India. What more intriguing than the adventures of a little Indian boy on a big Indian elephant in the jungles of India with all the jungle creatures? . . . This needed a producer, it must be admitted, of no little courage and enterprise. Fortunately there was such a one in London. There was Alexander Korda. Almost before we realized it, we found ourselves on his production schedule under the working title of *Elephant Boy*.

But, Mr. Korda now remembered, there was already a famous story of a boy and an elephant that almost everybody knew—Kipling's *Jungle Book* story of *Toomai of the Elephants*. Immediately the necessary arrangements were made between Mr. Korda and Mr. Kipling and the film rights to the character of Little Toomai and of Kala Nag and to the Kipling title were ours.[5] (F. Flaherty 1937:14–16)

David Cunnynghame (now Sir David), who was then a personal assistant to Korda, tells yet a third version. He recalls that Korda had been considering making *Toomai of the Elephants* as a film for sometime before this meeting with Flaherty and that if he had not been in England at that time, Korda would have brought Flaherty across from the United States to make the picture. He also confirms our belief that Korda and Flaherty had met in Hollywood in 1929.[6]

Flaherty and his eldest daughter, Barbara, set out for Bombay about the end of February 1935. Mrs. Flaherty was to follow six weeks later. David Flaherty and a production manager, Fred Elles, were already in Bombay. If this had been the complete unit, all might have come out well. But Flaherty had once again allied himself with the commercial side of filmmaking. No matter how deeply he believed in Korda's artistic integrity, Flaherty now found himself—for the first and last time in his career—the kingpin in a comparatively large-scale production. Before leaving England he was involved in long script conferences with Lajos Biro, the Hungarian writer and old friend of Korda's, who worked as a script editor for London Films. A professional cameraman, Osmond H. Borradaile, was assigned to shoot the picture; fortunately, he was sympathetic to the Flaherty method.[7]

From the outset, in the minds of Korda and London Films if not in that of Flaherty, *Elephant Boy* was conceived as a big picture. As time went on and production started, the unit in India was to swell at times to at least fifteen non-Indian persons plus local assistants and helpers. The reasons why so many people became involved over the next eighteen months are complicated.

First, there was Monta Bell, a Hollywood film director whose credits at that time included *The Worst Woman in Paris* and *West Point of the Air*. According to Cunnynghame, "Korda first sent Monta Bell to work with Flaherty in India because he thought that Flaherty needed help in view of

the very difficult conditions in which he was working in the jungle with elephants and a native boy."[8] Borradaile, however, recalls that Monta Bell had arrived in London and told Korda about a book recently published in New York called *Siamese White*, which was about elephants in general and a white ghost elephant in particular. Korda liked the idea of a ghost elephant and sent Bell to join Flaherty in India. "If it had not been such a tragic mistake," writes Borradaile,

> the whole affair would have been amusing, for Monta Bell didn't take to the jungle and wanted to return to the bright lights as soon as possible. But he didn't get away before Flaherty received and read a copy of *Siamese White*, which turned out to be a story of a man named White who lived in Siam—no white elephant, no ghost elephant. It was all a bit embarrassing because an elephant had actually been whitewashed to play the ghost. All the footage shot on this blunder—and a good chunk it was—went into the ash-can.[9]

At a later date, Korda sent his brother Zoltan out to India. At first, Zoltan did not wish to be associated with the project but was persuaded by Alex to assume the responsibility. Teddy Baird was also dispatched from Denham to be the production manager, and Bernard Browne was sent as a second-unit cameraman when Zoltan Korda began to direct sequences on his own. As time went on, a full arsenal of cameras, lighting equipment, an RCA sound truck, and laboratory apparatus accumulated.

Wide publicity heralded Flaherty's arrival in India. He dined with the viceroy, Lord Willingdon, was most cordial, and even perhaps jokingly asked if the viceroy could play the part of Petersen Sahib. Flaherty then went off to northern India to spy out the land. While he was there, he received a telegram from the prime minister to His Highness, the maharajah of Mysore, in southern India, some eight hundred miles from Bombay, suggesting that his terrain and his elephants, both tame and wild, were admirably suited to Flaherty's needs. David Flaherty and Fred Elles had already surveyed Mysore and recommended it. No doubt the maharajah and his dewan (prime minister), Sir Hirza Ismail, had a good sense of public relations and knew that to have the film made in Mysore would be profitable in more ways than one. His Highness owned a royal zoo and offered to place at Flaherty's disposal a large and historic unused palace in which to live. Flaherty settled for the maharajah's suggestion. All the newspapers in India carried stories that *Toomai of the Elephants* was going to be made in Mysore and that the producer was now looking for a suitable young boy to play the leading part. Letters applying for the job streamed in. David Flaherty went off to search in the elephant camps in Mysore and Malabar, Cochin. Meanwhile, the unit began to settle into the place after it had been rid of its cobras. It was named Chittaranjah Mahal, or Elephant House.

Flaherty, complete with *topi*, had appointed himself a bearer, Gul Khan, a much-traveled man. His last sahib had taken him round the world, including Mamaroneck, New York, which was familiar ground to Flaherty. Writes Mrs. Flaherty:

> We had to find one white character for our story, a white hunter of elephants, Petersen *Sahib*. There was no mistaking him when we found him, almost at once, in the person of an upstate coffee-planter, with a kind and competent, weather-bitten face, most photographable. He, Captain Fremlin, was actually a hunter—a *shikari* as they call them in India—and a very fine one, the best in Mysore; and a very fine shot. . . . Next we had to find our locations, i.e., to explore our surroundings for their picturable possibilities and decide where we were going to make our scenes. (F. Flaherty 1937:34)

Thus right from the start the prescribed Flaherty method of finding the theme and story out of the environment—as had been the absolute rule up till then—was discarded in this new picture. The group arrived in Mysore with the story ready-made, or so they thought.

The negative and the rushes were processed in a laboratory they established in the old servants' quarters at the palace. "It was a bold enterprise," says Borradaile,

> hoping to do all our processing in an old building without air-conditioning or filtered water supply, and with the exception of one man, a completely inexperienced staff. The one experienced technician soon found the task too much for him, however, and he returned to New York. Then we were fortunate to acquire an Indian, by name Sayne, who had worked in a European laboratory and he proved to be admirable. We had no developing machinery; all the film was developed in shallow tanks on 200 ft. racks, except for the sound track which was sent to Bombay for processing. Shooting tests for the labs., by the way, accounted for a big proportion of the negative exposed in India. (F. Flaherty 1937:34)

Mrs. Flaherty continues:

> There was to be no stint of people and everything possible to help us make the picture and make it quickly; which was all very good fun for our large Indian staff; for our confreres from London as well, who were enjoying the whole thing with us. I wish you could see us here; you who saw us in Aran! How you would open your eyes! [Mrs. Flaherty was writing to her two younger daughters who were at school in England.] It is so different that we hardly know what to do

about it—so many people about, doing for us all the things we have usually had to do ourselves—a fleet of cars flying here and there, a lorry as full of people as a Sunday School picnic plying daily from town (two miles) to our "bungalow"; thousands of cameras; thousands of racks bristling with tripods; a stills department with two assistants and I don't know how many still cameras; thousands of carpenters, electricians, tailors, bearers, coolies, sweepers, *mahouts*, animal-trainers, clerks, accountants, interpreters—you would think we were a b——y factory!

We've got a little elephant boy David picked up somewhere over in Malabar. He is the most endearing kid you ever saw. He is supposed to play around the yard, but no, he much prefers hanging around where Daddy [Flaherty] is and David, whom he adores, and with me. He is as bright as a dollar: learning something every minute. . . . We have three others besides, that we have gathered from here and there all over the country to try out for Toomai. They are all adorable youngsters but every one of them too thin. . . .

There is one boy among them whom Bordie (Mr. Borradaile, our chief cameraman) brought in the other day; found him at the elephant stables. He is different from the other sprightly little sprouts. He is rather pathetic, more reserved, an orphan. His mother's family came from Assam, where the people are part Mongolian. His name is Sabu. (F. Flaherty 1937:46)

The unit went out on an elephant hunt to one of the maharajah's hunting preserves at Karapur, to stay in a luxuriously appointed hunting lodge and guesthouse.

Sabu had to come with us, a little *mahout* boy we picked up at the Maharajah's elephant stables, who has been gradually eclipsing the three other boys for the part of Toomai. Arrived at camp, he set at once to work, helping David with the lamps, helping the bearers with the beds, turning the sheets neatly and smoothing them, so busy and happy showing us what he could do. . . .

And when we fussed with him over his costume, pulled him and poked him, tucked up his *dhoti* and wound and rewound his *puggeree* (making him look worse and worse), he took charge of the matter himself and told *us* what *he* wanted. He came out finally before the camera and all of us, as we stood around staring, perfectly businesslike, self-contained, serious, not a child at all. Perhaps it is because he is an orphan. . . .

If we could only operate the cameras from elephants' backs in the jungle! We have to get the wild elephants moving through the forest. Our script demands also that we get two tuskers fighting. The fight

can be staged in the mating-season, says our Jemadar. Wild tuskers will be decoyed into an area trenched around by a four-foot trench, an insuperable obstacle to an elephant because he cannot span it and cannot jump. The decoys will be tame cows, and that the fight will ensue is, according to everyone, a foregone conclusion. If the tuskers are evenly matched it will be a great show. Prince Jaya has already spoken for a front seat! . . .

One more day in camp to see the elephants swim the river and to talk with Jemadar, the chief of the *mahouts* of the Kakankote camp and the best trainer of elephants in the country. . . .

Sabu, transfigured, was in his element, thoroughly at home, ordering the elephants about, mounting them, riding them, sitting there as on a throne from which he looked down upon us common mortals. It is here, by the way, near Kakankote, that he was born. His mother died when he was a baby. His father taught his elephant to rock the baby's cradle—to rock the baby himself in his trunk. It is even said that a wild elephant came out of the forest and played with the child!

Sabu waved. There was no longer any doubt who was to be our elephant boy! (F. Flaherty 1937:58–61)

Flaherty built a special relationship between the boy and himself. He must have sole control over Sabu if he was to get out of him the performance he needed for the film. When making *Moana*, he had cultivated the idea that the islanders on Savaii should regard him as the Big White Chief. Only if they revered him and respected him could he get them to do what he wanted. In Mysore, Flaherty liked to make Sabu think of him as God. He allowed no one else in the unit to show him affection. The same had happened with Mikeleen on Aran and was to happen with Napoleon in Louisiana. Yet it is curious that Flaherty never was the one who discovered these children.

"I sometimes have an uncanny feeling about Sabu," continues Mrs. Flaherty.

This is the boy we *imagined* way back in '29 when we were writing the story in Germany.[10] We wrote down in so many words; "He is a little orphan boy and hanger-on of the Maharajah's stables." And then we wrote: "His father died, and the beloved elephant who had been in the family since his grandfather's time, went mad with grief and broke his chains and went off into the jungle."

And now here is Sabu in the flesh, a little orphan Indian boy, ward of His Highness's stables. And they have been telling us the story, how when his father died his elephant grieved so much that no one could do anything with him and there was nothing to do but take him into the jungle where he ran away—our imagined story and Sabu's

true story almost identical. It was as we were writing our story that all this happened to Sabu, six years ago. (F. Flaherty 1937:75)

A. K. Sett, honorary personal assistant to Sir Hirza Ismail, the prime minister of Mysore, in June 1935, remembers his first visit to Mysore conducting a distinguished guest, Sir Mohomed Zafrulla Khan, a member of the viceroy's council. He writes of his meeting with Flaherty:

> Accompanied by the Prime Minister and many officials and reporters, we arrived at the old and rambling palace of ample proportions with large garden. Mr. Flaherty was at the door to greet Sir Zafrulla and Sir Hirza. His wife, slim and gray-haired, dressed in a sweater and skirt, her head protected against the southern sun by a *topi*, assisted by others, was shooting a picture of our visit to their studio. Sir Zafrulla and Sir Hirza spent a lot of time in the studio with Mr. Flaherty's unit, inspecting the various cameras and their gadgets, costumes, the make-up department, the recording-machines and a hundred and one things that go to the making of a single full-length movie. . . .
>
> My most treasured memory of this day is of Sabu. He was introduced to the distinguished guests in a typical American manner. He was not ushered in and made to shake hands but he made his appearance slowly, astride an elephant [11] and there he stood in the middle of the large compound for all the world to see him. He was about seven, or maybe a little older. Very thin and naked save for a small *lungi* wound round his legs and his head tightly covered with a white turban in the typical southern way. . . . The manner in which he handled the ponderous, lumbering elephant was enough to stir one's confidence and trust in him. [12]

In October 1935, with five months gone and little shooting achieved (largely owing to bad weather), the monsoon broke and Flaherty started filming in earnest. The unit moved to its chosen village of Melkote, but on the way an alarming incident took place.

> Elephants, cars, trucks, cameras and crowds of villagers with their carts and bullocks and flocks are all bunched together when Irawatha suddenly took a dislike to the tusker next to him, let out a roar and gave him an awful push and dig with his tusks. The poor tusker squealed and gave a great bound. His *mahout* came tumbling off and rolled in the dust. . . . Little Sabu, perched all alone on Irawatha, was whacking away at his head with the goad. . . . The poor tusker, down behind and up at the head, had his tusks jammed in the thatch-roofing

of a house so that he couldn't move. Irawatha would have finished him, but just then the Jemadar stepped in, suddenly appearing between them. Facing Irawatha, he put a hand on each great tusk. It was an astonishing sight—Irawatha mad, with already a taste of blood . . . and the Jemadar, with nothing but a little stick in his hand . . . pushing Irawatha back. (F. Flaherty 1937:76–77)

The elephant had to be chained after this, and when Sabu had to ride him alone for the film, a *mahout* was hidden under the pack-cloth. It soon turned out that Irawatha was *musth* (crazy), and a substitute elephant had to be found. Irawatha's condition was, however, turned to good purpose, as Mrs. Flaherty records: "We took pictures of the poor creature in his painful, uneasy state, and it made him look just as we want him to look in the story when he is 'grieving his master'" (F. Flaherty 1937:81).

In November, after further delays caused by the little monsoon, but with the opening sequence shot, the unit moved to the jungle where they were to remain for several months. The location was Karapur, with a bungalow lent by the maharajah, and surrounded by a large camp. They soon had the good fortune to capture a wild tusker—"an extraordinary film property," as Mrs. Flaherty remarks. The script called for a scene in which Kala Nag runs amok and smashes everything, but Flaherty was doubtful how to achieve this. For "elephants are so incredibly slow and deliberate in their movements—so willing and intelligent but so—deliberate—for filming in action he is the most peculiarly awkward material." So they built a camp of bamboo huts for the tusker to break up.

> It was exciting. He was tethered by ropes from both hind-legs to a tree and the ropes were about sixty feet long so that he had a good range. The question, of course, was whether or not the ropes would hold him. The cameras . . . were all fixed in a row on top of a high platform, which would come down like so much matchwood if the tusker ever got at it. . . . Well, it didn't happen that way. The ropes held, and it was rather a pathetic scene. After plenty of smashing we called it off, for fear the poor tusker, straining and straining at his ropes would do himself in. He had taken one crashing fall. (F. Flaherty 1937:92–93)

Now came the major problem of the production—to film a genuine herd of wild elephants. There were plenty of herds about, one of them reported to be of extraordinary size. The forests in which these herds wandered had in the past been the scene of many elephant drives or *keddahs*, and Flaherty decided that only by staging a special *keddah* could he get the scenes he wanted.

> We decided to have . . . a real *keddah* in the traditional style; to
> call all the villagers from miles around to make a small army (11,000
> actually) of beaters, to pair these with jungle men, and to call out
> the forest officers to captain this army: to build the stockade and
> runways—an engineering feat of timber (10,000 pieces) and rope
> (9 tons); of digging, chopping, hauling—with hundreds of carts and
> all the work-elephants engaged. It sounded like a tremendous under-
> taking for just a film. (F. Flaherty 1937:104)

The *keddah* consisted of a funnel-shaped stockade some six hundred
feet long leading to an inner stockade seventy-five feet in diameter. Each
stockade had a gate made to "swing like a trap and crash down by cutting
rope." Theoretically, the operation of the preliminary *keddah* was simple.
The beaters were to drive the herd across the river past the cameras, then
in due course drive them back across the water and into the stockade.

The first attempt was a failure probably because the herd was averse
to crossing the main road, which was between them and the river. Flaherty
decided to drive them across an open jungle glade, and the camera em-
placements were reerected on this new location. But darkness fell before
the cameras had turned a foot of film. Nevertheless, the herd had now been
got into a strategic position for the actual drive, which finally took place on
January 4, 1936. What happened is best described by Mrs. Flaherty:

> From 2 P.M. our orders were to be in our *machans* (camera plat-
> forms erected in the trees), absolute silence, no smoking. . . . Our
> *Machan* was crawling with red ants, stinging beasts, almost as bad as
> bees, and was exposed to the sun without shade of a branch or twig
> . . . we could hear them coming . . . shouting, clapping, shots . . . vol-
> leys of shots and the clear, high, exciting "wind" of the bugle . . . stac-
> cato explosions of shots. It sounded like a battle. It came directly at us
> with a rush.
>
> Our big lenses were pointed, like machine-guns, at the shore,
> raking it up and down, not to miss the first rush breaking cover. Then
> bang, bang! There they came. But only for a moment, half a moment.
> They turned downstream *out of sight, out of sight* they crossed the
> river below us, and before we could even change our lenses . . . there
> they came pounding along directly under our *machan*, a bellowing,
> lurching sea of rushing backs, pouring into the stockade. (F. Flaherty
> 1937:125–26)

Nevertheless, eighty wild elephants were captured, and in the end all
the required material was filmed. But the result was a radical change in the
story line of the script.

When we saw our rushes a miracle appeared on the screen—no semblance of a drive but instead these most extraordinary creatures, as if in the heart of their mysterious jungle, "going places". Where were they going? Why, to the Elephant Dance, of course, just as it is in Kipling's story. So we remove our story all around this elephant dance. All we need to complete the illusion is their feet in action. All our camp of 25 tame elephants has gone into training like a ballet chorus—to learn to dance. Isn't it a quaint life?[13] (F. Flaherty 1937:136)

Before we leave the Indian location, some reminiscences by Osmond Borradaile, the cameraman who photographed the film at Flaherty's direction, round out the account:

Flaherty's character was both an asset and a detriment to his film-making. His love for people regardless of color or creed, and his consideration for their shyness and feelings, made him easily acceptable to all people—even the primitive, shy people of the Mysore jungle soon knew he was not to be suspected or feared. But his generosity and respect for the feelings of others allowed people to take advantage of him, and often he was a victim of people of various standards of life who imposed on his kindly feelings.

His love of freedom and his dislike for any form of restrictions regarding film-making made it very difficult for him to follow a written script or even a continuity of sequences. His great enthusiasm and energy made him restless and eager to start new sequences before he had finished the one he was engaged in at the time. His quick eyes would pick up little details which he immediately realized would bring interest and charm to the screen if properly filmed—such as the huge elephant straining while being goaded by the little Toomai to pick up the heavy teak-log, or the gentle searching by the tip of the elephant's trunk as it feels for the sleeping boy buried in the pile of leaves just in front of the feet of the great beast.

Flaherty was courageous and willing to take risks himself, but he loathed to see others subjected to the risk. He nearly went frantic watching Sabu riding his swimming elephant across a flood-swollen river. Although assured by the Jemadar and *mahouts* that there was no danger, he could not bear to watch the scene where a baby crawls out on to the roadway before a train of advancing elephants.[14]

This incident is also referred to in a letter Flaherty wrote to Korda:

Dear Mr. Korda,
Since cabling you last Sunday we have been shooting continu-

ously with perfect weather and good results. The monsoon has at last passed away, and I expect no hold-up from weather from now on.

Mr. Biro ever since we first started the story has been nursing a pet scene which I was rather reluctant to undertake. The scene in question is one in which, while Little Toomai is proceeding through a crowded street on his elephant, the elephant inadvertently walks over a baby. We tackled the scene last week. Having secured the mother's consent, we placed the baby in the street and called on Sabu and his elephant. There were hundreds of people about, all intensely curious. We started our cameras. Irawatha, looking like a walking mountain, approached. The tip of his trunk went down and momentarily sniffed at the baby. Then on he came. Each of his ponderous feet were thicker than the baby was long. Slowly he lifted them over, the baby looking up at him, too young to understand, of course. Then the elephant's hind feet came on. The first one he lifted over slowly and carefully; but the second foot came down on the baby's ankles.

I never heard such a yell in my life as that which came up from the hundreds of staring native onlookers. Someone swept up the baby, while our camera-crew made a circle round it to keep the crowd back, jammed it with its mother into a motor-car and raced off to the hospital. I thought there would be a riot, but fortunately nothing happened; and before we had the cameras struck, the car came racing back from the hospital. The baby was smiling and the mother was smiling.

When we ran the picture that night, we could see that the elephant, as soon as he had felt the touch of the child's feet, had thrown all his weight on the outer rim of his foot. He is truly a marvellous elephant. He picks up our Sabu by his ankle, holds him up in the air, and walks around with him. He picks him up in his trunk and does what we were repeatedly told would be impossible—lands him up on his head, on his back, or wherever the boy tells him to.

(Please do not mention this incident of the baby to the press. I have already been accused of trying to drown a boatload of wild Irishmen on Aran!)

Everyone is happy here. There has been no sickness at any moment, and I believe that every last man is in high spirits over the film.
. . .

<div style="text-align:center">

Yours sincerely,
Robert Flaherty. (Griffith 1953 : 121–22)

</div>

Borradaile also notes that although Flaherty had a Newman-Sinclair camera in India, he rarely used it during the production. Borradaile used a Vinten camera, which he operated himself. The only footage shot by Flaherty that appeared in the final film was the mother-and-baby-elephant

bathing sequence. "He frequently tried to use long-focus lenses but his panning with them was too jumpy to be used. I had complete freedom in the handling of the cameras. . . . We had a number of Indians in the crew— assistant-cameramen, grips, props, and, of course, the first-class lab technician. I often look back on this Indian crew as one of the best I've ever worked with anywhere."

Borradaile described the final day of production:

> The scene I shall always remember of Flaherty was when we were leaving our jungle camp for the last time and driving to Mysore City, a 40-mile drive we had got to know and love very much. Just the two of us were in the car. . . . Bob was quieter than usual and I looked sideways to see him wiping tears from his cheeks. I stopped the car and asked him if he was all right? He wiped more tears away and said, "Oh, hell, Bordie, it's just because we are leaving all this beautiful country and I never expect to see it again."[15]

Exactly when Alexander Korda took advantage of the supervisory powers included in his contract with Flaherty is not clear. After Flaherty had left for India, Korda stated: "For nine months I heard absolutely nothing. Of course, I heard from the business-manager . . . and money had to be sent to India, but still we had optimism but . . . you know, when you spend money for eight, nine months and no film comes back, you start to get worried."[16]

A no doubt apochryphal story says that Korda sent Flaherty a cable asking what was happening, and Flaherty replied: "Tests going well." Paul Tabori writes: "The original budget [of *Elephant Boy*] was £30,000, but when the cost reached £90,000 Alex became somewhat alarmed and sent his brother Zoltan to India. . . . The many months had produced only 2,500 ft. of film and another 7,000 were needed"[17] (Tabori 1959:193–94). Production manager Teddy Baird recalls that when he was sent to India in the spring of 1936, about twelve months after Flaherty had arrived there, Zoltan Korda was already with the unit.[18] Whether he had been appointed as co-director is obscure, but doubtless it was he, on his brother's behalf (and possibly that of Monta Bell), who called for the story changes Mrs. Flaherty mentions in her book. David Flaherty recalls that Zoltan Korda appeared to have been sent out to supervise Monta Bell, who was already the supervisor, and that Zoltan's ideas about the story differed from Bell's, and both differed from Flaherty's. "In the final weeks," adds David, "three separate units were frantically shooting three different stories!"[19]

By June 1936 all filming was completed, and some three hundred thousand feet had been shot, Flaherty's record total. Many synchronized sound and dialogue scenes had been recorded, none of which was ever

used except for some of the background sound effects. The unit sailed for England, leaving Baird to conduct a two-day sale of all the impedimenta collected during the fifteen months of production. At the last moment Flaherty was anxious to ship an elephant back to England with him (reminiscent of the mutilated basking shark in GB's window!), but this idea offended even Korda's sense of publicity.

While Flaherty had been away, however, the red light had begun to flash over the Korda kingdom at Denham. Prestige was no longer of such immediate necessity as quick cash returns from a world market. Korda and his associates scrutinized Flaherty's Indian material to see how it could be made into a picture quickly. John Collier, a young novelist who had as yet worked on only one film for Korda, was called in. He writes,

> Korda, as producer, had not thought it necessary to furnish Flaherty with a script, nor had Bob, as director, felt impelled to insist on having one.[20] He had shot some marvellous backgrounds. We ran some 17,000 ft. of them and, of course, the absence of a story was noticeable. It was suggested that a very simple story should be devised, such as could be shot (in the studio and on the lot) in about 5,000 ft. of screen-time and that this should be grafted into an equal amount of Bob's material. Korda declared that this involved 29 impossibilities; however, it was done.[21]

Some studio sequences were directed by Zoltan Korda; a professional actor, Walter Hudd, was cast as Petersen Sahib in place of Captain Fremlin (greatly distressing Flaherty); some elephants were hired from Whipsnade Zoo; model shots were put in hand for the "elephant dance"; a studio editor, Charles Crighton (later a director at Ealing Studios and elsewhere) took over the gigantic task of editing the Indian material; and London's East End cafes were scoured for black men of any nationality to play in the scenes staged on misty, cold autumn nights by the banks of the River Colne. Sabu was taken in hand to perfect his English. "The studio went wild about him," writes Mrs. Flaherty, "His acting amazed them; they called him a genius. They insured his life for £50,000 and set their best writers to work writing for him the story of another film"[22] (F. Flaherty 1937:138)

We should have thought that Flaherty would have kept well away from all this stupidity, but on the contrary he was much present. Tabori writes,

> The actors had to spend nights and nights in Denham Woods, complete with elephants and distracted assistant-directors. Poor Sabu, in a loin-cloth, almost froze in the October cold and had to warm himself between takes at a roaring fire. Allan Jeayes, the veteran actor who appeared in more Korda pictures than almost anybody else (because Alex "liked his mug") recalled how Korda used to come down in the

early hours, complete with walking-stick, to encourage his brother. But even the Korda charm could not extract the wayward elephant that got stuck in the river. Robert Flaherty was a great help to all at 4 A.M., with a bottle of whisky in his pocket—and Alex smiled as usual. (Tabori 1959:194)

Elephant Boy was Flaherty's last association with commercial film production except for a brief flirtation with Cinerama just before he died.

The story of *Elephant Boy* requires no space because the film had no theme. Sabu as Toomai introduces the picture in the studio with an apologia for what is to come. Then we go to India, where Toomai is set up on Kala Nag, the tallest elephant of all Mysore. The monkeys are chattering in the trees. The incident of the elephant stepping over the baby in the street, the sequence of elephants washing in the river, and some monologues between Toomai and Kala Nag follow. Petersen Sahib is then seen recruiting elephants for the hunt, and little Toomai steals the occasion when Kala Nag sweeps him up onto his back. Toomai then prays to the gigantic Jain statue. A title introduces us to the jungle. A great herd of elephants is expected. A stockade is built to trap them, during which Kala Nag with Toomai displays his skill at timber lifting. After several more titles, a tiger kills Toomai's father, and Toomai is sent home by the great white hunter, Petersen Sahib. Kala Nag's new *mahout* brutally ill-treats the beast, which runs amok. Toomai returns to quiet Kala Nag before Petersen Sahib can shoot it. The *mahout*, whose leg has been broken by the mad elephant, demands its death. Toomai then slips away with Kala Nag at night into the jungle. The boy falls asleep, and the elephant steals off. Toomai wakes, searches for the beast, and stumbles on the secret dance of the elephants.

In the early morning, the boy and the elephant wake up by the river. A great drive by the hunters begins, and the herd of wild elephants is driven in a trumpeting stampede into the stockade. Everyone, even the great Petersen Sahib, proclaims Toomai a great hunter. The film ends happily.

The viewer is tempted to pick out which scenes are by Flaherty and which by Zoltan Korda. Doing so is easy. First, the studio scenes shot at Denham are obvious for their gaucherie. These include all the ingenuous dialogue sequences, the white hunter interludes, the unbelievable elephant dance, and the revolting ending sequence. If these are discarded as the crude and astoundingly bad pieces of filmmaking that they are, what remains is worth looking at. Surprisingly, a good deal remains, but it cannot save the film from being anything but a wretched piece of cinema by all standards; but it does contain some fine examples of Flaherty's work.

The sequences in which Toomai prays to the giant statue, the building of the *keddah*, and all the scenes of Toomai and Kala Nag in which there is

no naive superimposed dialogue are beautifully handled in the most sensitive Flaherty manner. The climactic drive of the elephants into the *keddah* is exciting. Some magnificent back-lit shots of the massive animals charging into the river under the dark trees are memorable. One misses, inevitably, the individuality of Flaherty's own handling of the camera—his special use of camera movement—but Borradaile's photography is admirable. Nothing exists, however, to warrant the following description:

> To make it, Flaherty spent over a year in Mysore, and he made full use of his peculiar genius for sympathy with and understanding of a foreign people. The fundamental difference between Indians and westerners lies solely in their respective attitudes to human beings. In the west, man has always been, and still is, the measure of all things. He considers that animals have no souls and are, therefore, vastly inferior to him. They simply exist for his pleasure: to hunt, to eat, and domesticate. The vegetable kingdom comes still lower in his opinion. The Indian thinks just the opposite: according to his view, everything has a soul, that is to say everything contains in itself a part of the great Universal soul. . . .
>
> Once you have grasped the significance of this outlook, you are halfway to an understanding of Indian art and life. You will realize that a human being is of no more importance than a *canna* lily. You will sympathize with a king who renounces his throne to become an ascetic and identify himself with nature. Robert Flaherty had realized and appreciated this Indian sense of unity, and has made you feel throughout the film that Toomai is identified with the jungle: that he is a part of the teak leaves and creepers and elephants, just as they are a part of him. (Chatwode 1937)

We suspect that this review was based on the rushes of the film, because it is not true of the finished film, which was not shown to the press until some three months after the article would have been written. The concepts she describes so hopefully vanished into the cutting rooms at Denham, never to reappear. They are non-box-office elements, which Flaherty may have captured but the Korda brothers eliminated.

II : *Elephant Boy*, released through United Artists, had its first showings in London and New York in April 1937.[23] Flaherty attended the London premiere, and went to Paris with Mr. and Mrs. Borradaile and Sabu for its opening at the Colisée Theatre. It was one of that year's official British entries at the Venice Film Festival, where it gained an award for best direction.

Like *Man of Aran*, its critical reception was very mixed. There was a

major difference, however, between the two films. *Man of Aran* was completely Flaherty's film; he believed in it; it was what he intended it to be. *Elephant Boy* was the Korda brothers' film; it was far from what Flaherty intended or indeed from what might have been made out of the material he brought back from India. The final film shattered his illusions that in Korda he had found the great producer who understood and believed in him.[24]

Oddly enough, the kindest words for *Elephant Boy* came from Flaherty's self-styled "critical attorney." Others were blistering, although their wrath tended to be directed at the Kordas rather than at Flaherty. Grierson wrote:

> So established now is the tradition of *Nanook, Moana*, and *Man of Aran*, that filmic expectation lies with the old master who first taught us what a realist cinema could mean. A few directors like Capra are slick as the devil. A few greater ones like Griffith, Eisenstein and Pudovkin strike a gong in film history and teach us a new command of the medium. Fewer still, and these I think are the greatest directors, provide us with a whole philosophy of cinema—a fresh vision which, glancing past all questions of skill and technique and even sometimes past success itself, give us an inspired sight of things. Of these is Flaherty. Vertov talks of the kino-eye, but Flaherty, who never talks of it, has it. Those who like myself have known him for a long time remain in this sense his students. We can whack him in theory and outdistance him in economics but the maestro has caught the eye of the gods.
>
> If ever proof were necessary how old-fashioned the Kipling idiom has become it is here in *Elephant Boy*. Walter Hudd, the *pukka sahib* Petersen, hunter of elephants, is Kipling to the bone. The patronage of the jungle is perfect. There is the fairy pomp of the *sahibs* and, to the rhetorical parlance tale of the all too fairy-tale hunters, are added the wood noted wild of the Oxford accent. But striding through the jungle in a golden truck is the other thing: Flaherty with his elephants and Toomai the boy. They are real and in the great tradition of cinema: seen and, with affection, felt. So far as I am concerned, nothing in cinema this year is likely to show anything like it, and despite the cluttering incidentals of Kiplingesque nonsense, I am grateful.
>
> I find the film nicely symbolic for I have watched Flaherty for some years striding in just such isolation through the synthetic jungle of movie. One time picturing a Hollywood director "on his knees" before a radio in Samoa, trying to get the Coconut Grove orchestra from Hollywood; another time describing the exhortations of a producer after seeing the women of *Moana*, to "fill the screen with all they've got." Flaherty has been defending sometime or other against the synthesis all his life. He would call it "a sense of smell. . . ."

It takes Flaherty to remind us that we film people live in two worlds and the two, Kipling fashion, do not often meet. The studio mind does not understand the realist mind, nor *vice versa*. One hopes continually a producer will arise who will take a genius for great observation like Flaherty's and combine it naturally with the orders of the studio. Korda has not in this case quite succeeded in being that producer. (Grierson 1937)

Less tolerant was Graham Greene:

Mr. Robert Flaherty is said to have spent more than a year in India gathering material for this picture: a scene of elephants washed in a river, a few shots of markets and idols and forests, and that is all. It cannot be compared in quantity or quality with what Mr. Basil Wright brought back from Ceylon after a stay of a few weeks.[25] *Elephant Boy* has gone the same way as *Man of Aran*: enormous advance publicity, director out of touch with the Press for months, rumors of great epics sealed in tins, and then the disappointing diminutive achievement. In *Man of Aran*, a so called documentary, Mr. Flaherty had the islanders taught to hunt sharks for the sake of an exciting climax; there is nothing quite so flagrantly bogus in the new picture, but in all other respects it is inferior, even in the inevitable Flaherty skylines, against which elephants in single file tactlessly take up the graduated positions of those little ebony and ivory toys Indian administrators bring back to their female relatives at Cheltenham. With this exception, Mr. Flaherty's faults are negative: the more positive crimes, the bad cutting, the dreadful studio-work, the pedestrian adaptation so unfair to Kipling's story, must be laid at Denham's door.

The climax of Kipling's story of an elephant drive is the dance of the wild elephants which Little Toomai, the *mahout's* son, watched from the back of Kala Nag. The story is quite legitimately padded out up to this point with incidents. . . . This is all reasonable and necessary embroidery on Kipling's story, but Mr. Zoltan Korda, who is associated as director with Mr. Flaherty, has made nothing of these incidents. The episodes are not led up to, they just happen, and are over before you have time to feel excitement or even interest.

Kala Nag's attack on the camp should have been the first great climax of the picture, but through lack of preparation and rhythm in the cutting, the scene is thrown away. As for the elephant dance—I suppose the fault rests with the Indian elephants who will not dance as Kipling describes them, stamping heavy as trip-hammers, rocking the ground, though a little could have been done with music and we might have been spared the models. But what has no excuse at this

point is the story construction. To use the gathering of the wild elephants on the jungle dance-floor merely to resolve the problem of Petersen *sahib* who has got to trap a certain number of elephants for labor if he is to retain his job—this is to throw away the whole poetic value of the original. . . .

Kipling's mind, heaven knows, had its chasms; he was capable of crudities and cruelties, but not of that, and it is noticeable in this faltering and repetitive picture that it is only when Kipling speaks—in his own dialogue when Machua Appa apostrophises Toomai—that the ear is caught and attention held. "He shall take no harm in the *keddah* when he runs under their bellies to rope the wild tuskers; and if he slips before the feet of the charging bull-elephant, that bull-elephant shall know who he is and shall not touch him." Unwise, unwise, to let those weighted and authoritative syllables fall among the cheap china values, the "Presents from Mysore." (Greene 1937a)

Greene's review sparked off some correspondence (Wright 1937):

"Sir:—

Mr. Graham Greene enjoys a wide reputation as the most acute and reliable film critic in this country. It was therefore something of a shock to read his review of Flaherty's *Elephant Boy*, in which he does less than justice to one of the most important figures in the cinema today. Mr. Greene should by now be capable of distinguishing between the function of the producer and the function of the director. Instead, he blames Robert Flaherty for every thing which was not his responsibility, but Alexander Korda's.

The conflict between so personal an art as Flaherty's and the demand (possibly justifiable) of executives with an eye on the box-office raises an honest and genuine problem. Korda preferred to add to Flaherty's own genius the co-directional work of Zoltan Korda, and to shoot extra sequences at Denham. As producer, he no doubt had his own good reasons for doing so, and he also had every right to do so.

If Mr. Greene feels—as many may feel—that the resulting compromise is a disappointment, let him direct his able invective to the right quarters. It is quite unfair to blame Flaherty for this state of affairs.

One point more. Does Mr. Greene seriously believe that the sum total of Flaherty's work in India consists of "a scene of elephants washed in a river, a few shots of markets and idols and forests?" I am perfectly certain that if Mr. Greene were to see privately—and I hasten to add that I have not—all the scenes taken in Mysore, he would

prefer to rewrite his review with a little more respect for Flaherty's unique feeling for cinema, his depth of human understanding, and, let me emphatically add, his intense personal sincerity.

Yours etc.,
Basil Wright."

Greene replied:

In spite of Mr. Basil Wright's generous championship of Mr. Robert Flaherty, I am unrepentant. Mr. Flaherty was sent to India to direct a fictional film. A director several thousand miles from his studio and his producer must undertake some of the responsibilities of production as well as of direction, and nothing Mr. Wright mentions alters the fact that Mr. Flaherty has not delivered the goods—the right setting for a particular story. Mr. Wright exhibits what I can only call a religious faith in something he hasn't seen—the unused Mysore material. A critic must depend on the evidence of the eyes, and my memory of the bogus sharks hunt in Mr. Flaherty's last picture does not incline me to believe in his "depth of human understanding" any more than the melodramatic photography of *Man of Aran* convinces me of Mr. Flaherty's "unique feeling for the cinema." (Greene 1937b)

The most fulsome review of *Elephant Boy* came from the American James Shelley Hamilton, who had also lavished his adjectives on *Man of Aran*. His final sentence was: "For Flaherty has accomplished his customary magic and recreated one of those far-off places the ordinary person can only read and dream about, and put it vividly and beautifully" (Hamilton 1937). Hamilton, however, failed to say if he was referring to Denham or Mysore.

Elephant Boy possesses one striking quality: of all Flaherty's films seen in retrospect, it is the most outdated and lacking in living essence. But such a result is reasonable to expect from a hybrid.

Little Toomai—Sabu—was brought to England for the studio scenes and, like the Aran Islanders, shown the sights of London, thereby creating excellent publicity for the film. David Flaherty colorfully describes the sightseeing:

He [Sabu] has been sculptured by Lady Kennet, painted by Egerton Cooper, has broadcast over the BBC and televised at Alexandria Palace. . . . Sabu has no illusions as to his future. He knows that the life of a boy star in the films is short. After *Elephant Boy*, another picture, another year, perhaps at the outside two. . . . When he goes back to Mysore, as he probably will one day, he will have added

to his good earthy wisdom some of the knowledge that is power.
(D. Flaherty 1937)

Sabu did go back to India, but he went to Hollywood first, and A. K.
Sett recorded his metamorphosis:

> Years later, Sabu dined with me informally and alone, at my an-
> cestral home in Bombay and with Scotch before the meal and cham-
> pagne during dinner. I told him how and where I first saw him and we
> talked of the nostalgic past and of persons who had either died or had
> faded into the shadows of obscurity. This time he did not make his
> appearance on an elephant. He arrived in a luxurious Cadillac. He was
> most elegantly clad, not in a tight turban and a skimpy *lungi*, I can
> assure you. And he spoke with a distinct American accent.[26]

Flaherty came back to the brasserie at the Cafe Royal, holding court,
his always generous, warm-hearted self, picking up the check no matter
how many might be there with him. He had added Indian tales to the rep-
ertoire such as the fabulous one about the cobra (see Appendix II). The
Flahertys had taken a flat in Danvers Street, Chelsea, renting it from Mrs.
Fleming who, with Sir Alexander Korda, lived in the same building. For a
time, too, they stayed at a guesthouse in the country called Hurtmore Farm,
at Godalming, in Surrey. And after the *Elephant Boy* debacle, until his de-
parture to the United States just before war broke out, the documentary
people in London again saw more of the man from whom they learned so
much and regarded with so much affection.[27]

It was in the saloon bar of The Highlander, the new haunt of film
people with its semicircular mahogany counter, its steep stairs down to the
toilet, and its curious air of Victoriana brought up-to-date, that Flaherty be-
came accomplished on the shova-ha'penny board. He never latched onto
darts—they were in the public bar—but he did become a slave to a pin-
table on which he would play for hours. During these same two years, he
often joined a few of us later in the evening (if he had not wandered off to
the Cafe Royal) at a strange little place called the Star Club on the first floor
of an Italian restaurant called Castano's in Greek Street, which led off the
south side of Soho Square. (The GPO film unit was housed nearby at
No. 21 Soho Square, the Strand Film Company was at the old EMB unit's
premises at No. 37 Oxford Street, and the Realist Film Unit, newly formed
by Basil Wright [of which Flaherty became a director and remained so until
his death], was located at 62 Oxford Street.)

Here would gather the older documentary people—Golightly, Legg,
Elton, Davidson, Donald and John Taylor, occasionally Grierson and our-

selves. Flaherty would play for hour after hour on the billiards table and we remember his ferocious howl of rage when, after he had accumulated a vast score, he would knock over the red mushroom, which lost him the lot. Alternatively, he would work the fruit machine until it grew red hot. At late hours the club was frequented by shadowy strangers from Soho's underworld, who sat moodily drinking at the tables, wondering no doubt who and what we were, although Mr. Castano had presumably "cleared" us as being harmless.

It was a time of idleness for Flaherty—the longest time until then that he had suffered the demoralizing frustration of unemployment. For two and a half years, from when he quit work on the Korda film until he left for New York, no one asked him to make a film and he was unable to launch any new film project. Like some other documentary filmmakers, he turned to writing to help make a livelihood, but it never came easy to him. It was during this time that he wrote *The Captain's Chair* and *White Master*, both based on his memories and experiences in the Hudson Bay territory. Although vivid in visual metaphor, from a literary viewpoint they tend to become repetitious. Perhaps this extract from Grierson's review of *The Captain's Chair* puts it best:

> And what is it but just a lot of life and a lot of death struggling out of the north—a Dane who puts all his money in a ship and drives it ashore by mistake, and elects to live in it thereafter, with the deck all cock-eyed and the winds of hell blowing through the gaping timbers—the epic ten year Odyssey of Comock the Eskimo, whose friend loses his wife in an ice-split, goes mad, and has to be murdered, with Flaherty, the old Greek, putting the murder off-stage, and keeping his story on the eyes of the madman.[28] Or is it Nucktie the Owl, the sissy Eskimo with the frizzled hair who had to see God to keep the tribal focus on him, and of course duly saw him, and how his fellow Eskimos got wise to the racket and began to see God too. And, keeping the narratives together, there is the story of the ship whose spirit broke: getting round the Bay and getting later and later, the rumors flying— God knows how—over a million square miles of advancing winter, the human disasters popping off like corks one after another all along the coasts of the Bay, and the sound of men screaming as loud as a war. I doubt if there are half-a-dozen writers in English who could match the scale of it. (Grierson 1938)

We are indebted to Denis Johnston, the Irish playwright, for reminding us that he adapted *The Captain's Chair* as a play for television for the BBC in 1937, when he was also a producer for the British Broadcasting Corporation at Alexandria Palace. Flaherty appeared in the program as the narrator and John Laurie played Captain Grant. "It was one of the earli-

est television scripts to combine live performances with film-sequences," writes Johnston, "together with live and recorded sound. All of this is commonplace today, but *The Last Voyage of Captain Grant*, as we called it, was quite a small landmark in TV technique at the time, and Bob's appearance as the Narrator was one of the highlights in it."[29] At a later date, Orson Welles became interested in buying the film rights to the book, but at that time, 1942, his relations with RKO fell apart, and nothing happened.

During this period, Flaherty was commissioned by S. C. Leslie, of the British Commercial Gas Association, to produce a story idea for a film. He evolved a treatment about the adventures of a small Newcastle boy who stowed away on a coastal collier and after various adventures came to London. It was in some senses an adaptation of the "Boy and the Pit Pony" idea which Flaherty had been keen on earlier. The Gas Association story was turned into a full-length dialogue script by Cecil Day Lewis and Basil Wright. After many tests, a boy was found for the main part, but the imminence of war put a stop to the production. The script is still in existence, as is that of "Pit Boy."

Many people have recollections of Flaherty in London at this time, and all remark on his generosity. For a time he must have been able to live on his savings from the Korda film, and it is said that "his profit from *Elephant Boy* ran to several thousand dollars, the largest amount he had made up to then on a movie" (Taylor 1949). This figure, however, probably refers to his share of the returns and not to his fees as a director in India. But whether in the Cafe Royal, the Star Club, or at his home, he was munificent in his gifts. He would gather a group of people with him, collect some liquor, and the entire company would return to his home for a garrulous evening.

Flaherty was delighted when he "discovered" the Players Theatre Club, which had been started in 1936 in historic premises at No. 43 King Street, Covent Garden, by Leonard Sachs and Peter Ridgeway. The show consisted of a chairman who introduced a number of individual turns or sketches, usually musical and burlesquing the Victorian music hall. The first chairman was Alex Clunes, who was later succeeded by Leonard Sachs and Don Gemmell. Song sheets were distributed to the audience—who could drink at tables—and the chairman bandied his wit with members of the audience who came night after night for the sake of gentle bar-racking. Many performers who have since become well known had their first chance at the Players. Among visitors were the Duff-Coopers, Marlene Dietrich, the Lunts, Vincent Sheean and, oddly enough, De Valera.

Flaherty became a well-known figure at the Players, always with a party. He found the place characteristically English. But he always had, we suspect, a fondness for the mystique of the English tradition, an affection for the courtly way of life.

At the time of Munich it came as a shock to Cedric Belfrage to find that

Flaherty was a supporter of Neville Chamberlain. He could not fit it in himself, he said, to believe that the German people wanted war. He was under the current American delusion, says Newton Rowe, that British diplomats and statesmen were fiendishly clever and would outwit Hitler. In point of fact, and we think that all who knew him would agree, Flaherty was wholly apolitical. To us, the betrayal of the Czechoslovakian people came as a numbing shock. We remember even now the shameful words as they came over the radio in the saloon bar in The Highlander.

But to Flaherty, who had not known World War I at close hand, the thought of appeasement was perhaps acceptable because he did not believe that mankind could be so futile as to betray itself again. In the Canadian far North he had been untouched by the war years of 1914–19 in a way that would have been impossible if he had been a European. Like many Americans who remained at home, World War I to him had an unreal quality that made it very distant, and that distance grew with the years. All Europe had been deeply hurt by that war; America had taken part only in the final throes.

To someone who came to know the Flahertys well in London from the time of the Aran film on, this feeling of Bob's was certainly not that of physical fear. "To him," says Winifred Holmes, "the war was to come as a crucifixion: it was a betrayal of all that he held to be true in mankind. He could not believe that it could be real and possible. He just had to get away from it—when it finally came."[30]

But although Flaherty found it impossible to face up to the fact that another world war was imminent, Mrs. Flaherty, who, it will be remembered, anticipated the world economic collapse of 1929, now foresaw the coming conflict. "Mrs. Flaherty came to ask my advice as to what to do," says Newton Rowe, "and I remember the declaring of war to be an absolute certainty in my mind. I advised her to go back to America at once and buy a farm. That is just what she did."[31] Barbara, the eldest daughter, had married and become Mrs. van Ingen and had gone to live in India. Frances and Monica went back to the United States with their mother in September 1938. Flaherty moved into a large, comfortable studio just at the back of the old Chelsea Church.

Both Jack and Winifred Holmes visited him a good deal there, taking their daughter. Mrs. Holmes recalls especially Flaherty's great concern with children. He always found presents for them. He had a capacity for giving them great confidence in themselves. At the same time, he expected them to cooperate by making themselves scarce when he was not in the mood for them. Many people, each in his or her own way, showed affection for him. Olwen Vaughan, then working at the British Film Institute, called daily and got breakfast for him. Osmond Borradaile recalls the following anecdote:

His love of the good things of life, good food, theatre and good companionship demanded that he had some funds, but his generosity often put him in embarrassing positions. I recall one such occasion. His family had returned to the States. . . . Funds he had expected were late in arriving. He telephoned me and told me his predicament. I went to see him and lent him what he thought would be enough to see him through until the expected funds arrived. We then went out to a little pastry shop in Chelsea to get something for tea. It was spring and in the window of a little flower shop we saw the first sweet-peas of the year—a huge bowlful of blooms. Bob could not resist going in to see them more closely; he buried his face right into them, inhaling their fragrance. Then he turned to the salesgirl and said, "They are lovely, I'll take them." The girl and I were both amazed when he added, "Yes, all of them." So I saw more than £5 paid for a bunch of flowers. While enjoying tea and the scent of the sweet-peas, I hoped that the expected funds would arrive before the blooms faded and would need replacing.[32]

"After the parties at the studio," says Hayter Preston, "it was sometimes necessary to stay the night, which one did by sleeping on the floor. When you woke up in the morning, you would always find a new toothbrush in cellophane and a box of fifty Balkan Sobranie cigarettes beside you, thoughtfully placed there by the host."[33] "He was," adds Newton Rowe, "forever emptying the ashtrays."

In January 1939, the eminent French director Jean Renoir visited London, and a reception and screening of his films was given at Film House, Wardour Street. During his stay, Flaherty gave a party for him in his Chelsea studio. The two became great friends. Renoir arranged for Flaherty to be invited to Paris by the Cinémathèque Française, where a performance was prepared by Mary Meerson (the widow of the admirable French art director) of his films to a select audience of filmmakers, artists, and intellectuals. A year or two later, when Renoir and his wife Dido had to flee France, Flaherty—by then in New York—was the first person to welcome them to America and to use his influence to help them.[34]

During the early summer of 1939, while John Grierson was in New York, he was visited by Frances Flaherty, who was anxious about her husband in London because of the threat of imminent war. She bluntly asked Grierson if he would go across to England and literally bring Flaherty back home—which Grierson did. But to pave the way for success, he sowed the seed in the mind of Pare Lorentz, head of the newly formed U.S. Film Service, to initiate a major film about American agriculture and to invite Flaherty by telegram to come back and make it.[35] When the telegram arrived Flaherty was elated.

Two nights before he finally left London in mid-August 1939, Flaherty gave a wonderful and memorable party at his studio. Hayter Preston, Harry Watt, Olwen Vaughan, and the Holmeses remember the occasion well, as no doubt do others whose names have not gone on the record. It was a party, we are told, that fitted the occasion. There were a dozen crates of Islay Mist and huge steak-and-kidney pies that were ordered from the Cafe Royal.

"The following day," says Winifred Holmes, "we felt we couldn't let Bob just leave London on the wave of a party, especially as there had been so many there who had no real affection for him but who were not averse to drinking his liquor so generously provided but which he at that time could ill-afford. So we went round to see him. He was alone, trying to sort out a tableful of unpaid bills and wondering how he was going to raise the money to pay them. A lot of people helped."[36] He also owed income tax and could not leave the country until it was paid. Some others helped.

The day before he departed, Flaherty announced to Hayter Preston, who had shared the studio with him for the last two months, that he must give him a present to commemorate the occasion. "He went out of the room for a moment," says Preston, "and then came back with an old copper coffee-pot, which he insisted I accept. It was the one he had had with him during the making of all his films, including *Nanook*."[37]

Meanwhile, Grierson had returned to London and fulfilled his promise to Mrs. Flaherty, although Flaherty never knew that it was Grierson who had inspired Lorentz's telegram. The two of them left Southampton on July 26 on the *Empress of Australia* for Canada. "Flaherty was worried," recalls John Taylor, "because he had left some work unfinished for a publisher for which he had had advance money. He hoped that Grierson would help him complete the writing on the voyage."[38] Some days later, Grierson delivered Flaherty safely to Frances in the Windsor Hotel, Montreal. Adds Grierson, "At that moment of reuniting, I was the most forgotten man in the world."[39]

Acoma dance, photographer unknown

Acoma man, photographer unknown

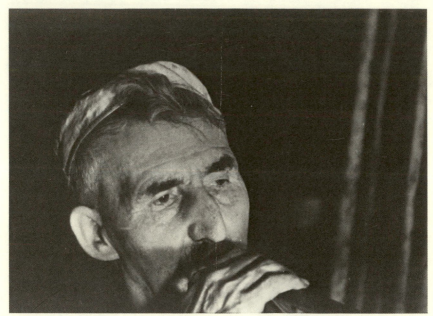

"The human factor remains the final factor," frame enlargement from *Industrial Britain* (print courtesy National Film Archive/Stills Library)

Robert Flaherty takes a Pathex movie of Captain Jack Robertson, who does likewise, June 21, 1928 (print courtesy Museum of Modern Art Stills Archive)

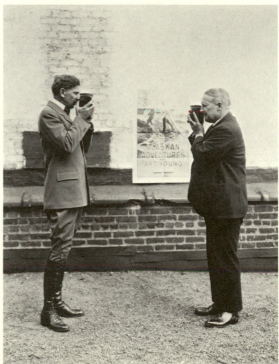

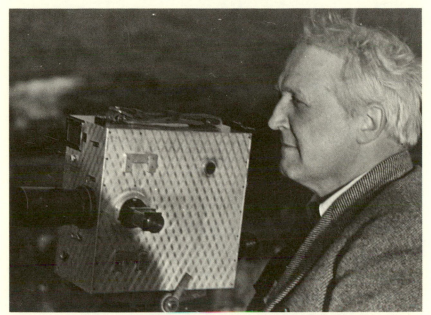

Flaherty and his Newman-Sinclair Camera, England, 1930s, photographer unknown

Maggie Dirrane, by Frances Flaherty

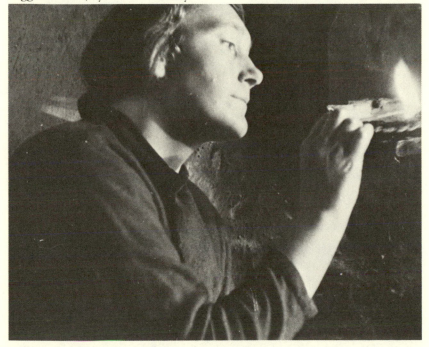

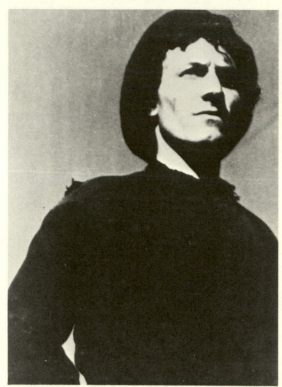

Tiger King, by Frances
Flaherty

Seaweed, by Frances
Flaherty

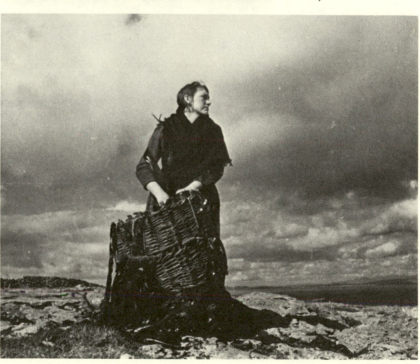

Sharks, attributed to
Frances Flaherty

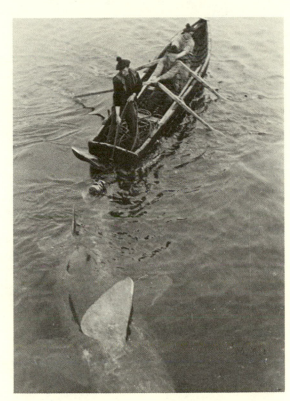

Mikeleen, attributed to
Frances Flaherty

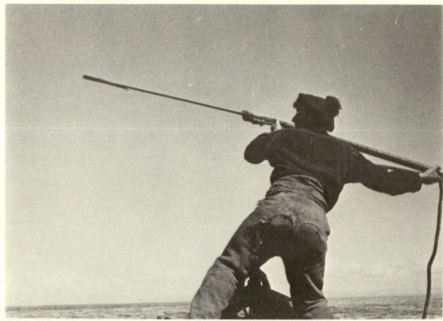

Tiger King, attributed to Frances Flaherty

The sea, attributed to Frances Flaherty

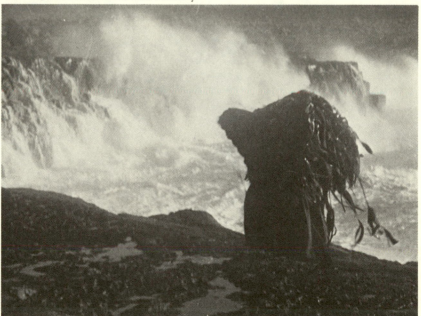

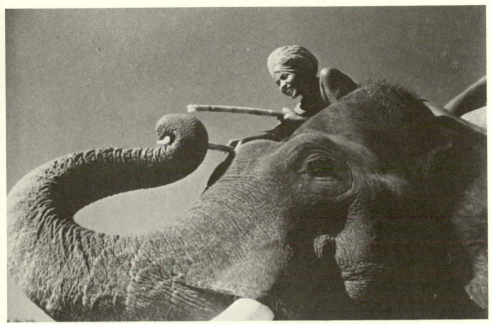

Kala Nag and Sabu, photographer unknown (print courtesy Museum of Modern Art Stills Archive)

The elephants charge, photographer unknown (print courtesy Museum of Modern Art Stills Archive)

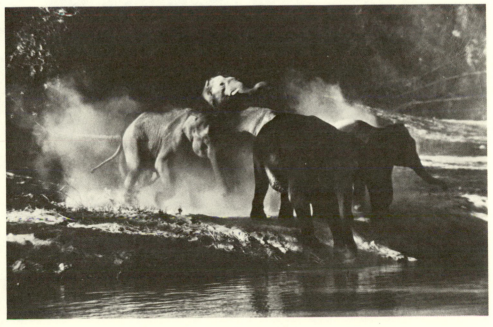

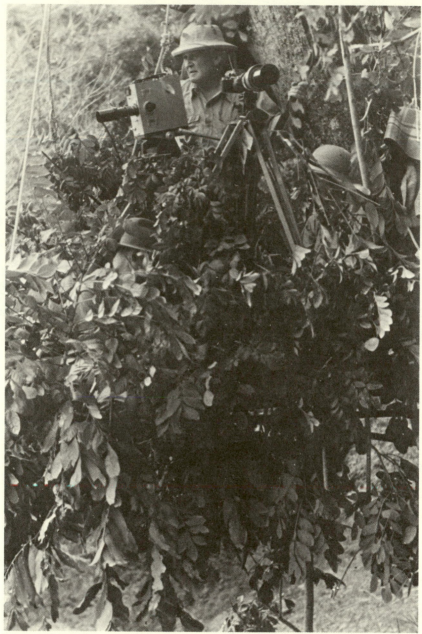

Filming *Elephant Boy*, photographer unknown (print courtesy Museum of Modern
Art Stills Archive)

United States and *The Land*

Chapter 5

I : The story of American documentary films in the 1930s was not so spectacular or unified as that of the British movement, but it contained some individual plums. One of these was a motion picture critic turned filmmaker, Pare Lorentz, who achieved two fundamentally progressive things with his two well-known films, *The Plow That Broke the Plains* (1936) and *The River* (1938). He introduced a brilliant derivative of Whitmanesque poetry into American documentary narration, which was to influence many subsequent filmmakers both in America and elsewhere. More important, after the British model he obtained official government sponsorship for his films, no easy task in the United States.

The time was auspicious for such changes. The New Deal was at its height, with government backing to encourage the arts under the Federal Arts Project, the Theater Project, the Writers Project, and other organizations that stimulated creative work. The success of *The River*, which won American critical acclaim and a wide showing (albeit free of charge) in the public theaters "opened the way for big-time Government sponsorship," according to Richard Griffith.

> It showed the worlds of education and business what could be accomplished in their own interest both inside and outside the theatres. A United States Film Service was set up, with Lorentz as its creative head.[1] While it had no power to initiate films of its own, it could and did stimulate the various government departments into dropping their limited programmes of instructional films in favour of backing important documentaries devoted to forwarding the philosophy of the New Deal. (Rotha 1952:308–9)

189

But after three films—two of which were Lorentz's own *The Fight for Life* and Joris Ivens's *Power and the Land*, both made in 1940—"a Congress growing increasingly restive under Roosevelt's rule investigated the new agency and killed it out of hand" (Rotha 1952:308–9). Griffith says that when the congressional committee held its hearings to determine whether the U.S. Film Service should be granted a regular appropriation, Lorentz mistakenly did not appear but sent a representative. The committee took exception to his absence, and the more conservative members easily made a case for disbanding the service.[2]

The third film of the U.S. Film Service before its death was actually the first to be commissioned and brought Flaherty back to the United States.

Of the inception and production of *The Land*, we are indebted first to Russell Lord's account and second to Helen van Dongen, who edited the film. Lord, a government official, author, and lover of the soil, was closely associated with the film from its start and finally wrote (in collaboration with Flaherty) its admirable narration.[3] Lord remembers:

> One hot summer afternoon in 1939 a brisk young man drove into Thorn Meadow and strode down to where we were swimming in the pool. "I'm Arch Mercey—Pare Lorentz's heatman," he said. He had handled, he went on to explain, that infinite variety of "hot potatoes" which went with the making of Lorentz's *The Plow That Broke the Plains* and *The River* for the Farm Security Administration. Now there was being planned another government film, for the Agricultural Adjustment Administration—Triple-A. Pare was in Hollywood, making a documentary on safer childbirth, *The Fight for Life*, for a medical foundation. On leave to make that film, yet still operating as Director of the U.S. Film Service on the side, he had cabled to Robert Flaherty in London asking Flaherty to make the Triple-A picture as co-director. . . . Lorentz, finally, had told Flaherty that I would be the man to do the script and work on the sound-track. So would I come over to Washington at once and talk with Flaherty and then send to Pare by airmail to Hollywood my idea for a story-line.[4]
>
> Knowing nothing at all about movie-making, I had, none the less, certain premonitions of what might come of two major luminaries in the heavens of the documentaries, Flaherty and Lorentz, colliding as directors. But I had long wanted to meet the man who made *Nanook of the North* and *Moana*, so I went over to Washington to meet Bob Flaherty for a story-conference and was charmed. . . .
>
> He still had the eye of an explorer when he went out to film *The Land*. The first thing he noted, coming down to Washington from where his boat docked in Canada, was the "fierce, electrical violence of the American climate. That is why our soils wear down so fast if we treat them rough," he said. . . .

This projected American film, the first they [the Flahertys] had ever undertaken as a government movie except of course, *Industrial Britain*, had them baffled at the outset. It was supposed to cover not just one restricted locality and its growths and people but most of a continent. It was expected by its New Deal sponsors to advance an argument, and not simply an argument against erosion. Triple-A, the sponsoring agency, believed that parity payments to farmers advance farm and national security, and wanted that shown. Flaherty never even tried to get the functions of the varying farm-relief agencies straightened out. When Wayne Darrow and other Triple-A information officials of the period would call him into friendly session to explain the intricacies of that sacred word *parity*, they would sometimes cover blackboards with diagrams that looked like play-by-play accounts of a football game. Then: "Alphabetical soup in the bureaucratic jungle," said Bob. Or somewhat sharply, "What *is* Triple-A, Wayne?" (Lord 1950)

Thus from the start *The Land* was to be a totally different assignment from the comparatively simple "bravery" themes of *Nanook*, *Moana*, and *Man of Aran*. Its theme could not be a celebration of the past, nor did it offer much scope for Man Against the Sky. But the subject was very appropriate to the times. In the summer of 1939, all literate Americans were reading John Steinbeck's *The Grapes of Wrath*, whose theme was the desperate trek of the Okies from poverty and unemployment in their home state of Oklahoma to the mirage of prosperity in golden California. It was a shocking, tragic story of mass migration told through the experiences of a single family, and it left a deep impression on the millions who read it. The novel was filmed by John Ford that same year and, although not a wholly adequate adaptation, the picture showed that Hollywood could have a social conscience if it liked to use it but perhaps only if it could be latched on to a best-seller. The year was also one in which Secretary of Agriculture Henry Wallace's project of the "ever-normal granary" as a panacea for farm overproduction was receiving publicity.

The film offered Flaherty, for the first time in his adult life, a chance to discover for himself something of what made up the United States and its peoples. Most of his youth and early working years had been spent in Canada. Now, at the age of fifty-five, he was to go out across the nation and be confronted with places, people, and incidents of which he knew nothing. He may have been born in Michigan and lived in Connecticut and New York, but he was wholly out of touch with the reality that was America at the end of the 1930s. What he was to find came as a shock.

In all, Flaherty made three journeys to get his film: south to the cotton fields, west to the irrigated, mechanized farms of Arizona, and north through the dustbowl states to Iowa and Minnesota.

Mrs. Flaherty accompanied her husband for the shooting in the South

and in the East (notably Pennsylvania), when Flaherty did his own camera-work. Russell Lord also went with them part of the time. He writes: "The first field trip on the picture jumped on a straight drive to the heart of the country. Iowa in August enchanted Flaherty. 'The glory, the richness of this earth,' he said. He shot a sequence on corn, then some more on corn-machinery; then up to the lake country he rolled in his station-wagon, with a camera-platform atop it, to film granaries, boats and swarming railyards, bursting with the bounty of the great valley" (Lord 1950).

Until this point the mood of the expedition was robust and cheer-ful. The weather was good; clear sunshine fell day after day on the land. Flaherty was like a boy revisiting, rediscovering his homeland, marveling at its beauty, friendliness, and power. Everything was "marvelous!"—the farms, the hotels in little places, the pinball games in the lobby, the apple pie in dog-wagon restaurants, the prizefights on the radio, the poker games with matches for chips at night. Bob Flaherty had great gifts as a traveler. He was at home anywhere. He could eat anything. He could sleep in any bed or in any car. And whenever there was no one to sit up and talk with, he could always use the telephone. His long-distance phone bills—all "personal"—startled many a hotelkeeper along the way. And a great, white-haired man with a ruddy face who gave small boys handfuls of nickels to play the pin-ball machines is remembered from Muskogee, Oklahoma, to the coast and back to Chillicothe, Ohio. "He must be Santa Claus without the whiskers," one wise child said.

Southward, the mood and temper of the party were not so happy. The heat was terrific; the hotels were ovens; the food, though occasionally "marvelous" was not invariably so. England was at war, under bombard-ment. England, to Flaherty, was a second home. But what most continually darkened his spirit was the condition of great stretches of cotton country. "It is unbelievable!" he kept saying, "unbelievable!" As the party worked westward, following the historic march of cotton, they came across home-less migrants in large numbers. He started talking with them and taking their pictures. As he heard their stories, his anger and compassion knew no bounds.

Archibald MacLeish, the poet, has expressed the conviction that, as a moving picture, *Man of Aran* is the greatest documentary or factual film ever made. "And what," MacLeish asked, when told of Flaherty's forthcom-ing American picture, "what are you going to have that compares in effect with that woman wailing against the roar and beat of the sea?" Flaherty was feeling low in mind the day this question was put to him. He lifted his arms and replied with simple dignity, "God knows. There is too much to this land. Our picture is no good now. It stinks!"

But later: "It's coming to life! I distinctly feel that gentle thumping kick," said Flaherty, jovial now and expectant. Some of the pictures he took the summer of 1939 in the cotton wasteland and on the garden ranches to

the west—"American refugees wandering in a wasteland of their own making"—may be the answer to MacLeish's question.

Twenty thousand miles of travel over a period of two years were required to complete the shooting of the picture. The camera crew and management staff were somewhat changed in 1940, when Pare Lorentz's U.S. Film Service was dissolved as a government agency. It was arranged amicably that Bob should continue the direction of his film in the studios of the Department of Agriculture.

To work with Bob Flaherty, and live through it, is to behold a world as radiant and new as the day it came from the hand of creation and to find a great friend for life.

Another account of the production in the field comes from Irving Lerner, who worked on much of the film as a cameraman:[5]

> I had only been west of the Hudson River once before, and that was a trip to Hollywood in 1938. I was still essentially a provincial New Yorker and the job with Flaherty was a very stimulating prospect. I was glad to be able to get away from the "inbred" documentary movement in New York and perhaps to widen my experience. I was excited by the idea of working with Flaherty, even though I didn't "worship" him. It would give me a chance to see the Man and how closely the Man related to his films. The most remarkable thing of all was to be my discovery that they were very much integrated—and that was what gave him and his films stature and what made them so personal. . . .
>
> Flaherty was trying desperately to formulate his ideas for *The Land*, based on meeting with Pare Lorentz. There was a deadline, of course, and Flaherty was forced to leave for location—Des Moines, Iowa—without a script or even an outline. The war in Europe had just broken out and he was extremely disturbed, distressed and confused. He left me with the job of rounding up various bits of equipment and this I was to bring with me by train to Des Moines. It was of course typical of Flaherty to find a Newman-Sinclair in the United States. This was his favourite, but we also rented an Akeley as a spare. Consistent with his photographic philosophy, most of the equipment consisted of the long-focus lenses, from three to twelve inches.
>
> I had, I remember, formed a critical opinion of Flaherty's work before meeting him. This was first of all a rejection of a cult which even at that time was quite prevalent. It was also based on an examination of his films. Most of them dealt with so-called primitive people. They were idyllic. He was interested in the ceremonial, he was interested in the ritual of pain, he was moved by the struggle of man against nature, of man against machines, or the machines against man. He was interested in the romantic concept of the Noble Savage.
>
> This approach was present in his observation for the new film.

But there was a difference. During the making of *The Land*, Flaherty was in a state of shock; the war was destroying a world. He saw that advancing industrialization, combined with ignorance and greed, was ruining the American land and the people who had to live from it. For the first time, he tried to relate in emotional terms and in global terms the effect this would have on the people of the country as a whole. He had to absorb the scene, and try to understand it, but the scene itself was confusing; it was wonderful and horrible, beautiful and ugly.

Then, too, he hated getting involved in the politics of the U.S. Film Service which, although it had the personal approval of the President, was being used as a political football by the anti-New Dealers. This made Flaherty angry and more confused, and, moreover made it impossible for him to sit down and write a script. And he could never really pin down Lorentz. He was talking all the time about man against nature and man against the machine but never about man against man. He kept talking about the "good old days" when life was simpler—without machinery; even though the technology he was complaining about was enabling him to propagandize his own version of paradise.

Lerner quotes from letters he wrote to his wife from location:

August 30, 1939.

A few days later, we went out for our first day's shooting and what happened on that day will always vividly remain with me. As was regular photographic practice, I pulled out my exposure-meter. . . . Flaherty blew up. He did not want to have anything to do with an exposure-meter or anything else that did not rely on intuition and experience. There are, of course, some photographers—especially still-photographers—who work that way. But it was a novel experience for me. I put my exposure-meter away but I admit, on occasion, I did use it subversively. And in the end, I must say that Flaherty did accept it. This may be symbolic of something, because in his next film he even gave up the use of the Newman-Sinclair and Akeley cameras and allowed Ricky Leacock to use an Arriflex.

Bloomington, Illinois.
October 5, 1939

. . . Now Flaherty is very worried about a story. Since the meetings in Chicago, which were good-natured enough, there simply is no script and we're still shooting in the dark. The upshot of it all is that no one knows what to say about American agriculture; there are so many contradictions that everyone is hopelessly confused. In the

meantime, there are certain things we must shoot no matter what the story-line will finally be.[6]

<div align="right">Memphis, Tennessee
October 12, 1939</div>

Well, we finally got the film-stock and Flaherty advanced me some more money to live on and we set out to make a movie once more. About 130 miles north-east of Memphis, we found a section of eroded land that made all of us shudder. We'd only up to then read about the rape of the land, but when you see it, the impact if so terrifying that your first impulse is to say, "the hell with everything, I'm going to devote the rest of my life to planting trees and putting this land back into shape." If the land itself is not terrifying enough, the people who still live on the land, who still try to sustain life on that land, are the most horrible sight of all. Human life, human standards of living, are obviously in direct ratio to the condition and the fertility of the soil. In this county there are very few Negroes; the "poor whites" live in a fashion that is as bare as the poorest Negro share-cropper. We see them as we drive by; they have seldom seen an automobile. The children are without exception quite beautiful.

We are really beginning to film now. Up to this time, we've been mainly shooting machinery and farm-processes. Now Flaherty is beginning to see some kind of story. . . . We've had trouble with our automobile and have been wiring Washington for a new one. . . . On arrival in Memphis, Washington wires that they are still working on a car but the driver can't leave before Friday. So here we are again, with no more film-stock and no more money. We can't even check out of this hotel and move to Lexington, Tennessee, where we want to shoot our next sequence, because a 275-mile drive in a day is too difficult with the car.

<div align="right">Memphis, Tennessee.
October 16, 1939</div>

Flaherty seems discouraged about the Washington red-tape. He is on the verge of flying to Washington and having it out with Pare Lorentz. I think that if it wasn't for the fact that he's never been up in a plane, he would have gone days ago. . . .[7]

<div align="right">Muskogee, Oklahoma
October 18, 1939</div>

The situation is still in a flux. Flaherty must have until the very end of November (or more) for the shooting. Lorentz and the Triple-A men (who are putting up the money) have insisted that there will be more money forthcoming. In the meantime, we've had trouble getting our paychecks, but Flaherty says, "Not to worry or think about anything

but the shooting." He told one of the officials back in Washington over the phone that "I won't stop shooting until I see the whites of all your eyes. . . ."

<div style="text-align: right">

Tucson, Arizona

December 1, 1939.

</div>

This morning we left El Paso on our way to New Mexico and Arizona. We came across our first Okies. There were three people, an old man, his wife, and a young man of about twenty-five, sitting outside their "Covered Wagon" (a disheveled truck), by the roadside warming themselves by a meager fire. It was about 6 AM. We filmed them, talked with them and they told us that there were thousands of migratory workers in Arizona around Phoenix, picking cotton, lettuce and fruit. We gave them six dollars, a sack of Texas oranges and a pack of cigarettes and went on our way. . . .

This meeting resulted in one of the most touching sequences in the film. At first, Flaherty was quite shy about intruding on these people. For many of the scenes in the film we would stop and shoot what he or what some of us thought would be useful for the picture. Since we had no script, this was a kind of documentary improvization. He began shooting this particular sequence with a 12 in. lens, but as we got warmed up and as the Okies got used to us, we finally moved in and got some really close-shots with a more conventional and sharper lens.

When we got to this hotel, the Santa Rica, we found that it was overrun by a Samuel Goldwyn crew, headed by William Wyler, with a cast including Gary Cooper and Walter Brennan. The production was called *The Westerner*.[8] So here we are in the same hotel—the two extremes of film-making. Flaherty ran into a few people he knew, including Gary Cooper.

<div style="text-align: right">

December 4, 1939.

</div>

It is early morning—after midnight—and I've been taking part in a drinking bout with Flaherty. Any refusal on my part would be in bad taste, it seems. We've had terrible weather and have been unable to shoot. William Wyler invited Flaherty and the rest of us for lunch on the location set. The next day we went south of Tucson for 20 miles to watch them shoot a fight scene. . . . When we got back to the hotel, we found a wire from the U.S. Film Service production manager to say that he was arriving in Phoenix that night. It seems they realise the difficulties under which we have been operating and want us to make a good and complete film. Flaherty now says that we definitely won't be back in the east by Christmas. . . .

December 13, 1939.

Still at Tucson. The past week has been pretty much hell. We've been shooting a lot during the day, really working hard, and then at night drinking sessions with Flaherty, looking at rushes and arguing with him about the film in general until all hours of the morning and then up again at 6:45 AM. We're leaving in a couple of hours, as soon as the lenses get here, for Boulder Dam and Las Vegas.

Bakersfield, Calif.
January 8, 1940

We've been working in a Government migratory camp, getting portraits of Okies in a couple of scenes. We've gotten some good stuff, although Flaherty seems to have lost interest in the film. In addition, he revealed that he is incapable of handling people in a film. It's a good thing we have Floyd Crosby. He has been doing most of the shooting, although I worked alone on a second camera and have also been doing some still-photographs.[9]

Shooting on *The Land* was completed in the early summer of 1941. "They returned to Washington," says Griffith, "with a sense of insecurity." Early in 1940, Flaherty had written to Jay Leyda, "'The truth is that I am sweating pretty hard over the film. I am trying to finish for the Government. I never tackled a tougher or more confusing job and there are times when I don't know whether I am standing on my head or not'" (Griffith 1953 : 140).

If Flaherty felt insecure, it was not because of the vast amount of film he had shot—he was used to shooting plenty—but rather because its content was so diffuse and scattered. Here was no family unit to follow through a daily or seasonal round. He tried to introduce the family concept in some shooting in Pennsylvania but he could not sustain its continuity all through the picture. Moreover, he had had no chance to settle down in any one place and let the story develop out of the environment in the accepted Flaherty way. The only off-the-cuff filming he had done before had been for *Industrial Britain*. Now he was on the move the whole time covering a gigantic amount of territory compared with the small islands of Savaii or Aran or even the jungle of Mysore. No wonder that he felt he had no firm grip on his material, that the theme eluded him.

If the problem of the filming worried him, however, it was nothing to what he was to find when he finally returned to Washington. In his absence, the European war had suddenly blazed into a full-scale blitz. Short of declaring war, Franklin Roosevelt was doing everything in America's power to send help to Britain—food, arms, munitions, ships—by means of a magic formula called lease-lend. Thus, instead of the American farmer

facing depression, as in 1939 and 1940, when Flaherty had started his film, the war needs of Britain had provided a palliative, if only a temporary one.

"Every Government policy," writes Griffith, "of the early New Deal days had been altered, agriculture's most of all. Officially, the land problem was no longer that of conservation but of getting marginal lands back into cultivation as quickly as possible. The human problem was not one of unemployment but where to get farm labor to replace the young farmers who were going into the armed forces. Even while Flaherty was making his film, its theme had dated irrevocably" (Griffith 1953 : 141).

When he returned to Washington after his first expedition, Flaherty had made an important decision. As his footage grew in size during 1940, he decided to hire a professional editor who could assemble his material. He chose Helen van Dongen, one of the most creative and skilled editors in the documentary film world.

Helen van Dongen had grown up in the tradition of European documentary films. In 1928, she had worked with the distinguished Dutch director, Joris Ivens (whom she had later married) on most of his films, including *The Bridge, Rain, Zuiderzee, Philips-Radio, Borinage*, and *New Earth*. In June 1936 she followed Ivens to the United States and worked on an experimental film project for the Commission on Human Relations of the Rockefeller Foundation. Later she edited for Ivens *The Spanish Earth* and his film about China, *The Four Hundred Million*, in 1938–40.

She made many notes about her experiences with Flaherty, both on *The Land* and *Louisiana Story*. Quoted here, they provide an invaluable record, throwing much light on Flaherty and his methods in his later years.[10]

> I had just returned from Hollywood, where Joris Ivens and I had finished the editing and music-scoring of the China film. Ivens was now to make *Power and the Land* for the US Film Service, for whom Flaherty was already shooting *The Land*. He had in fact returned from his first trip with an approximate 75,000 ft of film and he needed it edited so that he could see what he had and what he should shoot in addition. . . .
>
> When Flaherty asked me over the phone outright to work with him, I hit the ceiling. One hour later I was in my car driving down to Washington, where I was to spend the next year of my life. . . . I admired Flaherty as the greatest documentary director of them all but had never dreamed that he would ever ask me to work with him. Thus far, I had either worked independently or with Ivens, with whom my collaboration was so close and of such long standing that it seemed hardly ever necessary to enter into deep discussions. Sometimes half-words were enough to render a meaning, or the mention of a single shot would clear up a long unsolved problem. Now I was to face working with a director of great stature, about whose reputation was

world wide. During the 250-mile drive to Washington, I prepared my-self for the first work-session and concentrated on what proper questions I should ask about his script and his approach to his subject.

Actually, I did not say anything the first time I met him. It was at dinner and he was surrounded by friends in a little French restaurant on Connecticut Avenue. All evening long he talked and told stories about his experiences as an explorer in the north among the Eskimos, or about *Nanook*, or the feasts the Samoan chiefs gave him while he was making *Moana*, all told so vividly that one had the impression of participating in the event. Not one word was said about *The Land*, which I found extraordinary because most film-makers cannot stop talking about the film they are making at the moment, citing all their frustrations and difficulties. So I did not venture to ask my questions and waited until the next morning.

Our first work-session was at the Department of Agriculture the next day. . . . Flaherty was sitting at his desk reading the morning-papers. After a cheerful hello, he said, "I find it too long and too diffi-cult to say Miss van Dongen all the time, so I'll just call you Helen, OK?" Then, without interruption, he began to speak about the world situation which took up several hours of that first morning as well as other hours of any other day as long as the film lasted.

I never had a chance to make any intelligent remarks, or to ask my specific question. Without transition, he said, "Come, let's screen." My consternation at finding 75,000 ft of apparently unorganised material changed to horror when I learned that there was no story outline or synopsis in the accepted sense. It took us several days to screen all the films and with every shot that appeared on the screen, I was hop-ing that he would tell me why he shot it, how he wanted it used, what it belonged with, or in general what he expected me to do with the mass of material. The most important things he said were groans every so often, sufferings through the screenings, moanings of, "My God, what are we going to do with all this stuff?" And back in the of-fice, some more groaning, interrupted by things he had seen during his trip, and the terrible plight of the "Okies," the influence of civiliza-tion, the killing of human skill through the introduction of the ma-chine, the unemployment it caused, the amount of food in the world and the simultaneous starving, all interrupted in turn by comments about the war.

I was too new and inexperienced in Flaherty's method of work-ing to make head or tail out of any possible connection between his remarks and the film. After three weeks like this, I was utterly at a loss. All we had done so far was to screen the same material over and over again, but he never came to the point at which he would outline his story. And though I became familiar with all the raw material, I could

not yet see the connection between the separate subject, nor was there time to read up all the background on the subject. There were shots of harvesters in a broccoli field; living camps of the "Okies;" an old dilapidated southern mansion of which the only occupant was an equally dilapidated old Negro who, every day at noon, dusted the old plantation bell, an experimental cotton-picker just invented; an almost overgrown sugar mill lovingly caressed by the camera lens.

In desperation, I finally wrote to Joris Ivens, complaining that all Flaherty did was to talk about the war and machines and civilization in the morning and screen the same old material in the afternoon, and that I was completely baffled by the method of this great man. Obviously he could make films, but *how* in heaven's name?

Actually, Flaherty was not without a kind of script outline, but I did not know that at the time. Not understanding his method and approach to film-making, the material as screened in its order of shooting did not always make sense, looked chaotic, as if he had filmed just about everything that he had happened to see as he moved around.

(In hindsight, I can say that actually Flaherty looks and observes simultaneously through the camera and therefore catches so many unrehearsed events that are authentic and could never be repeated or planned. He has the uncanny eye of the explorer, living in his surroundings, becoming part of them. Being a poet, he sees the beauty and poetry around him which others, not having the same sensitiveness, do not see because they do not know how to look. Even a smokestack through Flaherty's eyes become poetic because he has noticed that it looks more beautiful seen through a haze, or surrounded by billowing smoke. . . .)

Ivens's answer to my complaint was cryptic. "Observe, look and listen and you'll find out what he wants." At the time I didn't think that this was any great help, as all I was doing was to observe, look and listen. Indeed, there was nothing else to do. I did not find out anything until some time after, when Flaherty was about to go on the second shooting expedition. . . . Reducing many unspoken questions and hoped-for discussions into a single question, I asked him before he left, "And what shall *I* do?" He answered in the most charming way, "Oh, *you* just go ahead!"

During his absence I made an initial selection of his material, selecting good from bad, dividing it into first and second choices; some editing of separate sequences and working on possible connections and inter-relations of sequences as best I could. . . .

But one day after he had come back to Washington again, it suddenly occurred to me that his worrying about the war, or his preoccupation with machines, were simply a different way of saying what he wanted to express in his film.

Why did I not discover this before? Because it takes time to enter into an artist's mind but once you do, you discover a rich field of interpretation, and as Flaherty transposed his thoughts about the film, the "Okies," living and food in terms of war, destruction and machines, so could I later transpose and interpret them through his film material which, though not my own, had in each shot a meaning that Flaherty wanted to put into it.

I also discovered that it was worthwhile listening to all he said. . . . There were certain inflections, certain ways he used, certain remarks, certain preoccupations, of which I was at once reminded when looking at his film material. Shots which previously had had no meaning for me, now looked entirely different . . . what I had to discover was how to look at them through Flaherty's eyes. . . .

My personal style of editing a film is not the same as Flaherty's. The question at this moment was not which was the better style; it was that if Flaherty had . . . left the entire editorial composition of *The Land* to me, another film would have come out of it and probably a good one because the raw material was good, but it would not have been as good as Flaherty's *The Land*. Very soon I should have been forcing Flaherty's material to fit my own style of editing. There would have been a clash between two personalities; and although I believe, like Flaherty, in letting the film material itself dominate and tell me what to do, it would have been very difficult.

This last statement refutes a comment we have heard made that Helen van Dongen's editing "ruined" Flaherty's material in this film because she did not understand his method of shooting. We believe that with great skill, patience, and intelligence she welded a unified film out of a vast mass of what could seem to be unrelated footage shot over eighteen months in dozens of different locations to no script or even pattern. And the official policy about the film changed frequently.

Russell Lord tells of an incident that occurred during the editing:

The Giant declared in one cutting-room crisis that a scene which seemed to the rest of us perfect (the old coloured man in the rat-infested mansion, mumbling, "Wheah they all gone?") would require "more fiddling with" before it was right. "You and your fiddling!" cried Frances Flaherty, and burst into tears. "Ah, these women!" said Bob, beaming, "I wear them all down." "He then," added Helen van Dongen, "turned to me with a shrug of his huge shoulders and added, "Except you, you are a Dutch mule." (Lord 1950)

Throughout the summer and autumn of 1941, Flaherty and van Dongen and an appointed group of the agriculture department's officials

wrestled with the mass of footage in an attempt to shape it not just into a film but a film that would conform to the changed events and policies. Every kind of reshuffle of the footage was tried. Eventually, a compromise was agreed on. Says Russell Lord:

> Came a day at length when the Chiefs or Directors of most of the Department's bureaus and action agencies were gathered into a projection-room in the South Building to see the first completed rough cut of Flaherty's *The Land*. All were impressed. Some were stunned. But the head men took it well. Afterwards I joined company with R. M. ("Spike") Evans, head of Triple-A, and Milton Eisenhower, Director of Information, walking back to the Administration Building.
>
> "It tells a story that ought to be told," said "Spike" stoutly.
>
> Milton asked me quizzically, "Whose picture *is* this, Farm Security's or Triple-A's?"
>
> Answering in the same free sprit that Bob had aroused in all of us, I reckoned that Triple-A had ordered the picture and that, since the earlier Triple-A adjustment drives had unquestionably accelerated the displacement of smaller operators and share-croppers along the historic western trail of Old King Cotton in particular, his terrific shots of migrant families—latter-day "pioneers" floundering in "a wilderness of our own making,"—were properly a part of the story, and should stay in. (Lord 1950)

They did stay in. And it was infinitely to the credit of our Department of Agriculture that this was so. The seamy human side of a headlong emergency government program, involving deepset political consequences, was shown in a government picture along with triumphant examples of improved land use, without policy cuts. I think that could not have happened under any other government on the face of the earth.

Before *The Land* film could be finished, however, two more important technical decisions had to be taken. First, it was clear that a narration should be written to hold the picture together and to give it a coherent continuity. Russell Lord was the obvious choice, but he is today modest about his contribution to the film. "You should make it plain," he writes, "that the narration was by no means mine alone. The voice-track as was at length meshed-in was mostly Bob's—what he said while shooting in the field and again in the cutting-room. He said it—and I just wrote it down for the most part. And then we cut it and wrangled about it."[11]

Helen van Dongen thought Flaherty should speak the narration:

> It was an act of desperation. No actor could speak Bob's broken sentences. Early in the production, he had begun to phrase tentatively what ultimately, with Russell Lord's help, became the narration of the

film. After all unnecessary words and half-sentences had been slowly removed, one after another, Flaherty was so familiar with the minutest inflections he wanted to impart that he himself could say it in no other way. I had had a previous experience of a similar situation. I had convinced Hemingway that no one except himself could speak the narration he had written for *The Spanish Earth*. Especially in my memory remains the short phrase: "Three Junker planes did *this*." It could be spoken in the right manner of righteous indignation only by the man who had not only written the words but had actually *seen* the incident happen, as had Hemingway in Spain. If we had employed a professional narrator to speak the words that Flaherty had found for himself for *The Land*, all he could have done at best would have been to repeat the words after Flaherty but never getting quite the same inflection.[12]

Even when Helen van Dongen had made this decision in her own mind, there were problems. First, Flaherty did not like microphones, so she promised him that his voice would be recorded only for the purpose of getting the right intonations so that a professional narrator might study it. Second, Flaherty disliked spending even two or three minutes without a cigarette and would thus puff and wheeze in the middle of a sentence. He was still under the impression that the recording was only for study so he could not be asked to keep his wheezing to a minimum. This defect was partly overcome by placing him far away from the microphone. Even then the recording was made only after many retakes. What Flaherty finally said when he realized that his recording was going to be used in the completed film is not repeatable.

The second important decision was to commission a musical score for the film to be written by Richard Arnell, a young English composer, who describes the experience:

In the winter of 1940, Lady Dorothy Mayer invited me to a music festival being held in Washington at the Library of Congress. While I was there, she introduced me to Russell Lord, who told me that he was the writer for a new Robert Flaherty film. Knowing my interest in Flaherty, Lady Mayer said, "Why don't you just go and see him?" So I did. He was working on the film in its early stages of editing. Bins full of film were strewn all over the basement of the Department of Agriculture building. I brazenly told him that I was the only person who could write the music for his new picture. I remember now only the immediate sense of friendliness which came from the man. I went away not particularly hopeful. I was young, 22, inexperienced and unknown—I had had very few performances. So when I received a cable "Come to Washington" I was surprised and thrilled.

Another session took place in the basement but this time I was armed with two acetate recordings, my *Divertimento No. 2* and an overture, *The New Age*. As the Flaherty family, Frances, daughter Frannie and Flaherty himself sat listening I again felt hopelessly inadequate. At that time my style was very contrapuntal, leant heavily on Hindemith and was *absolutely* removed from the pastoral or the folksy. To my astonishment, I was commissioned to write the score. Although I was not an American, the Department of Agriculture signed a generous contract with me and I settled down to work in a cheap furnished room near the Library of Congress. Every now and then Bob would ask me to come down to see the film. This I disliked, since it interfered with the time I had available to complete the score. Forty-five minutes of music to be written and orchestrated for a large orchestra in one month!

Flaherty put up with my foibles in the most amazing way. Once he asked me if I wouldn't include some folk music. I refused. He said, "It was good enough for Dvorak, so it should be good enough for you." Out of the arrogance of youth, I answered, "I think we can do better than that!" It was our only quarrel.

To keep the costs of recording low, one of the U.S. Government's subsidized orchestras was used, namely the National Youth Administration Orchestra, composed of post-graduate students who, due to the hard times, could get no employment. Stokowski was asked to conduct. He came to see the film and sat watching it turning over the pages of my score. At the end, he remarked that all music was now academic which was not composed for electronic instruments. The score was actually conducted by Robert Hofstader. . . .[13]

I believed in making each section of the film a more or less self-contained work. To name one or two, the Kentucky farmer's nostalgic story, the "machine" section, the old Negro's story—all were complete works and not just background snatches. The migrant family's removal sequence, for example, was treated like a piece for clarinet and horn solo with string accompaniment. It could have been from a short concerto for these instruments.

To avoid the monotony inherent in a continuous work of such length, I used two different sizes of orchestra—a full orchestra—and a chamber orchestra of strings, wind and horns. The separate movements were linked by two themes, one of which was heard at the beginning—in fact, the whole score was rather like a Purcell fantasia, many short individual parts connected by an underlying mood. This was a similar technique to the one used by Prokofiev in *Alexander Nevsky*, the film of Eisenstein. To express the idea of hope and creative energy in the finale, I wrote, of all things, a fugue on two subjects! It

succeeded, I think, because of the mounting tension of the successive entries on the brass.

The experience of writing this work with Flaherty altered my life. I am quite sure that it gave me the initial encouragement I so much needed to go on creating music in an indifferent world. It still comforts me to this day to remember that if the music for *The Land* was good, it was entirely due to the judgment of a man who gambled on a green young composer, guessing that he would give him what he wanted.[14]

Helen van Dongen remembers that the final recording session mixing the music with the narration of the film was difficult because Flaherty wanted the music to be recorded as softly as possible so as not to distract from the visuals. "He played havoc with the sound-recordists!" she adds.

Finally, by the end of 1941, the film was complete in a forty-three-minute version. But after all the blood and sweat, it was fated to be seen by very few people. *The Land* was a very brave film for Flaherty to have produced and was an answer made with great passion to the critics of his romantic escapism.

II : The film begins with a title as stipulated and written by the U.S. Department of Agriculture:

FOREWORD

The strength that is America comes from the land. Our mighty war effort is the product of its land and people. Land: our soil, our minerals, our forests, our water-power. People: their skills, their inventiveness, their resourcefulness, their education, their health. Land and people, in war or in peace, this is our national wealth.

This is the story of how rural America used machines to achieve an unbelievable production—but at a terrible cost to land and to people through the wastes of erosion and poverty: the story of the beginnings of reconstruction, and the hope of a world of freedom and abundance through the workings of a democracy and through man's mastery of his own machines.

From then on, and for the only time in all the films of Robert Flaherty, words matter a great deal to the film. Instead, therefore, of synopsizing the contents of *The Land*—as has been done with previous films—we believe that a fairer idea of the picture will be given if we alternate passages of

the narration with brief descriptions of the visuals they accompany (Lord 1950:29–36).[15]

The film opens with a farmer, his wife, and child, strolling around their fine old stone farmhouse, built to last centuries, with great, roomy barns and outbuildings: rich country, rich grazing, rich crops.

> It takes good land to raise a house like this.
> It takes good farming
> To have full barns,
> Full bins.
>
> Good people,
> Of the solid old stock
> That settled in this country
> Three hundred years ago.
>
> They built their houses to last forever.

In the same part of the country, beautiful but derelict farmhouses, desolate and discarded: crumbling old walls.

> But even here,
> In this rich state of Pennsylvania,
> Which has some of the best farms and farmers in the country,
> Trouble has crept in.

In the distance men walk across eroded land, the worn-out soil and farmers staring at it. Elsewhere, people wait in the shade, wait for surplus food. Then to a meeting of farmers: they are discussing their many problems. Close-ups of their anxious, worried faces as they talk or listen.

> All over the country there has been trouble.
> Farmers meet and talk it over,
> Talk over the deep problems of the land,
> And the people—
> Problems that no longer can any one man solve alone.

Big storm clouds in a black sky, the countryside darkened by cloud shadows. Fields with furrows made by trickling water. Rushing water meeting more rushing water: together they make a torrential stream. The soil is washed away—and so erosion starts.

> It is amazing what the wash of rain can do!

From Pennsylvania to Tennessee. Tremendous areas of eroded hillsides, scarred and pitted by rushing water. Deep gullies and torn soil with the scabs of topsoil wearing off.

> Tall trees grew here once,
> And grass as high as a man.

A once lovely farm now surrounded by eroded land with patches of cotton. From the bare tree roots, the soil has been washed away. Stranded fenceposts stick up from the desolate landscape. Negroes pick cotton. Then scenes of the dilapidated shacks of sharecroppers. A sign reads: "Prepare to Meet Thy God." A Negro mother and her children stare at us from a field— hollow-eyed. And more vistas of barren, eroded land.

> We found this in Tennessee,
> But you can find it,
> In greater or less degree,
> In every state.
> These devastated, sod-like patches of soil
> Contain the vital elements
> Upon which all life depends.

Old southern mansions, once so wealthy and so beautiful, are now only beautiful in their decay. Built to last for generations, now sharecroppers live here. The sad, staring face of a young sharecropper girl haunts our memory: she looks half-witted standing idly beside a crumbling pillar. Another skull of an old mansion on the bleak hillside.

> It is here, in the old Cotton South
> Where our great Southern culture grew up,
> Grew up on this land
> Which was once so rich and beautiful,
> Once so marvellous for its vigor;
> But a culture that grew up on two great soil-wasting crops—
> Tobacco, Cotton;
> And the land, year after year,
> And generation after generation,
> Was beaten.
> It is here that we see what erosion,
> What the loss of the soil can do!
> When soil fails, life fails.

The decayed ruins of what was once a fine old mansion; Spanish moss blows gently in the wind. Slowly the tall doors of the house are opened. An old, old Negro comes out. He walks across the hen-pecked forecourt and approaches an old plantation bell. He dusts the bell and slowly touches the clapper to its side. He looks around questioningly.

> In one ruin of a house
> We came upon an old Negro
> Who lived there alone,
> Along with the rats.
>
> He didn't seem to know we were there.

No answer comes from the decayed, deserted mansion. Only the Spanish moss blows. Only a skinny chicken pecks on the pillared porch. The old Negro, murmuring to himself, climbs down from the bell. Slowly he retraces his steps to the mansion. He stops and looks around. The Spanish moss blows. The old Negro goes into the house, turns around and very slowly closes the doors.

> "Where are they all gone?" he mutters.
> "Where are they all gone?"

To Oklahoma—flat, dry, barren land. The dustbowl. Blowing dust and fine sand pile up against a tent and car. Tumbleweed capers away in a whirlwind of dust. A great vista spreads out of the Arkansas River.

> A thousand miles west,
> Here, spread over forty thousand square miles
> Of our Great Plains
> Is probably the most spectacular,
> The most sudden, incredible erosion
> This country ever had.
>
> Millions of tons of topsoil
> Blown away—
> Three hundred million tons in a single storm!
> Farm after farm blown into the sky.
> And more farms,
> More hundreds of thousands of tons,
> Washed into our great rivers—
> Washed, as here, into the fifteen-hundred-mile-long Arkansas.
> Boats steamed up and down this river
> Seventy years ago.
> You can almost walk across it now.

Desert land with barbed wire fences. Black naked land, streaked white with erosion. Cows scrabble for food in the far distance. And more dilapidated houses, on the verge of collapse, stand isolated in the barren landscape.

But the most sinister erosion,
Because it cannot be seen,
Is sheet erosion.
The gradual wasting, grain by grain,
Of nearly half of all our cultivated land.

Wasted land,
Wasted rivers.
Nowhere in the world
Has the drama of soil destruction
Been played so swiftly.
And on so great a stage.

We enter along the main street into a deserted ghost town. Shacks lean crazily sideways. Broken-down wagons and rusting machinery stand by derelict sheds. A starving cow, its bones sticking out of its hide, its eyes rimmed with black, crops at the stunted bush. It can hardly drag one leg after another.

We came to a town that cotton farmers founded
Not so many years ago.
Go Forth, they called it,
Go Forth, Texas.
It died with the soil,
It died with the sort of farming
That kills the soil.

Three old people, migrants, an old man, his wife, and a young man squat round a fire, trying to warm themselves in the early dawn. They are just passing through. Their car-trailer, looking like an old covered wagon, has a chair tied on the back. The old woman's face is pitted with poverty. The starving cow stops to stare at us: then it hobbles away.

At the edge of the town
We came upon a scene
That is part and parcel of eroded land—
Migrants—landless, homeless people.

They had fire—but no food.

*A recapitulation of the beginnings of erosion. A tiny, trickling stream grad-
ually gets bigger until it cuts through its banks. Gullies are formed and
eventually the hillsides are eroded. Billboards are erected on the useless
dustbowl land—advertising this, selling that—but to whom? Migrants
have no money. And over all and all the time, the fine dust blows.*

Once a soil begins to go, it is hard to stop it.

In three hundred years
We conquered a continent
And became the richest nation in the world.
But our soil we squandered,
Squandered at such a rate
That in less than a century,
If we go on as we have in the past,
The days of this nation's strength will be numbered.

"If my land cry out against me,
Or that the furrows thereof likewise complain,
Let thistles grown instead of wheat,
And cockle instead of barley."
Job said this, more than two thousand years ago.

*Encampment of migrants beside the road—with bleak, tired faces and hol-
low eyes. Some of them look up at us, as if they are animals being stared at;
and then they look away. A mother prepares food for a girl sleeping under
a tent attached to a battered Model T Ford. A thin little girl moves her hand
in her sleep. Families living on wheels—in broken-down cars and old
trailers. The Wilder family of eight—seven of them children—live in this
old trailer. Their Ford is completely collapsed. A little ragged boy stirs beans
in a pot and upsets them. A little blond girl chews gum. Another little boy
has his arm in a sling. Their father sits on an upturned box absently smok-
ing a cigarette. They have no mother. They have been living this way—"on
wheels"—for six years.*

A family of eight lives in this box of a trailer.
Some of them were born in it,
Born on the road.
They make the best of it.
Work is what they want—any kind of work.
Along our highways
There are more than a million
Homeless people.

*Outside a cabin, a man leads horses drawing a wagon. Another man
crouches in the shade, watching. A third man leans against a tree; watch-*

ing. The father begins to load the wagon with bits and pieces of furniture from the cabin. Their Ford has broken down for good. The mother nurses a baby. A little boy plays with a scooter. When the wagon is loaded and the family has clambered onto it, the father takes the reins. For a moment he looks back to what was their home, from which they have been evicted. They couldn't pay the rent any more. The wagon drives away. The cabin door stands open. The Model T stands derelict. A broken chair and a doll are in a corner of one of the rooms. The wagon disappears into the distance. The man leaning against the tree stares after it.

We came to this family moving out:
The land had played out on him, he said.
Most of the migrants are young people,
With young children.
We had another name for these people once:
We called them pioneers.

Heading west—
That's where most of them go.

Great vistas of empty desert, with low hills on the horizon. A few stunted cactus. A solitary steer. A distant train sends out a plume of smoke across the sky. A big mountain stands across the valley. Twisted trees stand up from a plain.

America! The New World!
Three hundred years ago
This cry rang through Europe
To lift the hearts of the defeated,
The persecuted, the dispossessed.
A new world,
A new chance to live.

Migrants fill their Ford roadster up with water from a ditch. Three of them are packed in front. Two girls are in the rumble seat. Their license plate says they are from Oklahoma. A mattress is on the car's roof, and a tractor behind. Another car with O.K. daubed on it drives away. The trees and fields pass by. Now they are big, rich, irrigated fields belonging to big corporations. Many cars and trailers, most of them at breakdown point, jam-pack the dirt roads.

Arizona!
Forty-niners who passed through this country
Couldn't see how even a coyote could live in it—
No water.

But engineers came in not so long ago.
"We'll get more gold out of this country," they said,
"Than the forty-niners ever dreamed of."

They went into the mountains,
Built dams, and impounded it—
Great reservoirs of water!
Water, and sun that never fails—
Four crops a year!

A roadside fruit stand, with prices showing how cheap the fruit is. Empty baskets and idle boys are at the edge of a vegetable field. Groups of migrants on the roadside by the fields look for work, too. Men and women, young boys and girls. A bunch of men play dice. A man leans against an auto. A variety of license plates shows where they have come from. Not one state, but many.

Fruit—a boxfull for the price of a dozen!
On they come
From almost every state,
A hundred men for every job.
They come to fields like these,
So rich, such is the magic of irrigation,
There is no end to the bounty they produce.

In a richly irrigated lettuce field, Mexicans bend and swiftly cut lettuces, throwing them up into waiting trucks that move with them down the long rows.

But they go to the lettuce fields
And what do they find?
Filipinos and Mexicans do the work,
For the work is hard, and Filipinos and Mexicans are strong
And can do it better.

In the packing sheds, lettuces go through the crating machine. Hands pluck them off the ever-moving belt. The work is monotonous and hard.

In the sheds—
They might find a job there—packing.
But whether it's in the sheds or in the fields,
It's like a machine—
An endless belt.

Vast carrot fields, with whole families of Mexicans picking at great speed. One man watches them: he wears a hip pistol. He bootlegs them across the border. Children carry empty baskets back and more children stagger under baskets loaded with carrots and beans.

> Down on the Rio Grande,
> On the Mexican border,
> Mexicans mostly do the work,
> Many of them children.
> Their pay is forty cents
> Good pay for a day
> Down on the Rio Grande.

In the broccoli fields, women and girls cut and tie broccoli at a feverish speed. Men carry the full crates to a wagon drawn by horses. Hundreds of acres of broccoli and armies of pickers.

> And here
> Women get the work,
> And glad they are to get it—
> Lucky to get a day, two days', work a week—
> Women who had land and a roof to cover them once.

> Thousands upon thousands on the move
> From field to field—
> One of the greatest migrations
> In all the history of this restless country.

A migrant camp in the heart of a town. Children rummage in the garbage. Tents, trash, and inevitable broken-down autos. Inside one of the tents an old woman is sewing. She looks down at her little son sleeping in a cot. He is emaciated. His hands move restlessly in his sleep. The woman leans over and strokes his forehead. Then she looks up at us.

> "He thinks he's picking peas," she said.
> His hands keep moving
> Even in his sleep.

Arizona cottonfields. A tent town at the edge of the fields. An empty truck is driven up. Men crowd toward it. They clamber up over its sides. The fields are so huge that the pickers have to be transported to them. The men stand in the truck and stare at us. Indians, Negroes, Mexicans, whites. . . . One Negro smiles at us. The loaded truck drives off.

But erosion alone
Is not the cause of all our driven people.
There are other forces at work,
And one, especially,
Much more powerful.
They come for the chopping,
Come for the picking,
Come by the thousands.
The cotton-pickers in our country
Number millions.
More migrants depend on cotton
Than on any other crop.

First in close-up, a new kind of cotton-picking machine noses its way through a cottonfield. It comes up close and passes us, the cotton dropping into the machine's basket. Sinister and robotlike, with only a single driver, one man.

But more powerful than all these millions
Is the machine.
It can pick more cotton in twenty minutes
Than a human hand can pick in two days.
It doesn't pick quite clean enough yet;
It is being perfected.
But who can tell?
One day it may be picking
Every boll of cotton in the world.

An angle-dozer uproots huge tree stumps with effortless ease. A woman and two children come out of a house to watch the angle-dozer push aside two great boulders as if they were toys. Treetops shiver as the angle-dozer appears. The trees crash onto us and are pushed away by the giant machine. Nothing can stand in its way, it seems.

An acre cleared in an hour—
That's how fast it goes.
The man who drives it owns it.
He clears his neighbors' farms with it—
Charges five dollars an hour—
Clears anything you like.
Multiply this monster by ten thousand—
Take it to some new state in the world.
With such an army

You could clear the ground for a great new country
In no time at all!

A truck deposits empty boxes in a carrot field. A carrot-picking machine pulls up the carrots like a zipper. Filipinos, Negroes, a young white girl, tie them into bundles.

Even for little things
There are now machines.
All they have to do is tie them up.

A grizzled old man—a farmer from Kentucky—stares at us with far-away eyes.

"I ain't had a piece of land for twenty years," he said.
He told us he was a mountain man
From the Cumberland Mountains.

Scenes of the Kentucky mountains: a hillside with wheatfields and the old man's farmhouse. Beautiful animals about the farm—shining horses and a donkey, a rooster and some fat chickens, a gleaming calf, a white horse rolling on the lush meadowland.

"Some of that country is just the same today
As it was two hundred years ago.
The old farm's still there.
My great grandfather built the house;
Had everything a farm ought to have,
Everything a man needed."

An old-time river steamboat, an old-time waterwheel. A man pressing sugarcane and then boiling it for molasses. Finally, a lovely vista of a smiling and serene valley, a wheatfield with heads of wheat against the sky.

Stern-wheelers still running
Up and down the river;
Grist mills still grinding.
It's just an old-time country
With old-time ways.

The scene dissolves back to the carrot field. A girl is listening, a Negro smokes a cigarette, the eyes of the old Kentucky farmer are dim with tears.

I wake up nights sometimes
From dreamin' about it
And wishin' I was there.

*In rich Iowa, the fields are filled with crops and the barns are stacked high
with corn. There are fine fat cattle and hogs. A group of plump bulls turn
their heads to look at us. A man plows with a team of horses. A hay wagon
draws up at a barn. The hay is hoisted in. A team of eight horses stands in a
field. Other teams are plowing. And then a small tractor skirts the edge of
a field.*

This is Iowa.
Nowhere is there better land.
Good cattle, well fed,
Good homes,
Good farms.

But even here in this rich state
There is trouble.
For years farmers have been struggling
With prices too low
To pay for the things they have to buy.
It's been hard for them
To make both ends meet,
To clothe and educate the children,
To pay taxes, to meet the notes at the bank.

Here and everywhere,
So many don't own their homes any more,
Nor the land either.
Almost fifty percent now are tenants,
Living in other men's houses,
Working other men's land.

Horses were working all over the country
Not so long ago.
An area as large as England
Grew feed for them.

But that market is gone,
For today the feed is gasoline
For a machine.

*A huge cornfield. Above the high corn in the distance is seen just the head
of the cornpicker advancing toward us. It approaches like some monster
through the corn until it is revealed in full as it passes close by us—a picker*

and husker combined—driven by one man. Its metal head is reared up like some pterodactyl as it goes relentlessly through the high cornstalks.

And now this machine has come in—
The cornpicker.
You don't see many people in these fields any more,
Even at harvest time.

First, cascades of pouring grain. Then row upon row of advancing giant combine-harvesters. Great armies of wheat machines.[16] *Close-ups of grain streaming from a machine-spout into a truck. A glistening boy shoveling to keep the funnel clear for the flowing grain. The cornpicker again mowing through the cornfield: the giant harvesters on the vast plains—they vie with each other for speed and efficiency in the rich Middle West.*

Out in these wheat fields farther west
You don't see many people either.
Thousands upon thousands
Only a few years ago
Harvested wheat.
Thousands more
Harvested corn.

People are waiting sullenly in the shade—waiting for surplus commodity food to be doled out to them at government relief points. A woman drags away a bag of food. Others carry away bundles. They stand waiting in groups—with hangdog expressions. A girl has her arm round her brother. A starving woman squints at us—the sun in her resentful eyes: her hollow cheeks are black shadows, her expression is agonized, never to be forgotten.

And here they are, some of them,
Crumbs of the machine.
A lame man who had walked in four miles on crutches
Said to us,
"I don't know what some of us would do
If it weren't for the food
The government gives us."

Tall grain elevators reach up to the sky. A Great Lake wheat barge, with its full belly, moves on the water. Cascades of grain are sprayed into a waiting ship. Men work in the grain up to their waists. Boats are tugged in the river. Grain ships head into open water. The giant grain elevators stand in ranks. Everywhere grain flows in abundance. Out in the fields the rows of wheat

machines advance toward us again. Locomotives puff past the elevators pulling wheat-laden trains. Grain pours down chutes into more grain-filled ships, boats, and barges. Abundance is rife—until suddenly—a group of four ragged, emaciated children stare at us accusingly with black-rimmed eyes. Then two others—silent, accusing. . . .

> The yield of fifteen thousand acres of wheat
> In a single cargo—
> The yield of armies of machines.
> During the first World War
> We started bringing these machines
> Out of the wheat-fields;
> And we fed the world.
>
> They drown like rats in a vat, sometimes,
> These men trimming the cargoes of wheat.
> The farmers themselves
> Have been drowned by this abundance.

More pouring wheat and then grain rising up moving elevators into an "ever-normal" granary, its aluminum shining in the sun. Row upon row of these cylindrical granaries with grain being fed up into them.

> To save themselves, our farmers
> Have developed a nationwide system of granaries
> To store the surplus of their important crops—
> Their wheat, their corn, their cotton.
> It was the only way
> They could release their markets,
> The only way they could carry on.
> It is called the "Ever-normal Granary"—
> A vast reserve
> Which now gives us tremendous strength;
> For in the disrupted world we face,
> It is vital as a weapon for our defense.
>
> Here is the Ever-normal Granary
> Of the Corn Belt—
> In every township,
> In every county,
> Bins like these
> Filled with corn.

A shepherd and his dog. The old man wipes his forehead and opens his collar. A flock of white sheep moves across a large valley. A great river of

sheep flows across a hillside. A cowhand on a beautiful horse watches a faraway moving herd of cattle. Snow-capped mountains are in the far distance. Other men on horses ride behind the cattle on the plain. Beef on the hoof. Then grainboats in the river again. Trains shunting in the yards. Wheat machines on the far horizon of the wheatfields.

> Abundance in the mountains—
> Abundance on the ranges.
> We have everything a nation ought to have,
> Everything a nation needs.
> We have the open strength,
> We have the hidden strength,
> Not only for today and for tomorrow,
> But for the centuries of the nation.

A white horse is plowing contours in a field. Two tractors are plowing contours round a hillside. A group of farmers discuss the contour plowing. The contours grow bigger and wider, eating into the fields. From the air, we can see the patterns made by different crops planted in the contours. A whole landscape is now streaked with curving bands.

> A change has come over the land
> In the last few years.
> Farmers are turning to a new way
> Of working it,
> A new pattern—
> New furrow lines,
> New terrace lines,
> To hold the rain where it falls,
> To prevent it from falling into torrents.
> It is a pattern
> That will always hold the soil,
> No matter what the slash of wind
> Or the wash of rain.
> Fields enriched with clover turned under,
> Enriched with lime,
> With phosphate—
> Enriched for the hearts and minds and bones
> Of our children
> And our children's children.
> It is a new design.

We are now back at the farmers' meeting in Pennsylvania where we were near the opening. A farmer is talking about the new methods of contour

plowing: others listen. Some nod their assent. Others join in the speaking. The farmer seen in the opening sequence listens. And finally there is a big vista of contour-plowed land in Texas.

The farmers talk it over.
It looks practical,
It *is* practical.
Six million farmers,
Six million strong,
Are beginning to farm together,
To think together,
To act together.

We see again the stone farmhouse in Pennsylvania. Our farmer and his wife are looking over their land, talking with each other. We see a hillside of black earth with young plants growing in contour formation. A white horse is busy at the spring planting. Young corn plants are shooting up. Last, a close-up of the farmer and his wife.

Down in the Carolinas,
Up in Oregon,
In New Mexico,
Indiana,
Maine,
In the high Northwest,
The Texas plains—
The face of the land made over,
Made strong again,
Made strong forever.
We are saving the soil.
With our fabulous machines
We can make every last acre of this country strong again.
With machines we can produce food enough
To feed the world.

At the farmers' meeting, our farmer is now speaking. Others listen in thought. Then we see once more the people waiting for the surplus food to be doled out—the hungry, the poor, the displaced. Waiting for food—for work—for help of any and every kind.

But what about the people?
These homeless thousands
Our machines have dispossessed,
And the thousands more

Who will struggle on the land.
When will we find the way,
Learn to live with the incredible power we have won—
These miraculous machines.

And now we are back with the great wheat machines, their blades rotating in the sunlight. Row upon row of them advance across the wide plains, as if nothing can ever halt them. Far up in the summer sky, the pale moon hangs like a ghostly silver disk.

The strength of man is not great.
He has not in his arms and back
The strength of a great machine.
But man has a mind.
He can think,
He can govern,
He can plan.
A new world stands before him,
An abundance beyond his dreams.
The great fact is the land,
The land itself,
And the people,
And the spirit of the people.

III: While the officials in Washington were sorting out what kind of a showing to give such a politically embarrassing but at the same time true picture of American agricultural and technological problems, the Japanese came out of the sky onto Pearl Harbor. This made up the official mind in a hurry. *The Land* would not be allowed any general public showing in the movie theaters, but it could have a reluctant and restricted 16-mm nontheatrical release.

Flaherty, however, contrived to arrange a private screening in New York at the annual conference of the National Board of Review, at which it created a sensation. Iris Barry, then curator of the Museum of Modern Art Film Library, thereupon persuaded the Department of Agriculture to allow *The Land* to have a "world premiere" at the museum's auditorium. This screening took place in April 1942.

Helen van Dongen recalls,

Before the "premiere," we had a screening of the first print which had just come from the laboratories. There was hardly time for Bob and I to view it in the Preview Theater at 1600 Broadway. We sat at the big

table at the back of the projection-room, as we had sat so many times before, and stoically and critically looked at every shot to see if the laboratory had done a good job. Groans were now and then audible on my right, but not one word was said. When the lights went up and I gave instructions for the print to be sent across at once to the Museum's auditorium, Flaherty's face suddenly brightened. As if to give me some moral support for the "premiere" which was to follow immediately, he slapped me hard on the back and said, "Now we know. We could go back tomorrow and *really make* this film!" [17]

The audience at the museum "world premiere" was made up of sundry officials of the museum, an assorted covey of New York documentarians, and, of course, representatives of the Department of Agriculture. The last-named group gave some indication of being delighted with the film but became mute when the delicate matter of distribution was raised.[18] The museum premiere turned out to be a hollow gesture because the film was to have no general showing in its country of origin, let alone the rest of the world. After Pearl Harbor the distribution of both the Pare Lorentz films, *The Plow That Broke the Plains* and *The River*, was also curtailed.

Since World War II, screenings of *The Land* have been rare, mostly by film societies in the United States and Britain and at retrospective performances of Flaherty's work. Permission was granted to the Robert Flaherty Foundation (now International Film Seminars) to exhibit the film nontheatrically provided a foreword title was inserted before the main titles as stipulated by R. L. Webster, director of information, U.S. Department of Agriculture. The title reads as follows:

> *The Land* was produced by Robert Flaherty for the Government of the United States in 1940. The film was withdrawn from circulation in 1944. This print has been made available to the Robert Flaherty Foundation in recognition of the historic and artistic contributions made by Mr. Flaherty to the film medium.

The film was not shown outside the United States while the war was in progress, but a fine-grain print was shipped to England in 1942 as a potential source of stock-shot material under the lease-lend arrangement.[19]

It is both sad and ironic that the first film in which Flaherty fully faced up to the sociological, technological, and economic problems of our times should have been so rarely seen. Few reviews of it appeared, and because it is in many ways one of the most important and timeless of all Flaherty films, marked throughout by the burning personal sincerity of its maker, some of the few criticisms that were made of the film at the time are quoted in full here. Richard Griffith wrote:

Pare Lorentz called Robert J. Flaherty "a wandering poet," and it is a simpler and more beautiful description than any of the critics have thought up. There is the grace of poetry on everything that he has done from *Nanook* to *Elephant Boy*, and of all the screen's masterpieces these films are freshest and most alive when seen today. He has been a wanderer in time as well as in place, for the societies and customs he has filmed were one and all left over from the world's primeval past. But now the fascinating arc of his camera's voyage of discovery has swung full circle and Flaherty brings us a film of his own country—the United States.

More specifically it is about the land on which that country is built, and which has seemed in the last decade to be falling away beneath us. For *The Land* is that new kind of documentary which other men have built on the Flaherty form, which does not merely lyrically celebrate a way of life but marshals facts about it, raises issues, dramatises arguments pro and con. Like *The River*, the new picture is a sort of government report on the state of the union—but how much more dramatic, how much closer to us, than any written report can ever be! . . .

It will seem a pity to some that Flaherty, in dropping his old form and adopting the new, should have begun on material which previous films have made familiar. Lorentz's pioneering *The Plow That Broke the Plains*, and his masterpiece, *The River*, have told us before what wind and rain and wasteful greed have done to the soil of our country. *The Grapes of Wrath* has dramatised with heartbreaking power the tragic fate of the thousands of farmers dispossessed by erosion and forced into serfdom of day-labour on the great fruit and vegetable farms of California. A hundred films (it seems) have shown man sacrificed to the juggernaut of the machine. So the movies have made words like erosion, share-cropping and technological unemployment come to life for us before. Now Flaherty does the same job over again, and he has to treat all three subjects at once, so that the film falls abruptly into three parts, with a brief, unemphatic coda which tries, not very successfully, to show what the government is doing to check erosion, stabilise farm prices, and put the farmer himself back on the land he owns.

In short, the picture lacks that wholeness and gradual building toward a climax which have hitherto contributed to the pleasure of seeing a Flaherty film. This is a fractured film, its skeleton is awry, the bones stick out through the skin. But I think Flaherty meant it that way. Edith Sitwell in her poems, Stravinsky in his music, deliberately adopted a jagged staccato form to express the confusion and distress of their vision of the modern world. And Flaherty, travelling through

his own country for the first time in many years, forsakes the graceful smoothness of his "primitive" films for a form which suggests the horror of his broken journey. "Here we saw this," he says, and passes on, but not indifferently. If ever there was a personal film, this is it. It is a cry, a groan; it has for me the terrible simplicity of the Book of the Common Prayer, or the Book of Job, which Flaherty quotes in the commentary. . . .

The images are equally as beautiful and near and part of common experience. Flaherty's relentless camera, Helen van Dongen's editing (her part in the film is a great and important one) make a machine cutting corn into The Machine, cutting lives. And we see those lives, cast off, broken down by the roadside, in the eyes which one starving woman turns into the camera. There is a dulled animal curiosity in those eyes, and some pain because she is squinting against the sun, but hardly anything human any more.

A man who brings his camera to such sights emerges not the same. It is hardly strange that the film is little more than a cry of pain, that Flaherty cannot tell us what to do to help, can only shout at us at the end of the film to do *something*. To many people the tragic beauty of *The Land* will not be sufficient to compensate for the fact that it provides no blueprint. But I have been thinking a long time that films should pose the problem and leave it in the lap of the audience, for it is we who must answer for our lives, not our teachers, not our artists. And I say now that this film is important and perhaps great because it means that Flaherty in the fullness of his years has come back into the modern world, to work alongside the rest of us. All his films and his film-making have been a timeless escape from the terrible vision he thrusts at us here. But for him who is joined to all the living, there is hope. (Griffith 1942:27)

An American film trade paper, having granted some pictorial merits to the film, summed up:

There is much to win eye-appeal. *The Land* is a message for farmers, but it has no place in the motion picture theatre of today. It will be distributed non-theatrically, principally to farmer and grange associations, agricultural schools, universities and students who explore the subject of soil-conservation. As an educational medium for that audience it has value. (Anonymous 1942)

Such curt dismissal of *The Land* as a film with restricted audience appeal was no doubt agreeable to the government department that commissioned it, but it is little short of monstrous. *The Land* had, and moreover

still has, an immensely urgent message to speak to all people in all parts of the world. It contains some of the very best filming that Flaherty ever made. The conception of the theme, complex as it may have been, was a grim challenge to a sensitive artist who had been flayed for having run away from modern reality as it existed in the Aran Islands and elsewhere. Flaherty was deeply aware of his need to come to grips with the problems of modern existence. He may have been politically unaware of the significance of his film, but what he said in it was born out of his sheer common sense and his immense goodwill as a true artist toward his fellow human beings. Having made what was for him a courageous and progressive statement, it was all the more tragic that the film was destined to be so little seen and appreciated.

Flaherty fell an innocent victim to that serious conflict which exists in official circles between the two schools of thought about what constitutes wise national publicity both at home and overseas. This is as true today as it was then. One view holds, "We have a problem in our country: no one must know about it at home (except those involved) and especially not abroad: we must keep it undercover." The other view says, "Sure we have this problem but, okay, we are facing up to it, doing something about solving it so let both our people at home and people overseas know openly that we've got the job in hand: they'll respect us for it."

The first view is, of course, nearly always that of the cautious, official bureaucrats, who would prefer to sweep the dirt under the carpet rather than clean it up. This is basically an authoritarian, antidemocratic attitude of suppression. The second view is the liberal, imaginative, and democratic approach to recognition followed by constructive action. There is no argument as to which is the better mass psychology from a public relations point of view. But it was clear which attitude would win over the showing of *The Land*[20] (Rotha 1952:217–26, 241–51).

When seen today, Flaherty's film has a vitality, a dynamism, a ring of sincerity nonexistent in some of his other films, despite the claim to timelessness which is so often made on their behalf. In his own special way, on his own home terrain (and this is particularly significant), Flaherty expressed for the first time in a film his deep feelings about the wrongness of contemporary life. Those journeys across the states had ripped a veil from his keen eyes. He saw for himself in a way he had not seen before what poverty and degradation could do to people—not in Samoa or Ungava or Aran or Mysore but in God's own country—the richest country in the world.

Griffith writes of the style of the film as being closely akin to the orthodox documentary of picture and commentary as developed in the 1930s on both sides of the Atlantic. *The Land* was far more than that. It was far from being an impersonal collection of visuals commentated upon by a

once-removed Voice-of-God narrator. The very fact that Flaherty himself speaks the admirably written narration, and speaks it with a poignant emotion straight from his heart, is tremendously integral to the whole film.

It is regrettable that technical deficiencies in the sound recording did serious damage to the film. Both the original recording of Flaherty's voice and the final mixing of the voice track with that of Arnell's music were disgraceful. The balance between the voice and the music is ill-kept, and at times the very words, maybe not delivered too clearly by Flaherty in the first place, are obliterated by the volume of the music.[21] Worse still, even after several screenings, it is still difficult to hear all that Flaherty speaks; not until one can read the narration are all parts of it intelligible.[22]

Confirmation that what Flaherty saw for himself during his expeditions across the states deeply affected him is found in Grierson's obituary of him:

> Yes, in one film he did face up to the modern facts of life, but only, I think, after the hard schooling of six years with us in England. He returned in 1939 to America to make *The Land* for Pare Lorentz. The spirit of FDR was over the nation, but, more particularly, there was in the White House a regime of personal patronage of the arts that had something of the flavour—strange and distasteful in America—of the Medici. Even at that distance, Flaherty had found the squire-archic environment to which he was attuned. I never knew a man more excited; from all over the continent and at all hours he would telephone to an old radical like myself how—and you would think it was for the first time on earth—he had discovered this poverty and that. The little Negro boy shelling peas in his sleep was a moment in Flaherty's education like the bursting of a bomb; and with it went the first fine careless rapture—surely unique for an American in 1939—of discovering the efficacy of the machine.
>
> Among other things, it was his quite personal discovery that it could do away with poverty. He told me so himself on a famous occasion. We had as usual dined rather well. Perhaps I was slower in sympathy than I should have been; perhaps I had heard it before somewhere; perhaps I had lived through some of the disillusionment of the original Industrial Revolution on my own Clydeside. I did no more than grin, but the old boy caught, as ever, the red light of a world to be thought out as he natively hated to think it out. Here he was in his big rich liberal moment, and still I seemed to be telling him that things did not happen thataway. He was on his feet with anger, his fists in the air—and with those shoulders of his he could in his earlier days look as big and wide as a sort of handsome blond gorilla, "My God, John, you don't realise it, but some people starve in this world." I rose to it but did not compete with the Man against the Sky. "That's

what I've been trying to tell you, you stupid old bastard, for twenty years."

I forget how long this particular silence lasted, but it was happily not as long as the one after *Man of Aran*. (Grierson 1951a)

Griffith tells us that Flaherty always continued to hope right up till the time of his death that *The Land* would one day find its audience.

> In the post-war world that has been, if anything, less possible than during wartime. Agricultural employment continues high, and, despite disturbing warnings from those who should know, our policy continues to be to plant every inch of land in order to feed an increased population, plus as much of the rest of the world as may be. Viewed against the background of our current thinking and doing (1953), *The Land* seems fantastically out of the argument, and today it is almost a forgotten film. . . . The loss of the soil goes on, whether we choose to recognise it at the moment or not. And this outcry against the loss of the land, which Flaherty loved as he loved all the elements of life, may yet seem to us a patriarchal warning. (Griffith 1953:142–43)

We hate to disagree with, of all people, Richard Griffith, but we must state one quality possessed by *The Land* which is more important than any other—the international significance of its themes. The despoliation of the earth and the rape of the land, the technological revolution in method brought about by the machine and the displacement of the old labor force, are gigantic problems that still face not only the American people but the peoples of every nation in the world today which depends for its existence on the soil. Are there any that don't? In 1959, it was still possible for the Food and Agriculture Organization of the United Nations to estimate that two-thirds of the world's population was not adequately nourished and that world agricultural production was not increasing in proportion to the increase in world population.

It is true that *The Land* offers no easy solutions—except that contour plowing can fight erosion and more efficient storage methods can rid the farmer of his fear of overproduction—but confused as its thinking may be, the film puts forward in understandable human terms basic problems facing mankind—problems still very far from being solved, least of all by the United States. The message of *The Land* is as vital and urgent today as when it was made twenty years ago.

Possibly the refusal to let this powerful film be widely released lies deeper than Griffith implies? If its emotionally stated questions—and the narration ends, we should remember, by posing them—stimulated people to search for the answers, such answers might not be acceptable to the

present American way of life. Flaherty in his film says much the same thing as was said some years later in *The World Is Rich*, and that film met many obstacles to being generally released, even on the part of the government that had ordered and approved its making.

IV: In 1938, Mrs. Flaherty, convinced that a new world war was about to break out, had returned to the United States. She had made up her mind that they should for the first time in many years possess a solid home of their own, which they had not had since the days in New Canaan. So, on November 12, 1938, she signed the lease for an old and somewhat dilapidated farm property set in magnificent wooded surroundings on the side of Black Mountain, near the village of Dummerston, near the town of Brattleboro, Vermont.[23] She set about putting the house into a habitable state so that a home would be there for Flaherty when he came back from England. That the odyssey should have an appropriate symbolic ending, she had the text "Wander No More" translated into Gaelic by the Boston Public Library and hand-lettered over the fireplace.

Things did not quite work out as she hoped, however. As we have seen, no sooner was Flaherty back in America than he set off, accompanied part of the time by his wife, on the twenty-thousand-mile trip that was to provide him with the material for *The Land*. But after the debacle that marked the completion of that film, he returned for a time to the farm at Black Mountain, where Richard Griffith visited him in May 1942: "He had no prospects at all, and was trying his best to listen to Frances's persuasions to retire and spend the rest of his life on the farm. (He was then 58.) I don't remember whether it was then or later that he said to me, 'I'm too old to lock horns with you young bucks any more. I'll have to go off and graze by myself.'"[24]

In early June, Griffith went into the U.S. Army but in a few weeks was seconded to the newly formed War Department Film Division, headed by Frank Capra, the well-known Hollywood director.[25] Writes Griffith,

> And when I got there on June 27, there was Bob! He said he'd come down to "put balls on the war effort." In fact, Flaherty had been brought together with Capra by a young man who had made some films for the Department of Agriculture and who was also anxious to join the Capra unit. Capra, with no previous knowledge or experience of documentary film work and unsure maybe of his footing, was keen to reach out for superior experience. "Incidentally, rejoice," wrote Eric Knight who was also working at the unit, "Old Bob Flaherty is with us, too, and out on a job of work—a big job. We took him to a

conference lunch and Bob was so good that the fine old Irishman shook his head like an innocent baby when a cocktail was suggested. Sure, think of that, now! Bob's knowledge and skill will be a great aid, and since his major fault is overshooting, we're all right, for we can use almost all footage these days." [26]

They got along all right, Bob and Capra, but the thing was doomed from the start. Nobody really knew what to give Flaherty to do. At last Eric Knight (I think) invented the idea of a weekly newsreel, to be called *State of the Nation*, a coverage of the home-front intended to be shown to civilians in the public theatres and to soldiers in the camps and overseas. This idea seemed less preposterous then than now: we were all new to the job and were very green and floundering around. Since at that time Capra had no professional film unit at Washington, he borrowed one from the U.S. Signal Corps, who were always our rivals. . . . It had been trained under Colonel W. B. Gillette, who had been in the Signal Corps for years, and whose idea of making military training films was that they were made in a military way—by numbers.

Thus when Flaherty (who went off with this unit) wanted to give instructions to his cameraman (a corporal), he had to do so through the unit manager (a second lieutenant)! You can imagine the results—constant bickering, with nearly all issues referred back to Capra and Gillette in Washington for a solution which resulted in further festering the feud between the Signal Corps and us. However, Flaherty worked away all through July, August and September, filming defense factories, parades, war bond drives, all that sort of stuff, all over the eastern United States. When his rushes came through to Washington, the editors—newsreel or Hollywood trained—were completely baffled. I remember one of them saying to me, "Flaherty sent us a shot of a man throwing a ball at a pile of ninepins, but he ain't sent us a reverse angle!" [27]

In August, Colonel Capra moved his unit to the West Coast, where all film activity tended to center. Flaherty was thus more and more isolated. In addition, Capra's own troubles began to mount. After nine months on the job, his unit had not completed a single film. The snipers in the Signal Corps and the Pentagon grew bolder. Something had to give. The Flaherty situation was the chief source of annoyance. So Capra decided to jettison both the newsreel project and Flaherty. He did it by remote control. Major Leonard Spigelglass (a Hollywood scriptwriter) performed the task. A year later Bob Flaherty ran into Frank Capra in a New York bar and said, "You know, Frank, I don't know which I hate worse, you or the Japs!"

Later, the newsreel project was revived—under Major Spigelglass—

and became the successful *Army-Navy Screen Magazine*, but by then Flaherty was back at the farm in Vermont eating his heart out and idle. In hindsight, Griffith adds:

> Something in fairness should not be overlooked: to a degree, Flaherty sabotaged himself. And not only in the familiar way of refusing to compromise in his methods. Let's face it, his heart was not in it. In spite of his jokes about adding to the virility of the war-effort, he loathed all war propaganda, however innocuous, and hated being part of it. There was also the simple stupidity of putting a man of Flaherty's gifts and caliber to work on a newsreel.[28]

The Flaherty footage was given by Capra to a young editor, who grouped it into subject sequences and then it was let slide. A year later, while Griffith was in Hollywood, he screened all the material, including the sequence assembly and all the outtakes, wrote a rough script around it, and asked Capra's permission to try to make a feature out of it. Capra agreed, but Major Anatole Litvak, who was just starting his *Battle of Russia* epic, requested all of Griffith's time for solving stock-shot problems. Griffith writes:

> I never did get the Flaherty footage into my cutting-room, where I could have worked week-ends and nights on it. Probably the footage still reposes in the Army's vaults at Astoria, if it exists at all, but this is *not* the story of an unacknowledged masterpiece going down the drain. There were, of course, flashes of brilliance in the shooting— chiefly camera-movements and often subjects unrelated to the theme. There was an idea somewhere behind it all that might have been developed but—his heart was not in it. Most of the shooting was frankly as undistinguished as—well, newsreel.
>
> I think it should be borne in mind that Bob was wholly out of tune with the mood of the country and most people during the whole war. That was one, but not the only, reason why he didn't get a job with the Office of War Information, or one or other of the war agencies. He wanted, very much, for them to hire him—but he didn't really want to do the kind of work involved. That's all there was to it.[29]

About this time Mary Losey quotes Flaherty as saying about propaganda films, "Some day we will wake up and discover that it takes more than machines to win this war: it also takes people" (Losey 1942).

The next three years, Flaherty was to suffer the unhappiest period of frustration in his whole life. He remained at the farm in the shadow of Black Mountain, silent and unhappy—though never bitter. The lovely surroundings may even have increased his frustration. He may well have felt

cut off from those who knew him and his work. When funds permitted, he would slip down to New York, stay at the old Concord Hotel on Lexington Avenue, frequent his old haunts at the Coffee House Club or Costello's bar, and remain there until the money ran out and he had to go back to the farm. He never referred to the latter as his real home; it was always "Frances's farm." And when he was there, he was forever on the telephone trying to devise some means of getting back to the city.

Around this time, Grierson recalls Flaherty telephoning him from the farm to the Warwick Hotel, New York. Grierson was on his way back to the National Film Board (of which he was then commissioner) in Ottawa, but Flaherty pleaded with him to break his journey at Brattleboro. He also added that he would welcome a little liquor. So Grierson bought a cheap fiber suitcase, called at a liquor store, and loaded up the case with a fine variety of brands of Scotch. At Brattleboro, he was met at the station by Mrs. Flaherty, who was curious to know why the suitcase was so heavy. Grierson promptly said that it contained some films he was taking back to Canada with him. That evening, both before and after dinner, they did good work with the Scotch in Grierson's bedroom until finally Flaherty rolled away to bed. Some time later, Grierson was wakened by a great noise from the direction of the Flahertys' part of the house. Suddenly the door of his bedroom opened and Flaherty stood there. "The trouble with you, John," he says, "is that you drink too much."[30]

In 1942, Flaherty had sold the "Bonito the Bull" subject to Orson Welles, although he had partially adapted it for *Elephant Boy*. According to David Flaherty, the deal was made during a telephone call between Flaherty in New York and Welles in Hollywood. Welles paid $12,000 for the story.[31] He incorporated it into a documentary trilogy with the title *It's All True*, the Flaherty episode being directed by Norman Foster and called *My Friend Bonito*. The three episodes were shot on 16-mm Kodachrome (for later enlargement onto 35 mm) during a Latin-American tour made by Welles and underwritten to the sum of $300,000 by the Office of the Coordinator of Inter-American Affairs, whose head was Nelson D. Rockefeller. RKO had undertaken to release the film, but its editing was never completed.

To Flaherty in 1942, Welles's purchase of the story was a godsend. Only a few irregular royalties had been coming in which, with Mrs. Flaherty's modest income, kept things going in a quiet way. But it is an ironic comment, wholly characteristic of the film industry, that a man who had demonstrated for all to see that he could use a movie camera in a unique and personal way should remain for so long with no demand for his skill and experience. Nothing is more hurtful to an artist who has proved himself than to feel that neither he nor his work is wanted.

If sponsors and producers of films passed him over, however, the admirers and friends of Flaherty did not. *The National Board of Review Magazine* (retitled *New Movies*), which had always stood by him, devoted

its January 1943 issue to a tribute to him. Under a heading, "Salute to Robert Flaherty," its editorial ran:

> The year just ended is the twentieth since *Nanook of the North* was released. It is a civilized thing to take time in these days so crucial for humanity to salute a man whose character and art have worked together so powerfully to reveal the fundamental human dignity of mankind. During all this score of years the National Board of Review has looked to Robert Flaherty as one of the foremost justifications of its faith in the motion picture, as an art and as a means of communication through which the peoples of the world may reach and understand each other. And he has always justified that faith. Fortunately he is in the prime of his powers, and we can expect even more from him than he has done already. Those who do not know him are unaware of one of the finest creative spirits of our time.

In the main article, headed "Flaherty and the Future," Richard Griffith wrote:

> For a long time now he [Flaherty] has been looking forward to the future and what it will bring for ordinary men and women, turning over in his mind a film about the Machine, man's blessing and bane, which was partly responsible for the wrecking of our recent past and which holds out so much hope for the future. But not alone do the movies need Flaherty today for this picture and the others he can make. What is needed more is a new respect for his quality and character as a filmmaker. We might even forget for a while his brilliant way with cameras, and imitate instead the adventurer in him, the explorer who, like a child, finds newness and beauty in every ordinary thing, who sees the world and its creatures with a wondering and sentient eye, and finds in its exotic diversity one final unifying thing— our common need, our common hope.

These noble tributes must have lifted the morale of the man at Black Mountain farm. But, as any out-of-work film artist knows, one cannot live on prestige, salutes, and tributes no matter how sincere, fulsome, and well-intentioned they are. What Flaherty wanted was not so much admiration and respect as an honest-to-God film to make. As he once said, "Prestige never bought anyone a ham sandwich."

Two more years went by before Flaherty was again associated with the medium he had made so much his own. In 1945 funds were made available for him to shoot some footage at the Museum of the Rhode Island School of Design. It was to be about the John Howard Benson technique of calligraphy. Shot on black-and-white 16-mm stock, the film was never com-

pleted, but a screening of a large proportion of the unassembled footage indicates that most of it dealt with lettering by hand with a reed pen, which was shown being made. It is probable that the film foundered because of the clash of two strong personalities—John Howard Benson and the film's director. The raw material as viewed did not reveal anything of any interest.[32]

In 1944, the Sugar Research Foundation sent Flaherty on a tour of the sugar-producing areas of the United States. He was asked to write a report on how the foundation might use films. At a later date, his report was adopted and Flaherty undertook to supervise three short educational films to be directed by his brother, David. The first was a one-reeler, *What's Happened to Sugar?*, mostly stock shots about sugar rationing with only two days of fresh shooting done by Boris Kaufman. The second, *The Gift of Green*, a two-reeler in 16-mm color, was about photosynthesis and was made under the auspices of the New York Botanical Garden, also photographed by Kaufman and edited by Helen van Dongen. Kaufman recalls that Flaherty astonished the experts at the Botanical Garden by knowing— or at least appearing to know—more about the subject of photosynthesis than they did.[33] The third, a three-reeler also in 16-mm color, was *Crystal of Energy*, and it gave a general survey of the sugar industry—the planting and harvesting of cane and beet sugar in the United States, Cuba, Puerto Rico, Haiti, and Hawaii; the refining; and the many and varied uses of sugar not only as a food but in medicine, science, and industry. Flaherty took the credit as producer on all three films, which were very successful.

At about the same time the Sugar Research Foundation approached him, the Standard Oil Company of New Jersey contacted Flaherty about a project which, although it took the best part of the next two years to mature, was to provide him with an opportunity to make another major work of art.

Louisiana Story : Chapter 6

I : Flaherty tells us how, in 1944, he began his next project:

It was a day in spring. . . . I was resting on my farm in Vermont with no particular plans in mind when a note came from a friend of a friend of mine in the Standard Oil Company of New Jersey.

The note put a proposition to me: Would I be interested in making a film which would project the difficulties and risk of getting oil out of the ground—admittedly an industrial film, yet one which would have enough story and entertainment value to play in standard motion picture houses at an admission-price?

On my next trip to New York, I had the first of a series of luncheon conferences with people in the Jersey company. In the course of these luncheons they managed to communicate to me some of the excitement and fascination that surrounds the oil-business. The upshot of it was that I agreed to spend three months finding out whether I thought I could make an interesting picture about oil.

Mrs. Flaherty and I set out in our car for the southwest. We drove thousands of miles. We visited boom-towns and ghost-towns and listened to tales spun by old-timers. We found limitless plains dotted with derricks. But we kept reminding ourselves that even in Westerns, horses galloped. In the oil country the derricks stood straight and rigid against the sky. Nothing moved. We couldn't get it out of our minds that the real drama of oil was taking place deep in the earth at that very moment, concealed from the eye of the camera.

In the course of our wanderings we came to the *bayou* country

of Louisiana. We were enchanted by the gentle, gay and picturesque people of French descent who inhabit this little-known section of the United States; a people who have managed to preserve the individual flavor of their culture. We were delighted with their customs, their superstitions, their folk-tales of werewolves and mermaids, handed down from generation to generation. But we weren't getting any closer to a film about oil.

Then one day we stopped the car for lunch near the edge of a bayou. Suddenly, over the heads of the marsh grass, an oil-derrick came into our view. It was moving up the *bayou*, towed by a launch. In motion, this familiar structure suddenly became poetry, its slim lines rising clean and taut above the unending flatness of the marshes.

I looked at Frances. She looked at me. We knew then that we had our picture.

Almost immediately a story began to take shape in our minds. It was a story built around that derrick which moved so silently, so majestically into the wilderness; probed for oil beneath the watery ooze, and then moved on again, leaving the land as untouched as before it came.

But we had to translate our thesis—the impact of science on a simple, rural community—into terms of people. For our hero, we dreamed up a half-wild Cajun boy of the woods and bayous. To personalize the impact of industry, we developed the character of a driller who would become a friend to the boy, eventually overcoming his shyness and reticence. The other characters in the film developed naturally around these two. All the parts would be played not by professional actors but by people who had never faced a camera. . . .

The story almost wrote itself. We shot it up to New York and got an okay from Jersey's board of directors. Only at that point did we make a definite deal to go ahead with the film.[1]

In their customary manner, the Flahertys established themselves and the unit in Abbeville, Louisiana, in an old rented house. They converted a vast closet in the house into a darkroom, turned the front porch into a makeshift cutting room, installed a silent film projector, and acquired both a station wagon with a camera platform on top and a cabin cruiser to move around in the bayous. For one of their most important locations they were loaned the use of Avery Island, which was owned by Colonel Ned McIlhenny, an internationally known explorer and sportsman. It is one of the showplaces of the South, a magnificent preserve teeming with wildlife, including alligators. For the oil derrick and drilling sequences, the Humble Oil and Refining Company (a New Jersey affiliate) put at Flaherty's disposal the crew of Humble Rig Petite Anse No. 1.

As in all earlier films, the first task was to find the main characters. The

company broke up into parties and searched the countryside for types which Flaherty had in mind, taking hundreds of still photographs of likely people. They were looking mainly for the boy and his father. Flaherty writes:

> Mrs. Flaherty and Richard Leacock, our cameraman, heard about a promising boy in a remote parish, and decided to drive over and have a look at him. On the way they stopped at a cabin to ask directions, and there, staring at them from a photograph on top of the radio-set, was the face of Joseph Boudreaux. . . . But Joseph had gone to the nearest town for an ice-cream cone, walking the twelve miles barefoot. My wife and Ricky immediately got into the car and went to look for him, afraid to get too excited until they had seen the necessary tests. They found him resting on a curbstone, took the necessary shots, and hurried home.[2]

The tests were highly successful and so Joseph Boudreaux became Alexander Napoleon Ulysses Latour for the purpose of the film. "From that time on," says Frances Flaherty, "Bob was insistent that no one should show any affection for the boy except himself. He wanted sole control over him, as he had done with Sabu and Mikeleen."[3] To play the boy's father, Flaherty settled for Lionel LeBlanc, an experienced trapper, who was also the overseer at Colonel McIlhenny's estate. For the part of Tom Smith, the driller on the oil derrick, they found a "natural" in Frank Hardy, a Texan, who was one of the crew of the Petite Anse No. 1.

Before leaving New York, Flaherty signed up the editor, Helen van Dongen, who was also to act as an associate producer, a combined status that gave her more say over how the picture should be shaped and shot.

Flaherty had hired a professional cameraman to shoot the picture. Richard Leacock, however, was not a tough professional of the Hollywood school but a sensitive and modest cameraman who at that time had done notable work on some documentaries, mainly in the eastern states.[4] Flaherty had wanted to use Osmond Borradaile, who shot *Elephant Boy*, again, but Borradaile was already committed to go to Australia to shoot *The Overlanders* for Harry Watt.

For all the silent shooting, which was by far the greater part of the film, Flaherty and Leacock used two Arriflex cameras. A Mitchell sound camera was brought down for the synchronized dialogue shooting at the end. This time, however, processing was not to be done on the spot but the exposed negative was sent to the Pathé Laboratories in New York and the rushes returned to Abbeville a few days later, the negative being retained at the laboratory.

The contract with Standard Oil was unique in the history of sponsored documentary films. The company paid in advance the sum of $175,000, the

estimated cost of the film. Flaherty was to be the sole owner of the distribution rights, with no obligation to refund the cost of production and with absolute control over all revenue. No reference to Standard Oil need appear on the titles of the film. It was to be a Robert J. Flaherty production. The company would be satisfied, in a highly imaginative public relations manner, with what editorial publicity it might reap from the film when made. It was without question the most generous and favorable assignment any producer of documentary films has ever had. But who shall say that Flaherty did not deserve it? He had waited long enough for such confidence in his artistry.

Richard Griffith remembers that Flaherty called him up just before taking off for Louisiana and said, "Come on down to the Colonial Trust Company's Bank and help me berth the check. You can't just deposit it in the ordinary way—it's too big. I need some tugs to help me roll her into the slip. Come along!"[5]

Production began in May 1946, with tests and material to provide background atmosphere. As on the earlier pictures, the Flahertys had many visitors. One of them, Edward Sammis, an official of Standard Oil, went down there several times and has given a colorful account of what he found:

> Nothing like Bob Flaherty had ever happened to Abbeville. . . . Bob and the Abbeville folk had an immediate affinity to each other. They were "Cajuns" (a contraction of French Canadians) by lineage. They were imaginative, poetical, a race of story-tellers who would describe to you the depredations of werewolves in as matter-of-fact a manner as city people might speak of the atom bomb.
> The Flaherty's [sic] had moved in . . . to a cool and cavernous old house on the edge of the town. I don't think anyone ever counted the manifold rooms. Certainly no one ever counted the guests that inhabited them, a heterogeneous lot, drawn from all over the world by the warmth and compulsion of Bob's personality. . . . One night there would be no one at table for dinner, all having vanished into the vastness of the bayous. The next, there might be seventeen, appearing as suddenly and mysteriously as the guests had disappeared the night before. The talk at that long table was of life in London and New York and Paris and Tahiti and Mysore; of films and stage and actors and life, and the dubious fate of man on this difficult planet. There was always the guest who had flown in from Shannon that morning on his way to Honolulu, side by side with the trapper from the bayous and the oil driller just off his rig. Bob saw to it that each had his turn with a tale, which gave to the conversation an extraordinary richness and flavor.
> Bob's day started about five in the morning, and with it the day of

the whole caravanserai. The night before, right after dinner, he would have started sniffing out the weather, listening avidly to reports on the radio, going out to study the clouds. "It's going to be fine tomorrow," he would invariably pronounce, "Good day for shooting. Luck of the Irish." A few hours sleep seemed to suffice him when he was working.[6] He would go through the house roaring at everybody to get to bed. Then he himself would sit up, reading, half the night. Again his voice was the first one heard in the morning, bellowing at everybody to rise and shine. . . .

Every trip down the bayou was a new adventure, every coral snake on the bank, every trapper's shanty, an unending source of fascination. "Location" was a fabulous long shanty built on an island, on a peak of clam shells, and known as Trapper Jake's place. Bob rented it from Trapper Jake, who moved further down the bayou for the location. Watching the shooting in that cabin was a memorable experience. . . .

Bob never showed to better advantage than when he was directing dialogue. The silent film was his natural medium, but here he had to make actors overnight out of reticent, shy people. . . . The end of the day would find the actors exhilarated and Bob as limp as a rag. He had sweated it out for all of them. . . .

"Luck of the Irish," he would say afterwards, sitting at his favorite card-table in the living-room of the Abbeville house, a cigarette dangling from his grin, his great frame shaking with silent laughter.

An engaging and typical sidelight was the mesmeric effect Bob had on the local telephone-exchange. He lived by the telephone. It was the instrument that kept him in touch with his cronies all over the world. You would come down first thing in the morning, and Bob would already be on the phone to London. You could hear him bellowing genially, as though to make his voice carry across the Atlantic. "How's the weather over there? You must come over and see us. Fly over. We've got plenty of room." It never bothered him that the house was busting at the seams already. . . .

Bob must have known the toll that *Louisiana Story* was taking, working as he did, day after day in the dank heat of the bayous. But, with his overwhelming confidence in his boundless physical energy, he never spared himself. (Sammis 1951)

Helen van Dongen joined the unit in August. She kept a combined personal and production diary from that date until shooting was almost finished at the end of March 1947. We are able, therefore, to draw on a firsthand account of the production and its problems by quoting selected extracts from this diary.[7]

Abbeville, August 10, 1946: I was greeted by the entire family, official and unofficial, with great glasses of Scotch. Bob and Frances, of course; Barbara (van Inge); Ricky Leacock and his wife, Happy; Sidney Smith, just out of the navy since two days: if he can't get a place in college he'll stay on in one capacity or another; while continually around and forming part of the crew are Joseph Latour,[8] [he is referred to by the initials J.L. all through the diary]—he is our Cajun boy actor, also accompanied by his cousin, Clarence, who takes care of him and is also assistant to Ricky. Then there is Burnell, a little brother of Clarence, who has no function at all but who cried so hard when he heard that his brother was leaving for Abbeville that Flaherty had pity on him and let him come along too. These three live in a boarding-house in the town. Then there is Mr. Herbert, the carpenter, who makes things almost as fast as you can ask for them.

Then in walks Lionel LeBlanc, whose screen-test I already saw in New York. He will play J.L.'s father. A good-looking man, powerful, one of the best hunters and trappers in this part of the country. Later on he told with great care about how alligators were caught. A sequence in the film calls for the trapping of a 9ft. alligator. "I'm not going in the water after him, no sir. If he's on land, I'll see first." Lionel speaks a beautiful, precise, careful English which should be excellent for recording. We screened several reels for him of what had already been shot. Also a reel from *Nanook* in which the Eskimos catch the walrus. He liked it, and undoubtedly understood better than anyone "how hard work it was." After that everyone disappeared to the local movie, while I slept.

Bob's standing joke: "What is the longest distance between two points?" Answer: "A motion picture."

August 12: Screened six reels of unassembled alligator material. Damned old fashioned projection-machine with parallel reels. I ought to join the projectionist's union just for being able to run the damned thing. The screen is buckled and half the silver from the mirror behind the bulb is gone. Bulb too weak and old, giving yellow light. All that with film printed on safety stock which is already slightly brownish. . . .

After dinner, temperature cooled off sufficiently to make working in the outside cutting-room inviting. . . . Fan perpetually going. Moviola not arrived yet. Looking temporally at stuff through a viewer. Very much involved in close-ups of ferocious-looking alligators, hissing and snapping at their as-yet unexisting victim. Suddenly an accompaniment of a Grieg Sonata! For piano and violin. Strangest combination—alligators and trembling violin. When I stole a look, the

artists were Frances and Bob, with Barbara sitting in a corner drawing a picture of her father playing the fiddle. The Sonata continued for at least half-an-hour, with the humidity so great that the fiddle was slightly out of tune. And I think the piano was too.

August 19: New projector and screen arrive. Ricky and Sidney are figuring it out. "Half the work of making a motion picture is opening packages." Suggested slogan to be painted on projector: "Let your light so shine before men that all may see your good works." Lionel LeBlanc signed his contract.

August 20: Shooting alligator going for bait. Alligator grabs bait, gets hook in his mouth, but refuses to put up a fight even though Sidney admitted that he had put a big plank on its tail and was dancing up and down on it to make him mad. Nothing doing. Lionel LeBlanc puts a beam between alligator's jaws and frees him from hook. . . . Moviola arrived.

August 22: While shooting around alligator sequence and everything is at last set, Colonel McIlhenny arrives and tells Mr. Flaherty that he did not want any of his alligators killed—though he had previously consented to have one killed which we would eventually replace. Now what? We'll have to stop shooting this sequence until the problem is solved. In the afternoon, Mr. LeBlanc arrives with his son and nephew. These two will go off for one week deep into the interior of the marshes and catch an alligator, which then will be taken to some place where there is enough water and light to film this scene.

August 28: Puzzle: coon in pirogue (wooden carved-out canoe)—when introduced what does he do? When lost—if lost—how found? Possible introduction when surveyor comes to home of J.L. Coon with family in kitchen. J.L. takes it with him on first trip to oil derrick. Shows it to Tom Smith, the driller. Does not always take it with him because animals are too lively and might distract attention from J.L. Coon in pirogue when J.L. in pond looking for alligator. Disappears when J.L. disturbs alligator's nest. Did alligator *eat* it? Question unsolved. J.L. takes revenge on alligator for eating his coon? Or does J.L. only *think* so? Does J.L. tell his parents that coon has disappeared? Most probably since it is his pet and he broke down and cried in cypress forest. When does coon appear again? Does J.L. go on looking for him? As planned, J.L. gets coon back at end of film. It is Tom Smith who found him and returned him to J.L. But what caused Tom Smith to find coon? Coon got lost in pond or cypress swamp. Tom Smith is driller—has no reason to be in cypress forest, nor would

coon think of going to vicinity of oil-derrick. Does J.L.'s persistence make him find coon himself?

The above entry is typical of many such, all illustrating the countless avenues that were explored for the many action sequences in the film. Despite the merits of spontaneity and naturalism of Flaherty's off-the-cuff method of shooting, it remained a headache for the editor of the hundreds of shots to find a logical way of using them in continuity to express what slight story there was. Thus Helen van Dongen's assembling of the footage as shooting proceeded was a more integral part of the film's construction than in any previous Flaherty film. John Goldman, it will be recalled, roughly edited only the storm sequence of *Man of Aran* while the film was actually being shot. Helen van Dongen's diary continues:

New problem: a new pirogue. Beautiful little thing, only 18 inches wide, hewn from half a cypress-log. It took six weeks to find someone who could make it, after having bought log through oil company. J.L. will now have to learn to paddle it![9] But most of the shooting for introduction of the film—cypress swamp, going around on lily pond and setting bait for and catching alligator has already been shot with the old pirogue! Can we match shots with old and new pirogues at random? *I* don't think so. New one is so much more slender and beautiful. If impossible to match, new pirogue can only be used for unfilmed sequences, but that would leave nothing but the end of the film, which is a pity. Also it will be necessary to find plausible excuse to introduce new pirogue. Or can make establishing shots where both pirogues are visible so that it is acceptable to audience that boy uses both pirogues at random? Only other alternative: reshoot everything with the new pirogue!

Best half of cypress-log unused; first pirogue made from less good part to experiment with. So now Flaherty wants same man to make another pirogue from second half of log and to film the whole procedure. Obviously no doubt that process of making pirogue is of extreme interest and beauty, but Bob wants to incorporate it in the film. "His father is building it for him. Every young boy in the audience will envy him." No doubt, but seems to me at the moment that it means changing the script too much. Are we going to make the same mistakes as Hollywood, cramming six stories and three generations into one picture?

Entire film cannot last more than one-and-a-half hours in my opinion. I want time enough in editing to give each sequence its chance and be able to put suspense in it. . . . We can always film the pirogue-making and make a short little film of it later. But will budget support such escapades?

Went out yesterday to location. Saw place where cypress swamps were filmed earlier, and alligators 1 and 2's nest. Was expecting to be dragged into Louisiana wilds. Instead to Avery Island, Colonel McIlhenny home, branched off to tropical jungle—park with mown lawns and beautifully cultivated flowers and bushes. So the camera never lies? Well, then the artistry of director and cameraman can darned well change location from an appealing jungle back to a forboding, weird and eerie swamp. The cypress swamp, which looks so expansive and monumental on the screen in the rushes, is in reality nothing but a little pool with a few cypress trees!

September 3: Someone dropped a magazine with exposed film in it. This is the second time we'll have to reshoot. Certainly brought R.F.'s disposition to a low point and his irritation brought on first collision. . . .

The frog and salt bag, carried by J.L. inside his shirt as protection against werewolves, appear for first time in film in cypress swamp.[10] They do not appear again until oil-derrick sequence later, when Tom Smith says to J.L., "What are you always scratching yourself for?" *Fundamental principle:* words alone do not carry story line. *Question:* Even though we do not see frog, will J.L. ever scratch himself in intervening sequences to justify Tom Smith's question? Such scratching not to be emphasized as carrying action but seen just enough unobtrusively because the frog is damned well itching him! *Answer:* Complete blow-up by R.F. and disagreeable humor for rest of day, aggravated by Arnold Eagle,[11] who comes in six minutes too late for dinner and is not invited to sit down, and by Lionel LeBlanc who comes in five minutes after that and is told to serve himself a drink and wait in the sitting-room. Both disappear, but without a drink!

September 5: Broke down script into separate sequences to see for myself how much we jump around. Script is *written* beautifully, but very often only just as you would *tell* a story. When it comes to breaking it down in such a fashion that you can *see* how the sequences run, and plan how they should be shot, then you find many discrepancies. Also, very often nice sequences occur with either animals or humans who are supposed to be part and parcel of the life of the character but who appear nowhere before the script. For example, the pet coon does not turn up in the script until much later, somewhere on the oil-derrick, yet the coon is the constant pet of J.L. and is supposed to have been eaten by the alligator . . . also coon is found back and returned to J.L. just before the end of the film—but by whom, and why, and how, and when?

Another thing: as script is written now, Jean Latour (J.L.'s father) speaks the language of simple-minded man, who does not know the value of money. Also, he speaks a sort of pidgin-English translated supposedly from the Acadian French, which is rather primitive in the script. Is this a left-over from behavior of primitive people such as the Eskimos in *Nanook* or the Samoans in *Moana*? This may be the result of Flaherty's writing the script in New York without having had any contact on his research here with real Acadians—therefore this primitive talk.

Yet, since having talked to several of them, and actually having worked with them daily either as actor, or as carpenter, or boatman, R.F. still tells the sequences the same way as they were written. Take, for example, Lionel LeBlanc, who plays the father. He knows the value of money and makes an excellent living with Colonel McIlhenny. He speaks a beautiful, precise, well-pronounced English. If he would sign a lease on his land with the oil company (as in the script) for wildcat drilling, he might certainly think that the oil-people are crazy but he would nevertheless study the contract and lease before signing it—just in case, and when receiving a cheque, he'd know damn well that he could cash it—with or without the Company finding oil! Though money to these people does not have as much importance as it has to people in large cities, they know damn well the value of land.

Eventually these things may get corrected in the film, but the big problem will be to begin a discussion with Flaherty about them. He has a tendency to take every point that is brought up as a criticism, even if presented to him in the mildest form as a question. It is hardly possible to have an exchange of ideas with him, merely in the interests of the film. This is one of the hardest parts of this job. Never a discussion, never an exchange of ideas about incongruities or possibilities or form, for that matter. Never an exchange of ideas about anything, be it politics or a way of living.[12] A curious one-track mind. To get it to change to a slightly different idea is almost the slow process of an evolution.

September 10: Bob and I start screening. At 8 A.M. the projector breaks down for the nth. time. Takes nearly all day to try and fix it. As day progresses Bob gets more and more impatient, approaching Sidney first every halfhour and then every five minutes with, "How's she doing, Sid?" by 5 P.M. Bob's humor is far below freezing point. Better not come too close. I hide in the cutting-room and keep busy figuring out how we can have four alligator sequences and not be repetitious? If this continues, we'll need a 20-reel picture to give oil a chance to tell its story in the last reel. . . .

September 12: Flaherty: The art of the motion picture is the art of exclusion.

September 13: In Memoriam: One baby-alligator—as yet nameless.
 Lost: two possums.
 Rushes of oil blow-up on Avery Island came in. They stink.
 Flaherty repeats again: "To know what to do, you have to know what not to do."
 Everyone gone to the oil-derrick again. Ran all rushes of J.L. tying rope to tree and watching for alligator, and the ones of Lionel rushing up to J.L. and looking at his hands. Exposure problems terrific; high lights too high, rest under exposed. . . . Wish Flaherty would make some shots of J.L. watching motionlessly instead of this continuous head-turning movement. Crew returned at 6:30 P.M. waited all day. Nothing happened.
 [On September 26, Mrs. Flaherty went to New York and Flaherty followed by plane, to see their daughter, Barbara, back off to India.]

September 26: I have now a new job. Am house-keeper and cook: completely new and strange task to plan three meals a day for three hungry guys who eat the strangest of things.

October 2: No meat, no fish, no vegetables, no nothing. Planning three meals a day with nothing to buy in this town. Film-making is a strange profession. Life isolated here. No newspapers, no radio, no exchange ideas. Only diversion: baseball game for which I don't care. Bob returns Sunday. If we continue at this pace, film will take another year-and-a-half. . . .

October 5: Unplaced sequence: J.L.'s pet coon which he takes along when shooting. Sometimes coon does nice things, which are filmed if seen in time, such as towing the pirogue, or climbing trees. We would use these shots in the film but do not know how yet. Thought develops to make coon actor in film. . . . This thought results in shooting new sequence: J.L. looking for coon.
 Editor's note: only two sorts of shots. J.L. running in cypress swamps dwarfed by trees, excellent material, and close-up of J.L.'s face looking around and purring for coon.
 Editor's headache: where is coon?
 Screenings and discussion: now decided that coon is an audience catcher. Should be played up more. How to introduce him? Who finds, and where, and why?
 Believe-it-or-not department: it takes trappers years to learn how to hook alligators and it's a pretty dangerous job. When we planned

this sequence, we decided to have Lionel LeBlanc come in very early. However, on the day of shooting, Lionel was not available and, credible or not, J.L. *did* pull in that alligator alone, though in an unorthodox way. We did *not* stage the scene.

Editor's note: a hell of a way to try making a sequence when still so many shots are missing! No use shooting all facial expressions of J.L. either because we change the plan so often. Vicious circle: no use shooting until story of sequence is right: not possible to edit sequence properly until shots are made! Story won't be good until it runs so simply on the screen that it seems as if it never could have been written otherwise in the first place.

October 20: Mr. George Freiermouth, New York head of public relations department of Standard Oil, arrived yesterday. We showed him about 20,000 ft. (i.e. approximately 3¾ hours of screen time) of organized but uncut material until he was cross-eyed, and generally gave him a good time. He seemed pleased when he left.

Discussion: As usual, Bob does not formulate exactly how he wants sequence but leaves composition of first cut entirely to me. Frances wants much hubbub around that big oil derrick to make it seem overpowering. J.L. in pirogue stays at safe distance to take it all in.

Editor's opinion: I want to take material back to cutting-room and screen it ten times over to myself and to let the material tell its *own* story without additions yet of any foreign material. Once the foundations are laid, one can embellish it. In my opinion, it's no good to start with the frills: you'll find out after a while that you have *only* frills, no floor. In stubbornness, we all match each other well: the Irish, the Bostonian and the Dutch! But what the hell of a spot to put an editor in! Maybe R.F. never intended to become a co-ordinator, diplomat and father-confessor all in one?

October 23: Difficulty of keeping film authentic: sequences such as the catching of the alligator, or J.L. disturbing alligator nest, which are staged and planned by us, could be shot according to a preconceived shooting-script covering the action from every angle, with far shots, medium-shots, and close-ups, in order to have sufficient cutting material. When trying to do so, it turned out however, that the sequence when edited told you that a camera had been ever-present. No matter how naturally and beautifully played, the ever-present camera ruins the authenticity of the scene. Films like *Louisiana Story* should be shot in such a way as if the camera were accidentally present to record the action while it happened without the subject being aware that a camera is present. This precludes automatically coverage from every

angle or with more than two lenses. Obviously this makes the editing of such a sequence sometimes extremely difficult.

Dear Mr. Director:

Please invent some other way of shooting little boy and give him something *to do*. He is always wiggling his head from one side to another and he is always "looking"—looking at alligators, looking at nests, looking at the coon, looking at trees, looking at birds. . . . In one word—just looking alla time. I know we want to tell the story from the boy's point of view and we want to have the audience see things through his eyes. In each sequence separately he is fine. But if you string all the sequences together, I'm getting damned tired of him! Will you please think of something—anything—to keep him busy in the film? I know I am a nuisance, but please think up something. . . .

Your Editor.

December 8: Rushes came in of J.L. crying over lost coon. Not much can be used. Forest looks much emptier than in shots made earlier this season. Not mysterious enough atmosphere. J.L. does not look tired enough. We must also use more glycerine or other medicant to make his eyes look more swimmy. When he looks up (after burying his head in his arms), he should look in *opposite* direction. Shots of alligator eating bird will work very well. They look already evil in temporary cut. David Flaherty arrives on 22nd.

Just before Christmas, Helen van Dongen went back to New York intending not to return to Abbeville. The strain of "collisions" had taken its toll; after one such, she had felt her professional status as the film's editor was jeopardized. After long-distance telephone calls from Flaherty, however, during which he promised that such a situation would not recur, she returned on January 14, 1947, and started editing again.

January 18: Rewriting the script. Some parts better, some not so good yet. Having hard time saying "Yes" all the time, since I'm doing the typing as well. Many sequences changed. Flaherty asked my opinion. Read it all again. As usual, extremely difficult to give honest opinion. R.F. too sensitive to any discussions (not even criticism). I brought up subject of oil-derrick blowing-up. Analyzing script, and putting aside all the oil sequences, we have told the whole story of oil we want to tell, ending with phantasmagoria of oil-world, like dream-world where nothing is impossible. All we have left to tell is that the well we have been drilling brings in oil as climax to our story. However, since this is a film, disaster always strikes just before accomplishment. Therefore, here is mechanically right place to have oil-well

blow-up. Moreover, fading-out on oil-dream sequence and fading-in on people staring at something that presumably happens at the well, then cutting to Tom Smith speaking into telephone explaining to person at other end of line what disaster has befallen them—this gives the whole story away.

Bob violently disagrees. He says it's dramatically correct to show blow-out only at the last moment that creates suspense. I say it does not. You give the whole story away by the mechanical device of a telephone conversation. When you finally do see well blow-up, there is no suspense left. . . . Then will people stop *looking* at this damned picture?

I still do *not* like the letter Jean Latour writes to the oil-scout at the end of the film. I *never* liked that letter. The more I stay here, the less I like it. The trappers here may be illiterate, they may not know correct English, but they are competent trappers. Words like "boss-man at the bank" are in my opinion the sort of pidgin-English always used to make natives ridiculous in the eyes of "superior" white people. It is condescending and uncalled for. If the character of Jean Latour in our film is correct and consistent, it is of no importance whether he can read, write or speak English. The audience would (or should, if the film is any good), accept him as a man who knows his job. They should not take him for a simple idiot who does not know the value of a cheque once written and signed.

Bob gets mad at this discussion. Calls it an isolated case. People here *are* that simple, he says, the ones that live in the marshes.

January 26: Almost finished with rewrite of script; now waiting to reread the whole. . . . Some good, some the same. The sequences written *after* the cut film are the best, but that is because they are simply a description of a finished sequence. I still do not agree with the long dialogue between Latour and the oil scout, nor do I like the letter at the end. Also think that the long conversation between the boiler-man and the driller is forced and gives the whole surprise away that the well is going to blow up. Bob admitted today for the first time that I was right on the first points. . . .

February 20: Made location maps. Having shot the sequences helter-skelter, and on as many different locations as possible, it became increasingly difficult to tell Bob from which direction to shoot and which way J.L. and others should enter and exit. Made camera-positions of sequences, tried to put these together like a jig-saw puzzle and filled in the rest. Now we have a complete location map for all sequences. This has been very hard to make for someone who always reads and draws maps upside down!

March 19: Discussion yesterday about off-stage voice. I am so deeply convinced we need a commentator for major sequences—outside of the few lines called "off-stage" voice in the script—that I added the costs for it subconsciously to the budget. Yesterday Bob said, "No commentator at all!" I do not see how certain sequences can be sustained without one. Justifiable conflict of opinion between "suspense" and "confusion." Not knowing at all and revealing much too late throws an audience into confusion. Bob and Frances call it "suspense." Lennie Stark arrived today with the Mitchell camera for synch-dialogue sequences.

Helen van Dongen's diary (of which only about one-eighth is quoted here) ends toward the close of March, when only a few days of shooting with sound remained to be done. Since there were no projection facilities for sound film at Abbeville, she returned to New York to screen the dialogue rushes there and to begin work on the vast task of finally editing the film. Estimates of the total amount of picture footage shot on the film vary. Van Dongen, through whose hands every foot passed, puts it at "close on to 200,000 ft," while Flaherty himself says it was nearly 30,000 feet.[13] There is, however, also a substantial discrepancy in their respective reports on the final cut length of the completed film. Van Dongen puts it at "about 8,000 ft" a reel, while Flaherty records it as being "some 7,000 ft."

Before leaving the shooting period of the film, it is worth repeating several incidents which Flaherty himself has described:

> We worked day after day shooting reams of stuff. But somehow we never could make that pesky derrick come alive. We could not recapture that exhilaration we had felt when we first saw it moving slowly up the bayou. Then we hit on it. At night! That's when it came alive! At night with the derrick's lights dancing and flickering on the dark surface of the water, the excitement that is the very essence of drilling for oil became visual. So we threw our daytime footage into the ash-can and started in all over again to shoot our drilling scenes against a night background.
>
> So far, so good. To make an unusual picture, we needed something out of the ordinary, something which does not occur in the usual run of events. But major disturbances seldom happen in the scientific, carefully controlled activity that is the modern oil business.
>
> I've been lucky in my motion pictures. But I believe in making your luck, too. So I set out to make my own luck. I arranged with one of the state conservation officers and with the tool-pushers of the Humble Company, who get around a lot, that if anything were to go wrong anywhere within reach, they were to let me know immediately. For weeks nothing happened. Then about 2 o'clock one morning we

got a phone call. A well at Atchafalaya Bay about sixty miles away had
had a gas blow.

We were dressed and aboard our cabin cruiser in record time.
We reached the well about 10 A.M. She was still spouting gas, water
and mud. With the temerity born of ignorance, we clambered aboard
and began to shoot. We got on the upper-floor of the derrick, and
shooting from there, got some magnificent footage looking right
down into the spouting gas.

Finally one of the rig bosses came up and looked curiously at
the camera. When he saw its electric-motor, his hair stood up almost
straight on end. He asked us courteously but firmly to get off the
derrick at once. When we were at a safe distance, he explained that
if the motor on our camera had generated a spark, with all that gas
floating in the air, we could have been blown to Kingdom Come.[14]
(Flaherty 1950)

As fate would have it, two magazines of that day's work, so vital to the
film, were fogged by the laboratories and thus made useless!

Flaherty shot dialogue on location for the first time in *Louisiana
Story*. Of this experience, we again have recourse to Helen van Dongen.

Flaherty had written specific dialogue lines for those sequences
which were going to be shot with a synchronous picture-sound cam-
era. (The Mitchell operated by Leonard Stark.) He soon realized how
hard it was for non-actors to learn prepared lines by heart. If they
don't forget them during the shooting of the scenes, they concentrate
so much on remembering their lines that their performance becomes
stultified. Flaherty solved this part of the problem by explaining to the
group of "actors" (father, mother and son) the action to be "played"
and the content of the dialogue to be spoken. One of the sequences in
which this happened is the one "played" in the kitchen after the well
has struck oil.

Flaherty told the group of "actors" that, to celebrate the event, the
father went on one of his rare visits to the nearest village to do some
necessary shopping. He has now returned to the kitchen, starts un-
packing the food and then remarks that he has also brought some pres-
ents. He asks the boy to hand one of the packages from the big box to
his mother, who unpacks it and finds a new double-boiler. The boy
gets a little impatient waiting for his own present, and asks the father
what he has brought for him? The father scolds him at first for being
unruly and then eventually hands him the present. (This is only a
rough description and does no justice to Flaherty's subtle direction.)

To make it easier for the "actors," Flaherty, after explaining to
them the content of their dialogue, allowed them to use their own

words. When "playing" this scene, they added a few unexpected twists and phrases. They also spoke in their own *patois*-French instead of using English. Not having to remember precise lines, their "acting" was excellent, but however beautifully this scene was played it could not be left all in one shot in the final film. Certain parts of the sequence had to be re-enacted for other camera-angles and lenses, so that, in the final sequences, we should get a more intimate response to some of the lines spoken. . . .

It was only when starting to edit the "presents-in-the-kitchen" sequence that I became acutely aware that, although the dialogue in each retake was similar in content, not once did the "actors" use exactly the same words or sentence-formation. And here was where a great problem arose.[15] (van Dongen 1951:64–65)

Van Dongen then goes on to relate how the problem, which is technically complicated, was solved in the cutting room. She does not say, however, that the problem would not have arisen at all if Flaherty had had a little more experience shooting dialogue, or if he had had someone to check and record such discrepancies at the time of shooting.

Although in various accounts of making the film, Flaherty tells with enthusiasm about recording of "wildtrack" sound effects on location, which would later be edited in the sound track in as subtle a way as the visuals, Helen van Dongen recalls that he did not appear at the time to be very interested in the recording of them. She and the sound recordist, Benjamin Donniger, went out and got most of them, including the dozens of separate sounds which were recorded of the oil derrick at work and which later were edited and "mixed" in relation to the visuals in several highly complicated sequences.

The final editing period of the film lasted from April 1947 to July of the next year, when the first show print was ready. Flaherty had Helen van Dongen work out an estimate of what the film would now cost to finish, including music, recording, optical work and so on. The contract also included some subsidiary films made from the leftover footage.[16] She found that the entire contract price of $175,000 had already been spent at Abbeville. A supplementary budget to complete the film was prepared and submitted by van Dongen to Standard Oil on Flaherty's behalf. Fortunately, it was accepted. It brought the total cost up to $258,000.

It had been clear that music was going to play an integral part in the film. Virgil Thomson was asked to compose the score, and it was sensibly agreed to invite him in at a fairly early stage. One of America's most talented composers, he had considerable experience with the problems of writing film music for documentaries. He had, in addition, an unrivaled knowledge of American folk songs, national melodies, and traditional dance tunes.[17] He was shown a version of the film just before Christmas, and the music was recorded in April of 1948.

The score written by Thomson was very subtle and was worked out in consultation with Helen van Dongen in immensely elaborate detail. Special themes were written for and allocated to the characters. Far from being a musical background in the conventional Hollywood style, the music grew with the film as it assumed its final shape in the cutting room and projection theater. Its relation to the complex sound-effects track which had been compiled by van Dongen from hundreds of sounds recorded "wild" on location was especially skillful.[18] It was perhaps one of the most successful scores ever to be written for a motion picture, not only musically but in its integration with the film and the rest of its sound track.

To conclude this account of the making of *Louisiana Story*, we quote again from Helen van Dongen's notes:

> During the making of *The Land*, I had noticed how important it was to watch Flaherty during the screenings of rushes and of assembled reels. During *Louisiana Story*, he hardly ever entered the cutting-room itself. His world was on the screen. Having edited a sequence, I knew, of course, its composition and effect through repeated screenings to myself on the Moviola. When satisfied at a certain stage, I would screen it to him, watching with one eye on the screen and the other on Flaherty. What he does not say in discussions is written all over his face during a screening. The way he puts his hand through his hair, or smokes his eternal cigarette, or shuffles on his chair, speak more than a torrent of words.[19]
>
> . . . Flaherty inspires the skill and creative ability of his fellow-workers; that is why working with him is such an experience. Leacock is an excellent cameraman but, going on his own to Louisiana to film the story, without Flaherty's continuous presence, he would have photographed differently and different things. Had I myself gone to direct Flaherty's story, it would have looked quite different. But working with already filmed material, filmed under the influence of Flaherty, I would have maybe altered a little here and there but essentially my editing would have resulted in approximately the same story and form. This would have been inevitable because, to use the random material to full value, the editor has to discover not only the inherent qualities of each shot but also must know the how's and why's, the director's reasoning behind each shot, or must know that no one else but Flaherty would have shot such a scene. To make such a remark and then set the shot aside, would be criminal. Having observed that here is a shot that only a Flaherty would think of filming, it is obviously intended to be used and should be used the way Flaherty intended it and no other.

The evening on which a final work print of *Louisiana Story* was shown to Standard Oil, Flaherty had a small audience to dinner first at the

Coffee House Club. Ernestine Evans, that very old-time friend, was among the privileged guests. The main topic of conversation across the dinner table, she recalls, was the Kinsey Report, which had just been published. Flaherty was disgusted.[20]

II : The film opens in a dark, eerie swamp, with strange birds, alligators, and many, many fantastic growths. Huge lotus leaves float on the surface of the bayous. Giant cypress trees drape their beardlike streamers of Spanish moss. Everywhere there is dark water, with mysterious bubbles rising to the surface. An alligator glides by smoothly and dangerously. A narrator's (Flaherty's) voice tells us where we are.

But there is something else gliding by, too, half-hidden among the hanging Spanish moss and creepers. A pirogue—a little slender dugout canoe—and in it, standing up as he paddles, a boy, skillfully guiding his boat among the giant trees and large floating leaves. He is Alexander Napoleon Ulysses Latour, a Cajun boy of twelve or so, who lives and hunts and roams the Petite Anse bayou country in Louisiana. He believes in were-wolves with long noses and red eyes and in mermaids with green hair who swim into these lagoons from the sea. To protect himself from their evils, he carries a little bag of salt tied to his waist and a mysterious something which he keeps inside his shirt.

A huge water snake zigzags through the water. An alligator rears its snout. The boy hears something, is worried, and looks around him furtively. Then he smiles. It is only a false alarm. Presently he sees a wild raccoon in the branches of a cypress tree. He calls to it, imitating the noise it makes. Then he leaves the swamp, tying up his canoe. He takes his rusty rifle with him and sets out on a hunting expedition among the tall reeds. He sees something and raises his rifle to take aim. Just as he is about to fire, there is an explosion. Before he has time to think what it can be, he hears another sound and sees a strange amphibious monster, a "swamp-buggy," on caterpillar treads, climbing up the bank out of the water. It crashes into the reeds close to where he is hiding. The boy is scared. He races back to his pirogue and paddles swiftly home.

In a cabin at the edge of the bayou, the boy's father, Jean Latour, is talking with a visitor, a stranger. A tale is told and an old Irish song is sung—"I eat when I'm hungry, I drink when I'm dry."[21] The boy reaches his home, where coonskins and enormous alligator hides hang on the outside wall of the cabin. He stares in wonderment at the stranger's beautiful motor launch moored to the bank. He goes up to the door of the cabin and listens.

Jean Latour is signing a document the stranger has brought. The stranger is an oil scout. The paper is an agreement to give the oil company

permission to drill for oil on Latour's property. Latour is skeptical about there being any oil but signs the agreement.

Soon the oilmen arrive and start their operations. Surveys are made. The oil scout's fast launch sends waves skimming across the water. There are more explosions. Latour hands out his raccoon skins, taking little notice of it all. One day the boy is climbing around in the cypress trees, playing with Jo-Jo, his pet raccoon. Suddenly he looks up. He sees something towering high above the tallest trees. A graceful, slender structure has appeared, its metal girders glinting like silver in the sun. It moves slowly and majestically up the bayou toward him. He races to the cabin to tell his father. Finally, the oil derrick comes to rest in the bayou not far from the Latours' cabin. It is going to probe deep through the water into the earth—two, maybe three miles down.

For some time the boy is too shy to go near the derrick, but one day he approaches cautiously in his canoe. Two of the oilmen call out to him to "come aboard." But he is too scared.

After some banter between the boy and the oil driller and his boiler-man on the derrick, the boy shows them a catfish he has caught. One of the men says, "You must have used *some* bait to catch that fellow." The boy replies, "It's not the bait. Watch! I show you how to catch a *big* catfish." He spits on his hook, drops the line, and in a moment pulls up a fish, but only a tiny one. The men have a good laugh. The boy again refuses their invitation to come aboard and paddles away in his pirogue. One evening, however, he plucks up enough courage to approach the brilliantly lit, strange monster, and as he grows close, the reflections of the shining steel derrick flicker and dance on the surface of the lagoon. He hears the strangest sounds he has ever heard in his life coming from within it. Ninety-foot lengths of pipe are being joined end-to-end and driven through the water down into the earth. The boy stealthily climbs aboard. Tom Smith, the driller, calls out, "Come on over!"

In the deafening noise, the boy goes over and fearfully and apprehensively watches the long pipes, one after another, plunging down into the earth. He is struck with wonder at the magic of this monster, but he wants Tom to know that he, too, has some magic. He shows his bag of salt to the driller. But the boy's father has been searching for him and appears on the derrick ready to scold him. Tom, however, cries out that he's glad to have the boy aboard.

Then we are back again in the cypress swamp. The boy is paddling his pirogue; with him is his pet coon, Jo-Jo. The boy is obviously intent on an errand—something that might be dangerous. And he is keeping an eye and an ear open for his enemies, the werewolves, and their accomplices, the alligators. Presently he lands the canoe, ties it up, and ties up Jo-Jo, too. He goes off into the deep forest, leaving the coon chattering away and fearful, trying to break loose.

An alligator slithers into the water. The boy clutches his bag of salt. He watches the creature disappear, then he stealthily approaches a mound of earth in a clearing. Down on his knees, he scrapes away the earth and reveals some alligator eggs. He picks up one of them. A baby alligator is breaking out of its shell. He holds it in his hand and is so fascinated by it that he does not see the mother alligator slowly coming out of the water and up the bank toward him. As the alligator lunges at him the boy jumps clear just in time and runs for his life.

When he gets back to his pirogue, he finds it empty. Jo-Jo has broken away. The boy goes back into the forest searching everywhere for the coon and calling to him. But all he hears are the birds mocking back at him. With tears in his eyes for the loss of his pet, the boy returns to the pirogue. Suddenly, he sees an alligator rushing through the water like a speedboat toward a large bird standing on a branch in the water. The alligator's jaws snap and the egret is between them. As the boy watches this act of sudden death, he realizes what must have happened to his coon. He makes up his mind to have his revenge.

Out in the water, the boy sets a trap—a hook baited with beefsteak—and then waits half-hidden by leaves at the end of a fifty-foot line attached to the trap. The alligator sees the bait and moves slowly and sinisterly toward it. At last it snatches the bait, the line pulls tight, and the fight is on. A fierce tug-of-war takes place between the boy and the alligator. The boy is dragged into the water, sliding further and further in through the slime. But his father has heard his cries and the noise of the battle and comes to the rescue just in time to prevent the boy from being pulled under the water. As he leads him away, the boy says, "He killed my coon." "Never mind," says his father, "we'll get him," and he points in the direction of the escaped alligator.

All this while, the oil crew has been drilling deeper and deeper. Latour and the boy, in their launch, pass the derrick. The boy displays the alligator's hide. "The boy got him," calls the father. "All by himself, too."

Then one day the boy, who is quite at home now aboard the machine that once terrified him, is out on the derrick, fishing. The boilerman grins at him as the boy spits on his bait and throws the hook into the water. Out on the marshes, Latour is setting his traps.

Tom Smith, the driller, has been telling the boy stories of the mishaps that sometimes occur with oil drilling. To the boy this is all magic: everything about the huge device is magic. But he knows what really makes the trouble at the bottom of the deep hole—it is the werewolves. The boy is still fishing from the derrick and the boilerman still watching him. Suddenly the boy looks up. The boilerman looks up, too. He begins to run. Other men run. Is it possible? It is happening: a blow-up. The boy runs for his life.

Newspaper headlines tell of the wildcat blow-out.

The derrick is now lying idle, the crew standing by, waiting to hear whether it is going to be abandoned. The boy is wandering about on the slippery derrick. He is very sad. His father calls out to him from the bank to come along home and goes off himself. But the boy creeps down onto the deserted floor of the derrick. He walks slowly across to the abandoned borehole down which they were drilling. He looks round to see that he is not being watched. Then he takes out his little bag of salt and lets it stream into the borehole. Then he puts his hand into his shirt front and takes out the "something" we have been wondering about for a long time. It is a live frog—his extra protection against the werewolves. For one moment he thinks he will drop this precious charm down the borehole as well. But he cannot bring himself to do it, and he puts the tiny creature back into his shirt. He starts to go away when another thought strikes him. He takes a furtive glance round and then, for good measure, spits down the hole.

The boy now goes down to the deck, where the idle crew are hanging around. The boilerman sees him. "Well, look who's here! What have you been up to? Lost your salt? Have those things been after you again?" The boy is hurt by the way they laugh at him, particularly his friend Tom. In all his life he has never felt so hurt. The men joke, saying that they could use some of that magic salt of his for the well. Tom snaps his fingers. "I've got it! Why don't we get him to do what he did to his bait?" The boy shyly says, "I did." They laugh raucously and the boy, deeply hurt, goes away.

The next day, the boy is at home in the cabin, peeling potatoes for his mother. His father is preparing some traps. The boy is sad. The derrick will be going away any time now. Suddenly, they all hear a sound. It is the derrick's pump working again. The boy is overjoyed. He knew all along that his magic would work. Now at last the derrick crew will strike oil. It will come gushing up. And it does.

This means, of course, that the Latour family can now afford some much needed things for their home. Jean Latour returns from town to the cabin with stocks of food and some presents. He brings a shining new boiling pan for the mother. The boy asks if there is anything for him. His father says that he has been too naughty to have a present and starts unwrapping a parcel, which he says is a new pump. But it turns out to be a new rifle— the one thing the boy has been longing for. He goes outside on the porch and sits down to examine it. While he is sitting there, he hears a familiar sound. It is the cry of Jo-Jo, the coon. He was not killed by the alligator after all. He has been wandering about in the forest and the swamp but has now found his way home.

The oil derrick, that fabulous structure which once amazed the boy so much, has now done its work. The tugs are towing it away down the lagoon. It moves slowly, imperiously, out of sight. Taking his coon with him, the boy goes to wave good-bye to his friends. The bore has been capped with a "Christmas tree." The boy clambers up onto it, with his coon in his

arms. He calls out and waves to Tom Smith for the last time. He spits into the water to remind the oilmen that it was *his* magic, not theirs, which brought the oil.[22]

III: *Louisiana Story* had its world premiere on August 22, 1948, at the Edinburgh Film Festival in the Caley Cinema to an audience of about two thousand people. Flaherty was not there, but Helen van Dongen was. Its reception was extremely enthusiastic. At the Venice Film Festival the same year, it was awarded a prize for its "lyrical valor." In September, it opened at the Sutton Theatre, New York. Virgil Thomson was awarded the Pulitzer Prize for film music in 1949, the first time this prize was given to a film score. At all these occasions, the film won unanimous praise.[23] Of all Flaherty's work, *Louisiana Story* received more critical acclaim than any previous film. Perhaps the only sour note that hurt Flaherty was when the Children's Film Foundation in England made the fatuous and wholly inexplicable decision that it was not suitable for child audiences! The film was taken for distribution in the United Kingdom by the British Lion Film Corporation (with which Korda was closely associated), and it opened at the Rialto Cinema, London, on June 27, 1949, in a version slightly shorter than had been shown at Edinburgh and Venice but with Flaherty's approval. He himself did the shortening and arranged the distribution contract.[24] "It could not have been too successful commercially in Britain," says David Flaherty, "since Bob never received anything more than the £5000 Korda paid him at the outset for distribution rights which included the whole world with the exception of North and South America, Canada, Denmark, Norway, Germany, Austria, Korea and Japan for seven years."[25]

On the other hand, we must remember that Standard Oil had assigned all takings to Flaherty and thus the £5,000 from the English market was wholly profit. In the United States it had a moderately successful distribution through Lopert Films, mostly in art houses. In 1952, it was released as a second feature under the title of *Cajun* to Armand Denis's film *Watussi*. Only a few hundred dollars came from this deal. Subsequently, it has achieved a large nontheatrical distribution in many countries and is still being booked. It was televised in the United States, Canada, and the United Kingdom.

For the first time we cannot call on a full appraisal of the film by the "critical attorney." His only recorded sentiment is that the film was "yet another brilliant evocation of the damn-fool sense of innocence this wonderful old character pursues: his eye keener than ever, sensibility ever softer and so on" (Grierson 1948).

Richard Griffith, on the other hand, wrote, "It is time to put an end to the perennial attempt to force Flaherty into the mould of social criticism,

or alternatively to cast him into outer darkness as an irrelevant reactionary. Both alternatives are false because they do not relate to the record. The record shows that Flaherty's role has been that of proclaiming to the world what a marvel the movie-camera can be when it is turned on real life" (Rotha 1952:321).

The film contains a great deal more, as we hope will emerge in our final assessment. Of the many appreciative reviews of *Louisiana Story*, we prefer one written by Iaian Hamilton, who was not then a professional film critic and who saw the film at its first showing at Edinburgh:

> He [Flaherty] has pitched away the last mechanics of prose, and the result is an undiluted poetry. For this reason alone his latest film is likely to be attacked; there are those, "social realists" and others, who can barely endure ten seconds of poetry, still less eighty minutes. . . . Like many a long poem in print it is remembered in part rather than in the whole, but to say that is to say nothing."[26]

> This is elegy. Its theme is the wonder of childhood—Wordsworth's great theme; the setting, the swamp land of Louisiana: the players, American oil-men and a family of French Canadians who have settled among the *bayous*. With the clear, true vision of a child, Flaherty contemplates place, people, animal and machine; and the lyrical intensity of his art evolves a slow statement of the marvel of life. How inadequate is the word "documentary" to describe such a work. It is like calling the ode "an article in verse. . . ."[27]

> There is no comment, no propaganda, no uplift. There is scarcely any dialogue. The actions of those people, as Virginia Woolf once wrote of Homeric characters, "seem laden with beauty because they do not know that they are beautiful." In every sequence where human beings are under the lens love is evoked. The machine is exhibited calmly, without hysteria. The floating derrick makes its stately arrival; oil is found and the well is capped; the derrick and its engineers depart; and Alexander Napoleon Ulysses Latour remains, a little enriched by the visitation.

> How sane is this, calm and sane and filled with meaning, like a deep pool in which now and then one glimpses the flicker and dart of fins. It is the very essence of romanticism. The Marxist critic, who would have us glued body and soul to the hot hob of our political and economic existence, will rage at its "escapism." But he is concerned with the false world. Here, from a remote corner of a remote state, is Flaherty showing us the true world, the source—and it is bathed, like the work of any true poet, in "the master light of our seeing." The allusion is not extravagant. Works like this redeem the cinema, and burn up like chaff the memory of its screaming vulgarities, its too solid mediocrities. (Hamilton 1948)

In our own view, the essential simplicity of the film is deceptive. At first sight, it tells us that the drilling for oil is a dramatic, fascinating, and even frightening process, especially to a half-wild boy who lives in a half-dream world filled with werewolves and green-haired mermaids as well as with real alligators that bring sudden death. But beneath all this, so superbly observed and photographed, lies a series of conflicts and contrasts. First is conflict between the people themselves. Then there is the bare-footed swamp boy, who will tangle with an alligator with his bare hands and whose bag of salt, hidden frog, and rusty rifle are his sole protection against the enemies of the swamps; on the other hand, the khaki-clad oil drillers, with their laconic banter and their calm confidence in the efficiency of their vast machine. The aging and dignified father, skilled in his art of trapping, skeptical that the oilmen will find oil but careful to safeguard his interest so that if they do, he will not lose out, is contrasted with the know-how of the oil scout, with his experience of machines and mineralogy. The power of the monster machine, with its clangor of noise and its smooth beauty of operation, stands against the quietness of the cypress cathedrals with their lily-budded waters, draping Spanish moss, and spreading lotus leaves.

The Acadian family—the mother a shadowy figure in the background—are not hostile to the strangers who invade their land. The two exist together while the oil derrick is there, each going its own way, but there is no common ground between them—except through the boy. The men of the oil crew and their mammoth symbol of the industrialized, technological world arrive, they do their job, meeting failure and then success, and they depart leaving all unchanged save for the shining "Christmas tree" sticking up out of the lagoon and the family enriched materially by household goods. But will the boy ever be the same again? That question is left unanswered, and in this case rightly so.[28]

The genius of Flaherty's conception is that the drama—he himself calls it a fantasy—is revealed entirely through the eyes and the thoughts of the boy. Alexander Napoleon Ulysses Latour comes alive as a character in the round far more vividly and centrally than did Mikeleen or Sabu. This Cajun boy, living in a real but at the same time half-imagined world, is the film—not an appendage. With beautiful clarity of perception we are shown the slow life of the lagoons and creeks, mysterious and awesome, the curving slither of a snake, the miraculous spinning of a spider, the sudden savagery of the alligator. Although the boy knows the dark backwaters like the back of his hand, his innate curiosity about all life is ever-present and becomes the viewer's curiosity. The same devices of suspense, of not letting the audience into the secrets, are here as they were in the earlier films but with greater purpose. They are more deeply integrated into the film, not superficial devices.

The appearance of the machine is heralded by explosions and by its outriders—the swift motor launch of the oil scout, the juggernaut advance of the swamp-buggy. Then the impassive structure of the oil derrick calmly floats into view to take up its position. At first it is static and harmless, but then it springs to life, powerful and dynamic. It has one single, repetitive process, driving deeper and deeper into the earth through the water, thrusting down pipe after pipe with a grim insistence punctuated by its rhythmic chorus of harsh sounds. To the men who work and control it, the job is routine but always carries the risk of a mishap. They are laconic, quietly tough, sure of themselves. To the boy, the derrick is a magic symbol. At first he ventures near it timidly, frightened by its unknown power, shy of the men who care for it. But as with any child, familiarity brings confidence, until he is completely at ease on its slippery decks. And then begins his discovery of the great machine.

From this moment on, the oil derrick seems to come alive. At first it works magnificently and ruthlessly, its drills thrust down into the earth with inflexible might, its giant claw seizing the shafts and driving them down and down. But suddenly it revolts against its masters. It will work no longer. It blows up. It creates havoc. And then, without warning, it resumes its regular functions and even produces oil. True, you and I and the boy know that it returns to life only because its ill-humor has been placated by the salt and the spit and almost the frog. In this way, Flaherty makes a beautiful, even ironic comment on the supposedly unbreakable efficiency of the modern machine of our technological world.

But always our attention returns to the boy. Where he goes, we go. Flaherty is anxious that we shall not laugh at his superstitions. The werewolves and mermaids become very real. This is no longer the Flaherty of Man Against the Sky. It is no recreation of primitive struggles for existence. It is rather a synthesis of old and new wedded together and interpreted through the boy. Into the old comes the new, to do its work and to pass on, leaving hardly a scar. The slow pulse and rhythm of the boy's life—fishing, discovering, learning, occasionally fighting—are placed in contrast with the dynamism, the controlled, monstrous strength of the invading machine. The film does not attempt to analyze, to dissect; it is content to reveal by contrast and by finding loveliness in both the swamp and the machine.

The angry critics of Flaherty's escapism and romanticism who were so noisy in the 1930s were significantly silent about *Louisiana Story*. We can find no review on the record from those who were so vociferous about the "social" elements missing from *Man of Aran*. There are, of course, certain criticisms, the chief of which is that the mother remains too shadowy, too much in the background. Mrs. Latour is almost an unknown quantity compared with Maggie in the Aran film, and she, it will be remembered, did

not register very strongly. Perhaps Flaherty was unable to find a woman suitable for the role. We are also in agreement with the film's editor, who believed that it is a serious weakness to rely on such clichés as a letter and a newspaper insert to help the story on its way. Flaherty used these devices because he failed to grasp the needs of cinematic continuity, a failure all the skill of Helen van Dongen's editing could not overcome; she was aware of and noted these shortcomings in her diary during the course of the filming. The dialogue is stilted and halting, which may be true to character, but it holds up the action, which elsewhere flows smoothly. An exception is the scene in which the father gives the boy the present of the rifle; here the halting speech and broken phrases achieve a spontaneous sense of pathos. But in general we do not agree with Edward Sammis's remarks that the acted scenes with dialogue reveal Flaherty's mastery of direction; if anything, they do precisely the opposite.

Although the film's conception, approach, and inspiration are wholly Flaherty's, each of his fellow workers made a special contribution to the whole. In spite of all Helen van Dongen's misgivings and headaches during the shooting, she achieved a brilliant piece of editing. She solved many continuity blemishes, which were inevitable given Flaherty's way of working, with a miraculous skill. Her composition of the sound track was particularly masterly. Its interrelation with Virgil Thomson's magnificent music is a classic example of creative collaboration. In his photography, Ricky Leacock caught and understood Flaherty's visual conceptions with an astonishing skill. These three—editor, cameraman, and composer— welded their special talents into an integrated whole to interpret Flaherty's overall conception. The result is lyrical simplicity, a poetic quality that is very rare in the history of motion picture art. Had *Louisiana Story* been photographed in color, its superb visual qualities would have been no better.

When *Louisiana Story* was finished and had been shown in New York, Flaherty is quoted as saying: "Documentaries haven't begun to be what they could be. They are a wonderful art form. But they need a segregated audience—the sheep from the goats—television will do the segregating, then we'll see" (Flaherty 1948). He did not mean that the future of documentary would lie with television but that television as the new form of mass entertainment would allow the cinema to appeal to more specialized and more selective audiences. It was his continued, unheeded message.

After the Hollywood premiere of *Louisiana Story*, Charlie Chaplin, Jean Renoir, and Dudley Nichols sent Flaherty a cable: "Do this again and you will be immortal and excommunicated from Hollywood which is a good fate." Well-intentioned as this message was, it must have seemed ironic to Flaherty. He had, after all, been excommunicated from Hollywood since 1929; and even after the worldwide critical success of *Louisi-*

ana Story, no worthwhile offers for his services came as he sat in the Hotel Chelsea or up at Black Mountain.

IV: The considerable growth in the number of art theaters—or specialized cinemas as they are called in England—in the United States after World War II not only opened up a limited but important market for some of the best European feature films such as *Open City* and *Shoeshine* but it also created an interest in what have been misnamed "art films." Films about art would be a fairer definition. In Italy, France, and Germany such films had been made just before and during the war in increasing numbers. One reason for their popularity among European filmmakers may have been that production of films admiring the work of the classic "accepted" painters and sculptors of the past enabled them to avoid political commitments. The production of "art films" increased after the war. They were made in all countries, including the United States and Britain, and they found an outlet in television as well as in the art theaters. Most of these European films, however, needed adapting and revoicing for English-speaking audiences, and their chances of commercial success were improved if a special publicity angle could be devised to attract critical attention.

One such film was *Michelangelo*, directed in Italy in 1939 by that well-known producer of German *kulturfilms*, Curt Oertel.[29] For the American market this film was thought to be too long: it needed reediting and revoicing and "presenting" under distinguished auspices. As Arthur Knight reminds us, one of Flaherty's favorite sayings was, "One good film deserves another" (Knight 1957:287). The film was first offered to John Grierson by the American OSS as captured enemy property, but Grierson refused to reedit what he considered to be another filmmaker's creative work. Helen van Dongen also turned it down.

Flaherty, however, associated himself with the American presentation. The new version of Oertel's film was retitled *The Titan*, "presented by Robert J. Flaherty" and issued in 1950. There is no doubt that Flaherty's association with the film did much to ensure its success and also to draw attention to films about the arts. But it also created a certain amount of confusion. Helen van Dongen comments:

> I saw *Michelangelo* in Europe in its original form. It was at least thirty minutes longer. It had background music and the commentator spoke almost incessantly. Though its original execution may have been less original than the new version, and did not make use of a very creative sound-track, we should not forget that Curt Oertel made

his film in 1939 and that in the eleven subsequent years we have learned a great deal about sound-effects, narrations, music etc. Now to me, personally, Oertel is still the creator of *The Titan—Michelangelo*—and in its original form the film was extraordinarily impressive. Undoubtedly that is also why Flaherty was so attracted to it and wanted to bring it to public attention in the United States.

The form in which the film is now presented can be called a "modernization" of the old form, though the "modernization" is actually a more artistic presentation of the old, with the use of music and sound-effects. As well as being shortened, the film has also had certain sequences changed around to make it more palatable to the ordinary audience. In general, I find it an improvement on the original although I miss the lingering over certain of the statues and other things. . . .

The remakers have done their work in good taste and with artistic feeling, but what has happened? How many people haven't asked me, "Did you also work on *Michelangelo* with Flaherty? When did he shoot it all?" The question was not entirely misplaced because I had spent some twelve months in Europe after *Louisiana Story* and had actually been in Rome, Florence, Sienna etc. where the film had originally been shot by Oertel. Had there been no continuous publicity in the Press that Flaherty was going to bring out this film, or had there been no title of "Flaherty presents" (repeated and printed in all advertising matter), would their reviews have been so laudatory? Flaherty's artistic success with *Louisiana Story* was still fresh in the minds of critics and certain audience-groups and it was obviously good exploitation to link the names Michelangelo and Flaherty; but Curt Oertel has all but been forgotten.[30]

Flaherty's interest in using his movie camera to "reveal" a painting in a way that the ordinary spectator would miss was demonstrated by some footage he made of Picasso's famous mural *Guernica* in 1948. The rushes he shot, at the financial invitation of Hemisphere Films at the instigation of Iris Barry of the Museum of Modern Art, were later assembled by David Flaherty into a single ten-minute reel, which bore the following preliminary title:

Robert Flaherty was deeply moved by the compelling statement of Picasso's famous mural GUERNICA. In the spring of 1949 he planned to film it from a script by William S. Lieberman. Before attempting a detailed analysis, Flaherty wanted to try the mural from various angles as it is installed in the Museum of Modern Art, New York. You are about to see a photographer's first experiments in looking at a painting.

The meaning of Picasso's nightmare allegory of the bombing of a Spanish town particularly interested Flaherty. His camera concentrates on the element of the bull, the anguished horse, the fallen warrior, the woman with a lamp, a body afire as it falls, a woman panic-stricken and dazed, a mother holding a limp body of her child. The film remained unfinished at Flaherty's death. A tentative study and not a complete film, it consists of exploratory camera-movements, some of them several times repeated.

Arthur Knight comments:

This writer recently had the good fortune to watch the veteran documentarian Robert Flaherty photographing Picasso's *Guernica* mural—not to make a film but to see if a film could be made from that giant canvas. Flaherty was moved by the painting, impressed by it, but was not certain why. He wanted to get behind his camera and feel around with it, to work out the structure and meaning of the mural through a medium he knew and understood. With greater and greater excitement he tried out each new camera set-up, each new camera-movement. "Now let's try this," he would say, squinting through his viewfinder. Not until the uncut reels of film were run-off in a projection-room could he say of what he had taken, what he could use, what would have to be thrown away. But what came out of his camera even, in that crude state, was as much the raw material of a work of art as the Picasso sketches that preceded *Guernica*. (Knight 1949)

The reel as assembled opens and closes with an overall shot of the entire mural. In the foreground are two spectators, Frances Flaherty and Iris Barry, with their backs to the camera, seated on a couch to give scale to the painting. The camera then moves in close to explore details of the mural; it creeps, it slides, and it probes in close-ups in the characteristic Flaherty style. The total effect creates a remarkable microcosm of what is already a microcosm of the bloody tragedy of the Spanish Civil War.[31]

Had he attempted to make a complete film, however, Flaherty could have done little more than to take further shots of other parts of the painting and then added a voice, music, and sound track.

The director John Huston tells an anecdote from this period which is very characteristic of Flaherty:

I have heard from men who have worked with him about Bob's wonderful ways with primitive people; how he would step into a critical, sometimes dangerous, situation and resolve the conflict through

his powers of sympathy and understanding. I can well believe this, having been present at a demonstration of those powers.

One night, Bob and I were coming away from a late party. I preceded him into the rainy street and stopped a cab. As I went to get in, somebody grabbed my arm. Turning, I beheld a dark little man, brandishing a toad-stabber. He was shouting something about the cab being his and my thinking I was better than he was because I was white. I stood very still and tried a rhythmic breathing exercise, while the toad-stabber described semi-circles near my throat.

"I'm going to kill you," he said.

Out of the corner of my eye I saw Bob approaching. When he got up to us he asked what was going on, and the little dark man replied that he was going to kill me because I thought I was better than he was.

"Nothing of the sort," Bob said. "And put that knife away this instant, d'you hear?"

The little man shifted his look from me to Bob and, taking the opportunity, I swung on him, knocking him down. The knife fell out of his hand and I picked it up. It was the kind where you touch a button to release a double-edged blade. It was for cutting throats—nothing else.

Bob helped the little dark man to his feet. "You ought to be ashamed," Bob said, "Pulling a knife! What made you do such a thing?"

"He called me a nigger."

"No such thing," Bob said. "This gentleman," indicating me, "is without racial prejudice."

The little man began to cry. "Call a policeman," he said. "Get me arrested. Have them send me to the Tombs. I want to go there, anyway, to be with my poor brother."

"What's that?" Bob said.

"My brother is in the Tombs. I must see him. That's where I wanted to go in the cab."

"He says his brother is in the Tombs," Bob said, as though that threw an entirely different light on the matter.

"Call a policeman," the little dark man sobbed.

"Get into the cab, young man," Bob said. "We'll drop you off."

"The hell we will," I said. "I'm tired and I want to go to bed and this little ape is coked to the eyeballs, can't you see?"

"See what I mean? He thinks he is better than I am."

"Have you been taking drugs?" Bob asked.

The little man nodded.

"Get into the cab," Bob said. "You too, John. We'll drop *you* off."

We told the driver my address. His manner towards me was a

little cold, as though I were the culprit—which, according to Bob's morality I was, for I was being ungenerous towards a human being in distress. I felt sure Bob was thinking that it had not been necessary for me to strike a blow; the little man would have put his knife away in due course, anyway. Bob was disappointed in me for having resorted to violence. He deplored violence among men. It was against the Divine will that we should do injury to one another. All his work bears this out; the conflicts in his pictures are those in which man engages his fundamental enemies—storm, hunger, cold. They are never between man and man.

Naturally Bob was on the little dark man's side. He was the miserable one. He was wet from the rain, his brother was in jail, he was a victim of the drug habit, he was of an underprivileged race, and he had lost his knife.

"Give his knife back to him, John," Bob said. It was his way of giving me the chance to redeem myself for having added to the little dark man's misfortunes—and perhaps for the sin of occupying a cab with him yet being so dry, so tearless.

"He's all coked up," I said. "He might use it on you."

"I want you to promise me," Bob said to the little man, "that if your knife is returned to you, you won't go about doing harm with it."

"Sure, I promise," he said.

Bob took the toad-stabber out of my hand and gave it to him.

"I don't think you should go down to the Tombs tonight, though," Bob said. "For one thing, they wouldn't let you see your brother at this hour and, for another, they'd probably arrest you on a narcotics charge. Have you got a place to sleep?"

"I will get out on 14th Street, and go to the all-night picture show," the little man said.

By this time we'd reached my door. As I was getting out, Bob said, "How about lunch tomorrow at the Coffee House Club?"

"Sure," I said. "And if, by chance, you don't show up, I can tell Oliver and everybody just how it happened."

Bob ignored this and, leaning forward to the driver, said: "Down to 14th Street."[32] (Huston 1952)

In the spring of 1949, Flaherty was asked by the Vermont Historical Society and the Vermont Development Commission to make a short 16-mm color film about the state of Vermont. He was, however, about to go to London and Europe to promote the distribution of *Louisiana Story* for Standard Oil. Thus David Flaherty was delegated to direct the film with Leonard Stark as cameraman and Stefan Bodnariuk as editor. Called *Green*

Mountain Land, the film was issued in the fall of 1950 and was taken by the State Department for worldwide release in some thirty languages. Robert Flaherty took credit as producer.

During 1949, Mr. and Mrs. Flaherty visited London, Edinburgh, Paris, and the Cannes Film Festival. Flaherty went alone to Stockholm and subsequently attended a special screening of *Louisiana Story* at the Brussels Film Festival, where he had one of his greatest triumphs. "He was," says Winifred Holmes, who was present, "moved to tears by the reception they gave him and his film."[33] Everywhere he was received with the respect and prestige he richly deserved.

In London, Flaherty led a quieter life than he had in the 1930s. His old haunts were either closed or changed beyond recognition so he made his social headquarters at Olwen Vaughan's Le Petit Club Français, off St. James's Street. There on the first floor, with a flagon of red wine to dispense and the inevitable box of fifty cigarettes, he held audience to those who liked to come and renew friendship and to make new friends. Sometime that summer the Flahertys also revisited Aran.

Between June and October, he made several recordings at the BBC for the producers Eileen Moloney and Michael Bell, some of which were used, some not. Bell remembers him as being very nervous in front of the microphone even if he knew his talk was only being recorded and not transmitted. He discussed all his scripts in detail beforehand with Frances, and she participated in some of the recordings. Bell finally found that the best way to get results was to send a stenographer to the hotel and let Flaherty dictate at his leisure.[34] Despite his nervousness, Flaherty took a lively interest in the techniques of radio recording and talked about the use of sound effects in *Louisiana Story*.[35]

Among those who renewed their friendship with the Flahertys was Winifred Holmes, and through her Flaherty became acquainted with the high commissioner for Ceylon in London, Sir Oliver Goonatilleke (then governor general). Both the high commissioner and Flaherty wanted him to go to Ceylon to make a film, but unfortunately no funds were available. While in London, he was interviewed by Penelope Houston, a member of the new generation of serious film critics. She wrote as follows about their meeting:

> He [Flaherty] remains the great individualist of the cinema. By all the odds, Flaherty should be remembered only as an old-fashioned, impecunious eccentric, turning up from the wilds every few years with a film altogether devoid of fashionable influences; a figure to be patronized by critics and ignored by audiences. That this is not the case, that his reputation is now at its height, is a justification at once of the serious cinema, and of Robert Flaherty. . . .

Flaherty cannot afford the luxury of living in the future. He has to sell his own films, to carry them around with him, to cut them for the exigencies of the double-feature program. He says that he is unable to escape from work that should be over and done with. This is the price of independence; it is no light price, and it is bound to color his outlook.

Flaherty looks rather like one of the massive, impressive, almost self-consciously patriarchal figures from one of his own films (the father in *Louisiana Story*, perhaps); he talks with a leisurely determination that reminds one that he has spent most of his life making himself understood in the more primitive parts of the world. . . .

Meanwhile, "All the reputation in the world won't buy anyone a ham sandwich," and he refuses to talk of a future so dependent on circumstances. We may regret this dependence but, in sympathizing with Flaherty, we are wasting time; he has made the films he wanted to make and will go on making them.[36] (Houston 1949)

But the interviewer did not say how her prophecy would be fulfilled. Flaherty certainly did not want anyone's sympathy; what he wanted was an opportunity to make another film and the help of all serious followers of the cinema in pursuing that honorable cause.

Flaherty did not return to New York until the end of the year. Word of his success and prestige in Europe had by then reached the alert ears of the State Department in Washington. He had hardly been back in the United States for a month when the State Department thought up the imaginative idea of sending him to Germany as an unofficial goodwill ambassador. According to Griffith:

Here, they reasoned, was an American creative figure of whom the right sort of symbol could be made, a figure nobody could identify with the alleged vulgarities of American industrial civilization, and who certainly could not be confused with high finance. He stood for art for art's sake and nothing else but, and, as such, would be the most perfect antidote to certain unjust but widely held notions about life in the United States.

The calculation proved correct. The Germans knew all about Robert Flaherty and what he stood for. His tour of the American zone was one of the positive achievements of the State Department. True, he said very little about American know-how, free enterprise, and so forth. He said, indeed, very little at all since he knew no German but had to speak through a translator. This proved to be no barrier to his achieving the desired effect. The Germans in any case did not want to hear from him about America, they wanted to hear about his life and

travels—to shut out the cold gray world of their defeat and go with him vicariously to Samoa and India and the Louisiana bayous. (Griffith 1953:158)

His headquarters were fixed at Frankfurt, where his wife joined him in March. Taking with him *Nanook*, *Man of Aran*, and *Louisiana Story*, he visited Dusseldorf, Stuttgart, Munich, Augsberg, Mainz, and Hamburg. In April, he was the guest of honor at a meeting of German film clubs at Schluchsee.

The State Department expressed satisfaction with the visit:

The tour program consisted of American *Haus* screenings of *Man of Aran*, press and radio-interviews, personal appearances at theatres, round-table discussions with professional people, film-club sessions, meetings with civic, religious and professional leaders and private as well as public screenings of *Louisiana Story* and *Man of Aran*. The schedule was tight and widespread. It was perhaps a trifle too strenuous. In Hamburg Mr. Flaherty contracted bronchial pneumonia and, unfortunately, had to cancel his appearance in Bremen. But this was the only place in which he did not appear. The audience reaction to these films was extraordinary. In some places the applause for the film lasted two minutes. It is the considered opinion of the writer that Mr. Flaherty's personal appearance in Germany plus the exhibition of his films exceeded in prestige value to the United States anything that has been done heretofore in this field.[37]

On their return to the United States, the Flahertys went to Ann Arbor, Michigan, where the University of Michigan conferred upon him the honorary degree of Doctor of Fine Arts. Thus was the self-education of the explorer-cinematographer acknowledged. During that summer, in Washington there was talk of asking him to make a film for the Division of Motion Pictures, which is charged with the task of making the "American Way of Life" known to the world. The thought was that Flaherty might find an ideal subject in Hawaii, where so many people of different races and nationalities exist peacefully under the American banner.

To that end, Flaherty submitted a memorandum headed "To the International Motion Picture Division, Department of State, November 10, 1950." The working title for the projected film was *East Is West*; its purpose and specific objective were described as "to show the successful amalgamation of races of the Far East (Japanese, Chinese, Filipinos, Koreans), with their different cultural backgrounds, in a progressive western democracy. The American territory of Hawaii, 'crossroads of the Pacific,' is the

scene. Such a film would be an implicit refutation of the Communist line that Asiatic peoples are ruthlessly exploited by 'American imperialists.'"

The memorandum continued:

> Everyone born in the Island, of whatever race, has the rights of citizenship. These citizens of Hawaii refer to our country not as the United States, but as the mainland! Though the territory has not yet been granted statehood, its people feel they are a part of the United States. The various racial groups and mixtures which comprise Hawaii's population of more than half-a-million respect each other, and rightly so, for their racial cultures are proud ones, not to be lost or discarded in the process of assimilation. A Buddhist temple is not at all incongruous among Christian churches, nor is a thatched Samoan village not far from modern Honolulu. One does not apply the term "Colonials" to the peoples of Hawaii, nor "natives" to the indigenous Polynesians. . . . Democracy really works in Hawaii . . . and democracy does not breed condescension. . . .
>
> The pictorial and human resources for a film to express these important truths would seem to be limitless. The greatest task would be one of selection. From the handsome pure Hawaiians through the many fascinating mixtures of Polynesian with Japanese, Chinese and Caucasian blood, some wonderfully attractive types are surely to be found; and the more memorable the film's leading characters are, the better will a film achieve its purpose.
>
> The main target area must not be lost sight of. Peoples of the Far East must see their descendants portrayed with sympathy and dignity in their successful assimilation into the new life which democracy offers them. They will see the reality of a bridge between East and West.[38]

Negotiations for the film dragged on and on. Flaherty got neither younger nor wealthier. Under the system of financing proposed by the State Department, the Flahertys would have had to raise more than $20,000 before the Department paid anything. "A State Department contract," they were told, "is legal tender at any bank." But the Flahertys found in practice that a State Department film contract was about the last thing on which any bank would advance money.[39] So the Hawaiian memorandum remained unfulfilled.

If this project, about which Flaherty was very enthusiastic, had materialized—if someone in the State Department's Motion Picture Division had been a little more realistic—Flaherty would not have forced himself to embark on a project which without question hastened his death and which was alien to his outlook and established way of working.

In late 1950 the announcement was made that Flaherty had formed a company consisting of a group of film workers "to extend the Flaherty film traditions to short, institutional and public relations films for industry." [40] Appropriately, it was called Robert Flaherty Film Associates, Incorporated, with offices in West 52nd Street. David Flaherty was vice-president. The press release continued:

> Through the years, Flaherty has become convinced that there are stories of vital human interest in almost every industry which are only waiting to be sought out by the sympathetic camera-eye. The question of the value of such films to their sponsors is not always easy to answer concretely—especially in advance as the sponsor would prefer. Flaherty and his associates feel, however, that the evidence brought in by the decades since *Nanook* of the effectiveness of worthwhile and entertaining institutional films points to the high value of the subtle approach to the industrial subject—notably where long-range goodwill is desired. (D. Flaherty 1949:13)

The announcement was similar to those British documentary companies in the 1930s presented to potential sponsors all over the United Kingdom. Its final statement, however, is enlightening: "Heretofore, Flaherty has generally preferred to select his assistants particularly for each production; hence the organization of a permanent group to work under him represents something of an innovation."

It would seem that Flaherty's name and reputation were the bait and that the group of technicians associated with the project would make the films under his producership. No films were ever actually made by this new corporation, but it would have been used if the Hawaiian film had materialized.

In January 1951, the Screen Directors Guild honored Flaherty with a film festival of his work on three nights at the Museum of Modern Art's auditorium in New York. Flaherty appeared on each evening and was presented with a special award from his fellow Guild members at the final performance. On January 9, *Man of Aran* and *Louisiana Story* were shown; on January 10, *Industrial Britain*, *The Land*, and *Moana*; and on January 11, *Elephant Boy* and *Nanook of the North*. Tributes to Flaherty as "The Father of Documentary" from European, British, and American film personalities came, in the order they were listed in the Guild's magazine, from Alexander Korda, Lewis Jacobs, Roger Manvell, John Grierson, Iris Barry, Paul Rotha, Jean Renoir, Richard de Rochemont, Arthur L. Mayer, Arthur Knight, Basil Wright, Howard Barnes, et al.

Griffith describes the scene at Flaherty's suite at the Hotel Chelsea on 23rd Street about this time:

The shabby old rooms were stocked with the loot of years of travel. Sunshine filtered in through dusty windows on cameras and tripods lined against the wall. Stills from the films were propped up on the mantelpiece for me to look at. On the coffee-stained worktable was a pile of messages from passers-through New York who wanted to give him a hail. He had lived there six years on and off, but it looked like a camp that might be struck at dawn. As ever, he was poised for flight.

Where to, this time? He paced the room as I quizzed him on future film plans about which he was vague. I was persistent: I wanted to know exactly what he saw ahead of him. Suddenly he sat down and looked at me and said, "Well, say what you will, there's one thing they can't take away from us, the way we've lived these thirty years."[41] (Griffith 1953:157)

Then came the most grotesque irony of Flaherty's life as an individualist, a director-cameraman, a lone-wolf cinematographer, who had always tried to operate in the simplest manner and had stripped the film medium down to its essentials. "Cinerama," one of the complicated devices (using three projectors to fill its gigantic wide screen), which the American movie industry had tooled up as an answer to television's inroads on cinema audiences, was to claim his services. While the State Department dithered about financing the Hawaiian film, the late Mike Todd and the news and travel film commentator Lowell Thomas asked Flaherty, who was then sixty-seven, to go out into the wide, wide world and use their mammoth apparatus!

According to Frances Flaherty,

Bob realized that Cinerama stood for everything against which he had fought all his movie life. He went into it solely because he needed urgently to earn a living, for no other reason. He continually quarreled with Mike Todd and Lowell Thomas, who represented the exact opposite to all that Bob believed in and had worked for. The great two-ton camera bore him to the ground. Added to this, the first subject allocated to him—to film the triumphal return from Korea of General MacArthur to Chicago on April 26—was utterly alien to Bob's whole outlook. It was just a newsreel item. The finished film was supposed to run to 60 minutes. The Big Screen, 3-D, Color, Cinerama, they could give Flaherty absolutely nothing.[42]

"About *Cinerama*," Flaherty said to Griffith, "I'm working now to destroy everything I've spent my life to build up." Mrs. Flaherty and Richard

Griffith saw the rushes. "They revealed nothing of any interest and could have been shot by anyone" was their verdict.

Two accounts of the events following the visit to Chicago are available. First, there is Herman Weinberg's reminiscence:

> It was to be a going-away party. In a week, or a little more, Robert Flaherty was to start round the world by air with a battery of new, three-dimensional, color cameras, to film and record the sights and sounds of the earth. It was to be a veritable "film symphony" of the world. The sponsor was Mike Todd, the theatrical producer. He had invested in a new film process and Flaherty was to try it out, full scale.
>
> But what the creator of *Nanook* and *Moana*, the director with the most gracious camera-eye of them all, would do with such an opportunity was sure to be unprecedented, and this project has been the film world's most exciting news of the year. . . .
>
> Flaherty was in high spirits that night. . . . The setting was the Coffee House Club. . . . At first, of course, the talk was of the forthcoming journey. Everyone wanted to know about the new cameras—were they *really* three-dimensional? Flaherty did his best to explain, but his heart wasn't in it. "Oh, it's a lot of technical stuff . . . you can only show the picture in one theatre at a time . . . costs too much to equip all theatres with the special screens and so forth that's needed . . . or something like that." Anyway, they were going ahead, undaunted, and making the picture. . . .
>
> We piled into several cars and headed east for Beekman Place, where Monica Flaherty and her husband have an apartment overlooking the East River. . . . Flaherty went from one [group] to the other, a fine, jolly man, as young in heart as the youngest. How often I had marvelled at the zest of this man of 67, who played Corelli and Mozart on the violin for relaxation, who used to lumber up the stairs of Lopert Films to ask about *Louisiana Story*, which they were distributing. "How're we doing?" he would ask, and then invariably to me, "Come on, let's have a drink!" . . .
>
> He was usually in a contemplative mood when we were alone, and sometimes spoke wistfully of the films he had wanted to make in Japan and China, and of one based upon the medieval festival staged each year in Sienna. How often he had said, when reminiscing about the many difficulties he had encountered in trying to achieve his ideal in films, "Film is the longest distance between two points."
>
> I then told him that once when Pabst complained that if he hadn't been so choosy about the scripts offered him, he could have directed many more than twenty films in some twenty-five years, I had remonstrated that Flaherty had made only six films in thirty years, and that Pabst had shot back, "But what films!"

It was getting late at the party. Flaherty suddenly begged to be excused and announced that he was going home. In the doorway, he paused, glanced at each of us in turn, and smiled a collective farewell. (Weinberg 1951)

Richard Griffith, ever the faithful disciple and admirer, tells us with great eloquence of the last weeks:

So Bob has slipped away from us without saying Good-bye. Or almost. The last time I saw him, sitting miserably in an armchair, half-unconscious from drugs, he muttered at me, "I'm through, I'm done for this time." But I had heard this sort of thing before in black moods, and paid not much attention because I have been apprehensive ever since.

He went to Chicago in April with that damned three-dimensional camera to shoot the MacArthur parade and caught something there that turned into virus pneumonia. He threw that off. Then he began to suffer terribly from arthritis—the first time in his life. That seemed to go away and he was getting ready to follow Frances up to the farm at Black Mountain when the pains came back and the doctors wouldn't let him leave until they had "done something" about it. Doing something consisted chiefly of drugging him with morphine to the point that half the time he didn't know what was going on.

Of course, he didn't let anyone know how bad he was, even Frances didn't take it in, and there he sat, alone in his room at the Chelsea, day after day and night after night. He couldn't lie in bed, the pain was so bad, and he had to sit out the nights in an armchair. When finally we all caught on to what was happening, and Frances came down to New York from the farm, he rallied, fought off the arthritis—and then came down again with shingles, equally painful and equally requiring constant drugs.

I visited him every day at this point and while he would welcome me and follow conversation with his eyes and occasionally say a pertinent word or two, he had really withdrawn to some region of his own where none could follow him. All this we attributed to the morphine, and when Frances told me one day, with tears of joy in her eyes, that a new "miracle" drug had been found which had cleared up everything, I felt safe in taking a few days off, Frances's intention being to take Bob up to the farm at once.

That day was the last time I saw him. When I got back, I discovered that he had been pronounced too weak to travel, though entirely recovered, and had been moved from the discomforts of the Chelsea apartment to a hospital. When I telephoned and explained why I hadn't been to see him, I heard him say, "Tell Dick not to give me any

of that stuff!" He seemed much better but didn't want to see anyone. Frances moved him to the farm, where things rapidly got worse. He had thrown off all the plagues that had descended upon him at once but his heart, always sound before, just couldn't stand the strain.[43]

The official cause of death was cerebral thrombosis. The date was July 23, 1951. They buried his ashes on the hillside at Black Mountain under a slab of white stone.

"Couldn't see how even a coyote could live in it," frame enlargement from *The Land* (print courtesy Museum of Modern Art Stills Archive)

"Most of the migrants are young people, with young children," frame enlargement (print courtesy Museum of Modern Art Stills Archive)

"A new world stands before him," frame enlargement (print courtesy Museum of Modern Art Stills Archive)

Contour plowing, attributed to Frances Flaherty (print courtesy Museum of Modern Art Stills Archive)

Son, director, and "father," by Arnold Eagle

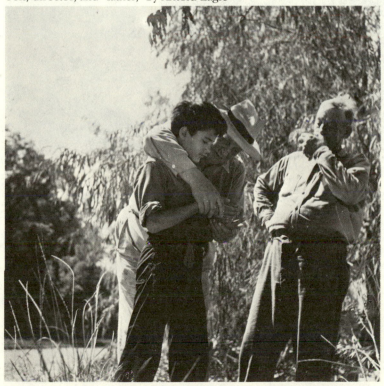

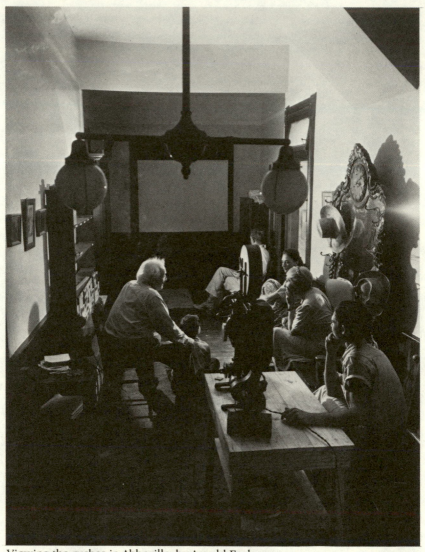

Viewing the rushes in Abbeville, by Arnold Eagle

Flaherty and Helen van Dongen editing, attributed to Frances Flaherty (print courtesy Museum of Modern Art Stills Archive)

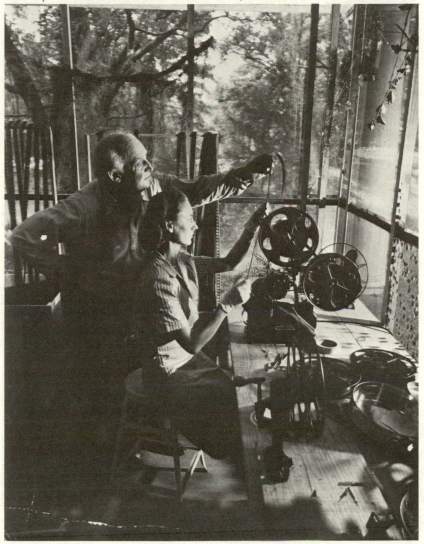

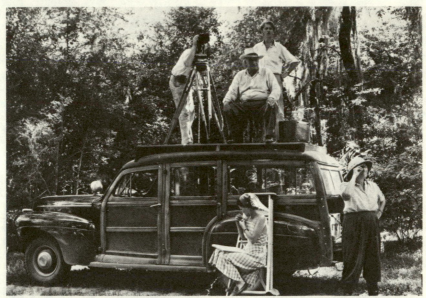

On location in the Bayou, photographer unknown (print courtesy Museum of Modern Art Stills Archive)

Frances and Bob relaxing, photographer unknown (print courtesy Museum of Modern Art Stills Archive)

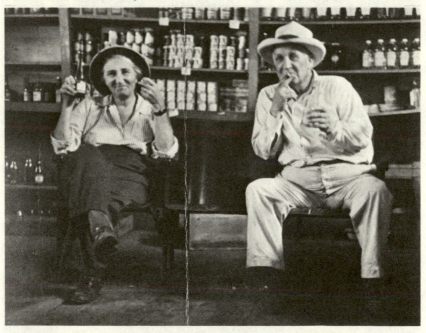

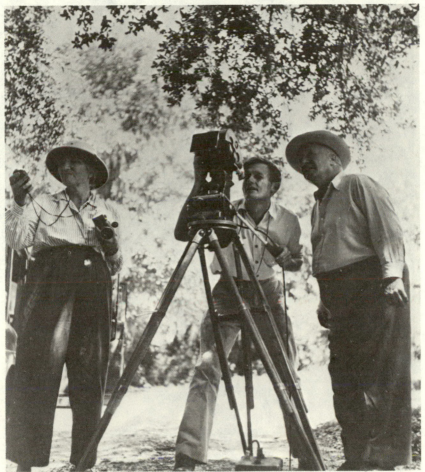

Frances Flaherty, Richard Leacock, and Robert Flaherty, photographer unknown (print courtesy Museum of Modern Art Stills Archive)

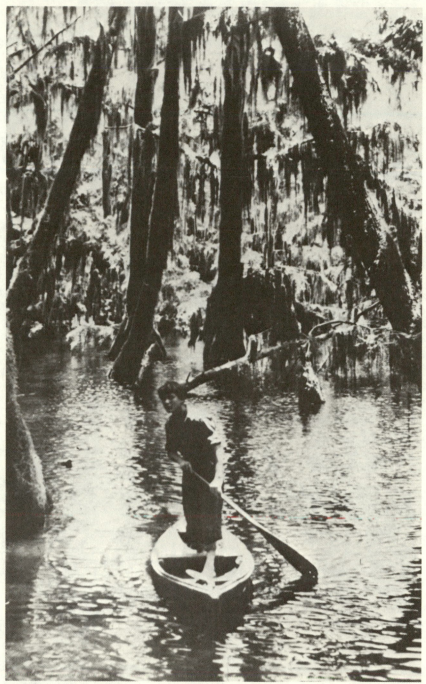

Napoleon Latour in his pirogue, frame enlargment from *Louisiana Story* (print courtesy Museum of Modern Art Stills Archive)

Man and Artist : Chapter 7

The first time you met Flaherty, and indeed on all other occasions, you noticed, before anything else, his eyes. They were a limpid, brilliant blue, lying like lakes in the broad and rugged landscape of his face, the smooth, rosy cheeks making a strong contrast of color. In later years his broad and barely wrinkled forehead was crowned, like Fujiyama, with silky, frosted-silver hair that had once been blonde. He had a broad and expressive mouth, a solid chin and jaw, and a bull neck. In his fine head you saw and felt a sense of permanence; the bone structure was magnificent.

Hayter Preston has said that Flaherty strongly resembled the bust of Goethe at Weimar and added: "He could very well have sat for Rembrandt as a model for a Saint." And Grierson, in addition to his famous phrase, "the finest eyes in the cinema," has remarked on "his great square head and kind of face you see carved on the side of a mountain." He had a smile of singular sweetness.

Flaherty stood five feet nine inches tall. He was bulky and sensitive about it. He was immensely strong, especially in his youth. But for all his bulk and strength his walk was sure and soft-footed, his movements slow and gentle.

When he sat down, he squared himself into an area sufficient for two lesser men and put his broad hands on his knees. His voice was musical and could therefore achieve strident discord as well; it captured your entire attention. We remember him as a monolithic figure.

Flaherty was not a complex character. He was in fact an extremely uncomplicated man. You knew him well very soon after you first met him, and as acquaintanceship ripened into friendship the first impression of the

salient points of his character did not change. In many respects he was like a child—perpetually inquisitive, perpetually surprised or delighted by new and usually simple discoveries, prone to tantrums or temper which lasted only a short time. He was fundamentally a kindly man, as proved by the repeated testimonies of those who knew him. We have heard him called "an eccentric." He was far from that.

We need not dwell further on his fabulous generosity or his brilliance as a talker and as a storyteller, except to note what might be called his externalization. He hardly ever talked about himself. His stories—even of his own personal experiences—were built around the other people concerned in the incidents he described. This is not to say that he pretended to be a lay figure; it was, rather, that he had a passionate interest in everything he saw around him and a passionate desire to tell others of what he saw. He was less interested in telling of his inmost personal feelings.

John Grierson makes a shrewd point in this respect: "It is a fact that I never heard Flaherty at any time speak intimately, far less untowardly, of his personal life. Nor have I known anyone who has—outside his family circle. It was a most gentle aspect of him. His film troubles everybody might know about and everybody by God *had* to know about them. But there was an awful reticence in him in all that attached to his more private self."[1]

But in all else his passionate desire to communicate his experiences produced a constant flowering of his personality, of course without conscious intent. He might have made a fine actor, but such a thought would never have occurred to him.

It was perhaps his continual curiosity and enthusiasm, combined with the magnitude of his travels, which made it difficult to ascribe a nationality to him. You knew he was an American with an Irish name—but you thought of him simply as Bob Flaherty.

For John Goldman,

He was not even an American in the sense that he felt the American pattern and identified himself with it. . . . He was child of the Canadian mining-camp, facing North, on the edge of the unknown, to the edge of the unknown, to whom prospecting, hardship, personal achievement in the face of incredible conditions of nature was natural. He conformed to his background and to his upbringing and conditioning. To have expected him to be different would be absurd. When, after his years in the North, from the Cobalt district of Ontario to the eager lone-wolfing in Hudson Bay, Ungava and Baffin Land, he came South and met industrial twentieth century man for the first time in New York, he didn't rebel against it; he was fascinated and astonished and when he contrasted it with his own knowledge and ex-

perience of life as he had lived it up till then, he found his own way was very good, that his world was real (to him) and our world was a sewer. It never occurred to him to rebel against our world because he never accepted its reality at all.[2]

Grierson makes the same point in a slightly different way:

This American spent a great part of his life in faraway places—and most of it, incidentally under the British flag. The social background of his memory and his predilection was, at the latest, Edwardian. He never knew the modern metropolitan world nor had the training or taste to understand it. He was a sort of belated Pre-Raphaelite, intensely hating everything industry, mass-production and regimentation had loosed on the highly personal world he most enjoyed, and the more so as they stormed in on his own chosen medium. (Grierson 1951a)

If Flaherty was a citizen of the world, he was an uneasy one. One-half of the world he understood—the world of his upbringing in the stern North where he learned "the poetry of the virgin lands. . . . [The] poetry of lone-exploration and the discovery of the heroism of utter self-reliance in the face of natural forces."[3] In the other half, the modern world, he remained a stranger until the end of his days, although in his two last films we see an attempt at reconciliation. But once away from his film locations he was a stranger in a strange land. Hence perhaps his chosen oases—the Coffee House Club in New York, the Cafe Royal in London. Here he felt protected, surrounded by friends, able to exercise his prerogative as a monologuist.

Oliver St. John Gogarty tells a story of Flaherty which well illustrates his unease in the metropolitan world. "When you met him, he always hailed you with a little smile, and then if you were in his company too long, he seemed to get a kind of melancholy as if he was brooding on something. One evening he took me to an expensive restaurant in New York where the waiters were all attention to him. Suddenly he said 'Let's get out of this, I can't stand the pressure.' And so we went to a tavern instead of to the best restaurant in the city."[4]

Inside Flaherty there lived a lonely man. In addition to his desire to communicate his experiences there was an urgent and compelling need for company, for companionship. "I never saw a man so worried about being alone," writes Grierson, "that's why he poured out the best of his creative power in conversation."[5]

John Goldman remembers that at the time of the editing of *Man of Aran*,

My own impression is that he had become (although he could not al-
ways have been that way) curiously unaware of people. He drank with
them, gossiped with them, passed deadly time with them, time he had
somehow to kill. He could not stand being by himself. He demanded
diversion. And remember, he was no conversationalist. He would not
listen to other people. Unless he was the centre of a group, he lost
interest. The world of intellect was largely closed to him so he could
not go to books or to thought for solace or for refreshment. . . . All of
this, what seemed to me his aversion to people as opposed to com-
pany, and his addiction to his concepts of the box-office, have strong
bearing on his films and especially on *Man of Aran*.[6]

Richard Griffith, on the other hand, who knew Flaherty perhaps better
than any of his friends from 1939 until the time of his death, adds this com-
ment about the belief that Flaherty needed an audience round him: "I have
sat with him in long companionable silences lasting whole days. I have seen
him often and often happily participate in the long give-and-take of conver-
sations with groups of people far too individualistic themselves to be flat-
tened by the Flaherty steam-roller. There were times when he encouraged
others to monopolize the talk."[7]

Of all his hundreds of stories and anecdotes not one was about sex.
(The story of the grizzly bear on the railway train is perhaps an exception,
but as far as we can establish, it was not his own.)[8] He was profoundly,
perhaps excessively, shocked and horrified by the sexual license of Berlin
in the early 1930s. His films ignore sex. The famous publicity blurb about
Moana must be the most inaccurate ever coined—for in this film, apart
from the ceremonial dance whose sexual symbolism is so heavily dis-
guised as to be almost unnoticeable, we are presented with a Garden of
Eden before the Fall. The studies of the modern anthropologists might
never have existed. It was not that he deliberately avoided sex in his films.
It simply never occurred to him to include it.

But it is to be noted that after *Nanook* all his films, all his unrealized
ideas for films, save *Industrial Britain* and *The Land*, are haunted by the
image of a youth or a boy, symbol perhaps not only of purity and inno-
cence but also of the son he desired and never possessed. Indeed, his pos-
sessive jealousy toward Mikeleen, Sabu, and Joseph Boudreaux, of which
there is such ample evidence, seems to strengthen this theory. A number of
people, too, have been struck by the interesting and marked resemblance
between Boudreaux's father and Flaherty himself.

This boy image, however, may be explained in other ways. John
Goldman inclines to the idea that Flaherty, sickened by our modern civi-
lization and comparing it to that of the simple Eskimos and Samoans,
whom he loved because he regarded them as happy and childlike, turned
to the boy image as an only solution. Goldman feels that increasingly as his

life went on, Flaherty began to dislike grown-ups (other than his closest friends) and tried to lose himself in the world of childhood. He feels further that in doing so he lost the vital element of his earliest films:

> In *Nanook* you have quite simply the feeling and grasp of the family, and in *Moana* not only the family but the feeling of the community. . . . But when we come to *Man of Aran* where are the people? They have become divorced from themselves and from each other. . . . Only the boy remains, but already a kind of idealised boy, living in Arkadia. By the time of *Elephant Boy*, a whole film is now built round the boy. In *Louisiana Story* again nothing really remains but the boy. The adults are almost banished.[9]

Although we do not agree with Goldman's general feeling that all Flaherty's work from *Man of Aran* on shows a deterioration of theme and reality, there is no doubt something in his thesis of an escape back to childhood. From the psychological point of view we could say, with Jung and Wilhelm, that the boy represents an archetype deeply embedded in Flaherty's subconscious and the center of the mandalas he constructed in the form of films. It would be difficult, however, to speculate on the archetypal myth—Atthis, Adonis, Ganymede, the infant Dionysus.

On the other hand there is Freud's thesis that "the goal of mankind is childhood." Newton Rowe, to whom we are deeply indebted for comments from the Freudian point of view, believes, as does John Goldman, that by the time Flaherty left Savaii his character was fixed and did not change further. He also thinks that Mrs. Flaherty's preoccupation with Zen Buddhism in relation to her husband's work may well have been an attempt to explain the transformation he underwent during the making of *Moana*.

Rowe develops this theory of transformation in relation to the Arioi cult of the Tahitians (which made them different from other Polynesians), by which the infant, from the moment of birth, became head of the family. He remarks further that the Tahitians attempted to get rid of war (in which they were continually engaged) by means of free love and dramatic entertainment and that the Arioi cult's substitution of the God of Love for the God of War was an anticipation of Freudian theory.[10]

According to Rowe, Flaherty was unconsciously but instinctively in search of Freud's Nirvana principle and its forerunner in Tahitian life. He believes that Flaherty was in search of perpetual happiness and that he found happiness among the Eskimos. To quote Freud again, "Happiness is the deferred fulfillment of a prehistoric wish. That is why wealth brings so little happiness; money is not an infantile wish." Rowe recalls that Flaherty was genuinely upset when he was told that he would not have liked living in ancient Tahiti. "Then," cried Bob, "there's no hope for the human race."

We must remember that before making *Moana*, Flaherty had spent most of his life in the far North, first as a lone prospector and explorer and second as the maker of *Nanook*. During this film his latent abilities as a creative artist emerged. This sort of self-discovery, coming as it did in his case quite late in life, could, we presume, be quite dangerous.

When in the first flush of this self-discovery and of nascent fame, Flaherty went from his Eskimo friends—people, Rowe points out, who have never engaged in war—to the far more complex Tahitian culture, he must have found the impact of change very violent. This impact may well have caused a considerable turmoil in his subconscious. His intimacy with two remote civilizations—the simple Eskimo and the complex Polynesian, both deeply rooted in the basic essentials of man's primitive soul—may have satisfied the already existent urge in his subconscious to "return to childhood," that is, to express and explain life in terms of "except ye become as little children."

This reaction can be regarded as a form of escapism, but also can be explained on the theory that "the artist is the man who refuses initiation through education into the existing order, remains faithful to his own childhood being, and thus becomes 'a human being in the spirit of all times, an artist'" (Brown 1959:66–67).

Assuming that such ideas as these explain the boy theme, and remembering that the boy theme was good box office, we could further adduce that the absence of this theme in *The Land* is in part reflected in the tortured and agonized protest Flaherty made in that film. Its power may rest partly in the fact that its maker was faced with a situation in which the prerequisites of his subconscious attitude were not available. There is one shot in *The Land* of a small boy who, even in his sleep, makes the motion of stripping peas.

If any of these speculations are true, Flaherty was never conscious of them. Nor is it necessary to overload any analysis of his work exclusively with psychological theories. He remained, outwardly at least, an uncomplicated individual.

Of course, to be uncomplicated means some limitation in character, nor is it always wholly advantageous. To some he may have appeared sentimental, but underneath this was the hard self-reliance and single-handedness which obviously came from his early exploring days in the North and his mining-camp boyhood. Some criticisms of him as an artist are not unjustifiably based on his tendency to oversimplify, which in turn led him sometimes to make his locations and people fit an ideal conception of his own rather than the actual facts. We must hasten to add that there could never be any imputation here of bad faith such as is revealed in certain travel films, where deliberate faking for the sake of sensationalism is the order of the day.

As has been seen, these criticisms of Flaherty's approach to his subjects burst out over *Man of Aran* and still remain largely centered on that film. It is probably true that the most violent of the attacks resulted from a failure to take account of the fact that Flaherty was not a reporter with a camera but a creative artist. We do not complain that Veronese and others dressed their biblical figures in contemporary clothes; we *do* complain if an essential artistic truth is missing from the result. In considering Flaherty's work, such a distinction is essential if we are to be fair and reasonable. And of course some of the criticism will be seen to be perfectly justifiable.

Looking back again to *Moana*, there were, as has been noted, a number of social, political, and economic changes going on in the South Seas which the film completely ignores. Flaherty disliked and mistrusted the spread of Western civilization to areas such as Samoa. He was bitter about the diseases and commercialities introduced by traders and missionaries—especially the latter. His expressed intention in making *Moana* was to preserve for all time habits and customs that were rapidly dying or deteriorating to tourist attractions. There is nothing basically wrong in such an idea, which indeed he carried out to perfection, producing a beautiful and memorable film. Later documentarians might have preferred a film that overtly drew attention to the dangers threatening the ancient Polynesian civilization and even suggested a way out; but in our opinion *Moana* is a true work of art. Years later, Flaherty said to Newton Rowe: "You and I were just in time to see the end."

Flaherty's approach to the Aran Islands was different and is less easy to justify. Here he deliberately recreated the past. The islanders had long since ceased to hunt basking sharks. They had to be taught (and persuaded) to do so. The economy of the islands was no longer closed. They were not only strongly linked with the mainland of Ireland but to some degree with America. Yet the film presented its recreation of the past as though it was valid in a completely contemporary sense; and this was the basic falsity of which many critics, either by instinct or by direct knowledge, complained. The enormous and abiding reputation of *Man of Aran* in France, Italy, and Germany may well have resulted in part from an ignorance of the true facts of life in Aran. The film has more impact if the viewer believes it entirely.[11]

In any case the conflict of opinion over *Man of Aran*, and the fact that here, virtually for the first time, the validity of his theories, and even his own position as a creative artist, were powerfully attacked, makes it necessary to review in some detail his behavior and feelings when making a film, and this film in particular. Here once again the experience of John Goldman in working with him on *Man of Aran* is important evidence. He writes:

It is said that Flaherty's world was romantic. There was a saying in Canada around that time: "You go North to live; you go South to be robbed." South, the parasites; North, the purity of man. That's how Bob saw it from his earliest childhood. And by and large that was the subject of his films. . . . Man is degraded and debased by society; man is purified and cleansed and achieves manhood and dignity in his struggle with nature.

And this makes me ask: was *Nanook* really about Eskimos, or *Moana* about Polynesians or *Man of Aran* about Aran Islanders? Or were they the affirmation of belief of the golden boy from the mining-camp looking North to the eternal challenge to man's qualities? One of Flaherty's favourite expressions when I was working with him was "It's like looking for a gold nugget"; this he would say when we were screening reel after reel over and over again of the same film. . . .

This stage in Flaherty's film-making was a long, long tedious and soul-destroying process, utterly exhausting. . . . I can see Flaherty prospecting in the vast lands, horizon beyond horizon, no man knows what lies beyond, behind or any way, distance upon distance, alert for the sign that may never come of the presence of iron-ore, that one single objective in that limitless universe of exploration. So he sat too in the projection-room, month in, month out, alert for that sign of magic. And all this time he suffered; make no mistake about that, he suffered. Then the process would begin all over again.

. . . I think it is important to add that the man on the film was utterly different from the man in the Cafe Royal. As different as the prospector blueing his cash and out in the field panning for gold. Flaherty on the job in Aran was not only bereft of all humour and wit, but was utterly concentrated on the film to the complete exclusion of all else, and this was 24-hours a day, waking and sleeping. His being was, as it were, both wrapped around the subject but at the same time engulfed within the subject. Nothing else existed or had meaning for him. The result, of course, was an atmosphere difficult to describe if not experienced. It was heavy, thick and charged. There was tension everywhere, unbearable thunderous black tension, tension you could feel with your hand, smell and sweat in, stale tension, sulfurous tension, all-pervading, contagious and paralytic. And like some self-charging gasometer, it would swell and inflate and grow thicker and darker; emptiness and frustration and failure; pressing at the sides, bursting at the seams; your very blood thickened into a sludge and life slowed down into profound depression, explosive and dangerous. The subsequent explosion was like a volcano blowing its top. It had to be. The atmosphere lightened, work began anew and grew into a

furious pace until the tide ebbed again and the fog gathered around and the tension grew and stretched and brooded once more. There was no relief.[12]

This personal and firsthand portrayal of Flaherty during the making of *Man of Aran* needs of course to be related to other factors of the production, not least those of box office. Flaherty, there is no doubt, had the strongest reasons for wanting the film to be a commercial success, not least because he wanted to revenge himself for the treatment he had received from Hollywood. His conception of box office was not the same as that of Gaumont-British. It is possible that the latter, whether consciously or unconsciously, influenced him in shooting and editing the film, as many of his friends and admirers suggested after the premiere. Goldman now thinks that after the incidents of *White Shadows*, the Pueblo film, and *Tabu*, Flaherty became haunted by the idea of box office. Hence the sharks in *Man of Aran* and the stampede in *Elephant Boy*—the box-office gimmick exploited as a box-office gimmick. We doubt if this is wholly true, especially in view of *The Land* and *Louisiana Story*, although the alligator in the latter might meet Goldman's thesis.

But the main theme in both these films is not a gimmick but a genuine expression of something Flaherty passionately felt—the need for reconciliation between man and the machines made by man. It is no gimmick when in both films the machine first appears like a prehistoric monster moving through a primeval jungle. These scenes are a perfect example of the fundamental artist in Flaherty, for he worked less by inspiration than by revelation. Like a child, when he found something new (new to *him*) he wanted to tell everyone about it; and because he was a genius his communication of his discovery comes to us in aesthetic form. It is transmuted because he tells us what it meant in terms of self-revelation.

But, like a child, he could cheat himself and try to cheat us. The discovery that there were basking sharks off Aran had to be forced into his film; the islanders had long since ceased to hunt them. And this in essence is the gravamen of the various charges against *Man of Aran*—that he falsified his own revelation.

Nevertheless, when all criticisms have been made, *Man of Aran* remains memorable for the validity of Flaherty's filming of the angry sea. No one but Flaherty could have used the lens—and especially the long-focus lens—with such mastery. The violence, the physical impact, the revelation of the smallness of man against these gigantic breakers produces a terrible beauty, which never loses its effect however often one sees the film; and, as we have seen from John Goldman's description of the editing of the film, the sea was Flaherty's main obsession—an angry sea which was perhaps prefigured in certain scenes in *Nanook* and certainly in *Moana*.

Finally, those critics who never gave Flaherty an even break after *Man of Aran* are answered in the following statement by Helen van Dongen who, as we have seen, had her own troubles (not unlike Goldman's) in working with him on *Louisiana Story*:

> His work should be studied and evaluated not as an isolated phenomenon to be copied and perpetuated by hundreds of little Flahertys, but in relationship to the development of the film as an art and a vehicle for mass-education and against the changing tides in world history. If his films are used in the educational field to show how such and such a people live, then they are dangerous; if they are used to show what one visionary poet wanted to sing about a small incident in the lives of another people, with all the artistic license permitted, they are beautiful and enjoyable.[13]

His next film, *Elephant Boy*, however, does not illustrate this thesis other than, perhaps, in the sequence of the Jain statue and one or two other isolated scenes. But the answer here is, of course, that Flaherty was sidetracked. As we have seen, much of the filming was not his; and whatever he was trying to say did not come through. It seems to us that the entire making of *Elephant Boy* represents the very opposite of what Flaherty, as a creative filmmaker, wanted to do.

Flaherty's approach to filmmaking was essentially simple. He used the camera lens to make us see things in the image of his own unique and brilliant eyes. He was happy with a small film camera. He was uninterested in dissolves and other optical tricks. The lens was an extension of eye and arm; when he moved the camera it followed precisely his own vision—hence the miraculous anticipation of movement which we can observe over and over again, the most famous example being perhaps the featherlike delicacy of the pans and tilts on the potter in *Industrial Britain*.

We know that huge studio cameras and large film units were a bother to him. It was a cruel mockery of fate that his last and uncompleted assignment involved him with the most cumbersome system of all—Cinerama.

Moreover, Flaherty's method of filmmaking could not in its nature take kindly to the discipline of a script. In a sense, he created a film by instinct as the Eskimos created their carvings. Each shot was like a seed, which, if the soil was good, germinated and produced first a plant and then more seeds. He did not need a script. He needed, desperately, time and film stock.

Because of his method, the editing process was vital. But, as we have learned from those who worked with him, he could not approach editing from a pragmatic or doctrinaire point of view. For Flaherty, editing was an extension of the camera process. The projection room rather than the cutting bench was the scene of his creative work.

For all these reasons *Elephant Boy* must, throughout its production, have been an episode of cumulative frustration for Flaherty. In his wife's book on the subject, a feeling is apparent even if it is not expressed of a despairing determination to keep to the original idea, which was, stripped to its essentials, to let Flaherty loose to shoot something roughly based on *Toomai of the Elephants*. In light of the final product, we can only admire the Flahertys' faithful belief that what they were trying to say would appear finally on the screen. Alas, it did not.

It is easy to blame Flaherty for this failure, as did Graham Greene. It is less easy to understand the slow and insidious process by which he seems to have allowed the executives to take over the production. He was in many ways a man with a mind as innocent as his eye. He never believed that people were betraying him—until afterward. It was always afterward, when it was too late, that the truth dawned on him, and then he raged. In this case, however, he seems to have kept his reactions to himself. There is little or no record of what he really felt about the debacle of *Elephant Boy*. But anyone who knew him cannot but feel that—apart from certain joys of filming—it must, in the end, have been an unhappy episode in his life.

Flaherty, the innocent and uncomplicated artist, was also, inevitably, a frustrated man. He had to work in a field where interests other than his own dominated both production money and the means of distribution. With the exception of *Nanook* and *Louisiana Story*, he never really had an even break.

It is of course easy to make too much of this. Others in the cinema have suffered similarly—Griffith, Eisenstein, Dovjenko, Vigo, Orson Welles, Renoir, to name but a few. Nevertheless there is something horrifying about the long gaps between most of Flaherty's films (remembering especially that he started to make films comparatively late in life). Somewhat horrifying, too, is the evidence of all his attempts—so outside his real character—to play the catch-as-catch-can, clever-clever, rat-race game of the film trade in the hope, so often abused and disappointed, of getting the creative freedom he wanted.

Of course, the box-office complex was tied in with a certain vanity. As Grierson remarked, "He had come out of Hollywood punch-drunk with box-office. This was partly a matter of very proper vanity; it also had something to do with his increasing need for money. I don't think he ever wanted money for itself. He needed it to be a *Grand Seigneur*. He hated not being a *Grand Seigneur*. It got him into some odd company sometimes." [14]

Flaherty's attitude toward money was, to say the least, curious. Newton Rowe thinks that it could be explained by some unpleasant incident in his boyhood days in the mining camps, which may have left a deep complex. All who knew him confirm that he spent money as if it had no meaning for him. This was not just generosity or profligacy; it was almost an attitude of contempt. Cedric Belfrage makes the point that when he was in Hollywood

in the late 1920s, although he associated with many wealthy Americans, he never met anyone like Flaherty for "reckless spending." Flaherty himself once remarked to Newton Rowe that if you threw things away in life, they always came back. "Maybe," says Rowe, "he was not so crazy and wildly extravagant as he was reputed to be." He also told Rowe that all his life he could never keep a watch; as soon as someone gave him one, he either lost it or dropped and broke it.[15]

His regard for the money provided by a sponsor for his films can hardly be called responsible, although this is not meant to imply dishonesty. The unfortunate experiences while *Industrial Britain* was being made have been related in detail. On another occasion Grierson remembers Flaherty saying, when he was gently warned not to overtax Standard Oil's generous sponsorship of *Louisiana Story*, "There's plenty more where it comes from." (In fact, the production cost was eventually considerably more than the original contract price.) It is certain that at no time did Flaherty understand, or want to understand, the theories of sponsorship, propaganda, and public service which underlay the economic basis of most British and American documentary filmmaking.

Flaherty had a flair for publicity and enjoyed it increasingly as his life went on. His writings (other than his books and his pieces in the *Geographical Review*) were often written as publicity and created a somewhat fictitious picture of himself. He was aware of this but did nothing to dispel it, just as he made no public comment on the inaccuracies or distortions in Taylor's *New Yorker* "Profile" (1949), which he is known to have disliked.

"His voice was the voice of protest against authority and commercialism," says Hayter Preston, "but not against what we today call the Establishment. He was too much a Tory at heart for that."[16] Politically, we add without need for elaboration, Flaherty was an innocent.

But this is only a small part of the picture. The basic fact is that the story of Flaherty is the tragic story of the artist in cinema—the artist sooner or later overwhelmed by the industrial demands of the medium, borne down by the weight of commercial or trade union demands. Nor is it true that Flaherty never complained about this. Publicly he may have made no comments on, say, his treatment regarding *Elephant Boy*, but most of his friends often heard him rage against the film tycoons, both personally and in the more general terms arising from the frustrations of trying to get films started, the frustrations over distribution, and the frustration of being swindled out of a fair share of the receipts. We sometimes wonder whether there is now any place left in the world of commercial cinema for an artist like Flaherty.

Every artist must to some degree come to terms with the less attractive aspects of his medium, and here Flaherty may have been at fault. Writes Grierson,

He remained something of a Sunday painter. He wouldn't learn, or rather he wouldn't work at learning. Sometimes I thought he was too grand to learn or too indolent to learn. But that was not really the secret. There is a clue to it in his inordinate pre-occupation with hospitality and friendliness and the good cheer of conversation. He just hated to come down to the disillusionments of the practical world and especially of the film world in which the practicalities of sponsorship could be more than ordinarily disillusioning. . . . No, he wasn't good at facing up to the realities of the film world and he felt guilty about it and it haunted him and he hated to be alone. Of course you can say, why shouldn't a man pursue hospitality and friendliness and the good cheer of conversation as an end in itself? The trouble was that Flaherty never found the right country and the right profession—conjointly and together—to allow him this luxury. It did seem to happen sometimes though not for long, and—Oh my! *what* a wishful thinker—he fell for the illusion every time. That is the story behind all his adventures in India, the East and elsewhere. But with all this . . . you had to like him the way he was, and all our tributes were utterly genuine.[17]

The tributes were indeed genuine. There were those who, however disappointed in the hodgepodge that was *Elephant Boy*, realized the predicament in which he had been landed and continued to speak up for his genuine qualities as an artist. And then from the doldrums that followed *Elephant Boy* came a commission to make a film which, although after its completion it caused Flaherty one of the worst frustrations of his life, stands out in nearly every respect as the most significant, though not the most perfect, of all his works.

The importance of *The Land* has already been fully analyzed earlier. It remains here only to emphasize its position as a watershed in his development as an artist. That it came toward the end of his life, and not in the middle, is a sad fact of fate. But its significance may be easily judged by the perfection and mastery of *Louisiana Story*, which followed it and which contains no elements that can be criticized as "escapism" as was his earlier work. Apart from *Twenty-Four Dollar Island*—itself an aesthetic and uncompleted experiment—Flaherty had never beamed his magnificent eyes onto the urgent problems of contemporary Western civilization. He had made films based on the myths and legends behind reality and in far-off places. Here he made a film on the facts and deployed the same genius of eye and lens. Someone who saw *The Land* soon after it was made remarked, "The old boy doesn't know what it's all about, but by God he makes you *feel* it." This was not a harsh criticism but a genuine tribute.

Although Flaherty was uneasy with the technological complexities of high-powered studio filmmaking, he had a naive interest in and almost a

passion for machinery. We remember the day in 1931 when, at the EMB Film Unit, he first got his hands on a Newman-Sinclair camera. It would not be true to say he was like a child with a new toy, because a child often breaks the toy. A nearer analogy would be that of a noble savage discovering a wheel that was completely instead of partially round; but this, too, would be inaccurate, for he had used good cameras before. No, it was the joy of an artist finding a tool ideally suited to him, the existence of which he had never suspected. He was as happy as a sandboy.

Orson Welles remarked, "He loved a gadget in a very American way, as a thing itself and not for what it could do." [18] This description does not, of course, apply to cameras; but he had a passion for contrivances which he picked up heaven knows where, carried around in his pockets, and displayed to all and sundry with hugh enthusiasm. "But," adds Helen van Dongen, "he very soon lost interest in them"; and she suspects he may have used them as gimmicks to get conversation started.

In *The Land* Flaherty made a new discovery of himself. Returning to North America—but much farther south than the location of his first film—he looked at the contemporary agricultural problems of the United States, and he was appalled. He suddenly saw a situation in which the present was more important than the past. He saw that the technological age, which could bring untold potential happiness to man and woman, was, owing to financial and political greed, bringing only misery; and in the very moment of his cry of protest, he saw Armageddon bringing a solution, and with it, the virtual banning of his film. For the first time he had magnificently tackled a contemporary theme, and, typically, had given a gigantic roar of anger and a passionate appeal to our conscience. And *The Land* was quietly and indecently put away in a cupboard. This, surely, was the acme of frustration.

Yet in making *The Land* he found a new certainty as a creative artist. Before *The Land*, his conception of *Louisiana Story* could never have existed; for here he found a balance, almost a peace of mind, as did Oedipus at Colonus. Here he mastered an equation he had unwittingly been trying to solve all his life—the balance between the pagan or primitive past and the definitive present. If *The Land* is impressive because of its passionate incoherence, *Louisiana Story* is sympathetic and compelling because of its acceptance of two ways of life.

Flaherty worked by instinct, and there is no reason to suggest that he consciously sat down and thought out this particular form of acceptance. It was, surely, much more—the logical development of his lifelong search for a perfect form of expression through the camera and the projector he loved so much. We have already elaborated our belief that he learned much from his firsthand contact with Eskimo carving and drawing, an approach that came "from within." We know well enough that the way he made his films—by unwinding them in agony from his own belly—made

him difficult to work with; for he could seldom explain to his co-workers what he was after, what he *meant*. We know, too, from Helen van Dongen, that the making of *Louisiana Story* was no exception to his rule—very much, in fact, the reverse. Yet out of all the tantrums and sulking and mis-understandings and slamming of doors came a simple and almost perfect work—the meeting of two different worlds in a romantic landscape, the acceptance of each by the other, the parting of the two, with each having learned from the other—and then, alas, silence. It was his last film.

But not the last of Flaherty. His influence on others has been and will continue to be significant. It can be seen in the work of Sucksdorff, Haanstra, Rouquier, Satyajit Ray, and others. John Huston has gone on rec-ord as saying that directors such as John Ford, William Wyler, Billy Wilder, and certainly himself were all profoundly influenced by Flaherty.[19] And the influence is all the more profound because it is not just a question of imi-tation. It is an influence on an approach to life as seen through the film medium. As Jean Renoir said, "Flaherty was not the type of artist we can consider as the teacher. There will be no Flaherty School. Many people will try to imitate him, but they won't succeed because he had no system. His system was just to love the world, to love humanity, to love animals, and love is something you cannot teach."[20] And it must always be remembered that Flaherty had by no means exhausted his wonderful talent when he died. He had plenty more films in him, as he had had all through the years, if only more sponsorship had been available.

Yet when all has been said—the films analyzed, the stories told, the character of the man described—the eternal question mark of genius still remains. The ancient craftsmen described their particular skill under the name of "mystery"; and so, too, it may be said that there is a mystery of genius which goes down into the grave with the artist, leaving us forever groping vainly for its solution. The Beethoven who wrote the last quartets, the Giorgione who painted *La Tempesta*, the Dostoievsky who created Alyosha—these men, whatever we have found out about them, are not fully known to us. And about Flaherty there is a similar mystery; in the end he defies critical scrutiny.

This explorer, always roaming with a hungry heart, traversed the world without charts—proud perhaps to take no more than a penny atlas with him into the mysterious regions of creative expression; and this per-haps is one of the grand gestures of genius. He traveled alone, for even those who went with him could not be told whether the destination would be paradise or a barren landfall. As handsome in style as he was handsome as a man, he fought his way to a result with an immense, an almost terrify-ing simplicity of purpose. If the result was a failure, the rest of us can airily explain why; if a success, we can only guess at the reason for it.

Robert Flaherty's legacy to the world of film is wholly individual. His genius is not for imitation. His style cannot be reproduced, even by those

with a wider education and a more ordered intellect than he ever pos-
sessed. But his influence remains; for he made men look at this world with
new eyes.

Those who have shared in the innocence of his gaze, whether at the
anger of the seas, the cold of the ice wastes, the heat of the tropics, the
desolation of man-made deserts, or the darkness of the bayous, and at
the people who dwell in all these places, will have gained a knowledge and
an understanding that will help them to map, as did Flaherty, the journey

> beyond the sunset, and the baths
> of all the Western stars

until they die.

Afterword

One basic fact about Flaherty's films is that, just as he was unable to write a script, so he did not understand, or even want to understand, the fundamental technique of film editing. Neither *Nanook* nor *Moana* could be thought of as edited films; they were just shots joined together in the right order to tell some kind of narrative coherently.

Man of Aran had the benefit of John Monck, a professional editor. *The Land* and especially *Louisiana Story* had the brilliant skill of Helen van Dongen, trained from 1928 by Joris Ivens. When Helen van Dongen surprised Frances Flaherty in the cutting room in Abbeville, her reaction was wholly understandable and indeed would be supported by any professional filmmaker. Her quitting to return to New York was finally overcome by her loyalty to Flaherty, to her official status as associate producer on the film, and to her deep respect for the film medium to which she devoted her life. (Her production diary from which extracts are reprinted in my text more than proves her professional integrity.) To have an amateur, which was what Frances Flaherty was, interfere, or even meddle in her work, was unthinkable.

Flaherty had the wisdom to realize this, and hence he beseeched her to return to Abbeville. Later, when he found that his ample budget was overspent, it was not to his credit that he left it to van Dongen to go to Roy Stryker at Standard Oil to ask for more money with which to finish the film. (Where were all the mostly well-heeled visitors who accepted the warm hospitality at Abbeville?) Small wonder, then, that Frances and Helen were unable to appear in public together in the future without mutual frigidity. I was therefore not surprised when I talked to Frances Flaherty at

Black Mountain Farm in the summer of 1957. She would not talk about my manuscript (which she had had some months) but only of Bob as an interpreter of Zen. I felt, poor Bob!

I admire Flaherty as a cinematographer able to capture the most magical visual images, often with a camera movement born of instinct, yet at the same time I deeply respect van Dongen's skill, both creative and technical. As e. e. cummings wrote, "He was a God among men," and who am I to challenge that?

Paul Rotha
Wallingford
Oxfordshire
England
February 1983

Appendix I

Appendix

The Films of Robert J. Flaherty

1. *Nanook of the North* (1920–21)
 Produced for Revillon Frères, New York
 Script, Direction, and Photography: Robert J. Flaherty
 Assistant: Captain Thierry Mallet
 Assistant Editor: Charles Gelb
 Titles written by: Carl Stearns Clancy and Robert J. Flaherty
 Copyright: May 17, 1922
 Distribution: USA: Pathé; UK: Jury
 Length: 5 reels (approx. 75 minutes) National Film Archive copy: 5,036 feet
 (silent).
New York premiere: June 11, 1922; London premiere: early September 1922
with: Nanook, Nyla, Alee, Cunayou
Reissued July 1947 by United Artists
 Sound Version Producer: Herbert Edwards
 Narration written by: Ralph Schoolman
 Narrator: Berry Kroeger
 Music by: Rudolph Schramur
 Supervisor of Sound: Edward Craig
 Length: 4,500 feet (50 minutes)
 Until November 1, 1960, distribution was controlled by Northern Productions
of New York City under an agreement made by Revillon Frères. But because the
latter company assigned to the Robert Flaherty Foundation in 1956 its controlling
interest in the film, control of distribution passed to the foundation on the expira-
tion of the agreement with Northern Productions. In 1960 International Film Semi-
nars assumed ownership of the film. In 1976 David Shepard restored *Nanook* to its
original silent form with titles. An original music score was composed by Stanley
Silverman and performed by Tashi. The 1947 sound version and the less complete

295

silent version which had been available from the Museum of Modern Art were withdrawn from circulation in favor of the 1976 version. (For a description of the restoration see Dobi 1977.)

[EDITOR'S NOTE: Additions and corrections have been made using Murphy (1978) as authoritative source and the editor's personal knowledge.]

2. *Moana* (1923–25)
 Production: Famous-Players-Lasky
 Script, Direction, and Photography: Robert J. Flaherty in association with Frances H. Flaherty
 Assistant: David Flaherty
 Assistant Editor: Lancelot Clarke
 Titles written by: Robert J. and Frances Flaherty and Julian Johnson
 Distribution: Paramount Pictures Corporation
 Copyright: February 24, 1926
 Length: 6,055 feet (approx. 85 minutes, silent)
New York premiere: February 7, 1926; London premiere: late May 1926
with: Ta'avale, Moana, Fa'angase, Tu'ungaita, and Tafunga

Paramount holds the copyright. The only remaining duplicate negative, however, is held by the Museum of Modern Art Film Library, New York, which is allowed to distribute the film nontheatrically in both 35 mm and 16 mm under certain conditions to nonpaying audiences. A sound version is currently being produced by Richard Leacock and Monica Flaherty Frasso.

3. *The Pottery Maker* (1925)
 Produced for the Metropolitan Museum of Art, New York (Arts and Crafts Department)
 Financed by: Maude Adams
 Script, Direction, and Photography: Robert J. Flaherty
 Length: 1 reel (approx. 14 minutes)
A copy is held by the Museum of Modern Art Film Library, New York.

4. *Twenty-Four Dollar Island* (1927)
 Production: Pictorial Films, Inc.
 Script, Direction, and Photography: Robert J. Flaherty
 Editor: John D. Pearlman
 Length: 2 reels (15 minutes, silent)
 Distributor: Pathé Pictures
 Copyright: December 12, 1927
A 1-reel copy is held by the Museum of Modern Art Film Library, New York.

5. *Industrial Britain* (1931)
 Production: Empire Marketing Board Film Unit, London
 Produced by: John Grierson

Script, Direction, and Photography: Robert J. Flaherty
Additional Direction and Photography: John Grierson, Basil Wright, Arthur Elton
Production Manager: J. P. R. Golightly
Production Assistant: John Taylor
Editing: John Grierson and Edgar Anstey
Narration spoken by: Donald Calthrop
Distribution: Gaumont-British Distributors, Ltd.
Length: 1,928 feet (approx. 21½ minutes)

First British screening, November 1933 as one of the "Imperial Six" series.
Copyright and distribution rights held by the Central Office of Information, London.

6. *Man of Aran* (1932–34)

Production: Gainsborough Pictures, Ltd. (associate company of the Gaumont-British Picture Corporation)
Script, Direction, and Photography: Robert J. Flaherty in association with Frances H. Flaherty
Assistant and Additional Photography: David Flaherty
Additional Photography and Laboratory Work: John Taylor
Laboratory Editor and Scenarist: John Goldman
Recordist: H. Hand
Music: John Greenwood, under the direction of Louis Levy
Distribution: Gaumont-British Distributors, Ltd.
Length: 6,832 feet (approx. 76 minutes, sound)

London premiere: April 25, 1934; New York premiere: October 18, 1934
Characters: Colman "Tiger" King as a man of Aran; Maggie Dirrane as his wife; Mikeleen Dillane as their son; Pat Mullen, Patch Ruadh, Patcheen Flaherty, and Tommy O'Rourke as the shark hunters; Patcheen Conneely, Stephen Dirrane, MacDonough as the curragh men.
The copyright is held by the J. Arthur Rank Organisation, Ltd.

7. *Elephant Boy* (1935–37)

Production: London Film Productions, Ltd.
Producer: Alexander Korda
Screenplay: John Collier (based on Rudyard Kipling's *Toomai of the Elephants*)
Screenplay Collaboration: Akos Tolnay and Marcia de Silva
Location Direction: Robert J. Flaherty
Studio Direction: Zoltan Korda
Assistant Director: David Flaherty
Photography: Osmond H. Borradaile
Production Manager: Teddy Baird
Sound Recording: W. S. Bland, H. G. Cape
Music: John Greenwood
Music Director: Muir Mathieson
Editor: Charles Crighton

Distribution: United Artists Corporation
Copyright: In U.S. by London Films Productions, April 22, 1937
Length: 7,300 feet (approx. 85 minutes, sound)
London premiere: April 7, 1937; New York premiere: April 5, 1937
Characters: Sabu as Toomai; W. E. Holloway as his father; Walter Hudd as Petersen; Allan Jeayes as Muchua Appa; Bruce Gordan as Tham Lahl; D. J. Williams as the hunter; W. Hyde-White as the commissioner.

8. *The Land* (1939–41)

Produced for the Agricultural Adjustment Agency of the United States Department of Agriculture
Script, Direction, and Photography: Robert J. Flaherty, in association with Frances H. Flaherty
Additional Photography: Irving Lerner, Floyd Crosby
Production Manager: Douglas Baker
Editor: Helen van Dongen
Music: Richard Arnell
Narration written by: Russell Lord
Narration spoken by: Robert J. Flaherty
Music played by: National Youth Administration Symphony Orchestra, Director: Fritz Mahler
Distribution: nontheatrical only, U.S. Department of Agriculture
Length: 3,900 feet (approx. 43 minutes, sound)
First shown at Museum of Modern Art auditorium, April 1942.

9. *Louisiana Story* (1946–48)

Produced for the Standard Oil Company of New Jersey by Robert J. Flaherty Productions, Inc.
Script and Direction: Robert J. Flaherty, in association with Frances H. Flaherty
Associate Producers: Helen van Dongen and Richard Leacock
Photography: Richard Leacock
Editor: Helen van Dongen
Assistant Editor: Ralph Rosenblum
Music: Virgil Thomson
Music Technical Assistant: Henry Brant
Music Recording: Bob Fine
Sound on location: Benjamin Donniger
Rerecording: Dick Vorisek
Music played by: Philadelphia Orchestra, Director: Eugene Ormandy
Distribution: USA: Lopert Films; UK: British Lion Film Corporation
Copyright: September 28, 1945
Length: 6,300 feet (approx. 77 minutes, sound)
British premiere: Edinburgh Film Festival, August 22, 1948; London premiere: June 27, 1949; New York premiere: September 1948.

Characters: Joseph Boudreaux as the boy; Lionel LeBlanc as his father; El Bienvenu as his mother; Frank Hardy as the driller; C. P. Guedry as the boilerman.
Copyright is now held by International Film Seminars.

10. *Guernica* (1949) (Unfinished)
 Production: Museum of Modern Art, New York City
 Direction and Photography: Robert J. Flaherty
 Editing: David Flaherty
 Introductory Titles: Richard Griffith
 Length: 12 minutes, silent

11. *A Film Study of Robert Flaherty's Louisiana Story* (1962)
 Sponsor: University of Minnesota, made possible by a grant from Louis W.
 and Maude Hill Family Foundation
 Study Material Prepared and Assembled by: N. H. Cominos
 Study Project under the Direction of: George Amberg
 Narrators: Frances Flaherty and Richard Leacock
 Length: 114 minutes, sound
 The outtake footage assembled under this title in the custody of the University of Minnesota is 1,000 minutes.
 "Consists of the opening sequence of *Louisiana Story* in the final version, the related outtakes or portions not used in the final cut, and ends with a repetition of the edited opening sequence. During the showing of the outtakes Frances Flaherty and Richard Leacock intermittently discuss the artistic considerations that went into the shooting of each scene, the day-to-day physical conditions that confronted them, and the sense of discovery that was essential to the Flaherty method. This version is circulated by the Museum of Modern Art" (Murphy 1978:111).

Appendix II

Some Flaherty Stories

Flaherty's natural gift for storytelling is remembered by all who knew him. John Huston writes:

> "Hullo, John," his voice would say. "This is Bob. How are you?"
>
> "Bob!" I'd say. "When'd you get back?"
>
> "Just this morning. How about coming right on over to the Coffee House Club?"
>
> "Sure!"
>
> "Oliver's coming too. Hurry up."
>
> I'd find Bob in the centre of a group in the middle of a story. He'd say, "John, you must hear this too," and go back to the beginning. At about the time he'd reached the middle of the story again, Gogarty would come in, and Bob would say, "Oliver, you must hear this too," and start all over.
>
> You could hear Bob's stories time and time again and never weary of them. He told them in quick cadences, in a high, clear, sweet voice. His voice was a delight in itself—not that Bob had any such notion; he spoke without listening to the sound of his voice, which is one of the reasons he was a great story-teller. The main reason was that the stories he told were great stories—that is to say, they were profound and yet simple. . . .
>
> Bob himself never figured prominently in his stories, much less did he ever take the hero's role. As a rule, people are talking about themselves even when they seem to be describing the behaviour of others. Not so with Bob, because he was far more interested in those who inhabited the life around him than he was in himself. Nor did you feel that he took any great pleasure in holding the centre of the stage. No, his sole preoccupation would be with the people he was telling about. (Huston 1952)

303

The text of the following stories was dictated by Flaherty in London during the late summer of 1949 at the instigation of Michael Bell, of the BBC, but none of them was ever actually broadcast.

BOZO THE BEAR

Once I had a beautiful fight with a bear. Well, I was younger then than I am now, and a lot more active. It was in the 20s and I had been prospecting in the land north of Lake Superior, which was then quite unknown country and prospecting was a tough racket.

I was going up a river with one Indian in a birch-bark canoe, and we had to carry our gear over a stretch of rapids in this river. I had got a pack-sack on my back, and I was in the lead with the Indian behind me. Well, we followed the trail—it was awfully hot and there were lots of flies and mosquitoes bothering us—and at last I realised we had wandered off the trail. We were now in the bush, with this pack-sack on my back scratching the branches of the low-hanging trees and scrub, and all that sort of thing.

I kept on floundering ahead, and finally I got out of the depth of the spruce trees in the forest. It was most gloomy, with very little light trickling through, and suddenly we came across a little glade, still very gloomy, but covered with grass and buttercups and so on. Now there were no more branches to impede us, and the grass looked very inviting, so I thought this was a very nice place to take a rest and get this pack-sack off my back for a while.

I was just going to take my pack-sack off when I looked across the glade—it was only 20 or 30 feet or so across—and I saw a shadow there. I looked again, and I began to realise what it was. My God! It was a bear!

There he stood up on end. He was nearly seven feet high—quite a big fellow. And while I was looking, he started to come towards me—slowly—on his hind legs with his paws weaving. I had just managed by this time to get my pack-sack off before there he was in front of me, weaving and sparring.

Well, I don't expect you to believe me, but I was getting desperate—there was only one thing to do. To hit him. And I did it. I hit him hard on the chin. And down he went. By God!

It was sickening to hear the thud as he fell to the ground. And as I looked down at him I never felt so sorry for anything in my life as I did when I saw that bear on the ground. He was looking up at me. He was an old bear—poor old fellow—and he had only one eye. One eye had gone, no doubt in some fight long ago; and he kept looking up at me with his one good eye in the most pitiful manner and a tear was glistening in the corner of his eye. I looked down, and I gulped, and instantly I bent over him and got him to his feet and straightened him up a little. And he looked at me in the most reproachful way—you can't imagine how I felt.

He was trying to talk—and he almost could. He almost called me Bob—I could swear he was mumbling "Bob." And I called him Bozo. My Indian boy was rather frightened—he didn't know what to do; but I told him everything was all right. I said that instead of continuing on the trail, we would pitch camp and stay here and I'd do a little exploring.

Well, we got our tent up, and got a fire going, and, of course, just before, I had out a rope round Bozo's neck and tethered him to a stake. But we didn't need it; right from the start we were really pals. We got our fire going, and our bacon and beans fried, and we sat round the fire eating our supper—and, of course, we shared some with Bozo. Then we turned in for the night.

Next day we went through a cross-section of the area, to see what the country was like—what the rock formations were and all that sort of thing, you know. When we got back that evening, Bozo was still there all right. I had kept him tethered, though there was no need to really—it was more for appearance sake. And that sort of thing went on for several days—our friendship developing all the time. He would always grunt us a welcome when we came back into the camp.

On the fourth day we came back to camp a bit earlier than we had expected. And Bozo was not there. Then, by God, I heard something which would make any man fear God. There was an Indian reservation just across the river, and I heard someone shouting for blue murder. The Indian boy and I jumped up and rushed over just in time. By God! This Bozo had the Chief's daughter in his arms and was squeezing her to death! As I came up, the Indian Chief and the others came up too. And that Chief was white with anger. He told me, through my Indian boy, that they knew all about this bear. He had an evil name—he was the durndest bear in the country—and they weren't going to put up with him anymore.

I could see the Chief was furious, and while he was caressing his daughter who was by now out of the bear's arms and examining her scratches, I slipped across to Bozo. Bozo looked at me again with that reproachful expression in his one eye. I could see the situation was going to be pretty serious unless something was done quickly; so I told Bozo I was very ashamed of him and he'd have to go without food for his bad behaviour unless he apologised. Well, I managed somehow to quieten all the others, but the Chief I could not quieten. He said, "Look here, you've got to get that bear out of this country at once. We don't want him around here any more. We know all about him—everyone knows all about that bear. Get out!"

Well, I thought discretion was the better part of valour, too, and I decided anyway that it was as well if I finished my exploration pretty soon and got the next train, which started some hundreds of miles further east. And I thought it would be a marvellous idea to take Bozo with me. I could tell the story of our friendship in these northern woods and of all that had happened. It would make a good story.

We got down to the railway, but we had to wait that night for the "Overseas Limited"—the great train from the west which normally would not stop here. I got the station-master to flag the train. It came to a grumbling halt and finally pulled up—and there was I with a bear and an Indian and a lot of luggage ready to board this train.

There was the conductor looking down at us, and the brakeman behind him. I told him I wanted to take the bear with me. He said he wasn't going to take a bear on his train. But I thrust a twenty-dollar bill into his hand. He swallowed a bit and then said, "Oh well, I'll fix a place in the baggage-car until we can figure out something better."

So Bozo and I clambered aboard, and the Indian passed up our luggage, and I said "Goodbye" to him, the conductor pulled the bell, and the train rolled on through the night. The conductor gave us a place of a sort—the train was packed absolutely full. It was a "swank" train of the Canadian Pacific—but the conductor gave us what he could, not a Pullman, of course, just a rough and ready place next to the baggage-car. Anyway, we were on the train; and I fixed my pack-sack in the corner and settled down into a seat, tethering Bozo to an iron leg of the seat. And I finally fell asleep, and Bozo did also. And the train went on roaring through the night.

Some time in the early hours of the morning I woke up and looked around. My God! Bozo was not there! I looked out of the coach and called him—but there were no signs of him, not a sign anywhere. My heart began to race. What had happened? I knew the train hadn't stopped at any place. Where could he have gone? Was it possible that this bear with such a famous reputation among the Indians was clever enough to have got away from me and found himself a seat in a Pullman?

I didn't know what to think—I daren't let myself think what might have happened. Well, I had to call the conductor, and as soon as he came, he was even more surprised than I was. There was only one thing to be done—we had to start to look for Bozo.

We came to the first Pullman, and the Negro porter asked what we wanted, and when we said we were looking for a bear, you can imagine his expression. We looked in the gentlemen's washroom, and I called out in the most wheedling tone I could muster, "Bozo, are you there? Bozo, come on." Not too loudly, of course, because we didn't want to wake the sleepers. But there was no answer.

We went through the Pullman, and peeped behing the green curtains into the upper and lower berths full of people snoring and whistling—all sound asleep. I kept calling Bozo's name, but the only sound to be heard was the roaring of the train through the night. Finally, we got to the ladies' room at the end of the car and we looked in there, but there was still no sign of Bozo. We had gone through Pullman after Pullman, the whole length of the train. And there was no sound to be heard of the bear.

And it was not until we got to the end of the very last Pullman, that we heard anything—a voice—a lady's voice—just a whisper from behind the curtains of a sleeping-berth:

"If you're a real gentleman, take off your fur coat!"

RED-NOSE JONES

One does meet some very queer characters in the South Seas, and one of the queerest I have ever met was a chap who went by the name of "Red-Nose" Jones. I often used to see him sitting on the verandah of the *Cercle Bougainville* with a "rainbow" thrust in his hand—all by himself, looking dreamily out over the sunlit blue seas.

He had a Pompadour shock of gray hair, and a great bulbous peaked red-blue nose, and the saddest expression you could ever imagine. And as the

seas sighed over the coral-reefs, you'd hear him sigh too. Then he'd take another drink.

He had first come down there many years before, and for a long time had lived on the beach—beachcombing, as they say in the South Seas. Finally he had become such a nuisance to the police that they told him to clear out.

What he did was to get tangled up with a Tahitian girl—and she would follow him just like a dog, and take care of him. Of course, he had to have his liquor, and the only way he could get it was to cut copra—that is to get the coconuts from the trees, cut out the meat, and bring it back down the jungle trail in a sack and sell it in the market.

Well, of course, Red-Nose himself couldn't climb a coconut tree—his wife would do it for him. She would get up the trees and drop down the coconuts, and then the two of them would crack open the shells and build up a pile of this copra until he had enough to make it worthwhile taking down to the market.

But sometimes things didn't go very well; they quarrelled. Then she had a curious way of climbing up to the top of a coconut tree and sitting there, sulking, and not coming down. She would be sitting at the top of the tree and he would be at the bottom, pleading with her to come down, because without her, of course, he was absolutely helpless and had no chance of surviving. Finally, when she was in the right mood, and he'd apologised for his bad behaviour, she would descend. Then life would be resumed.

One day they were going through the jungle and he slipped and almost broke his ankle—which is a bad enough thing to happen to anyone at any time; but she managed to nurse him through it, and finally got him on his feet again.

Well, as I say, they used to cut this copra and bring it down through the jungle trail to the port where he'd sell it in the market. And, of course, as soon as he'd sold it, and got the money for it, he'd start drinking again. This girl would follow him faithfully until all the money was spent, and then they'd both go off into the jungle again. And this sort of thing went on for a long time—for years, as a matter of fact; but at last the chap solved the riddle of his existence. He began to distil perfume from one of the most rare odorous flowers in the world—the Tahiti—which grows only in one island of the South Seas.

Of course, you know what distillation of perfume is—how you have to learn a most intricate process—indeed it calls for the qualifications of a most expert chemist, and all that sort of thing. Now, what it was that Red-Nose had done, I never found out—but it transpired later that at one time he had been one of the chief chemists in the great American corporation of Duponts, at an enormous salary. But he'd run into some sort of trouble with his family, and had launched out into the South Seas eventually, where he was living this life. An old friend one day got a pile of money together and bought him a passage back to 'Frisco, but it was no good. As soon as he got to 'Frisco, he took one look at it all, and came back on the return of the ship.

Well, to get back to the perfume. When I last saw Red-Nose Jones he was still distilling this perfume in Tahiti; but he was very careful only to distil

enough to keep him in liquor. When the ships came in once a month, to or from 'Frisco, there he would be on the wharf selling this stuff to the passengers and getting enough money for more drink.

Well, he's dead now. His great pals were Gouvernor Norris, Norman Hall and Harrison (Borneo) Smith. Yes, he's been dead several years now—Red-Nose has gone. But I can see him still sitting there, outside the club, sighing with the reefs and shouting, "Give us another drink." A great character was Red-Nose—a great chemist.

CAPTAIN ALLEN

Another of these great South Seas characters was one known as Captain Allen. He had a boat—the *Dawn*—a queer boat with an old brass bell-mouth; and she was humped in the middle—her back was humped—and she wasn't allowed entrance to any civilized port of the world because she'd been condemned for years. But he had got this boat and a crew, and he'd got a plantation somewhere in the islands, no one knew where.

He was a typical fellow—and a bit of a blackguard; and during the days when Samoa was a free port and there were no laws, he had murdered someone. He was a wonderful chap. He had a very neat way of clicking his teeth together. And he had a great big flamboyant Samoan wife, who was dressed in silks, and he had two sons who followed behind him like two dogs—terrified of him, they were. He was good-looking himself, but he would do you in very quickly and neatly if he felt that way.

He had a whole gang of people working for him—natives—getting copra for him, and the *Dawn* would come in as near the shore as possible— she would have to wait out on the high seas because she wasn't allowed into any harbour—rolling this way and that. And he'd come ashore and sell his stuff, and then get out, and sail away again to his mysterious island. Yes—he was a great fellow—with wonderful white teeth, and a wonderful chap to talk to.

LADY WOLSEY

Once, many years ago, I got aboard a P & C ship in Tahiti bound north from Australia to 'Frisco, and I was given a seat at the Captain's table. The Captain, of course, sat at the head of the table, and next to him sat Sir Someone, Governor of one of the states of Australia, and on the other side sat his wife; then there was the British Consul in Tahiti and his good wife, and next to me was a little old Queen Victoria sort of woman—like one dumpling on top of another, and wearing a doyley on her white hair—who looked at everything and everybody through her lorgnettes. She was introduced to me as Lady Wolsey.

Well, we subsided in our seats, and the steward brought the soup. Up went My Lady's lorgnettes and she looked at me and said, "Are you an American?" I said, "Yes, Lady Wolsey, I am." "Oh," she said, "I don't like Americans." After that pleasing introduction, we got on with our soup. The soup

plates were taken away and another course came in; and up went her lor-
gnettes—more microscopically this time—and then she said, "Don't tell me
you're a Catholic too?"

By this time I fairly frowned at her as I said, "Look, Lady Wolsey, as a
matter of fact I'm half-Canadian, half-American; my mother was a devout Cath-
olic and my father was an Irish Protestant." Lady Wolsey had nothing more
to say.

So we limped through the meal, which was one of the dreariest I have
ever sat through; and when it was over I went to the steward and said, "Look,
would you transfer me from the Captain's table—I have some companions
whom I'd like to join." And, as a matter of fact, I wanted to play cards all the
four thousand long miles to San Francisco.

So the steward took note of my wish, and next morning Lady Wolsey and
I met in one of the passage-ways. I think she was rather conscience-stricken
about what she'd said at dinner the night before. At any rate, she wanted to
know would I not please come back to the Captain's table? I forced a smile
and tried to be as pleasant as I could, and explained that I have found some
very dear friends of mine on board, and that I had some very detailed busi-
ness to discuss with them on the way to 'Frisco—and would she please for-
give me? But she didn't—she said nothing more, but just swept on.

And all the four thousand long miles to 'Frisco I walked up and down the
deck, slipping past Lady Wolsey, who no longer even acknowledged me.

Finally we got to 'Frisco, and immediately I had run the gauntlet of the
customs I managed to get my luggage and impedimenta on to a taxi and I was
chugging up the hilly streets of 'Frisco to the hotel. Well, I got in there and
registered, and the bell-boy snatched my luggage, and we stepped into the
elevator and shot up to the top-floor. The bell-boy opened a door and we got
into my room. We stood there a little while talking about what was on in town,
and as he left he thrust a newspaper into my hands. I opened it.

Headline: "Lady Wolsey Arrives. Lady Wolsey, formerly Miss Mary Mur-
phy of San Francisco."

Well, there is an aftermath, as it were.

Years later—about ten years have gone by—we had just come back
from India. We got off the train at Waterloo, and amongst the other people
who met us was a news-correspondent of one of the London papers. After
we'd shaken hands and passed a few words, he said, "Bob, I've a wonderful
idea for you—Iceland—that's where you've got to go next. I want a talk with
you about it as soon as possible. There's a man crazy to meet you."

So, we parted, and a few days later this correspondent of the newspaper
came along and brought with him this man from Iceland; and we sat discuss-
ing the Iceland programme. The Icelander suggested that we go to the Danish
Ambassador and have a talk with him about it because apparently there were
a lot of people getting interested in this idea—and he was one of them.

We had lunch at the Danish Embassy, and the Ambassador said, "If I re-
member right, there is an exhibition of Icelandic paintings on in London
now—why don't you take Mr. Flaherty to see it." But the Icelander said, "The

exhibition is over now, but by chance I happen to know where some of them are; they're in Kensington, a friend of mine is there." "All right," said the Ambassador, "why don't you take Mr. Flaherty there?"

And a few days later this chap calls for me in a car, this Icelander, and off we go to Kensington. There we come to a fine old house, and get into a fine large room and see the paintings. And then our hostess swept in—it was Lady Wolsey. It was her house and her paintings.

SNAKES!

You know what snakes are in India, don't you—they're very deadly, you know; and the little Kri, which is no longer than a pencil, well—if that bites you, you drop in about two-and-a-half minutes. It's simply terrific the amount of venom in this little thing.

I remember an instance of a cobra getting loose in a bus in Madras— and all the people piling out of that bus to get out of its way. The cobra had crept into the engine of the bus one night for warmth, and of course next morning when the driver got in and started up his engine, the rocking and shaking of it disturbed this cobra and he got into the bus. It fairly scared all the Indian passengers, I can tell you—but it managed to strike four people and these four people were all killed. Yes, I think that will show you that people think twice about snakes out there—you don't want to get struck—if you do, it's all up.

Well, one afternoon we had been shooting some scenes for *Elephant Boy* and we were going home, and we were wandering through the jungle, and somehow I got lost from the rest of the crew. I was awfully tired and I finally got to a little open clearing in the jungle, and I sat down to rest for a few minutes. I may have had a touch of the sun because I wasn't too careful about wearing my pith-helmet—anyway, I sank down on the ground and finally I fell asleep.

Now you know, when I sleep I usually sleep on the broad of my back and my chest heaves up and down—and not only that, but the family tells me I snore, and, so I'm told again, I whistle at the end of the snore.

Well, I don't know how long I had been asleep, but after a while I began to be conscious of something heavy on my chest; and as I became more and more awake I realised what it was. It was a cobra!

Now, whether it had been attracted by the free ride up and down on my heaving chest, or by the snore with the little whistle at the end of it—I don't know—or whether it was an accommodation of both. All I do know is that there was the cobra lying on my chest.

And as I came to realise this, I became frightened and froze; and as soon as I did that it became angry and his tail began to wiggle down in the pit of my stomach. My God, how it was tickling—it was all I could do to stop myself from laughing—and me within an ace of being struck. What a situation to be in!

And as I looked up at him I could see he was weaving over me, his great hood swelling enough to cover the whole wide world. And I could see his beady eyes. And as he moved his head this way and that way, and that tail of his

keeping on up and down in the pit of my stomach, I had to hold myself in check as much as possible, because at my slightest movement he would strike.

I kept watching his every movement. All I could see was his beady black eyes and that enormous hood swaying to and fro above me, and all the time his tail was tickling my stomach. But I dare not move. And there was his tongue darting to and fro across my eyes. And I became conscious of nothing but that tongue. By this time I was in desperate fear lest I was losing my senses.

I watched that cobra and I became conscious of nothing but that vicious tongue. And what did I do? I had the feeling that I'd stick out my tongue too. And as soon as I did, he struck. But my mouth was open, and all I had to do was to bite, spit out the head, get up and walk away!

Appendix III

On the Record

Of the many appreciations and tributes paid to Robert Flaherty in the days and months following his death and printed in newspapers and magazines the world over, we feel that a few should be placed in the permanent record.

By John Grierson

"He was at times as difficult with his admirers as he was with his commercial collaborators. Yet I will say in the end that, not in spite of but because of all difficulty, he was a great man to know. His troubles came out of the very special sense he had of a man's relationship with his art: out of his deep inner revolt against all the conditions which modern life was imposing on the artist—not least so in the complicated and expensive world of film-making. He, so to speak, carried with him always the burden of the individual and personal artist in a world—and a medium—growing ever more impersonal. He hankered after, and often bulldozed his way to getting, a species of freedom—with art, with money—that only the anarchists any more allowed for in their theories. In all, and never frivolously, he was born to be troubled.

"Yet the crazy thing about Flaherty was that he could never see the logic of his role or why it should always be painful. He was a conservative who deplored the implication of being actually a revolutionary. It was a pity that inevitably, on this paradox, he could never meet his brethren; for he was an enormous friendly man and you might almost say built in physique and heart for friendship. He was big, wide-shouldered, and handsome, with the sort of face and forehead you carve a hundred feet high on rocks. He had the clear blue eyes of the sailor and explorer. With it all went a sort of boyish innocence of expression, and enjoyment that invested his hospitality with a spontaneity and his conversation with an enquiring eagerness which made him one of the richest men to knock around with in a generation. . . .

"The fact was that Flaherty had not been brought up in the metropolitan world in which he was finally compelled to operate. He was born in Michigan of an Irish father and a German mother, but went to school and grew up in Canada. By and large, the best part of his life was spent so close to the far frontiers of Britain's Empire that he absorbed unconsciously, not the technological traditions of the United States, but the Victorian, or at the latest Edwardian, traditions of a nation and a period in which the highly personal command over far places and the paternal privilege over distant peoples went with a precise sense of the graces that wealth could bring to the personal life.

"It was a world in which, at the least, no one ever grew sick for the lack of leisure or of understanding how to use it. Indeed, Flaherty was a lost soul in the United States, save perhaps in the near-English atmosphere of the Coffee House Club; and he was never more comfortable in London than in the red-plush marble-topped Cafe Royal, which the exquisites of the mauve decade had left behind.

"How deeply and how often I had to come up against the problem he created in our very different midst; for one came to adopt an almost passionate care in preserving this lost child of the arts in his once fashionable illusions. This exponent of real life had, it seemed, to be preserved from even the proximity of reality; and no one could be more damnably hurt by the differing viewpoint which brought in for him a world he could not accept and could not live in. . . .

"I think the issue over *Man of Aran* best describes all that was best, as well as all that was, to other minds, limited in Flaherty's art. I personally regard him as one of the five great innovators in the history of film. I think that with him go Méliès, the first of the movie magicians; D. W. Griffith for developing the strictly movie terms in which a drama could be unfolded; Sennett for transferring comedy from the limited space and conventional props of circus and vaudeville to the infinite variety of the world about; and Eisenstein for his study of organised mass and movement and his great sense of the films' potential in both physical and mental impact. Flaherty, great personal story-teller as he was, did not especially think of films as a way of telling a story, developing a drama, or creating an impact, either physical or mental. For him, the camera was veritably a wonder eye, to see with more remarkably than one ordinarily saw.

"It never really occurred to him that a shot should be foreseen, and when we came later, because of the expense of the thing, to work out everything beforehand as best we could, there was something in Flaherty that instinctively revolted. Some have said it was indolence, or disorder, or even a will to waste in him, but I will say it was nothing of the kind. For Flaherty, it wasn't what he saw or thought he saw which was important, but what the camera revealed to him.

"Whence the infinite and infinitely patient experiments with movement; when, incidentally, his pioneering work—not nearly sufficiently recognized—with panchromatic film, with filters, with telescopic lenses, with keys in black and white to make a graciousness of grays, with shooting at hours of the day, and under conditions of light that the orthodox discarded. No one ever, or so significantly, studied his rushes so closely. Rushes were not the result for Flaherty, but the beginning: the moment of revelation. Expensive? Yes, it was. But the reason for it was as I have said, not otherwise. If paper had been as expensive as film, they would have said the same of Flaubert.

"On one level the camera was for Flaherty an extraordinarily convenient way

of recording one's reminiscences; and reminiscences meant for him what they once meant for Boswell: the test of a man's penetration and of his capacity for life. It meant, moreover, an extension of horizons for everyone, the backwall of the proscenium out and a window on the world. He loved to emphasise the mobility of the camera, and he was, to the end, a man impatient and even angry with the great heavy contractions which not only needed a team of men to handle them but put half-a-dozen other pairs of eyes between Flaherty and the object.

"It was with a hand-camera, the Newman-Sinclair, that most of his work was associated with this lightweight affair, one had the notion of a camera as a highly personal instrument, like a pen or a brush; and in nothing did Flaherty depart so considerably and perhaps importantly from the studio conception. Take this personal contact away, for whatever purpose and by whatever means, and Flaherty was lost, as he was on *Elephant Boy*, *Tabu* and *White Shadows*. . . .

"It may not seem so on what I have said, but, behind the explorative and modest and near-mystical belief in the camera's power of sight, there was, of course, a basic pattern in his observation. His long early years in the Far North had given him a special affection for primitive peoples and an intimacy with nature and man in his relationship with nature which showed always in his clear blue eyes, and, in the pinches of more complex argument, never left him.

"His first instinctive revolt against movies—and I think nearly all movies— was that the story was imposed on the background and did not come from within. He was shocked when Hollywood, following up *Nanook*, made a film on the Arctic with a phoney Eskimo girl and a love-story that had nothing to do with the Eskimo's normal and very proper appreciation of polygamy. [MGM's *Eskimo*, directed by W. S. Van Dyke.] Flaherty was no theorist and tended, like so many, to fit the theories afterwards to the facts. He faked a bit like all of us, and a little more so after they whipped him in Hollywood with the charge that he had no sense of box-office, but he had a genuine passion for the genuine.

"When he talked of the difference between a hunter throwing a spear and John Barrymore impaling a rubber-shark with his profile, he had something which the camera, if no one else, understood with him. When he discoursed, after reading my piece on the subject, on the 'movement of craftsmen and priests that time had worn smooth,' be sure it was not I that had done the shooting to deserve the theory but Bob himself who was the only begetter. He was too dramatically precise for his day when Nanook didn't make any fuss at all as he came out of the blizzard and found the shelter of his igloo, or when everyone, more or less, had a pleasant Polynesian Sunday afternoon flaying poor Moana in the big tattoo. He stayed where people were, and if he did not greatly impose upon them, except to gentle everything he saw of them, it was again, as with the camera, in the modesty that forever the Almighty was a considerable artist and that you had only to look on His works under and under, and you couldn't miss.

"It is a point of view shared by Wordsworth in some of the best, as well as in some of the most naive, of his works. It is a point of view shared at the present time by many of the younger colonial peoples, and you could pick it up easily in Canada, for example. It is not exactly fashionable these days among European artists and metropolitans generally, but this is to be said for it. Flaherty returned us to the origins of all observation: where the seasons are, where flowers not only grow but are worn in the hair; where people take, or fight for, the fruits of the earth, and dine

well and pour a ceremonial libation on the ground to the gods and dance in thanks-giving; where the difference between a man and an animal of the wild is only one of degree; where storms come and go and are merely a great spectacle in their passing, and children are forever the assurance that time is timeless, and the horizon, finally, without too much pain.

"Perhaps he was over in love with the merely decorative, and nothing on earth, for example, would keep him from putting his most staggering shots at the opening of his films. He made it possible for the less sympathetic to say of him that it was all packed away at the beginning, with nothing thereafter deeply to emerge. But something there always was, even if it did not come in the classical cathartic terms. He thought, for instance, that the opening of a flower was a sufficiently dramatic sequence in itself; but he was in fact better than that. The day fulfilled itself to the last shadow; people rested after the burden of the day; there was always a nice sense of the world tucking its head under its wing for an inevitable sunrise.

"The child motif was constant. The boys in *Moana*, *Aran*, *Elephant Boy*, and *Louisiana Story*, the bullfighting boy, whom Orson Welles took over, and the Hudson Bay and coal-mining boys he never made represented an essential to him. Some chose to say it was the boy Flaherty that never grew up, the admiring son of a remarkable father, or again that it was the son Flaherty never had. I choose to think that this child forever growing up, affectionate but always a little detached from his elders, finding his own solitary contact with birds, beasts, and trees, fishing from cliffs, capturing alligators, taming raccoons, riding elephants, and paddling canoes, gave Flaherty a path to expressing a detachment from the world and a sense of innocence among the tumbling facts of life which he personally craved.

"On one occasion, he talked of 'the poignancy of the horizon,' and perhaps it was the same thought in him. It was after *Aran*. He had felt bitterly the implied criticisms of his friends that he had idealized this tough world of tough men and lost the reality of a landlord-ridden poverty to decorative horizons and artificial issues with basking—and very harmless—sharks. 'Isn't the horizon a larger reality?' he protested. And, 'Why do they always want me to make things shabby with their poverty, poverty, poverty?' Like Wilde, he hated the grotesque and deformed, objected to the thundering noise of *March of Time*, and I suspect that the Russian films—Dovjenko's *Earth* always excepted—troubled him more than he confessed. But this only means that he was a faithful disciple of Rousseau or, better still, that he was a pre-Raphaelite beyond his time. He sought beauty as passionately as any, but it was not of his origin, his nature, or his habit, to find it in the gutter. There the critical world split with Flaherty and not without a certain sadness; for it was those who denied him most who had learned most from him and were the first to acknowledge it.

"Picture, however, the forces that were impinging on film-making in the 1920s. It was by and large a liberal world, with democracy everywhere on the move. Here was Flaherty pointing a way to the extended observation of mankind: proposing, in effect, an art which could match in its sweep not only the speeding interrelations of peoples but men's conscience in regard to them. Here too were other voices—from Russia, Germany and England especially—saying with equal validity: 'Ware the ends of the earth and the exotic: the drama is on your doorstep wherever the slums are, wherever there is malnutrition, wherever there is exploita-

tion and cruelty.' 'You keep your savages in the far place Bob; we are going after the savages of Birmingham,' I think I said to him pretty early on. And we did.

"In doing so, we aligned ourselves in many ways more closely with the Russian method than to Flaherty's. We borrowed from him his emphasis on the spontaneous; and something of his affection for seeing for seeing's sake crept into much of our work. But the Trotsky theory that art is 'not a mirror held up to nature, but a hammer shaping it' and John Stuart Mill's injunction that it is 'in the hands of the artist that the truth becomes a living principle of action,' drove us to a certain deliberation of effort which Flaherty natively deplored. We were propagandists, not just discovering the dramatic patterns of 'actuality' in a vacuum, but of deliberation, bringing the working-man to the screen, revealing the social relationships inevitable in a technological society, demonstrating the follies of poverty in a world of plenty, and so on and so on.

"Inevitably we were taken up by governments and powers and became one of the instruments of public education, public management, and—in the days of greater crisis—of public persuasion, exhortation, and command. Flaherty watched it all with a sense of bewilderment and no wonder; for, in fact, this other documentary school had correctly estimated its relationship with up-and-coming social democracy and was riding in on the tide. Sir Stafford Cripps put it generously—but it may be with a modicum of justice—when he said later that nothing made the new social-reform Government so certain in Britain as the work of the documentary film people in making the patterns of social justice patent to everyone.

"For myself, I think the bombings helped not a little; but the point to make is that we had taken Flaherty's documentary film away from its more contemplative origins. 'I don't like this business of looking at people as though they were in a goldfish bowl,' said one early exponent of the different view. So he went down to the East End slums of London, got to know the people pretty intimately, set up his camera and microphone, and invited the people to 'take over the screen, it's yours.'

"The result was the remarkable *Housing Problems*, which revolutionized film approaches. Its maker, incidentally, was Flaherty's own pet pupil, John Taylor.

"Flaherty made a handful of lovely films, all with enormous difficulty both in finance and collaboration. The documentary people who went the other way got financed by the million, established educational and propaganda services for governments all over the world, and made themselves films by the thousand. And yet and yet . . . I look at it all today and think with the gentler half of my head that Flaherty's path was right and the other wrong.

"The new way became as easy and complacent as Flaherty's grew more difficult and finally distressing. In the ardent pursuit of good works there has been overmuch accommodation to expediency. The film people have learned to be diplomats, politicians, administrators, fixers. They have got so involved with technique and technicians that you would hardly know the glossy, chromium-plated, over-weighted contraptions of a documentary unit today from the Hollywood set-up from which Flaherty revolted. Till recently, a great number have been all too comfortable in the secure jobs and the inevitably repetitious formulas which safety breeds. One might almost say that the heads got fat.

"Be sure something has been lost in the process. I miss the poetry, as I miss the personal fervor of the original inspiration. I shall say it in short by saying that I

miss Flaherty. I figured it more practically than he did, but have little comfort in the world I figured with so much, as they barrenly put it, 'political correctness.'

"I would not today take issue with Flaherty so hopefully and confidently as once I did. The old boy was like a lighthouse; not much to do with the comings and goings of the people on land, but much to do with more abstruse journeys of sailors. There is a fundamental in art which is greatly concerned with such. Perhaps Flaherty's 'poignancy of the horizon,' like Leopardi's *Ode to the Moon*, comes as close as anything to expressing what most we are missing in the sick and close-eye which now attend us." (Grierson 1951d)

By John Huston

"Everything Flaherty was and did hung together. He was all of one piece; the way he looked, the way he spoke, the way he did. As he went on the outside—gay, noble, compassionate, simple, brave, patient and profound—he was within. Look for a little while at a photograph of him and you will recognise all those qualities.

"He was a hard man to fault. As a rule, there is something inhuman about people you can't find anything wrong with, but this doesn't go for Bob; he was human above everything else. I think he was just a little more human than almost anybody else I ever knew." (Huston 1952)

"Pioneers in the arts usually explore their new world to its furthest limits. Those who come after only exploit what has already been discovered; sometimes they even corrupt. Robert Flaherty was a pioneer. He went all the way and saw everything. Let other picturemakers draw inspirations and power from his great works, to strengthen them in their own adventures. But sweet Christ, don't let them try to imitate or advance what he did, for nobody else will ever do it half so well." (Huston 1951)

By Charles Siepmann

"First and foremost (well, perhaps not first, the order is immaterial), *Bob had a rare eye for beauty.* . . . Beauty was there, indeed, in the things he shot, but Bob made it over into something that was never there before. This is what all poets do. They lend us their eyes, and we see life afresh. Bob did this again and again, throughout his life in every film he made. He lent us his vision, and he had a rare eye for beauty.

"*And Bob had zest*. He drank life to the lees. He had Olympian laughter. When Bob laughed, he shook; and it seemed as if the whole world shook with the glee and the delight he found in it. He laughed as did no man I ever met—except one, and a very different man he was, but he had something of Bob's build (only more so) and the same outgoing, generous zest for life and people. That was G. K. Chesterton. Both laughed the same way and for the same reason. It came from deep inside, from love and compassion for the wayward follies of mankind, laughter that at times was near to tears.

"But for all his companionable zest, *Bob was a lonely man*, lonely in the sense that he had deep, inarticulate reserves. He spoke much, and he was a wonderful speaker, and even more wonderful at telling stories. But, first and last, he

walked alone, for he lived essentially in his imagination. And, when it comes to imagination, 'the mind,' as Milton said, 'is its own place.'

"Bob was very much *in* this world, but on one side he was not *of* it. Most of us take life as it comes, and take our color from it. And as a consequence we are not greatly distinguishable, one from another. We are part of the motley. Bob *drew* on life as food for his own thoughts. Some of those he gave back to us—in the language of the film, at whose tyrannical limitations he railed and fretted as often as he mastered them. But there were more that he withheld, aware that, of our deepest insights, some are incommunicable and others not to be communicated. Bob knew the true meaning of privacy. He never overstepped its bounds. His loneliness and his reserve, on this side, is something I cherish and honor as I remember him. . . .

"Bob saw the grandeur, winced at all (in and out of film) that is so scarred with trade. But above all he knew that there lives, indeed, the dearest freshness deep down things—in you and me and people rich and poor, educated or not. He sought to feed that freshness, using the common language of the eye. The one universal language of our time: film. Bob made it great by bespeaking in it, through it, a philosophy of life—communicated in the language that even children understand: the language of poetry and imagination. Bob knew that the key to a good picture is the integrity of the man who makes it. Every film he made, despite many a fault and flaw, speaks, shouts, that one word: integrity. Not how he made them, but what he brought to them, and what he made them for, is, I suggest, what's worth your study. Bob, in a broader context than that of film alone, recalled what many in our time have forgotten, or are scared to face: the fact that in life, as in art, there is but one key to truth, to self-respect and mutual relation, the key that Shakespeare offered when he wrote: 'To thine own self be true and it must follow, as the night the day, thou canst not then be false to any man.' It was thus Bob approached and used the film." (Siepmann 1959:57–58, 74–75)

By Orson Welles

"I think that if you tried to relate Flaherty to anybody else in films, it would be difficult to do it decisively. But it's very easy to identify him with certain great streams of American cultural life—with Thoreau, for example, and Whitman. I don't see where he fits into films at all, except as being one of the two or three greatest people who ever worked in the medium." ("Portrait of Robert Flaherty," BBC Broadcast, September 2, 1952)

By Sir Alexander Korda

"I am quite certain that Flaherty occupies one of the most important places the cinema has for any of the creative artists. Flaherty was one of the best—one of the very few persons who with his contribution helped to shape the cinema. His influence was very large—far beyond the number of pictures he made—not only on the public but chiefly on the younger directors; they learned an immense amount from him." ("Portrait of Robert Flaherty," BBC Broadcast, September 2, 1952)

By Oliver St. John Gogarty

"It's an easy thing to judge men by the way you feel when you leave them. When you left Flaherty you felt like a stag of ten, or somebody for whom the police had held back the traffic. Other people, when you leave them, you'd think you'd given them a pint of blood. . . .

"But it was different with Flaherty. When you went into a room, you knew he was there because there was some sort of magnetic feeling as if you went into a room where there was a dynamo in action. And then he hailed you with his nimbus of white hair and his smiling pink and white face. He was unique in New York, where 'brunettisation' was going on apace. In fact, in a couple of decades, every-body will be red again. But Flaherty was pink and white. You'd think he was born on the other side of the world in Europe." ("Portrait of Robert Flaherty," BBC Broadcast, September 2, 1952)

By John Houseman

"In an industry where the very best have shown themselves—with the years and pressures—insecure and corruptible, Flaherty has persevered . . . alone, unhur-ried, uncovetous and unafraid. With him life and art are indivisible. His energy, his obstinacy, his fine visual sense and natural gift for words, his cunning and his mas-sive personal charm—all these have been marshalled and exploited without stint for the artistic realisation of his own personal myth.

"All his pictures are variations on this one theme—man's response to the challenge of nature. It is the measure of his greatness that after a quarter of a cen-tury, Flaherty's myth is today more valid, more universal and more significant than ever before. And it is no wonder. For it is rooted in love. And what it tells is a story of the innate decency and fortitude and invincibility of the human spirit." (House-man 1951)

New York Times editorial

"Through the years Mr. Flaherty's work became increasingly important in its influ-ence both here and in Europe. While this man himself brought great beauty and honesty to the screen with his own documentary masterpieces, his death serves to remind us that his greatest contribution was that he planted seeds the full richness of whose grain has yet to be harvested." (1951)

By Terry Ramsaye

"Robert J. Flaherty's passing the other day, ending an adventurous career as pros-pector and cinematographer, brings long thought from an old friend. He goes into history as a great and pioneer film documentarian, and with a deal of technical folderol from the esoteric criticism about remote considerations of his art. They discovered mysterioso elements in his pictures that he was delighted to learn about. . . .

Mr. Flaherty stayed decidedly arty, often displaying a gift and feeling, rarely penetration. Documentary production took little from his approach and has fol-

lowed a more incisive order of concept and technique, largely derivative from newsreels. But Bob dreamed magnificent dreams and enjoyed their pursuit. In that he had success. Tradition will make it greater." (Ramsaye 1951)

By Gilbert Seldes

"NO FLOWERS"

"A three-line notice on the fifth page of the *Hollywood Reporter* announced the death of Robert Flaherty—the only recognition by the movie-industry of the passing of one of its great men. Flaherty disliked much that Hollywood would have asked him to do, but the movie-makers in Hollywood had no cause to dislike what he did. He made *Nanook* and *Moana*, and *Louisiana Story* and *Man of Aran*, transmuting fact not into fiction, but into poetry, creating the documentary as an interpretation of life. Hollywood gave him no Oscars when he lived and sent no wreaths to his funeral when he died." (Seldes 1956)

Appendix IV

Notes by
John Goldman

[EDITOR'S NOTE: John Goldman (now John Monck), the editor of *Man of Aran*, has specially contributed the following notes about Robert Flaherty's methods and techniques which he had the opportunity to observe at firsthand during the shooting of the film on the Aran Islands and the subsequent editing in London. They are considered likely to be of such technical interest to filmmakers and admirers of Flaherty that we include them for study and information.]

I. *Flaherty's Attitude Towards Lenses in Cinematography.*

Flaherty's use of the long-focus lens was not solely dictated by the need to photograph objects at a distance from the camera, though he recognised its use for this purpose. Nor was it dictated solely by the greater naturalness he could get from his real-life actors, a lack of self-consciousness by having the camera a long way off instead of being right up close to them. The more important factors in his choice of lenses were his feelings for texture, composition and "colour" in his photography.

He hated the short-focus lens; I never knew him to use it if it could be avoided. Once I asked him why. He said that the short-focus lens is flat and colourless, whereas the longer the focus the greater the degree of roundness and the greater the effect of cushioning the object being photographed. The short-focus lens cuts the atmosphere, whereas the long-focus lens photographs the atmosphere and gives "colour" and texture to the space *between* the camera and the object. Further, he argued, the short-focus lens photographs everything within its range with equal emphasis and light value and with no shading; whereas the long-focus lens throws the centre of interest into relief and emphasises the centre of interest, gives the shot rhythm. Your eye is not distracted by extraneous objects all in sharp focus as in the short-focus lens. The long-focus lens ranges the surrounding objects and lines in a gradual decline of clarity and emphasis. A long-focus lens adds drama,

whereas the short-focus lens destroys it. Moreover, the long-focus lens alters the relationship between the object and its background and surrounding objects, giving it force and directness. The making of a film, he would say, is the art of eliminating the non-essential. The long-focus lens was one of his main tools in so doing.

Flaherty's use of lenses lay at the heart of his photographic quality. They were inseparable from his approach to films. It was not just that with a long-focus lens you could photograph a girl, as he used to say, changing her mind a mile away; it was that you could see her rounded and in relief. This question of relief was very important to him. He strove always for a kind of stereoscopic effect. If an object was moving, he wanted to feel it moving, see it moving and he would argue that if seen at certain angles with a long-focus lens, you could feel you were seeing *round* the object, that it was moving out from its background. To get this effect, it was also necessary to include the atmosphere that lay not only *between* the object and the camera but also *between* the object and its background. Only by doing so could you feel the object in space. Thus the long-focus lens was necessary in composition, giving emphasis to the centre of interest and eliminating the non-essential; but it was also essential to the texture, to the relationship between the centre of interest and its surroundings, its position in space.

Further, there was the question of "colour." I have always thought that Flaherty's photography was outstanding for its "colour"; its gradations were such that you really felt you were looking at a polychrome image and not one in monochrome. This was ever of the greatest importance to him. His first use of panchromatic film in *Moana* was one big step on this road. His use of lenses the other. In spite of his often disparaging remarks about actual colour film, I have seen him very excited by it especially when he saw what could be done by closeups in colour. And also he was stimulated by the effect of colour in shadow, away from bright light. Many times he said he would like to make a film in colour. Basil Wright and I once took him to a Mr. Wagner, who lived near London and who had done a lot of colour-filming on 16mm in Central Europe. It was the first colour film which we had seen where the whites were white; all colour photography must depend and start from a proper value for white. Flaherty came back from that visit very enthusiastic and went straight round to Newman Sinclair's to ask about equipment. Then he went to the laboratories to ask about processing and if 16 mm stock could be "blown up" to 35 mm size. But unhappily nothing came of it.

His use of black-and-white photography depends on a full range of graduated tonal values. To obtain tonal values of this kind, the camera must have something to photograph which possesses these values. They are to be found particularly in the air, in the atmosphere. Now if you use a short-focus lens and get up close to your object, you are eliminating this surrounding air. You are reducing the amount of light-reflecting matter between the camera and the object so that the camera has nothing to photograph between itself and the object. The further you get away, the greater the amount of light-reflecting matter between you and the object. This can then be captured by the camera; hence the paramount importance of the long-focus lens.

We know that sympathetic camera-movement is far more difficult with a long-focus lens than with a short-focus one. Flaherty always said that the Akeley camera was the best camera in the world because of its wonderful gyro-head tripod with which you could pan with great smoothness with almost any lens. He was delighted

when he found a Vinten gyro-head tripod in England so that he could use the New-man Sinclair camera with its full battery of lenses. But the Vinten gyro-head gave a good deal of trouble at various times on *Aran*. It would get jammed and would start jumping for no apparent reason, except that it was possible that the sea-air and the sand might have got into its bearings.

All the time on *Aran*, Flaherty longed to be able to perform the most sensitive pan-shots with a 17 in. lens, which is no mean feat, and even with longer-focal lengths if he could find them. He would use a great deal of film in these experi-ments, since the flexibility of the camera was vital to him. Camera movement, he would say, was essential both to maintaining the centre of interest and also for creating that stereoscopic effect he so much desired by giving the feeling by move-ment that you were seeing *round* the object. Moreover, camera movement was vi-tal to collect the quality of the movement of the object, that same quality which Grierson remarked on when writing about the shots of the potters in *Industrial Britain*.

II. *A Note about Composition.*

For Flaherty, the horizon had to be either high in the frame or low in the frame, never in the middle. This, of course, is the elementary rule of classic pictorial com-position. But he preferred to exclude the sky altogether if he could unless he was shooting with a low horizon. It is all a question of the laws of dynamics, drama as he would call it.

For close-ups, his feeling was particular. He liked to bring his object close into the picture, to cradle it in the frame, with the most sensitive feeling for the centre of interest and excluding all that did not lead towards it. As far as human figures were concerned, he refused to shoot full-face at any time. The full-face re-vealed too much. The art of drama in a film according to Flaherty's tenets was to know how little you could show, never how much. A long-shot revealed too much and if used as a resolution shot, then it must be cut short before the full impact is felt, before the audience has time to take it fully in.

It will be remembered in the storm sequence in *Man of Aran* all the shots of the waves breaking against the cliffs and throwing up their spume of spray, these of necessity were either medium or long-shots. Every shot had to be cut off before the spume had reached its maximum, often long before, irrespective of the cutting rhythm. Many magnificent shots were rejected altogether because they revealed too much in themselves. The curragh in the seas: it would be hidden in the trough of a wave. In the instant that it could be seen rising behind the trough, the shot had to be cut off irrespective.

At the very end of the film, where it was necessary to slow down the tempo to allow the majesty of the scene to sink in, I had the utmost difficulty over many months to get Flaherty to allow those last four or five shots to play themselves fully on the screen until the spume rises up and hangs and then sweeps across the face of the cliffs with a white cloud hanging down from the dark sky.

"What will the audience get from this film?" he was asked once. His reply was characteristic. "Wanting to know more." The discussion about *Man of Aran* and the Aran Islanders that arose after the film delighted him. "I've got them," he would shout, "they're interested. They want to know more. They are angry with me for not

showing more. If I had shown them everything, they would not have discussed what they did not see. It is enough that I have aroused their interest."

That thought lay behind every shot, every scene, every camera-angle, every moment of screen-time. To arouse interest, never show more than you have to.

Such a ragged method of cutting, such a shortening of shots can, of course, lead to a very slow tempo, nervous and taut. That is the great danger, and in *Man of Aran* that danger was not always successfully overcome. In *Moana* there was a far greater ease, less nervous tension. I remarked on this to Flaherty once and he replied that the South Seas were full of ease, Aran was not. In this I think that there was an element of the same danger that Pabst fell into with his film *Westfront 1918* in which he confused his tempo with the boredom of war until the audience itself became bored. Let us suppose that the atmosphere of Aran was tense; I myself would question it, but let us suppose it to have been so. You would have so to present it that the audience is aware of the tenseness in the subject but not itself become too tense. —December, 1959.

Notes

Introduction

1. Ironically, her devotion to his memory caused her to neglect her own considerable accomplishments as writer, photographer, and diarist. This lack needs to be filled through the exhibition and publication of her photographs and the publication of the full biographical treatment she deserves.

Chapter 1. The North and *Nanook*

1. "Knobel had studied at Heidelberg and was now a recluse who loved to live alone in the wilds. Wherever he lived, he took his piano with him into the wilderness and was particularly fond of playing Chopin. He died years ago of pneumonia. He was in his 80s" (David Flaherty, letter to the author, August 21, 1959).

2. This account is a synthesis of two prerecorded radio talks (transcribed from telediphone records) made for the BBC in London, June 14 and July 24, 1949, in which Flaherty was interviewed by Eileen Molony.

3. Interview, August 15, 1957.

4. Transcribed from "Portrait of Robert Flaherty," a radio program comprising the recorded memories of his friends, devised and written by Oliver Lawson Dick, produced by W. R. Rogers, broadcast by the BBC on September 2, 1952.

5. Excerpts from letters to the author, April 5 and 10, 1958.

6. Extracts from these diaries can be found in Griffith (1953).

7. Eskimos have a reputation for remarkably accurate mapmaking. When compared with modern maps prepared as a result of aerial survey, the old Eskimo ones are astonishingly correct. Professor Edmund Carpenter lays special emphasis on this in his fascinating book *Eskimo* (1959). Thus when Flaherty eventually reached the Belcher Islands, he found that the maps given him earlier were far more accurate than the vague dots on the Admiralty maps, especially those drawn by the Eskimo named Wetalltok (Flaherty 1918b).

8. He had been provided with a thirty-six-foot sailing craft quite unsuitable for

this type of navigation. It is characteristic of Flaherty's art ideas to find a dramatic event like being wrecked thrown away in a single sentence.

9. Similar incidents are elaborated at length in Flaherty's novel *The Captain's Chair* (1938).

10. A fascinating, detailed account of these two hardy and remarkable Eskimo expeditions by Flaherty will be found in *My Eskimo Friends* (1924a) and in two articles in the *Geographical Review* (1918a, 1918b). They are also described by W. E. Greening of Montreal in an unpublished manuscript of the life of Sir William Mackenzie to which we have kindly been given access by the author.

11. Edmund Carpenter, then professor of anthropology, University of Toronto, in a letter to the author, May 24, 1959.

12. David Flaherty, letter to the author, June 29, 1959.

13. Presumably what would be called today camera magazines.

14. Letter to the author, January 27, 1958.

15. Letter to the author, August 21, 1959.

16. John Taylor and John Goldman, who worked as assistant and editor respectively on the film *Man of Aran* in 1932–34. Richard Griffith also recalls the story.

17. By specimens, we presume that he refers to the examples of Eskimo carving and drawing which he brought back from his journeys. His collection of 360 pieces, said to be one of the best in existence, was acquired by Sir William Mackenzie and donated to the Royal Ontario Museum in 1933. Some photographs of them appeared in Edmund Carpenter's book *Eskimo* (1959). Flaherty himself published in 1915 *The Drawings of Enooesweetok of the Sikoslingmint Tribe of the Eskimo, Fox Land, Baffin Island*, subtitled *These Drawings were made at Amadjuak Bay, Fox Land, the Winter Quarters of Sir William Mackenzie's Expedition to Baffin Land and Hudson Bay, 1913–14.* These drawing have been donated by Mrs. Flaherty to join the carvings in the Royal Ontario Museum. A half-hour film is, at the moment (1959) being made by Lawrence Productions, Canada. [EDITOR'S NOTE: the film was never released.]

18. A similar version also appeared in *Theatre Arts* magazine (New York, May, 1951) and a slightly different version was printed in the magazine of the Screen Directors Guild (January, 1951) under the title "Film: Language of the Eye."

19. In an interview with the author (January 13, 1960), Grierson gave this additional information: "When invited in Toronto, 1930, to the house of an old ex-film distributor who had turned furrier, he screened for me in his private projection room what could only have been the Harvard print of *Nanook*."

20. Martin Johnson was a big game and adventure filmmaker, whose approach to the cinema was the exact antithesis to that developed by Flaherty over the years.

21. The rushes are the first print made from the developed negative so that the filmmaker can see the result of his work projected onto a screen. In the United States, they are called dailies. Every filmmaker naturally wants to screen his rushes as soon as they are available.

22. Flaherty pursued this method of taking preliminary still photographs of types, architecture, landscapes, and the like on all his subsequent films. Often they were made by his wife. They have sometimes been confused with stills from the actual films.

23. Taylor in his *New Yorker* "Profile" (1949) says that Flaherty explained the reason for an Eskimo holding a photograph upside down was that previously he had only seen his reflection in a pool of water.

24. For this and subsequent diary extracts, we are indebted to Richard Griffith, who included them fully in *The World of Robert Flaherty* (1953) by permission of Mrs. Frances Flaherty. The complete diaries have not been published, but we have noted that extracts used by Griffith coincide exactly with the accounts in *My Eskimo Friends* (1924) which must therefore have been partly transcribed from the original diaries although the book does not state that they were.

25. "The Aivilik Eskimo are first-class mechanics. They delight in stripping down and reassembling engines, watches, all machinery. I have watched them repair instruments which American mechanics, flown into the Arctic for this purpose, have abandoned in despair" (Edmund Carpenter in *Eskimo* [1959]).

26. Lecture notes by Frances Flaherty, used on many occasions by her in North America and Europe, accompanied by extracts from her husband's films. (The lectures became a book, *Odyssey of a Filmmaker*, in 1960. ED.)

27. The copy screened for us by the National Film Archive, London, was black and white, but our memories tell us that when first seen the final night sequence, at least, was printed on blue-tinted stock. This was a common practice at the time; sequences were often printed on amber, red, or blue stock as thought appropriate to the story.

28. *With Captain Scott to the South Pole* was directed and photographed by Ponting and issued in two parts by the Gaumont Company in Britain, 1911–12. In the early 1930s, it was reedited, and a sound track added, and given the title *Ninety Degrees South*. A copy of this version is preserved in the National Film Archive, London, which also has the negative of the original films. An instructive comparison in method can also be made between *Nanook* with its primitive methods of production and the later Ealing Studios film, *Scott of the Antarctic* (1948), with its elaborate studio fabrication.

29. *Geboren*, Rothapfel, anglicized to Rothafel, known as Roxy, was one of the great early showmen in the United States. He introduced the three-console electric organ to cinemas, and when he revamped the Victoria Cinema in New York into the Rialto, he announced it as A Temple of Motion Pictures: A Shrine of Music and the Allied Arts. He died in 1936.

30. Notes to the author, January 4, 1960.

31. A similar theory is touched on by Frances Flaherty in *The Odyssey of a Filmmaker* (1960) but did not appear in her lecture notes upon which this pamphlet is based. Our own manuscript was made available to her in November 1959.

32. Edmund Carpenter, letter to the author, January 22, 1960.

33. Frances Flaherty, interview at Black Mountain Farm, Brattleboro, Vermont, August 17–23, 1957.

Chapter 2. *Moana* and the Pacific

1. Lasky first rated prominence as a producer with *The Squawman* (1913) directed by Cecil B. De Mille. His long chain of pictures for Paramount and later as an independent included *Zoo in Budapesth* [sic], *The Power and the Glory*, *Sergeant York*, and *The Gay Desperado*. In 1925 Paramount distributed *Grass*, a low-budget

film by Merian C. Cooper and Ernest B. Schoedsack about the migratory movements of the Baktyari tribe in Northwest Persia.

2. Notes to the author, January 27, 1960.

3. Considering the prestige accorded to *Moana*, it is curious that Lasky does not mention this historic utterance in his book.

4. Frances Flaherty's lecture notes.

5. Letter to the author, August 21, 1959.

6. The *Delhi Durbar* film was made in Kinemacolour in 1911, distributed by the Urban Trading Company, and first shown in London at the Scala Theatre in 1912.

7. Frances Flaherty's lecture notes.

8. Ibid.

9. Flaherty's preoccupation with the violence of the sea was not to find an outlet until the Aran film some ten years later, but Weinberg (1951) in his Film Index Series No. 6, says *Moana* had a subtitle *The Sea* (which is what *Moana* means in Samoan), although this does not appear in the copies of the film available for screening today.

10. Synthesized from the manuscript of *South Seas Story* and the BBC talk, August 29, 1949.

11. Flaherty noted that when he played a record of Caruso to the villagers, they found it very funny that a man should have to struggle so hard to sing (Grierson, personal communication, n.d.).

12. Frances Flaherty's lecture notes.

13. BBC talk, September 5, 1949.

14. In 1942 Flaherty sold a story about Fialelei to *Reader's Digest* for its "Most Unforgettable Character I've Met" series.

15. When viewing *Moana* for the purpose of reassessment, we noted that a few shots of the Siva being danced by the men toward the end of the film have a gray, flat, almost newsreel quality of photography as compared with the rest of the film. Mrs. Flaherty thought they were probably scenes taken on orthochromatic stock because there had been neither the time nor the opportunity to retake them on panchromatic film.

16. Letter to the author, August 21, 1959.

17. Interview with Newton Rowe, January 20, 1960.

18. According to Rowe (1930:149), Ritchie was director of agriculture.

19. Letter to the author, September 21, 1959.

20. Notes to the author, January 4, 1960.

21. This was the second version of the film, directed by Henrik Galeen, in 1920. Wegener had directed as well as played in the 1915 version. It was remade as a sound film by Duvivier in 1936.

22. David Flaherty's notes to the author, January 4, 1960.

23. Letter to the author, August 21, 1959.

24. Cf. *Man of Aran* and *Louisiana Story*.

25. Obituary notice, *The Reporter*, October 16, 1951.

26. Notes to the author, January 4, 1960.

27. Duplicate negatives are deposited in several of the national film archives and museums, and prints are available from these sources (see Appendix I). But this does not mitigate the act of vandalism by which the original negative of a historical masterpiece was destroyed by the Paramount Pictures Corporation.

28. Viewed in London, August 14, 1959, by courtesy of the Museum of Modern Art Film Library and the National Film Archive.

29. Herman G. Weinberg, Film Index Series No. 6 (supplement to *Sight and Sound*, published by the British Film Institute, May 1946). Flaherty collaborated on and approved this index. David Flaherty, in a letter to the author, January 22, 1960, writes: "I have found a clipping from the *New Yorker* in the early summer of 1927 which says that the Manhattan Island film was financed by Pictorial Clubs, an organization in which Mrs. Ada de Costa Root and Colonel Henry Breckenridge, with their business manager, Mr. Pearmain, are the moving forces."

30. Letter to the author, May 27, 1958.

31. It was shown by back-projection apparatus. Margery Lockett (see note 36 below) accompanied Flaherty to the first night.

32. Interview, January 13, 1960.

33. At nineteen Thalberg became general manager of Universal Pictures and in 1924 production manager for MGM. He died at the age of thirty-seven in 1936. Among many films associated with him were *The Big Parade*, *Ben Hur*, *The Good Earth*, and *Grand Hotel*. He is generally assumed to be the prototype of Monroe Stahr in Scott Fitzgerald's unfinished novel of Hollywood, *The Last Tycoon*. Industrious readers could do worse than consult Ezra Goodman's *The Fifty-Year Decline and Fall of Hollywood* (1961).

34. Letter to the author, November 2, 1959.

35. In his book *The Vagrant Viking* (1954), Peter Freuchen, for many years a close friend of Flaherty's, describes Clyde de Vinna as a tall, lanky fellow who was an excellent photographer and an ardent amateur radio operator (p. 237). Freuchen worked on the script of a later Van Dyke film, *Eskimo* (1931), for which was used a ship named, ironically, *Nanook*.

36. Interview, November 24, 1959. Miss Lockett was at the time an official of the League of Nations visiting the United States. She was later influential in the development of educational films in Great Britain, and the Flahertys saw her on their London visits.

37. In 1934 the *Sunday Referee* (London) published what it called an autobiography of Flaherty in seven installments (July 29–September 9), but it was almost wholly reminiscences of Arctic days that appeared later in his two books and was intended to publicize *Man of Aran*.

38. Letter to the author, September 23, 1959.

39. This total reversal in Murnau's attitude, from what had been up till *Our Daily Bread* a mind that visualized everything in terms of studio fabrication, to an interest in reality and natural surroundings, had its counterpart in his former collaborator, Carl Mayer. After seeing *Potemkin* in Berlin in 1926, Carl told me that it was as if a veil had fallen from his eyes. He came out into the street and saw life going on in front of him for the first time as cinema. It was after this that he had the conception of making *Berlin: The Symphony of a City*, but in which Ruttman deviated widely from Mayer's first ideas. Griffith believes that Murnau became infatuated with the wheatfields of Oregon and that his change of attitude stems from that experience. "Hollywood snowstorms are nothing but cornflakes," Murnau told David Flaherty.

40. A revealing sidelight on Murnau is provided by Carl Freund, who photographed several of his films in Germany, in Huff's Film Index No. 15, on Murnau:

One of the most interesting stories about Murnau's life was his friendship with Walther Spies, who lived on the island of Bali in the Dutch East Indies. Spies was an excellent painter and musician, good-looking, the son of a very fine Baltic family. Civilization at the end of the first World War proved too much for him, so he decided to run away from it all and start a new life in the Dutch East Indies. Murnau, however, could never forget Spies, and many, many times attempted to persuade Ufa to make a South Seas picture—naturally, so that he could again see Spies. While he came quite close to fulfilling that desire during the filming of *Tabu* in Tahiti, I don't think Murnau actually ever did see Spies again. Spies, who was known to all travellers to Bali, including Noel Coward, Vicki Baum and Covarrubbias, died as a prisoner-of-war when the boat on which he was being transported to a concentration camp was torpedoed during the second World War.

Covarrubias refers to Spies in his book *Island of Bali* (1937), and it is not without point that Murnau changed the name of his yacht, David Flaherty tells us, from *The Pasqualito* to the *Bali*.

41. Interview at Black Mountain Farm, August 17–23, 1957.

42. Among many documentaries, Crosby photographed *The River*, *The Fight for Life*, *The Land* (parts only), and *The Power and the Land*; among his many feature credits are *The Brave Bulls*, *High Noon*, and *The Wonderful Country*. He is one of the most accomplished realist motion picture cameramen in the United States.

43. Letter to the author, June 29, 1959. Two different versions of the story were printed in *Film Culture*, no. 20 (1960).

44. Letter to the author, July 31, 1959.

45. According to David Flaherty, in a letter to the author, August 21, 1959, the amount was $3,000.

46. "We had shot a scene with magnesium flares," writes David Flaherty, in a letter to the author, September 1, 1959, "and when the shooting was over Bob Reese tried to put one out by dousing it in the sand, which was almost fatal. He was terribly burned."

47. Rotha wrote to Richard Griffith, London, December 14, 1931: "Flaherty has been in London some time and I have been much in his company. *Tabu* was nothing more or less than I expected. It bore obvious traces of the Murnau-Flaherty conflict: the continual struggle between the studio-mind and the pioneer spirit. Its titling by Paramount was terrible and so also was much of the editing.· Flaherty seemed very much ashamed of many parts of it."

48. A similar experience took place in Germany in 1960. Walking along the Lange Reihe in Hamburg, I passed a very old shop, one of the few remaining after the bombing. A large picture frame hanging outside caught my eye—or rather four very familiar pictures in it. They were from *Moana*. Across them was printed BAMBO CAFFEE—Il Beste—DM 2.05. "Prestige," Bob might have said, "never bought anyone a cup of coffee."

Chapter 3. Europe, England, and the Atlantic

1. Later that year Zinnemann went to Hollywood as Berthold Viertel's assistant. Viertel, graduated from theater to the cinema, had made several artistic suc-

cesses in Germany, notably *Die Abenteuer eines Zehnmarkscheins* (The adventures of a ten mark note), and he officiated at Murnau's funeral. He later worked in London. Zinnemann had a long experience in Hollywood studios and later gained world repute with such films as *The Search*, *The Men*, and *High Noon*. His information about Flaherty was given in an interview in New York, September 1957.

2. Grierson, letter to Sir Stephen Tallents, December 31, 1951. Weinberg (1946) gives the same information and also quotes Flaherty as saying that "Germany is the most decadent country in Europe."

3. Interview with John Goldman, July 21, 1959.

4. The various models of the Newman-Sinclair camera, with many refinements and improvements over the years, played an important role in the technical story of British documentary. It was such a simple camera to operate that most of the directors soon learned to use it without employing a professional cameraman. Several hundred of these cameras must have been in constant use both on the home and combat fronts during World War II.

5. Interview, August 14, 1959.

6. Unpublished MS written by Sir Stephen Tallents in 1945, which was to have been a part of the second volume of his autobiography, of which only Volume 1, *Man and Boy*, had been published at the time of his death, September 11, 1958. The MS was left to Sir Arthur Elton, whom we acknowledge for making it available.

7. For this account of Flaherty on location in England we are indebted to an interview with J. P. R. Golightly, March 26, 1958.

8. Flaherty wrote in a very strange way. He clutched a pen or pencil between his first and second fingers, not as most people do between thumb and forefinger, and then wrote with his left hand somehow turned upside down.

9. This is the account as given by Grierson and Golightly; John Taylor had been sent to bed.

10. Interview, July 9, 1959. John Taylor, on the other hand, puts the film shot at twenty thousand feet in notes to the author, January 1, 1960.

11. Letter to Sir Stephen Tallents in connection with a memorial performance of Flaherty films by the New London Film Society in 1951.

12. Unpublished MS referred to in note 6 above.

13. Compiled from Flaherty's own account in *The World of Robert Flaherty* (Griffith 1953) and from the BBC talk, October 1, 1949.

14. Notes to the author, July 16, 1959.

15. The account that follows was written for us in July 1959.

16. Pat Mullen's account (1935) of Flaherty's arrival at Kilronan with a Mr. Jaques is incorrect. It may have referred to Flaherty's return visit in January 1932.

17. Notes to the author, July 1959.

18. Of the many sayings attributed to Pat Mullen, one of the nicest occurred when he pointed to a big stone beside the road and said to John Goldman, "The further a man gets away from that stone, the lesser he becomes." His daughter Barbara later married John Taylor and became a successful actress in England.

19. This account of finding Mikeleen, which is taken from Flaherty's radio notes and is corroborated in Pat Mullen (1935), does not square with Norris Davidson's record.

20. John Taylor refutes this story, stating that Pat Mullen fixed the deal in a pub with the boy's father.

21. This quotation and those following are drawn mainly from Flaherty's own account of the making of the film because it has not, so far as we can find, been reproduced elsewhere except in part in a BBC talk, October 1, 1949. We commend the reader to a full and very readable description of many incidents that took place in the Aran Islands in Pat Mullen's book (1935).

22. Notes to the author, January 1, 1960.

23. John Taylor's view is somewhat different: "In fact, it was Maggie who first recovered and called to the others to hold the net. Flaherty himself was at least 150 feet away on top of a cliff" (notes to the author, January 1, 1960).

24. J. Norris Davidson writes: "The Aran Islanders never turned back to harpooning themselves for the shark is valueless to them today (for fifty years they have used paraffin for illumination) but the people of Achill now catch them with nets and send them away to make fish-meal for fertilizers" (letter to the author, July 30, 1959).

25. Notes to the author, January 1, 1960.

26. It is interesting, to say the least, to compare Flaherty's revival of shark-hunting off Aran with his revival of Nanook's spearing of the seal and Professor Stefansson's remarks about same (1928).

27. Others of the group included Ian Dalrymple, Angus McPhail, Ivor Montagu, Robert Stephenson, and for a short time before going to the EMB Film Unit, Arthur Elton.

28. Notes to the author, December 17, 1959.

29. BBC recording made for the "Portrait of Robert Flaherty" but not used. Denis Johnston later wrote a play about his visit to Aran.

30. Notes to the author, January 1, 1960.

31. Notes to the author, December 17, 1960.

32. She is, of course, referring to his films from *Nanook* to *Elephant Boy* because subsequently he used ordinary commercial laboratories.

33. Although this statement is generally accurate, it does less than justice to the contributions made by such professionals as Osmund Borradaile, Helen van Dongen, Irving Lerner, and Richard Leacock, all of whom worked on Flaherty films. And there were others.

34. This, of course, is a common form of greeting among Catholics in Ireland, and, we are afraid, by no means peculiar to the unit making *Man of Aran*.

35. Notes to the author, December 17, 1959.

36. Letter to the author, October 2, 1959.

37. BBC "Portrait of Robert Flaherty," January 5, 1952 (Rogers 1952).

38. Notes to the author, December 16, 1959.

39. Notes to the author, January 1, 1960.

40. Notes to the author, December 16, 1959.

41. Notes to the author, July 16, 1959.

42. Notes to the author, December 16, 1959.

43. Notes to the author, July 24, 1959.

44. For example, Nanook fishing in a hole in the ice without the audience knowing what he is fishing for; the little boy searching for the crab in *Moana*; and many similar examples in *Louisiana Story*.

45. Notes to the author, January 1, 1960.

46. Notes to the author, December 16, 1959.

47. Lewis Milestone was the director of many films, including *All Quiet on the*

Western Front, The Front Page, and *A Walk in the Sun*; Albert Lewin, writer, producer, and director, was for many years associated with MGM.

48. Interview, December 12, 1959.

49. Its English length was given by the *Kinematograph Weekly* (May 3, 1934) as 6,832 feet (seventy-six minutes) whereas the American length is given by *Film News* (1953) on the film's nontheatrical reissue as 6,300 feet (seventy minutes).

50. Findlay says in an afterthought that of all the countless film people that it has been his job to publicize, Flaherty was the nicest by far (interview, August 14, 1959).

51. From July 29 to September 9, 1934.

52. We are obligated to John Goldman for these figures, to which he had access at the time.

53. Notes to the author, July 1959.

54. For more information we are indebted to J. N. G. Davidson and John Taylor.

55. Flaherty had described how the igloo was specially built in *My Eskimo Friends*, which was published in 1924, four years ahead of Stefansson's remarks.

56. Mrs. Flaherty's lecture notes.

57. Interview, August 14, 1959, and letter to the author, September 21, 1959.

58. *Observer*, May 6, 1934. Carter was the author of several books about the theater, especially the Soviet theater.

59. An oft-repeated phrase by Flaherty was, "All my films are only sketches . . . just an approach to what I hope some day to do, or what might be done by someone else."

60. As we have seen, Gaumont-British cannot be held responsible for the sharks!

61. If they risked no danger from the sharks, they did from drowning. John Taylor, a dauntless youngster, told us he refused a £5 offer from Flaherty to fall overboard among the sharks.

62. This accusation of fakery is disproved by eyewitness accounts. Bond also makes no allowance for the effect of using long-focus lenses.

63. Letter to the author, February 5, 1935.

64. The reference is to the international conflict that arose in the critical film world as a result of Upton Sinclair and Sergei Eisenstein's quarrel over the latter's unfinished Mexican film which Sinclair financed (Seton 1952).

65. Although we admired and respected Flaherty, we certainly did not "envy" him.

66. As was made clear in the foregoing account, this is an exaggeration of the facts.

67. Griffith does less than justice to Jean Vigo's *L'Atalante*, Renoir's *Toni*, and the Vassiliev "brothers" *Chapaev*, all of which appeared in 1934.

68. This was a mistaken belief. Flaherty's films were at no time "snubbed" or "ostracized" by the British documentary people.

69. Subsequently Griffith adds: "The scales fell from my eyes on a day when I was ushering at the Little Theater of the New York World's Fair in 1940 and was thus *forced* to see *Man of Aran* again. I sat through every performance for the rest of the week (notes to the author, December 21, 1959).

70. Letter to the author, June 29, 1959.

Chapter 4. India and the Elephants

1. We are indebted to Hayter Preston for this and other anecdotes.

2. For a superficial but readable account of Korda's life see Tabori's *Alexander Korda* (1959).

3. We are indebted to John Goldman for this story.

4. Frances Flaherty's 1937 book *Elephant Dance*, quoted at length here, consists in the main of letters written from India to her two younger daughters, Frances and Monica, who were at school in England.

5. Taylor says that the price paid to the Kipling estate was $25,000.

6. Letter to the author, August 13, 1959.

7. Borradaile had spent ten years as a laboratory technician, assistant, and operating cameraman in Hollywood with Jesse Lasky at Paramount before coming to England to shoot the exteriors for Korda's *Private Life of Henry VIII* and Zoltan Korda's *Sanders of the River*. He later photographed Harry Watt's *The Overlanders* and Charles Frend's *Scott of the Antarctic*.

8. Letter to the author, August 13, 1959.

9. Letter to the author, September 10, 1959.

10. There is confusion here: Mrs. Flaherty either means when they were writing "Bonito and the Bull" in Santa Fe, or when they rewrote the story, substituting an elephant for the bull, in Berlin in 1931.

11. This was Irawatha, the maharajah's favorite elephant, who had been chosen to play Kala Nag in Kipling's story. The Jemadar had trained him to lift Sabu in his trunk and place him up on his great back.

12. Letter to the author, March 11, 1958.

13. At the time the Flahertys could not have guessed how much quainter things could get, with model elephants' feet being deployed by trick experts in an English studio some months later!

14. Letter to the author, July 24, 1959.

15. Letter to the author, September 10, 1959.

16. Recording, July 19, 1952, as part of the BBC "Portrait of Robert Flaherty."

17. Presumably the footage figures are for cut length, not rushes.

18. Interview, July 24, 1959.

19. Letter to the author, September 1, 1959.

20. Collier was not told that Flaherty apparently suffered from having a surplus of half-finished scripts!

21. Letter to the author, September 1, 1959.

22. Immediately after *Elephant Boy*, Sabu was starred in *The Drum*, directed by Zoltan Korda.

23. Its length was given as 7,300 feet (eighty-one minutes) in the *Kinematograph Yearbook, 1938*. Its London opening was April 7, at the Leicester Square Cinema.

24. To set it in its historical perspective, that same year saw Renoir's *La grande illusion*, Pare Lorentz's *The River*, Joris Ivens's *The Spanish Earth*, Wellman's *Nothing Sacred*, Legoshin's *The Lone White Sail*, and Wyler's *Dead End*.

25. According to Wright, he was in Ceylon appoximately four months.

26. Letter to the author, March 11, 1958.

27. "The other night I sat up late into the night with Flaherty. . . . He says he will never make another film but has written a book about the Arctic. He is suing

Korda for his share of the receipts of *Elephant Boy*. He is just the same, talking without listening" (letter from Rotha to Eric Knight in the United States, April 28, 1938).

28. "The Story of Comock" was also recorded by Flaherty as a BBC talk in 1949 and reprinted in *The Cinema, 1952*.

29. Letter to the author, August 6, 1959.

30. Interview, June 25, 1959.

31. Letter to the author, August 17, 1959.

32. Letter to the author, July 24, 1959.

33. Interview, August 6, 1959.

34. A charming account of this meeting told by Madame Renoir in the BBC "Portrait of Robert Flaherty."

35. Interview, January 13, 1960.

36. Interview, June 25, 1959.

37. Interview, August 6, 1959.

38. Letter to the author, January 1, 1960.

39. Interview, January 13, 1960.

Chapter 5. United States and *The Land*

1. Lowell Mollett was actually the administrative head.

2. Letter to the author, May 22, 1941.

3. Russell Lord is the author of *Men of the Earth* (1930), *Behold Our Land* (1938), *Forever the Land* (1950), and others. From 1941 to 1954, he and his wife, Kate Lord, edited a quarterly magazine in Washington, D.C., called *The Land*.

4. Some confusion in dates occurs here: Lord implies that Flaherty was to be in Washington in June, whereas he did not leave London until mid-August.

5. In subsequent years, Lerner has directed several interesting "low-budget" films in Hollywood, notable among which was *Murder by Contract*.

6. There had been a script conference in Chicago between Flaherty, Russell Lord, and Pare Lorentz.

7. Albert Lewin recalls that once when he and Flaherty flew from London to Dublin, as soon as the plane left the ground, Flaherty wanted to get out.

8. This film was one of the finest Westerns to be made and contained some of the best of Wyler's direction.

9. Notes to the author, November 28, 1959.

10. After *The Land*, Helen van Dongen added to her reputation by much skillful editing of stock footage during the war (1951:329–30) and then edited *Louisiana Story* for Flaherty. In March 1950, she finished *Of Human Rights* for the United Nations Film Division and surprised the film world by announcing that she was retiring from it to marry Kenneth Durant. We gratefully acknowledge her kindness in making her notebooks available and also for many recollections she gave in an interview in her home in Vermont, August 21–22, 1957. [EDITOR'S NOTE: Some of van Dongen's recollections have subsequently been published—van Dongen (1965) and Achtenberg (1976).]

11. Letter to the author, October 12, 1959.

12. Notes to the author, December 16, 1959.

13. Arnell's recollection contradicts the credits on the film which state that Fritz Mahler conducted the score.

14. Notes to the author, December 18, 1959. In 1959, Richard Arnell wrote a

work for full orchestra entitled *Impressions—Robert Flaherty*, which had its first performance early in 1960.

15. The narration is the final version taken from the film as supplied by the Robert Flaherty Foundation, by whose permission and that of the author, Russell Lord, it is printed. A first draft was published in Lord's book (1950:29–36). Our description of the visuals is made from our own screenings of the film checked against the final recording script kindly loaned by Helen van Dongen.

16. These were stock shots, the only ones used in the film.

17. Notes to the author, December 16, 1959.

18. Notes to the author from Richard Griffith, August 12, 1959.

19. This copy remained intact in my vaults throughout the war, and I was deeply obligated to it and to Flaherty for a variety of shots that appeared in *World of Plenty* (1942–43) and *The World Is Rich* (1947–48), both of which dealt with the problems of world food production, distribution, and consumption.

20. This clash of viewpoint—often to occur in the history of documentary cinema—was the real cause of the violent storm that arose over British representation at the New York World's Fair in 1938–39. See chapter on this subject in my *Documentary Diary* (1973).

21. This problem is found in all copies of the film, 35 mm and 16 mm and was the first thing noticed when screening a new 35-mm fine-grain print in England in the summer of 1942.

22. Helen van Dongen confirms this opinion in notes to the author, December 16, 1959.

23. According to David Flaherty, Mrs. Flaherty regards November 12 as a memorable date: she was married on that date in 1914, she bought the farm on that date, and in 1951 a memorial service was held over Flaherty's grave on that date (Letter to the author, August 21, 1959).

24. Letter to the author, August 12, 1959. In May 1942, Griffith was assistant to the curator, Iris Barry, at the Museum of Modern Art Film Library, New York.

25. Among Capra's best-known films to that date were *American Madness, It Happened One Night*, and *Mr. Deeds Goes to Town*. He was originally a film editor. For a full account of early wartime U.S. official film activities see Rotha (1952).

26. Letter to the author, June 27, 1942. Knight had been co-scriptwriter on *World of Plenty* and was now working with the Capra unit in Washington.

27. Letter to the author, August 12, 1959.

28. Ibid.

29. Ibid.

30. Interview, January 13, 1960.

31. Letter to the author, September 23, 1959.

32. Viewed at the Museum of Modern Art Film Library, New York, September 1957.

33. Interview, New York, August 1957. As well as photographing the two great films of Jean Vigo, *Zero de Conduite* (1933) and *L'Atalante* (1934) in France, Kaufman also shot many admirably photographed films in the United States including *On the Waterfront* and *Twelve Angry Men*.

Chapter 6. *Louisiana Story*

1. Extracts from a leaflet issued by the Anglo-American Oil Company, Ltd., London, the British affiliate of the Standard Oil Company of New Jersey. This piece

in its entirety has been reprinted several times, including in Griffith (1953). We should remember that these notes by Flaherty were written for publicity and can give a fictitious impression of him, a fact of which he was not unaware.

2. Anglo-American Oil Company leaflet.

3. Interview at Black Mountain Farm, August 17, 1957. "Joseph Boudreaux is now married with several children and when we last heard was working with an oil-drilling crew in Louisiana," writes David Flaherty (September 21, 1959).

4. Earlier films of Leacock's were the *The Earth and Its Peoples* series for Louis de Rochemont Associates, Inc.

5. Notes to the author, December 21, 1959.

6. Helen van Dongen remarks that she has seldom known anyone who could steal so much sleep during the daytime sitting in a chair.

7. Helen van Dongen requests the important point to be made that her record is from an editor's point of view, not that of a director. She was also, however, an associate producer.

8. EDITOR'S NOTE: Van Dongen has apparently merged two names here. The boy's real name was Joseph Boudreaux. The name Flaherty gave him for the film was Napoleon Latour.

9. Cf. Nanook being taught how to spear a fish and the Aran men being shown how to harpoon sharks.

10. According to van Dongen, Flaherty got the idea of the frog and salt bag from one of the two books he read about the bayou country.

11. A still photographer sent down by Standard Oil to take production pictures.

12. Cf. Edward Sammis's previous account of his visits.

13. Helen van Dongen's figure is given in her informative article about the editing of *Louisiana Story* in *The Cinema, 1951* (p. 58). Flaherty's figure is given in the pamphlet referred to above. We regard the former as being correct.

14. In another version (Griffith 1953:152), Flaherty says: "'For God's sake, get out of here with those cameras!' he shouted over the noise of the gas."

15. Flaherty's method is, and was long before then, a common one when getting nonactors to speak dialogue.

16. They were never made. The footage is housed in the Flaherty Study Center, Claremont School of Theology, Claremont, California.

17. Among the films Thomson wrote music for were *The Plow That Broke the Plains*, *The River*, and, in collaboration with Marc Blitzstein, *The Spanish Earth*.

18. For the technically interested reader, there is a fascinating, detailed analysis of the editing of *Louisiana Story* by Helen van Dongen (1953); an analysis of Virgil Thomson's score is found in Manvell and Huntley (1957).

19. From Helen van Dongen's unpublished notebooks.

20. Interview, New York, July 23, 1957.

21. The tinkers sing the same song in *No Resting Place*, although we did not know it at the time.

22. This synopsis was compiled from Flaherty's BBC talk, July 6, 1949, produced by Michael Bell, and from our own notes on reseeing the film in 1957.

23. For the film historian, we note that contemporary with Flaherty's film were De Sica's *Bicycle Thief*, Gerassimov's *The Young Guard*, Meyer's *The Quiet One*, Kurosawa's *Drunken Angel*, Visconti's *Terra Trema*, and Reed's *The Fallen Idol*.

24. The length given in the *Kinematograph Yearbook, 1949*, is 6,300 feet (approximately seventy minutes); the copy preserved in the National Film Archive

is 5,854 feet (approximately sixty-five minutes); the copy held by the Robert Flaherty Foundation (now International Film Seminars) is 7,000 feet (approximately seventy-seven and one-half minutes). The National Film Archive copy is probably the version as shortened for United Kingdom distribution.

25. Letter from David Flaherty to author, n.d.

26. To suggest that "social realists" (which includes myself) deny the importance of poetry, Hamilton does scant justice to, say, the films of De Sica or Satyajit Ray, two of the most distinguished social realists in the cinema whose works are full of poetry, viz., the former's *Umberto D* and the latter's *Pather Panchali* trilogy.

27. This depends on the interpretation of the word "documentary."

28. Joseph Boudreaux became an oil driller; of Flaherty's other child stars, Sabu became a film star and Mikeleen, an itinerant soldier.

29. Oertel died in Wiesbaden, January 1, 1960.

30. From Helen van Dongen's unpublished notebooks.

31. Viewed in London, August 14, 1959, by courtesy of the Museum of Modern Art Film Library and the National Film Archive.

32. Among Huston's best-known films are *The Maltese Falcon, Treasure of the Sierra Madre, Red Badge of Courage, The Asphalt Jungle, The African Queen*, and two war documentaries, *Let There Be Light* and *The Battle of San Pietro*.

33. Interview, June 25, 1959.

34. These transcripts and the telediphone transcripts of Moloney's programs, made available through the kind help of the producers concerned, were drawn upon earlier in the book. The interview with Michael Bell was July 15, 1959.

35. Interview with Michael Bell July 15, 1959.

36. In the same article, it is stated that Flaherty "walked out undamaged" from the fire in his cutting room in Toronto in 1916, which we know to be incorrect.

37. Notes to the author from David Flaherty, September 23, 1959.

38. Document obtained from the Robert Flaherty Foundation. (EDITOR'S NOTE: now International Film Seminars, Inc. The collection today is housed in the Butler Library, Columbia University, New York.)

39. The same was true of British government film contracts during World War II.

40. On another page in the journal reporting on the formation of this company appeared the following news item: "Elephant Boy's Boy. Burbank, Calif.— Sabu Dastagir, famed star of Robert Flaherty's *Elephant Boy* and other movies, celebrated the forthcoming Flaherty Film Festival by presenting his own 'production,' January 2, at St. Joseph's Hospital here, where a son, Paul, was born to his wife, Marilyn Cooper, former stage actress."

41. The apartment at the Chelsea had been rented since 1945 and remained a pied-à-terre in New York until Flaherty's death.

42. Interview at Black Mountain Farm, August 17–23, 1957.

43. Letter to the author, July 27, 1951.

Chapter 7. Man and Artist

1. Letter to the author, February 1, 1960.

2. Letter to the author, July 24, 1959.

3. Notes to the author from John Goldman, July 24, 1959.

4. BBC "Portrait of Robert Flaherty," but not used in the program as broadcast.

5. Letter to the author, January 27, 1960.

6. Letter to the author, July 24, 1959.

7. Letter to the author, November 1, 1960.

8. This is confirmed by John Grierson, in an interview, January 1960.

9. Notes to the author, December 17, 1959.

10. Series of letters to the author, August 1959–January 1960.

11. It is interesting to note that in the various (and largely abortive) efforts to establish the twelve, twenty-five, or one hundred best films of all time, *Man of Aran* has frequently been listed but nearly always by foreigners.

12. Notes to the author, December 17, 1959.

13. Letter to the author, August 5, 1959.

14. Letter to the author, February 1, 1960.

15. Letter to the author, December 2, 1959.

16. Interview, August 6, 1959.

17. Letter to the author, February 1, 1960.

18. Recorded for BBC "Portrait of Robert Flaherty" but not used in the program as broadcast.

19. Ibid.

20. Ibid.

Bibliography

Achtenberg, Ben
 1976 "Helen van Dongen: An Interview." *Film Quarterly* 30 (2):46–57.
Anonymous
 1928 "Moana." *Close-Up* 3, no. 5.
Anonymous
 1942 "The Land." *Motion Picture Herald*, April 8.
Barry, Iris
 1926 *Let's Go to the Movies*. London: Chatto & Windus.
Belfrage, Cedric
 1932 "British Film Production." *Sunday Express*, June 19.
Bond, Ralph
 1934 "Man of Aran." *Cinema Quarterly* 2 (4):245–46.
Brown, Norman O.
 1959 *Life against Death*. London: Routledge.
Calder-Marshall, Arthur
 1963 *The Innocent Eye: The Life of Robert J. Flaherty*. London: W. H. Allen
 and Co.
Carpenter, Edmund
 1959 *Eskimo*. Toronto: Toronto University Press.
Carter, Huntley
 1934 Letter to the Editor. *Observer*, May 16.
Chatwode, Penelope
 1937 "Elephant Boy." *World Film News* 1 (11).
Danzker, Jo-Anne Birnie, ed.
 1979 *Robert J. Flaherty—Photographer/Filmmaker*. Vancouver: Vancouver
 Art Gallery.
Davy, Charles
 1934 "Man of Aran." *Spectator*, May 4, p. 697.

Davy, Charles, ed.
 1938 *Footnotes to the Film*. London: Lovat, Dickson.
Dent, Alan
 1951 "Man of Aran Revisited." *Illustrated London News*, September 8.
Dixon, Campbell
 1947 "Is Nanook a Fake?" *Daily Telegraph*, July 27.
Dobi, Steve
 1977 "Restoring Nanook of the North." *Film Librarian's Quarterly* 10:6–18.
Eisenstein, Sergei
 1949 *Film Form: Essays in Film Theory*. Edited and translated by Jay Leyda. New York: Harcourt, Brace.
 1959 *Notebook of a Film Director*. London: Lawrence and Wishart.
Evans, Ernestine
 1943 "Flaherty and the Future." *New Movies* (formerly *National Board of Review*) 13 (1).
 1951 "Obituary for Robert J. Flaherty." *Film News* 6 (8).
Evans, Walker
 1953 Review of *The World of Robert Flaherty* by Richard Griffith. *New York Times*, May 3.
Flaherty, David
 1937 "Sabu, the Elephant Boy." *World Film News* 2 (April).
 1949 Press Release for Flaherty Film Associates. *Screen Director* 6 (1):13.
 1952 "Tabu." *Canadian Newsreel* (Film Society Division of the Canadian Film Institute [May]).
Flaherty, Frances
 1937 *Elephant Dance*. London: Faber & Faber.
 1953 "Man of Aran." *Film Notes* 13 (3).
 1960 *The Odyssey of a Filmmaker: Robert Flaherty's Story*. Urbana, Ill.: Beta Phi Mu.
Flaherty, Robert J.
 1918a "The Belcher Islands of Hudson Bay: Their Discovery and Exploration." *Geographical Review* 5 (6):433–58.
 1918b "Two Traverses across Ungava Peninsula, Labrador." *Geographical Review* 6 (2):116–32.
 1924a *My Eskimo Friends*. In collaboration with Frances Flaherty. New York: Doubleday.
 1924b "Picture Making in the South Seas." In "Unusual Locations and Production Experiences." *Film Daily Yearbook*, pp. 9–13. New York.
 1934 "Autobiography." *Sunday Referee* (London), July 29–September 9.
 1938 *The Captain's Chair: A Story of the North*. London: Hodder & Stoughton.
 1939 *White Master*. London: Routledge.
 1942 "The Most Unforgettable Character I've Met." *Reader's Digest* 40 (March):14–44.
 1948 "Louisiana Story." *Time*, September 20.
 1949a BBC Talk. London. June 14.
 1949b BBC Talk. London. July 24.
 1949c BBC Talk. London. September 5.

1949d BBC Talk. London. October 1.

1950 "Robert Flaherty Talking." In *The Cinema, 1950*, edited by Roger Manvell. London: Penguin.

1952 "The Story of Comock." In *The Cinema, 1952*, edited by Roger Manvell. London: Pelican Books.

Freuchen, Peter

1954 *The Vagrant Viking*. London: Gollancz.

Goodman, Ezra

1961 *The Fifty-Year Decline and Fall of Hollywood*. New York: Simon and Schuster.

Greene, Graham

1937a "Elephant Boy." *Spectator*, April 16.

1937b "Reply to Basil Wright." *Spectator*, May 4.

1937c "Subjects and Stories." In *Footnotes to the Film*, edited by Charles Davy. London: Lovat Dickson.

Grierson, John

1926 "Flaherty's Poetic Moana." *New York Sun*, February 8.

1932 "First Principles of Documentary." *Cinema Quarterly* 1 (1):145–53.

1934 "Flaherty." *Cinema Quarterly* 3 (1):12–17.

1937 "Elephant Boy." *World Film News* 1 (12):5.

1938 "The Captain's Chair." *World Film News* 2 (5).

1948 "Louisiana Story." *Documentary Film Newsletter* 7 (68):108.

1951a "On Robert Flaherty." *Reporter* 5 (8):31–35.

1951b "Flaherty as Innovator." *Sight and Sound* 21 (2):64–68.

1951c "Flaherty." *ACT Journal* 16 (July–August).

1951d "Robert Flaherty: An Appreciation." *New York Times*, July 29.

Griffith, Richard

1942 "The Land." *Documentary Film Newsletter* 3 (2):27.

1949 "The Film Since Then." In *The Film Till Now*, edited by Paul Rotha. London: Vision Press.

1953 *The World of Robert Flaherty*. New York: Duell, Sloan and Pearce.

Hamilton, Iaian

1948 "Louisiana Story." *Manchester Guardian*, August 28.

Hamilton, James Shelley

1937 "Elephant Boy." *National Board of Review Magazine*, Summer.

Hardy, H. Forsyth

1934 "Films of the Quarter."

Hardy, H. Forsyth, ed.

1946 *Grierson on Documentary*. London: Collins.

Houseman, John

1951 "Flaherty." *New York Star*, July 15.

Houston, Penelope

1949 "Interview with Robert Flaherty." *Sight and Sound* 19.

Huntley, John

1957 "The Function of Music in the Sound Film: Scenic and Place Music." In *The Techniques of Film Music*, edited by Roger Manvell and John Huntley. London: Focal Press.

Huston, John
 1951 "Flaherty." *Sight and Sound* 21 (2).
 1952 "Regarding Flaherty." *Sequence*, no. 14 (New Year), pp. 17–18.
Jacobs, Lewis
 1939 *The Rise of the American Film*. New York: Harcourt, Brace.
 1949 "The Twenty-Four Dollar Island." In *Experiment in the Film*, edited by Roger Manvell. London: Grey Walls Press.
Kazin, Alfred
 1943 *On Native Grounds*. London: Cape Editions.
Knight, Arthur
 1949 "Art Films in America." In *Films on Art*. Brussels: UNESCO Editions de la Connaissance.
 1957 *The Liveliest Art*. New York: Macmillan.
Knight, Eric
 1952 *Portrait of a Flying Yorkshireman*. London: Chapman & Hall.
Kracauer, Sigfried
 1947 *From Caligari to Hitler*. Princeton: Princeton University Press.
Lasky, Jessie
 1957 *I Blow My Own Horn*. London: Follanz.
Lejeune, Caroline
 1931 *Cinema*. London: Maclehuse.
 1934 "Man of Aran." *Observer*, April 29 and May 6.
Lord, Russell, and Kate Lord
 1950 *Forever the Land: A Country Chronicle and Anthology*. New York: Harper & Brothers.
Losey, Mary
 1942 "The Land." *Documentary Film Newsletter* 3 (4).
Low, Rachel
 1949 *History of the British Film*. Vol. 2, *1906–1914*. London: Allen & Unwin.
Mullen, Pat
 1935 *Man of Aran*. New York: E. P. Dutton.
Murphy, William T.
 1978 *Robert Flaherty: A Guide to References and Resources*. Boston: G. K. Hall and Co.
Needham, Wilber
 1928 "The Future of the American Cinema." *Close-Up* 2 (6):48–49.
O'Brien, Frederick
 1919 *White Shadows in the South Seas*. London: T. Werner Laurie.
O'Neill, Brian
 1934 "Man of Aran." *New Masses* 13 (October 30): 29–30.
Paulon, Flavia
 1953 "A Brief History of the Venice Film Festival." In *Twenty Years of Cinema in Venice*, edited by The Management. Rome: Edizioni Dell'Ateneo.
Ramsaye, Terry
 1951 "An Obituary for Robert Flaherty." *Motion Picture Herald*, August 11.
Rogers, W. R. (producer)
 1952 "Portrait of Robert Flaherty." A BBC radio program, written by Oliver

Lawson Dick, comprised of recorded memories of his friends. (Some transcriptions are used in this book.)

Rotha, Paul

 1929 *The Film Till Now*. London: Jonathan Cape.

 1931 *Celluloid: The Film Today*. London: Longmans, Green.

 1934 "Man of Aran." *Sight and Sound* 3 (10):70–71.

 1936 *Documentary Film*. London: Faber & Faber.

 1952 *Rotha on Film*. London: Faber & Faber.

 1973 *Documentary Diary*. London: Faber & Faber.

Rowe, Newton

 1930 *Samoa Under the Sailing Gods*. London: Putnam.

 1956 *Voyage to the Amorous Islands*. London: Essential Books.

Ruby, Jay

 1979 "The Aggie Will Come First: The Demystification of Robert Flaherty." In *Robert Flaherty—Photographer/Filmmaker*, edited by Jo-Anne Birnie Danzker. Vancouver: Vancouver Art Gallery.

 1980 "A Re-Examination of the Early Career of Robert J. Flaherty." *Quarterly Review of Film Studies* 5 (4):431–57.

St. John Gogarty, Oliver

 1948 *Mourning Became Mrs. Spendlove*. New York: Creative Age Press.

Sammis, Edward

 1951 "Flaherty at Abbeville." *Sight and Sound* 21 (2):68–70.

Schrire, David

 1934 "The Evasive Documentary." *Cinema Quarterly* 2 (1):7–9.

Seldes, Gilbert

 1924 *The Seven Lively Arts*. New York: Harpers.

 1956 *The Public Arts*. New York: Simon and Schuster.

Seton, Marie

 1952 *Eisenstein: A Biography*. London: Budley, Head.

Sherwood, Robert

 1923 *The Best Moving Pictures of 1922–1923*. New York: Small, Maynard.

Siepmann, Charles

 1959 "Robert Flaherty—The Man and Filmmaker." In *Film: Book 1: The Audience and the Filmmaker*, edited by Robert Hughes, pp. 66–75. New York: Grove Press.

Stefansson, Vilhjalmur

 1928 *The Standardisation of Error*. London: Kegan Paul, Trench and Truber.

Synge, John M.

 1906 *The Aran Islands*, Dublin: Munsel.

Tabori, Paul

 1959 *Alexander Korda*. London: Oldbourne.

Taylor, Robert Lewis

 1949 "Profile on Robert Flaherty." *New Yorker*, June 11, 18, and 25.

van Dongen, Helen

 1951 "Three Hundred and Fifty Cans of Film." In *The Cinema, 1951*, edited by Roger Manvell. London: Pelican Books.

 1953 "The Editing of the Louisiana Story." In *The Technique of Film Editing*, edited by Karel Reisz. London: Focal Press.

1965 "Robert J. Flaherty, 1884–1951." *Film Quarterly* 18 (Summer): 2–14.

Weinberg, Herman

1946 *Two Pioneers: Robert Flaherty and Hans Richter*. Film Index Series, No. 6. Supplement to *Sight and Sound*. London.

1951 "A Farewell to Flaherty." *Films in Review* 2 (October): 14–16.

Wright, Basil

1937 "Greene and Elephant Boy." *Spectator*, April 23.

Zinnemann, Fred

n.d. "Reminiscences of Flaherty." In "Bob or Speaking of Robert Flaherty," edited by Gideon Bachmann. Unpublished manuscript.

Index